Contents

Acknowledgments

I AM ETERNALLY grateful to the individuals who spent time and shared experiences with me as part of the research I conducted for this project. Not only was their participation and engagement indispensable to the endeavour, my interactions with them have been life changing in more ways than I can describe here. This makes it all the more important for me to explain why I chose not to use real names in this book. As part of my research protocol, participants could let me know whether or not they were comfortable with being identified by name in future publications. This was one of the conditions under which I was able to conduct research about an industry in which issues of trust and exposure to criticism play a very important part. Some preferred not to be named, while others agreed to be identified. However, much of what each person shared with me, whether it was opinions, experiences, or practices, to some extent implicated other people, including participants who chose not to be named. Therefore, after careful consideration, unless the information is publicly available (as provided on websites, in publications, or on product tags, for instance), I have opted not to use individual and company names. I recognize and take responsibility for the fact that this may have caused certain voices, including Indigenous ones, to seem more anonymous than necessary, and that some people may have ideally preferred to see their words explicitly credited to them.

While readers will not have the benefit of knowing their names, I want to reiterate that each participant's singular contributions to this project were invaluable; I hope that what I have written will strike familiar chords with

them.[1] However, those who identify flaws in my analysis should understand that this book is not an attempt to have the final word on issues that are hotly debated both in the industry and in academia. On the contrary, I see this as my contribution to these debates – an analysis offered for critical engagement. As I go on to express my gratitude to all the other people who have supported me and provided feedback along the way, I also wish to take responsibility for any factual errors this book may contain despite my best efforts to fulfill my role as a guest and witness on the Northwest Coast by retelling what I have learned as accurately as I can.

At the University of British Columbia, I wish to thank Jennifer Kramer, Charlotte Townsend-Gault, and Anthony Shelton for their precious mentorship, as well as Bruce Miller, Patrick Moore, Sue Rowley, and Charles Menzies for their support at various points along the way. Among the many people from whom I learned about Northwest Coast art while at UBC, I extend special thanks to Aaron Glass, Karen Duffek, Pam Brown, Megan Smetzer, Alice Campbell, Eugenia Kisin, Mike Dangeli, and Mique'l Dangeli.

At l'Université de Montréal, I am indebted to my colleagues and friends in the Tapiskwan Collective, and in particular my supervisor, Anne Marchand, for their thoughtful engagement and ongoing support.

This research was supported by the Social Sciences and Humanities Research Council of Canada, and the Wenner-Gren Foundation provided crucial support during the writing and editing process.

Many thanks to Darcy Cullen and Ann Macklem at UBC Press for the care with which they guided me through the publication process. Thank you also to the two anonymous peer reviewers, and Sarah Wight, the copy editor, for their thoughtful recommendations and insightful comments.

I am delighted that Lyle Wilson agreed to the reproduction of his painting, *Raven Discovers Halibut Fishing*, on the book cover. This work is not only a perfect example of a thoughtful and striking incorporation of Northwest Coast art into the design of an everyday object, it also references one of the central themes of this book: local approaches to sustainable resource harvesting.

I am lucky that my family and friends have always been there for me; everything I do is made easier and more rewarding by their presence in my life. To say that publishing this book without their love and support would have been impossible is an understatement. Merci. Thank you.

Incorporating Culture

INTRODUCTION

(Giving) Back to "the way it should be"

JUNE 20, 2017. I am at my desk editing this manuscript, poring over my own words and wondering, one last time before sending them off to the press, what I can do to make sure that they do justice to what was shared with me during my fieldwork. Knowing the importance that "witnessing" holds in Northwest Coast societies, I don't take this responsibility lightly. An email from an Indigenous-owned artware company, Eighth Generation, drops into my inbox. It concerns the "giving strategy" for its new Inspired Natives grant and links to a blog post that reads, in part:

> Eighth Generation believes that art is like any natural resource; if we want it to thrive, we need to nurture the ecosystems, communities, and the people that are creating the resource. This is why we've supported countless organizations, community events, and ceremonies over the last few years ... This high level of community engagement and support – combined with our innovative, artist-centric business practices – is setting the gold standard for companies that invoke Native themes and aesthetics in their products. In short, we are proving that companies can support Inspired Natives, not "Native-inspired" – and still be profitable. And in a nod to [the] Northwest tradition of the Potlach, we aspire to give even more as our company grows.[1]

While I was one among many others on the company's mailing list to have received the message, the post's contents were so timely and so topical that I almost felt as if it had been sent to me as a personal confirmation, neatly summarized in one paragraph, of what I had witnessed while in the field: Indigenous artists and entrepreneurs pushing the Northwest Coast artware industry to nurture, rather than exploit, their cultural resources by mirroring the local potlatching economy and becoming centred on the values of responsibility and reciprocity. This book tells the story of how this is indeed becoming a "gold standard": not yet the way things are but an aspirational norm or, as one Indigenous entrepreneur put it, "the way it should be." My retelling of this long – and as yet incomplete – process takes us back a century, when the market was headed in a much different – some might even say in the opposite – direction.

◀ OVER

Culturally modified tree. When stripping bark from a tree, Pacific Northwest peoples remove only strips roughly the width of a hand to ensure that the tree will easily recover from the harvest.

In 1917, writing about "prehistoric Canadian motives," by which he meant the designs of the Indigenous peoples of Canada, anthropologist Harlan I. Smith suggested:

> These motives may be used as they are, or may be conventionalized, or dissected, or multiplied, or developed in several of these ways. Designers may use them as inspiration for designs which may be applied to fronts of buildings, gargoyles, fountains, terra cotta, pottery, china, ornamental work, cast-iron railings, stoves, carpets, rugs, linoleum, wall paper, stencils, dress fabrics, lace, embroidery, neckwear, umbrella, handles, belt-buckles, hat pins, book covers, tail pieces, toys, souvenirs, trademarks, and many other lines of work.[2]

Although Smith's advice was not followed by the Canadian industrialists of his time, close to a century later his vision for how and on what kinds of objects Indigenous designs could be used has become a reality – save for gargoyles, perhaps. In particular in the North American Pacific Northwest, one can find Indigenous motifs throughout urban and rural landscapes, adorning private spaces and public places, on clothing worn and objects owned by Indigenous and non-Indigenous peoples alike. Living in Vancouver, British Columbia, one comes across images and objects of Northwest Coast design on a daily basis. In continuity with the Indigenous practice of adorning objects of everyday life, Northwest Coast images are mechanically reproduced on countless decorative and utilitarian objects such as mugs, coasters, tote bags, T-shirts, scarves, jewellery, fridge magnets, chocolate wrappers, blankets, and pillow covers. The ever-increasing variety and sheer number of these Northwest Coast art-branded wares – which I call "Northwest Coast artware" – means that, in places like Vancouver, these are no longer reserved to aficionados who purposefully seek them out, but rather have become part of the fabric of life. At the neighbourhood coffee shop, the logo of the brewing company is a spirit bear. The person sitting next to you on the bus is wearing reading glasses bearing an eagle motif. At the bookstore with your children, you notice the Northwest Coast art storybook section. The earrings dangling from your physiotherapist's ears are cedar and abalone frogs. Coming back from a restaurant in Gastown, you pass the windows of several stores that sell Northwest Coast art. In the evening, your partner falls asleep in front of a movie while wrapped in a reproduction of a Salish blanket. Running along the Stanley Park seawall, you cross paths with a cyclist wearing a thunderbird-pattern hoodie.

Depending on how accustomed they are to seeing such images and how much they appreciate Northwest Coast art, Vancouverites may notice or ignore, admire or dismiss, stay silent or remark on them – but they are bound to encounter them. What is less clear, especially to the casual observer, is how many of these items are actually designed by Indigenous artists, as opposed to those that are merely "inspired by" the graphic design of Northwest Coast peoples. While this book focuses on examples in which Indigenous artists were involved, the market continues to generate many products without any Indigenous involvement at all. Indeed, a great number of companies do not work with Indigenous artists, and instead lift images straight from books or rely on the "Native-style" work of non-Indigenous designers. Even the companies that do work with Indigenous artists are seldom Indigenous-staffed, let alone Indigenous-run. This relatively limited Indigenous involvement in the artware industry has not only raised doubts as to the authenticity of these objects, but also spurred debates concerning the merits of Indigenous and non-Indigenous people working together in a field of business that some see as a risky form of cultural resource extraction.

Fragments of culture have long been transformed into commodities, local practices and identities placed at the centre of tourism ventures, and heritage work managed as a business. In the current era of what Jean Comaroff and John Comaroff call "Ethnicity, Inc.,"[3] culture is even more often regarded as a resource and discussed using the language of property.[4] However, there is a tendency to treat cultural commodification as primarily an issue of outside appropriation, with Indigenous peoples positioning themselves firmly against any and all commercial uses of their heritage. While such staunch opposition undoubtedly exists and is fuelled by past and current examples of misappropriation, cultural tourism and art markets have also long been considered as potential sources of income, pride, and cultural perpetuation for Indigenous communities.[5] As exemplified by the Northwest Coast artware industry, whether or not this potential is realized depends largely on how such markets are operated: by whom, for whom, under what conditions, and according to what values. Much as in the context of natural resource exploitation or bioprospecting,[6] the relationships and exchanges that come out of cultural commodification are varied and complex, and involve practices that are variably respectful of the integrity and renewability of the resources in question.[7] For instance, uses of Northwest Coast images without any form of Indigenous consent, compensation, or control are much more controversial and have different implications than previously negotiated, remunerated, and monitored uses of such images (although, to be sure, even these raise concerns).

This book examines how and why Northwest Coast artware industry norms are slowly shifting towards more implication of Indigenous individuals and greater respect for Indigenous laws and economic principles, and what this shift could signal for the future of Indigenous/non-Indigenous relations in the art market and beyond. The book's central thesis is that, as a result of the growing involvement of Indigenous artists, entrepreneurs, and employees in the artware industry, this market is progressively being infused with approaches to property, relationships, and economics that directly reflect the histories and cultures of the Northwest Coast's Indigenous peoples. As a result, the artware industry has been turning into an example of what I call "culturally modified capitalism": when the encounter between a capitalist market and the desire to protect culturally specific values and practices results in an economic system that remains recognizably capitalist and yet bears the marks of transformation by local worldviews. The concept of culturally modified capitalism highlights the reciprocal tension that exists between the use of capitalism as a means of perpetuating local cultures and, in turn, the perpetuation of capitalism by its integration of culturally specific values and practices. This conceptual framework is applicable to what has happened and continues to happen in a variety of other contexts, and thus provides a useful lens through which to further our understanding of cultural responses to and adaptations of capitalism around the world. However, it is undoubtedly an example of grounded theory.[8] It was generated through the study of a specific context, that of the North American Pacific Northwest, also known as the Northwest Coast, a region that has a particularly rich and fraught history of academic research, museum collecting, and interest from the art world, not to mention its deep entanglement in the politics and economics of resource extraction.

The Indigenous Peoples of the Pacific Northwest and the Idea of Northwest Coast Art

The region that anthropologists and others commonly refer to as the Northwest Coast corresponds to a segment of the Pacific coast of North America stretching from northern California to southern Alaska.[9] It is bordered by the Pacific Ocean to the west and by the Coast Mountains to the east. Though imperfect, these delimitations are not entirely arbitrary, since they reflect cultural differences and physical geography. Still, the designation of this space as an "ethnographic area" is also the result of intellectual and social processes to which anthropological studies have contributed considerably over the course of a century and a half of academic research.[10]

The Northwest Coast is arguably one of the most thoroughly studied regions of the world – from some of anthropology's founding figures such as Franz Boas and Claude Lévi-Strauss to twenty-first-century Indigenous scholars such as Mique'l Dangeli, Robin R. Gray, and Alexis Bunten.[11] Much of this scholarly work either focuses or touches on the institution of the potlatch and the material culture involved in these ceremonial exchanges, which are central to Northwest Coast spiritual life and social organization.[12] This book is no exception: it examines the relationship between the development of the artware industry and the age-old practice among Northwest Coast peoples of artistically adorning functional objects; it probes the link between the continued practice of potlatching and the development of an industry that enables the production, distribution, and consumption of large series of objects and images; and, last but not least, it shows how, in response to pressure to contribute to the well-being of Indigenous peoples, the artware industry is increasingly being infused with principles and practices that are typical of Northwest Coast potlatch economies.

This analysis is based on fieldwork conducted in the Greater Vancouver area, primarily in Vancouver itself and in North Vancouver, on the traditional and unceded territories of the Musqueam, the Squamish, and the Tsleil-Waututh. However, a good number of the Indigenous individuals I interviewed are affiliated to one or more other nations of the Coast Salish, Kwakwaka'wakw, Heiltsuk, Nuu-chah-nulth, Haisla, Tahltan, Haida, Tsimshian, and Tlingit.[13] More than a deliberate attempt on my part, this diversity reflects the urban Indigenous population. Since the 1950s, the city has attracted a great number of Indigenous individuals and families from across British Columbia and Canada, with a population of close to twelve thousand in Vancouver alone, and a little over forty thousand in the Greater Vancouver region.[14] In addition, Vancouver is one of the primary hubs of the Northwest Coast art market, giving artists who do not already live in Vancouver reasons to regularly visit and, in some cases, settle more permanently in the city.[15] Although faster modes of transportation, improved postal and other delivery services, and the development of electronic means of communication now make it easier for artists to remain based outside the city if that is their wish, many of the most prominent Northwest Coast art galleries and artware companies are based in Vancouver, which made it the ideal site for my fieldwork.

While I did not focus my attention on the artists of any particular Indigenous community, I did limit my enquiry to Northwest Coast art.

This expression designates the works, both historical and contemporary, that reference or make use of the "objects and ... stylistic conventions known [by academics] from the analysis of [the] native antiquities"[16] of the Indigenous peoples of the Pacific Northwest. This includes, but is not limited to, what art historian Bill Holm famously called "formline design" and the use of shapes he identified as U-forms, V-forms, and ovoids.[17] However, the region encompasses the territories of nations that have distinct histories, languages, and forms of cultural expression. As such, even though "Northwest Coast art" remains the expression of reference in both scholarly and popular publications on the topic, this label can be criticized for glossing over the particularities of the different styles it encompasses and, with these, the particularities of the peoples who developed them. This has been especially detrimental to the recognition and appreciation of Coast Salish art and design, which does not conform to the formline canon and was initially unfavourably compared to northern Northwest Coast art.[18] In fact, I have heard some Salish artists question the inclusion of their work under the umbrella of "Northwest Coast art" for this reason, arguing that the stylistic differences from the art of their neighbours are too important for their art to be subsumed into the same category – especially since the category was initially developed largely without regard to Salish aesthetic standards. This objection is especially significant given that Vancouver, where much of the Northwest Coast art market's activities take place, sits on Coast Salish territory. With this stylistic diversity in mind, in this book I have used the expression "Northwest Coast art" when discussing the region in general terms, but do so self-consciously in reference to the ideas that have come to be associated with this category over decades of study, analysis, commentary, and practice.[19]

Pacific Northwest Indigenous material culture and artistic forms are among the world's most collected, exhibited, and studied Indigenous arts, in that regard rivalled by only a few other regions, such as the American Southwest and the Australian Western Desert. Due to the thorough documentation and intensive collection of Northwest Coast material culture by anthropologists, missionaries, and government agents, Northwest Coast art quickly garnered international attention from academics and artists alike.[20] Since the early twentieth century, Northwest Coast designs have been used to represent British Columbia as a whole,[21] and even Canada's national identity.[22] Today, Northwest Coast imagery has become an integral part of the graphic repertoire of companies that wish to promote their products as

intrinsically "local" – at the level of this specific region or of the entire country, depending on the scale of reference. Pacific Northwest Indigenous people have met this use of their cultural heritage with a mix of pessimism and optimism. They have been very worried that these representational practices are yet another avenue of their peoples' dispossession in an ongoing "history of theft,"[23] and they have voiced these concerns very forcefully. Meanwhile, they have also seen a possible opportunity for cultural perpetuation and economic development in the face of assimilationist policies and extreme poverty. This book sheds light on this tension between cultural commodification as a threat and cultural commodification as a prospect, and the role Indigenous people have played in finding a balance between exploiting and protecting their own cultural resources in the context of an industry that is still currently dominated by non-Indigenous stakeholders. In that regard, the Northwest Coast artware industry exemplifies a struggle that many local populations around the world have faced and continue to face when it comes to the commodification of their resources, both natural and cultural.[24] For example, Cori Hayden notes that bioprospecting benefit-sharing agreements offer local peoples in Mexico "a double vision – prospecting as a promise/threat." B. Lynne Milgram argues that Philippine piña textile cooperatives rely on "capitalist relations of production to augment their livelihoods at the same time as they support extra-economic values, beliefs, and behavior." Jessica Cattelino explains that "Seminole crafts have been shaped by economic development initiatives and, simultaneously, have been a site for the production and consolidation of Seminole 'culture.'" And Jason Antrosio and Rudi Colloredo-Mansfield write that the work of artisans in Colombia and Ecuador "will not neatly measure itself in terms of a capitalist accounting of profit and returns on investment."[25] All these authors could have just as easily been writing about the experiences of Northwest Coast artists that are at the centre of this book. Even closer to the matter at hand, historian David Arnold's study of Tlingit fisheries showed that "a resilient cultural outlook allowed Tlingits to adapt collectively and as individuals to market capitalism while still maintaining important indigenous values [such as] social responsibility and reciprocity, allowing change and adaptation as well as cultural persistence."[26] However, one of the particularities of the specific example discussed in this book is that it concerns the production, distribution, and consumption of items that are a far cry from the food, medicinal plants, and handmade artisanal products that many typically associate with Indigenous peoples.

This book discusses a wide array of objects that could be construed as souvenirs, knickknacks, kitschy giftware, or commercial art, and indeed, I have frequently heard these terms used, sometimes almost interchangeably. However, none of these expressions fully captures the range and nature of the items in question, and many have pejorative connotations. In order to avoid these inadequate terms and be as specific as possible, I use the word "artware."[27] The word "ware" is a common suffix for different ceramic types classified according to variations in clay and manufacturing (e.g., earthenware, stoneware), as well as surface modifications such as glaze and decorative motifs (e.g., printware, lustreware). Beyond this specific usage, "ware" is also used in reference to a wide range of products, from computer programs (software) to wine glasses (stemware). As a suffix, it identifies objects of the same type, grouped in relation to the word to which it is affixed (e.g., kitchenware, or items used in the kitchen). In line with these various uses of the term "ware," I define "artware" as products that could be left blank but instead are decorated with an artistic motif. Thus, I group all wares that are adorned with Northwest Coast art under the category of Northwest Coast artware.

There is no denying that art and artware are not one and the same. Artware tends to be more affordable, portable, standardized, serialized, and one-size-fits-all than art. However, the artware industry is by no means impermeably separate from the art market. Most renowned Northwest Coast artists – Ellen Neel, Doug Cranmer, Tony Hunt, Bill Reid, Robert Davidson, and Susan Point, to name a few – have participated in the artware industry, and often still do years after they were heralded as among the best in their field. Much Northwest Coast art is made using technologies that are also used in the artware industry, such as etching, laser cutting, printing, and casting. Many of the materials used in artware are also among those used in contemporary Northwest Coast art, such as cedar, abalone, copper, and other metals, as well as glass, paper, and even plastic.[28] Most Northwest Coast art galleries carry a selection of artware items, while stores that call themselves gift shops often carry a selection of one-of-a-kind artworks. Also, in Vancouver, there is no clearly marked spatial division between the sale of artworks and the sale of artware. For instance, the neighbourhoods of Gastown and Granville Island, two of Vancouver's main tourism sites, are home to at least a dozen gift shops, but also to several of the most reputable Northwest Coast art galleries. Some sell expensive artworks side by side with their less expensive reproductions.[29] Finally, contrary to common belief,

the individuals who buy art and those who buy artware cannot be neatly divided into distinct categories: some art collectors routinely buy artware items, and tourists occasionally purchase artworks.[30] In sum, it would be a mistake to believe that there exist two parallel markets, one for Northwest Coast artware and one for Northwest Coast art, which is why this book inevitably concerns both, even if its primary focus is the world of artware. Arguably, excluding any mention of the art market from this book would have been as difficult as extracting a photographic subject from the setting in which it is being captured. However, by putting artware in focus rather than art *tout court,* this book brings attention to material culture that most authors usually only mention in passing, if at all.[31] And yet, not only do artware items play very significant roles in Northwest Coast societies – as sources of income, as potlatch gifts, as signifiers of identity – they also throw into relief the ways in which capitalism is usually neither adopted "as is" nor rejected in full by those on whom it is sprung by way of colonial encounters.

Capitalism(s) and Culturally Modified Capitalism

In general, it is difficult to say what exactly would constitute "pure" capitalism, and even more difficult to find a place in the world where such a model is actually being carried out.[32] Even in the most libertarian of nations, markets are affected by society and polity,[33] and everywhere the capitalist model is inflected by local beliefs, practices, and values.[34] As noted by anthropologist Daniel Miller, "the ideals of a totally free market, of a pure optimizing rationality choosing freely between utilities, etc., would seem quite bizarre to lay individuals reflecting on their own society."[35] Furthermore, a century after Max Weber discussed the relationship between the Protestant ethic and the rise of capitalism, the "spirit of capitalism" has found myriads of other "elective affinities," just as Weber himself imagined it could. Even what has recently been described as the "new" spirit of capitalism[36] is already being outpaced by still newer forms and practices. In fact, considering the variety of past and existing capitalisms, the unqualified and singular word "capitalism" may even seem empty of meaning altogether.[37] And yet, its prominent place in everyday vocabulary suggests that it does in fact carry meaning, if not as the attributes of one specific economic system, at least as a set of values and practices believed to be found across various iterations of the same model. Anthropologist Peter Luetchford has

argued that the concept of capitalism has come to be equated with the belief that, in order for the economy to work properly, the only imperative should be self-interest, an idea encapsulated in the ethos that "in looking after ourselves and disregarding the needs of others we promote general economic growth and paradoxically, everyone benefits." This conception of economic behaviour has thoroughly infused the ways in which the economies of the so-called West have been run, in particular since the 1980s with the ascendance of the neoclassical paradigm. The ethos of this model, explains Luetchford, "is one of personal achievement and merit, and it has become synonymous with the profit motive."[38]

Neoclassical or not, what most capitalisms have in common is, simply put, that the means of production are privately owned and are operated for profit. However, even such a minimal definition is not enough to clearly distinguish capitalism from Indigenous Pacific Northwest economies. For instance, anthropologists Charles Menzies and Caroline Butler have shown that Tsimshian society operates within a noncapitalist economy, and yet its kin-ordered social organization governs "ownership of, access to, and rights of use of resource-gathering locations," and the circulation of these resources involves "trade for economic benefit." What makes the Tsimshian system noncapitalist, they argue, is neither the absence of privately owned means of production, nor the absence of activities geared towards economic benefit, but the fact that the wealth produced through such activities in excess of personal needs is not meant to be accumulated or stockpiled as a means to restrict access to a scarce resource but should instead be redistributed.[39] This difference may seem subtle, and yet identifying and acknowledging such differences is crucially important when trying to understand the tension that exists between the determination of capitalism and the agency of local peoples around the world.[40] Paying close attention to a variety of such departures from the capitalist model, as well as what they mean to and for Indigenous peoples, is what has enabled me to depict the Northwest Coast artware industry with more nuance and depth than simply seeing it as the steamrolling of Indigenous cultures by means of hypercommodification.

At its core, this book argues that the interplay between Indigenous and capitalist models of the economy can give rise to forms of "culturally modified capitalism," that is, an economic system that emerges from efforts to use capitalist systems of production, distribution, and consumption to sustain local cultures and ways of life. I coined this concept with reference to the designation of culturally modified tree,[41] which is a tree altered by

Indigenous harvesting methods. For instance, Northwest Coast peoples harvest bark from cedar trees for weaving and other uses, taking only a narrow strip so that the tree is able to recover and can continue to grow. Trees with signs of such harvesting activities that occurred hundreds of years ago are still standing today, taller than they were then, demonstrating that the harvest was not a threat to their survival and growth. This care is what has allowed the practice to continue, as hundreds of cedar bark weavers today can attest it has. In other words, a culturally modified tree is a testament to the fact that something can be treated as a resource without disregarding its preservation and perpetuation. Similarly, culturally modified capitalism implies the adoption of business models that include provisions to protect and perpetuate the resources on which the market draws. Thus, culturally modified capitalism is not an alternative to capitalism per se, nor does it truly challenge the extraction of local resources for a global market; one could even argue that it merely amounts to a "culture-washing" of capitalism. However, it is nonetheless a manifestation of the belief that, in cases where participation in capitalism seems unavoidable, it may at least be possible to better harness it to sustain some aspects of Indigenous ways of life – but only on the crucially important condition that Indigenous stakeholders are able to bring their worldviews, values, and interests to bear on the market's configuration. The Northwest Coast artware industry has arguably started down this path, but it still has some distance to go before it can appease its detractors and shed its reputation of being rooted in unequivocal cultural appropriation and inequitable exploitation. Indeed, the Northwest Coast artware industry tends to be controversial to outsiders and conflicting for insiders. Given the breadth and depth of the damages caused by colonialism, the commodification of Indigenous heritage immediately raises questions of cultural appropriation and exploitation, even when it involves willing and active Indigenous participants. Chapter 1 sets the stage of this tense socio-political context, in which artists strive to increase their control over the market and Vancouver's artware companies attempt to (re)build trust with both artists and consumers. Each following chapter examines one of the specific points of friction that exist in the industry by way of the encounter of capitalism and Northwest Coast cultures.

In very broad strokes, the main features of capitalism are competitive markets, expansionism, private property, and capital accumulation. All these elements are present in today's Northwest Coast artware industry. However, it is also increasingly being shaped by pushbacks against each of these

characteristics by its Indigenous stakeholders. This pushback manifests in protectionist measures against outside and unhindered competition, mechanisms of local control to limit the market's globalization, pressures to recognize culturally specific regimes of property, and incentives to redistribute rather than merely accumulate capital. Each chapter of this book thus examines the frictions of capitalistic processes against local histories and cultures, and discusses how these are gradually shaping the Northwest Coast artware industry into a form of culturally modified capitalism.

In Chapter 2, I examine the history of the artware industry. The last century of this market's development has been defined by attempts to balance two objectives: promoting worldwide interest in Indigenous art to expand the market, while protecting this art against non-Indigenous misappropriation and international competition. This historical chapter discusses how, due to Indigenous participants' efforts to realize the industry's potential for economic development and cultural perpetuation in their communities, priorities have been progressively changing from expansion to protection.

However, as discussed in Chapter 3, one of the legacies of the artware industry's expansionism is that it brands its products as "local" by using Northwest Coast images, but largely relies on outsourced production and the global market of plain wares, such as mugs and T-shirts produced abroad. Counterbalancing this, local players are keen to keep control and maintain the Pacific Northwest as the market's central hub. This priority has placed limitations on the globalization of this market and encouraged stronger ties with local Indigenous artists. In consequence, much artware from Vancouver-based companies, while often produced at least partially elsewhere, still passes through a centralized distribution system located in the specific region it references.

And yet, as discussed in Chapter 4, most companies are not Indigenous-owned, and few of them hire Indigenous individuals for wages. In many cases, the involvement of Indigenous people is limited to artists who receive one-time payments or royalties for their design work. Most of these arrangements follow Canadian intellectual property laws and are often within overall design industry standards. However, Indigenous stakeholders do not always assess these business transactions as actually representing fair and appropriate remuneration because they scrutinize them in relation to Northwest Coast peoples' ongoing experiences of colonial dispossession and inequity, as well as their culturally specific notions of property and exchange.

Chapter 5 further discusses how the art market is considered an opportunity not only for individual livelihoods, but also for prosperity at the scale of communities. Beyond paying individual artists, Indigenous stakeholders have been urging artware companies to recognize the collective stakes of their business by "giving back" to Indigenous communities and organizations, monetarily or otherwise. This final chapter describes how such practices also help companies "make their name good,"[42] much as in Northwest Coast potlatch economies, where reputation and status is tied to wealth redistribution rather than accumulation.

The worldwide advance of capitalism tends to be seen as inevitably leading to the destruction of pre-existing local cultural, social, and economic systems. Most anthropologists, including myself, argue that many ethnographic examples show that this is not the case and instead demonstrate the ability of local cultures to bring their worldviews to bear on the capitalist system.[43] The extent of local peoples' agency in that regard is, in essence, what the concept of culturally modified capitalism aims to highlight. In this book's conclusion, I will use the example of the Northwest Coast artware industry to critically examine the implications of culturally modified capitalism, both as a concept – its aptness to describe how Indigenous peoples around the world are attempting to harness a system that is usually considered a threat to their ways of life in order to support their efforts of cultural perpetuation – and as a phenomenon – its potential to simultaneously threaten and reinforce these Indigenous peoples' economic and cultural sovereignty.

Producing a "Field" of Embodied and Discursive Practices

The methodology I employed was shaped significantly by the particularities of conducting research "at home,"[44] among people who do not really form a community but rather a tense, and not always trusting, network of business partners and competitors. Though initially challenging, collecting data in these conditions ultimately helped reveal the specificities of the world I was studying. For seven years, from 2006 to 2013, Vancouver was my home. During this entire period, I lived surrounded by Northwest Coast art and artware. However, my fieldwork more specifically spanned sixteen months, from January 2009 to August 2010, consisting primarily of archival research, participant observation, informal conversations, and ethnographic interviews.[45] As historian James Clifford has argued, any "field" must be "worked,

turned into a discrete social space, by embodied practices of interactive travel."[46] In this case, my interactions with artware industry participants created the social space of my fieldwork. Although the various people I encountered were involved in the same market, they were not all connected to each other via direct and sustained social interaction.[47] The people working in the artware industry are dispersed among their homes, private studios, offices, and warehouses. Although Vancouver as a whole is a hub of activity for the Northwest Coast art and artware market, there is neither one continuous district or neighbourhood where its activities are condensed, nor any discrete site that serves as this market's centre. The site to which I did consistently return, day after day, was that of my home – the backstage of my research, from which I made phone calls, wrote emails, took notes, and transcribed interviews. Thus my so-called "tent" was not set up in the middle of a "village,"[48] since there simply was no such village in which I could pitch it (not even in the sense of an urban neighbourhood, an institution, or as Kath Weston put it, a "village-as-corporate-boardroom" or a "village-as-scientific-lab"[49]). I was, however, able to conduct participant observation during a great number of public events related to Northwest Coast art, which occur weekly in Vancouver: exhibit openings, lectures, artist talks, and public discussions, as well as community events and ceremonies, arts and crafts sales, and trade shows. Attending these events allowed me to build up a list of contacts in the industry, and many of these initial in-person encounters ultimately led to further informal conversations and in-depth interviews.

Through these contacts, I was able to visit various studios, warehouses, and manufacturing spaces, which provided me with invaluable insight into the everyday practices of artware production and distribution. As with most behind-the-scenes access, some of the activities that take place in these spaces were closed off to researchers such as myself. This meant I was not able to observe some of the things I had hoped to see, such as start-to-finish artware production processes and in-person contract negotiations. Manufacturing processes often involve trade secrets, and third parties are seldom welcome at meetings in which contracts are discussed. In addition, research participants knew that I was going to be speaking with their competitors, and eventually write publicly accessible documents. They feared I might inadvertently share information not intended for public consumption. Some of my interlocutors explicitly raised the issue of confidentiality, and wondered about the consequences my research could have for their

livelihoods and relationships with partners and competitors alike.[50] Although it would have been interesting to be able to gain insight into certain practices from direct observation, the wide variety of first-hand perspectives I gathered through in-depth ethnographic interviews contained many important keys to understanding the industry's overall dynamics. In fact, the discourses I collected through interviews not only provide empirical data about certain practices, but are also practices in and of themselves. They are both a function of self-presentation, social differentiation, or political positioning, and also practices that produce the "world" in "worldview." Far from only being attempts at description or interpretation, what Michel Foucault called "discursive practices" also create the objects to which these descriptions and interpretations relate.[51] Thus, as well as interpreting the discourses I collected during my fieldwork within their context of reference, I also considered these discourses as directly constitutive of this context.[52]

In that respect, it is important to note that among the key characteristics of the industry at the centre of this book are the circulation of criticism and the constant making and unmaking of trust. For instance, my interlocutors repeatedly shared certain kinds of statements with me, including comparisons ("I do business in this way, whereas my competitor does it in this other way") and judgments ("This person is a terrible collaborator, whereas this other person is great to work with"). As well as potential indicators of differences in practices and values, these statements are also discursive practices that affect relationships between individuals and companies because of the reputational impact of these opinions and information. These discourses shape the reality of the artware industry and the climate of negotiated trust and distrust in which it operates, not only reflecting the industry's current "order" (who is who, who does what, who works with whom, and how), but also constituting a concrete way for industry participants to constantly shape and reshape this order by holding each other accountable for their values and behaviours.[53] For instance, an artist was contacted by an artware company owner about working on a collection of products, and in turn contacted a friend of his, another artist who had worked with this company for many years, to inquire about his experience and ask for advice. The friend discouraged the artist from taking on the project, saying that the company owner didn't always offer good rates and let too much time go by between payments. Interestingly, when I had previously interviewed this friend, he had assured me that this company was fair, supportive, and trustworthy. As far as I know, this company's practices had not significantly

changed since we had spoken, but clearly this particular artist's satisfaction with them had. Ultimately, his comments on the company owner's practices led the new artist to decline the offer to begin working with the company.

As this example shows, in the artware industry, discursive practices can be as constitutive (or not) of business relationships as business practices themselves. This point is key to understanding how much the artware world is the result of what people say and hear, in addition to what people do and experience. It is not that the "truth" of this world is relative, nor that "good practices" are merely a matter of opinion, but rather that any attempt to change the industry's configuration would fail without taking into consideration that the relationships that make it up depend on what its various stakeholders say and think about one another, perhaps even more than on what each of them knows and believes about themselves. After examining the roots of the particular role trust plays in the Northwest Coast artware industry in the first chapter, the rest of the book will show that some of the shifts that have been occurring in this market are due to Indigenous stakeholders demanding that their interests and worldviews be heard and better taken into consideration, *combined* with the importance for non-Indigenous stakeholders that their efforts to do so be reflected in what is said and thought about them (i.e., their reputational capital). As those concerned with social justice have shown, seeking to "have a voice" is about more than being able to represent your own experience to others; it is also about finding ways to improve that experience by instigating changes in the practices of others.[54]

Thus, this book tells the story of the Northwest Coast artware industry's transformation from a capitalist market dominated by non-Indigenous interests to an Indigenous-led effort to harness capitalist means of production, distribution, and consumption for the purposes of cultural and economic sovereignty. While this trajectory has been far from linear, and is even further from complete, it provides an example in which the "subalterns" of a market are able to "speak,"[55] while the circulation of what they say has helped them move progressively away from the subaltern positions which had been ascribed to them. This example has important implications for how relationships between Indigenous and non-Indigenous peoples will unfold in the future, in Canada and beyond. In a time when historical treaties are being closely re-examined, often revealing the Canadian government's failure to respect its own engagements, and when new treaties have been in negotiation in British Columbia for over two decades,[56] the stakes

of understanding how relationships are negotiated at an interpersonal level are higher than they may appear. For if we wait on governments to establish true nation-to-nation relationships before we examine what creates trust and respect between Indigenous and non-Indigenous individuals – as colleagues, business partners, neighbours, and citizens – we will have wasted precious time on the way to ensuring these relationships are centred on what Métis scholar Zoe Todd calls "loving accountability and reciprocity."[57] As this book will make clear, such is not yet the case in the artware industry, but many strive to have it recognized as "the way it should be."

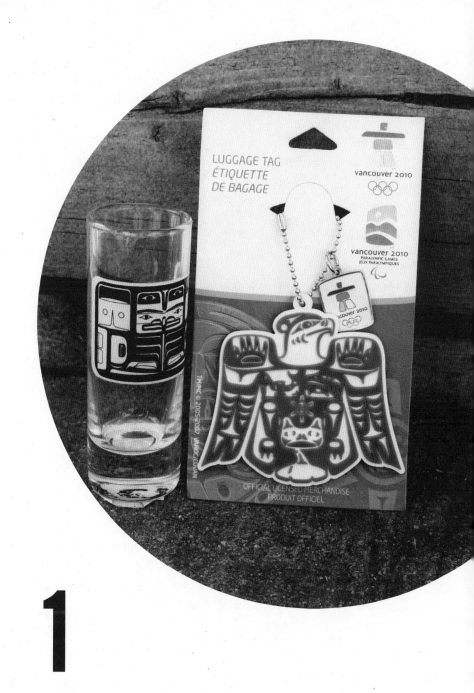

1

A Controversial Industry

IN THE PACIFIC Northwest, as in many other settler-colonial contexts, relationships between Indigenous and non-Indigenous peoples are complex and often tense. Whether they centre on natural resources or cultural heritage, business endeavours that involve Indigenous and non-Indigenous individuals are often affected by tensions that have grown from and tended to crystallize around difference. Canada's colonial history is filled with instances of relationships of interdependence going awry, as mutually profitable exchanges become exploitation. Today, some of the most controversial relationships involve resource extraction companies engaging, indirectly and directly, with Indigenous governments, often on terms that contrast dramatically with the level negotiations expected and in some cases promised in the early days of settler-Indigenous trade.[1] This has become even more apparent in the current context of British Columbia's provincewide land treaty negotiations and the "uncertain" political and economic environment this process is attempting to stabilize, largely in order to make way for large-scale private investments in relation to resources located on Indigenous territories.[2]

In the early days of exploration and later settlement in British Columbia, Indigenous people were indispensable partners and workers. As anthropologist Franz Boas put it, "Without them the province would suffer a great economic damage."[3] This undeniable dependence did not preclude the deterioration of the relationships between Indigenous peoples and settlers, primarily to the detriment of the Indigenous individuals whose participation and employment in the industries they had helped build progressively became more precarious and less remunerative.[4] This legacy lingers, and today not a week passes without news of a resource extraction project being proposed and reviewed, negotiated or imposed, supported or opposed. One only needs to browse the media coverage of these events to understand that, despite the legally sanctioned "duty to consult" Inuit, Métis, and First Nations governments,[5] many Indigenous people feel that their rights continue to be ignored and that their interests have yet to be truly taken into consideration, let alone become a priority. Among those who are dissatisfied with the current situation, attitudes range from wishing these resource extraction projects were true partnerships and involved fair benefit-sharing agreements, to believing

◀ OVER

Collaborating with Indigenous artists doesn't necessarily shield companies from being scrutinized, whether for the kinds of products on which they reproduce the images or for their association with mega-events.

Designs by Bill Helin, Tsimshian (glass), and Xwalacktun, Squamish (luggage tag).

that no collaboration or contract is worth risking Indigenous sovereignty and the environment, and fighting to stop them altogether.

Although they receive somewhat less media attention, similar debates also take place about the commodification of Indigenous cultural heritage. Despite the fact that the Northwest Coast art market would not exist if Indigenous communities had not developed their forms of cultural expression over centuries, this market quickly came largely under the control of non-Indigenous entrepreneurs. Situated in the wider context of Canada's "history of theft"[6] and the continuous process of dispossession it entailed, the commodification of Indigenous heritage is controversial, raising issues similar to those that surround natural resource extraction projects.[7] And just as neither all Indigenous nor all non-Indigenous people are unanimous on whether such projects should be stopped or under what conditions they should go forward, the artware industry's supporters and detractors are not neatly divided along cultural lines. There are both non-Indigenous and Indigenous individuals who denounce the industry as appropriative and exploitative, and both Indigenous and non-Indigenous individuals who see it as a positive and potentially beneficial opportunity. Some actively refuse to participate in it; others do so willingly.[8] In other words, among the various dimensions of social location (i.e., the position an individual occupies in society in relation to such factors as gender, age, race, or class[9]), cultural affiliation factors into but does not determine the positions individuals take in these debates. During my fieldwork, I frequently heard comments implying a fundamental distinction between how non-Indigenous and Indigenous people think and feel about the commodification of Indigenous heritage, sometimes accompanied by such stereotypes as that non-Indigenous people are inherently "greedy" or that Indigenous people are "maladapted" to the so-called modern economic system. These views not only draw on a culturalist, and at times racist, understanding of the world; they also tend to falsely represent Indigenous and non-Indigenous peoples as forming two distinct and homogeneous camps in this debate. As my fieldwork quickly taught me, the reality is much more complex. Instead of being the result of a battle between two distinct and mutually exclusive streams – pro- or anti-cultural commodification, with or against what Indigenous people want – the current configuration of the artware industry is the never complete and not always predictable outcome of "productive tensions" between a variety of possible positions and scenarios that are neither adopted nor supported along strict cultural lines.[10]

That being said, relationships between Indigenous and non-Indigenous participants in the artware industry are undoubtedly affected by cultural

difference and divergent historical experiences. In other words, while a strictly culturalist reading of individuals' values and behaviours[11] would be inadequate, the intercultural and historically situated nature of their relationships cannot be neglected when attempting to make sense of the incredibly tense context in which Northwest Coast artware is being produced, circulated, and consumed. In fact, taking into consideration the socio-historical context in which Indigenous and non-Indigenous industry participants selectively build relationships, and occasionally face off, adds an important layer to the analysis of the world of artware and the friction that is progressively turning it into an example of culturally modified capitalism.

Industry Participants and Stakeholders

I refer to individuals involved in the production, distribution, and consumption of Northwest Coast artware as "participants" in the industry. For the purpose of clarity, I reserve this term for those who purposefully and actively engage in its activities. Many other individuals (e.g., politicians, lawmakers, and scholars) affect the industry in less direct ways, just as the industry in turn affects and concerns more people than those who directly engage in its activities. I call anyone or any group whose interests are related to or affected by the industry a "stakeholder." These stakeholders do not need to have invested themselves or their resources in the industry in order to stand to gain or lose from its activities. Their perspectives on what participants in the industry do and how they do it are also important when trying to understand what shapes the values and behaviours of its participants, especially since these perspectives function as discursive practices that affect the industry's configuration, as explained in the introduction.

Given that the very existence of a Northwest Coast artware industry is directly based on the commodification of Northwest Coast images, Indigenous individuals and communities need not be participants in the industry to feel strongly that they are among its stakeholders. Indeed, when cultural products or practices are treated as a resource, they are often treated as "inseparable from the being-and-bodies of their owner-producers."[12] For this reason, without subscribing to a culturalist view, it remains useful to differentiate the industry's Indigenous stakeholders from its non-Indigenous stakeholders. This distinction does not signal the existence of two entirely separate, opposed, and organized interest groups. It bears repeating that a simplistic division along cultural lines does not hold up in the face of the variety of opinions and positions that exist among both Indigenous and

non-Indigenous people. However, this distinction does serve to acknowledge that certain practices affect individuals differently depending on whether or not they claim a direct connection to and responsibility towards the cultural expressions that are being commodified. The stakes of cultural commodification are indeed quite different, and arguably much greater, for Indigenous stakeholders than for their non-Indigenous counterparts. The risks associated with the commodification of Indigenous cultural expressions "gone wrong" – including misappropriation, misrepresentation, desecration, and cultural loss – are not borne equally by Indigenous and non-Indigenous people. A non-Indigenous person may care deeply about mitigating these risks, but the negative consequences of failing to do so would still fall largely on the Indigenous people whose heritage is being commodified. Similarly, the potential benefits of cultural commodification "done right" – such as accurate and respectful representation, fairly distributed resources, and growing cultural pride – are incommensurably more crucial to Indigenous livelihoods and ways of life than they are to non-Indigenous lives. Thus, a better future for all may very well depend on improving relationships and championing what Cree scholar Dwayne Donald calls "ethical relationality,"[13] including in business partnerships between Indigenous and non-Indigenous people. However, the history of colonial legislation and assimilationist policies that directly targeted Indigenous cultural expressions, as well as current power dynamics and realities, means that Indigenous stakeholders stand to gain or lose much more than do non-Indigenous stakeholders from the artware industry's present and future configuration. Consequently, the overwhelming representation of non-Indigenous individuals among artware industry participants is an understandable point of contention in the artware world.

Interpersonal and intercompetitor tensions exist in most if not all business environments, but only some are related to the kinds of friction that animate the Northwest Coast artware industry. None of my interlocutors were oblivious to the potential for tension between the industry's Indigenous and non-Indigenous participants, even when they themselves felt relatively impervious to it. In that respect, my intent is not to paint a picture of incessant, open, and direct conflict between each of the industry's various stakeholders. Some have developed strong business relationships, and even enduring friendships, in some cases because they hold similar positions about the state of the artware industry and, in others, despite diverging opinions. However, I was told on several occasions that one needs a thick skin in order to survive in this market, and that cultural identity factors into how one's values and practices are apprehended and evaluated by others.

One non-Indigenous company owner explained to me with regret that it seemed impossible to celebrate successes in the industry without reference to cultural affiliation: non-Indigenous successes necessarily seen as made "on the backs of" Indigenous people, Indigenous successes necessarily seen as a feat in the face of non-Indigenous opposition. He recognized that Indigenous artists encounter discriminatory attitudes on a regular basis, but wished that his own behaviour towards them, which he considered non-discriminatory, would shield him from the culturalist criticism that is regularly levelled against non-Indigenous industry participants. That this was not the case could be seen as a consequence of the tensions that afflict most intercultural milieus due to misunderstandings across difference and, too frequently, systemic inequality and discrimination. But some participants' distrust of this man, however founded or unfounded, also reflected his social location. As a non-Indigenous man whose company held one of the largest market shares in the industry, his position within the artware world was perceived as symptomatic of the larger dynamics that have placed non-Indigenous individuals at the helm of a market built on the commodification of Indigenous images. His position may make him vulnerable to unfair culturalist criticism, but also comes with significant levels of control, including over which images do and don't appear on artware, and what those images' creators receive in return. Even if he does not abuse this position, some consider it problematic that he has this kind of power in the first place. The fact that he is respected and well-liked by many of the people he works with is unlikely to change his critics' view, for their target is not necessarily him personally but rather the social figure he represents, that of a non-Indigenous person profiting from Indigenous culture.

In general, the distrust of non-Indigenous industry participants – even when unfounded with respect to specific individuals – stems from the existence of discriminatory behaviours in settler-colonial societies more broadly, and in the art market more specifically. Assumptions are commonly made about artists' behaviours and skills based solely on the fact that they are Indigenous. For instance, an artist told me how, as he was being paid for one of his works, the gallery owner told him not to "go drink the money away," although this artist has never struggled with addiction. It was also common knowledge a different (and now defunct) gallery would offer artists lower prices for their work if they appeared vulnerable, whether inebriated, in need of quick cash, or too inexperienced to hold their ground in negotiations. An artware company owner once told me that he does not hire

Indigenous employees because it would make things in his business "just too complicated," revealing a barely veiled racist perception of Indigenous workers as unreliable and unproductive.

Prejudice is perhaps most striking when it translates into such overtly discriminatory attitudes and practices, especially when their perpetrators do not seem to be concerned about repercussions. However, differential treatment of artists based on their identity can also take more subtle forms, including attitudes and practices meant to be socially progressive. For instance, a non-Indigenous retail manager explained to me that she carried products from a particular Indigenous company despite their low quality because she felt obligated to do so. Another retail manager similarly explained that, although she normally meets jewellers only by appointment, she makes exceptions for Indigenous artists who show up unannounced because she feels it is important to acknowledge their work despite their lack of organization. Whether interpreted as sincere expressions of respect, patronizing assumptions based on cultural difference, or a mix of both, these practices also show an awareness that non-Indigenous people are potentially exposed to accusations of disrespect and power abuse. These kinds of attitudes are not only aligned with their desire to counter structural inequalities; they also work pre-emptively to mitigate culturalist criticism that could be levelled against them as non-Indigenous individuals working in the Northwest Coast art market. In a sense, these are examples of what Eva Mackey describes as "recognizing difference" as a means to "manage" potentially tense relationships.[14]

As a result, however, some Indigenous industry participants have grown quite sceptical of others' goodwill towards them. For example, one artist commented on the support non-Indigenous industry participants expressed towards his career plans to develop his own line of artware products:

> There are a couple companies that really support what I'm doing. They make millions of dollars in First Nations art, and there are no First Nations people working for them, *but* they say, "Yes, I support you ... all I want to see is you being successful!" So I have a couple companies that say that, but really, talk is cheap.[15]

This artist's doubts as to the company owners' sincerity goes beyond the tensions inherent in any market competition. As mentioned above, the colonial history of systematic dispossession in the Pacific Northwest – from

land and resource dispossession and the scramble for objects and cultural knowledge, to the theft of people through disease, and of children through the residential school system and the Sixties Scoop – contributes significantly to the challenges of building relationships of trust between Indigenous and non-Indigenous individuals. Any practice that is or can be construed as a perpetuation of this violent history is almost inevitably ill received by Indigenous stakeholders and their allies. In this context, good intentions, and even a good track record, seldom translate into being given the benefit of the doubt. Trust must be continually earned, and in some cases, earned back.[16]

In sum, when Indigenous and non-Indigenous industry participants come together to work out common goals and sort out their competing priorities, they are not simply building business relationships and negotiating contracts. They are also grappling with the socio-historical legacies of Indigenous and non-Indigenous peoples' previous encounters, rendering the participants not merely representatives of their individual interests, but also differentially empowered stakeholders of more collectively borne interests. Therefore disagreements that may appear to stem primarily from the divergence of two people's views and priorities often also reflect, and are sometimes enhanced by, the tensions that animate the wider industry.

A World of Friction

Detailing his concept of "art worlds," sociologist Howard S. Becker explains:

> All artistic work, like all human activity, involves the joint activity of a number, often a large number, of people. Through their cooperation, the art work we eventually see or hear comes to be and continues to be. The work always shows signs of that cooperation. The forms of cooperation may be ephemeral, but often become more or less routine, producing patterns of collective activity we can call an art world.[17]

In other words, according to Becker, the relationship of interdependence between artists and other participants in the art world – which he describes as "an established network of *cooperative links*" – means that works of art are never the product of one person alone. And yet, notwithstanding his emphasis on the collective dimension of art-making, Becker also remarks that artists stand apart from other participants because without their unique

contributions, the art world would not exist.[18] The special role artists play in the Northwest Coast art market is well captured by one gallery owner's statement that "without these artists, we have no galleries, we have no collectors, we have nothing. So the most important thing is to support and encourage the artist." Becker's location of these artists at the core of a network, in direct and indirect connection with all its other participants, resonates particularly well with the position they hold in the Northwest Coast artware industry: their creativity is indispensable to the market, but they are also dependent on the work performed by those who turn their art into artware.

However, a few amendments to Becker's concept of "art world" are necessary in order to account for the intercultural and historical specificities of Northwest Coast artware production, distribution, and consumption. For instance, when arguing that artists are generally dependent on others to create artworks, Becker says little about how power differentials may shape artists' relationships with the other parties involved. In the context of the artware industry, such power differentials warrant consideration, as the interdependent relationship between artists and artware companies tends to be asymmetrical. During my fieldwork, I often heard concerns expressed by artists, and by others on their behalf, about how they are treated by other participants in the art market, and by some artware companies and gallery owners in particular. Although few would deny that these artists make essential contributions to the industry – the very "art" in "artware" – they are seen as standing at the front line of potential abuse within the industry. How does their important role not shield them from mistreatment by those who rely on their work?

Northwest Coast artists are usually free agents, rarely if ever locked into (or having the security of) long-term contracts with particular companies or galleries. They could be described as self-employed artists who also work as freelance designers in the artware industry. Usually they are paid a flat fee per design or royalties per item made or sold, two modes of payment I describe in more detail in Chapter 4. Thus when a relationship between an artist and a company lasts, this longevity is usually the result not of legal obligations but of interpersonal commitments. Artists rarely if ever have any official guarantee that a company will continue working with them beyond short-term contracts. Technically, this gives them the advantage of being able to work with whomever they want. However, this position can also be vulnerable: with dozens of other artists able to sell images on this

"free" market, artists are in constant competition with one another – and, at some companies, with non-Indigenous Northwest Coast–style artists. Thus, while Northwest Coast images are an indispensable ingredient of the Northwest Coast artware business, this does not mean that a company is dependent on the work of any particular artist. There are exceptions, such as when the company brand is built around a specific artist name, or when an artist is well enough known that his or her loss could greatly affect sales and company standing.[19] In general, however, although a company may need to access new Northwest Coast images, it can do so without being on good terms with each artist with whom it has ever done business.

Of course companies have both objective and subjective reasons to treat artists well, as some undoubtedly do: building stable business relationships, nurturing friendships, upholding their own ethical values, maintaining a positive reputation among artists, saving on the time-consuming activity of establishing working relationships with new ones, and so forth. As one company owner explained to me, when a conflict emerges between an artist and himself, he had rather not continue using their designs even if he owns the copyright to them. Despite not being legally obliged to do so, he felt that ceasing to use the artist's work was a way for him to show he respected their decision to terminate the relationship. It was arguably not in his interest to further upset artists, as even those who no longer work with him could easily harm his reputation. As one fashion designer put it, "In this business, you cannot afford to do something wrong; the word gets out and your reputation is tainted." The challenge, of course, is that not everyone agrees on what distinguishes doing business "right" from doing it "wrong."

Still, the overall power dynamics that govern artists' relationships with artware companies generally favour the companies. One reason is that there are far fewer companies than there are artists, and a company can run its business with several images from just a few artists, whereas an artist who wishes to generate a regular income through artware needs to regularly sell or license several images, year after year. In other words, even though companies often work with more than one artist and use more than one of each artist's images, the offer of Northwest Coast images still largely outweighs demand. This in no way dictates that companies will treat artists unfairly: just as artists are not automatically or necessarily in a vulnerable position in negotiations (i.e., artists being at a disadvantage), such a vulnerability will not automatically or necessarily be used to their detriment (i.e., buyers taking advantage of them). However, the supply-demand imbalance does

imply that, unless the artist is well off and well-known, the stakes of each company-to-artist negotiation tend to be higher for the artist than for the company. There are artists for whom a failed negotiation could mean not making rent that month, whereas for most companies it would typically mean merely having to pass on a specific image, or not working with one among many available artists.

In that regard, during my fieldwork, the figure of the struggling artist finding it difficult to make ends meet was often offered as a counterpoint to the well-off company owner making a fortune from the artware business. Of course, many artists are in stable and even comfortable financial situations, and company owners are not always as rich as they are thought to be. Still, several retailers and company owners discussed with me their awareness that some artists "live from piece to piece," counting on each sale to pay their bills, which sometimes makes it difficult to stand their ground in negotiations. For instance, an Indigenous consultant and entrepreneur described the negative experience of one of her friends:

> He took his design to a company to do art cards for him ... This company used the design, started selling it, didn't give him any royalties. He didn't even know about it until one day he happened to see his cards in a shop, went over there and they just treated him like "pfff" ... He was so frustrated ... He thought, "Well, what can I do, I'm just one little artist," and just let it go. Let it be. Didn't fight it.

At the same time, several industry participants – including fellow artists who felt it was important not to be always portrayed as victims – explained that artists should be held accountable for their decisions. For instance, one of them told me that he heard different artists tell stories where "it appears that they are taken advantage of, but you know, they are the ones that are putting themselves in the position to be taken advantage of, and then complaining about it after." Still, he recognized that artists can find themselves in particularly unfavourable positions, explaining:

> It's very tough for an artist to go in when they have bills to pay, and you know, they've got no money in their wallet, it's near the end of the month and they have to pay rent and whatever other expenses they have, and they've got this piece [to sell] ... I've been there myself. And it's just like ... it sucks. It's a terrible position to be in.

Not all artists rely on their artware design work to meet their basic needs, as was pointed out to me by a company owner about a very well-known artist with whom she creates artware. "He is doing totem poles that he is selling for over a million dollars," she remarked. "He's not thinking, 'Okay, well I need the royalties from selling these [items].' You know, he's in a position where he doesn't need that." However, not everyone has the experience, self-confidence, and means that these established artists can use to leverage artware companies' interest in striking a deal with them. In fact, some artists not only have less leverage, but are also hoping for a deal – any deal – in order to make a living and, only secondarily, a name for themselves.

Given the wide range of experiences and levels of agency among artists, it is important to understand that, beyond individual success stories, the underlying stakes of artists' relationships with artware companies are also collective. First, artists who are perceived to be too individualistic in the way they manage their careers, despite having made their culture the centrepiece of their livelihood, tend to be chastised for not putting their success at the service of their community. Second, when discussing what they considered unfair artist remuneration, several industry participants evoked the poor living conditions many Indigenous people endure on reserves and in urban ghettos. Given this situation of structural and systemic inequity, they argued, the artware industry should result in direct economic benefits for Indigenous stakeholders, above and beyond individual artists' payments. An Indigenous company owner mentioned that his desire to help alleviate the "abject poverty" some Indigenous families face was one of the main reasons he has made his company as focused on Indigenous interests as he could. Deploring the challenge of negotiating a "fair deal," one artist drew a parallel with how his people "get treated like second-class citizens in our own country ... putting our hands out." In his view, those buying his work needed not only to be supportive of him as an individual artist, but also, crucially, to contribute to improving the socio-economic situation of Indigenous people more generally. Non-Indigenous industry participants who fail to consider this as one of their responsibilities, especially as business people whose activities draw on Indigenous culture, tend to face heavy criticism.

Considering the existence of power imbalances between individual artists and the companies they work with, as well as the structural and systemic inequalities that characterize the settler-colonial society in which the industry

currently operates, the term "friction" is better suited to the ways in which artists and the other participants in the artware world engage with one another than Becker's "cooperative link." "Friction" is not exclusive of co-operation and does not necessarily imply conflict, but the term has the advantage of evoking the potential for divergent interests and unequal power relations, even between people who are working towards a common goal. I borrow the term from anthropologist Anna L. Tsing, who explains that "friction" does not imply the existence of open conflicts and unresolvable tensions but rather the complex engagement of different parties with one another, creating the points of contact that are necessary to the initiation of movement. In other words, friction is inherent to the interactions that make relationships move in a certain direction rather than in another. Friction, then, encompasses the "awkward, unequal, unstable, and creative qualities of interconnections across difference" that "can be compromising or empowering."[20] A wheel spins more easily before it grips the pavement, but "spinning in the air it goes nowhere"; only when "the rubber hits the road" – once the friction begins – can it provoke movement.[21] Thus, friction both moderates and generates motion, the direction of which is determined by the varying levels of pressure the different parties involved are able to exert. In the world of Northwest Coast artware, friction between the various and variably empowered stakeholders has both tempered and stimulated the development of the market.

Yearning for Change

In discussing the complexity of balancing priorities, one particular issue that was repeatedly brought to my attention during my fieldwork was the importance of making the artware industry not only treat individual artists fairly, but also better prioritize the interests of its Indigenous stakeholders. None of the industry participants I spoke to described their involvement in the artware industry as being motivated solely by the desire to serve non-Indigenous interests; in fact, all of them made a point of explaining what kinds of Indigenous interests their activities served, whether marginally or centrally, from expanding the appreciation of Northwest Coast art by non-Indigenous consumers to contributing to the well-being of Indigenous communities. However, many industry participants also stated that the market is a long way from benefiting its Indigenous stakeholders as much as it could. This observation, and the belief things should change, was, for

example, clearly expressed by a Tahltan artist: "It would be best that the money that the market creates stays within the Indigenous community ... Whatever formula needs to be established for that to happen would be the ideal way to go ... We need to find whatever model it is to achieve our end goal, which is to keep the money in the community." This particular comment focused on economic benefits, but a similar feeling was expressed by a Coast Salish artist with respect to obtaining more control over the art market, drawing a parallel with politics:

> It's almost like band office politics, where these positions of power are given to people who are from outside of the community, whereas what we need ... is to have people from within the community to be in the positions of power and make the decisions. The same can be applied to the art scene, for contemporary Northwest Coast artists.

Although such sentiments were expressed most strongly to me by the industry's Indigenous participants and stakeholders, they are not alone in thinking that the artware industry overall is seriously lacking in Indigenous involvement, as well as underserving the interests of Indigenous communities. Many of those with whom I spoke, including a good number of non-Indigenous stakeholders, believed that the scale of profit is tipped in favour of artware companies, which are usually owned and operated by non-Indigenous individuals. This sentiment was well articulated by a gallery owner:

> There are pros and cons to working with those companies on those reproduction pieces. You're able to get your name out there as an artist on a broad scale and very quickly, and then start working on commissions right away. But at the same time, it's obvious that the companies who are reproducing these pieces are making the bulk of the profits in comparison to the artists.

This gallery owner did not go as far as vilifying artware companies for this imbalance, and even encouraged young artists to work with them as a way to give their careers an early boost. At the same time, he felt strongly that artists should know exactly what to expect from companies in return, and be able to weigh monetary profits against other benefits and risks. Feeling at a disadvantage in the negotiation process due to inexperience, and

living through the experience of a company taking advantage of you, are not one and the same. Neither situation is ideal as they both imply imbalances of power; however, the point is that inequality does not dictate that one negotiating party must treat the other inequitably. Indigenous stakeholders' trusting this to be true is arguably crucial to the future of this controversial industry.

In fact, many of those I spoke to would like to see imbalances between Indigenous and non-Indigenous participants reduced, or even inverted, so that both real and perceived cases of abuse might cease to play such an important role in the industry and the relationships that develop within it. Although this objective has been present from the very start (as will be seen in Chapter 2), the yearning for an industry that better serves its Indigenous stakeholders, and that would therefore elicit less scepticism and opposition among them and their allies than it does, is slowly but surely gaining traction. The specific path to such a transformation is not always clear, as there is no real consensus on what means and alliances – or as the previously cited Tahltan artist put it, what "formula" or "model" – are best suited to this end. For instance, some Indigenous artware companies outsource production to overseas companies in order to enhance their market shares and profit margins, which can translate into a greater ability to support social and cultural initiatives in their community. In contrast, other Indigenous companies consider that keeping production local is the best way to contribute to the well-being of Indigenous communities, through such things as training and employing community members, who can in turn support their families and become role models for others. Some Indigenous entrepreneurs prefer to ensure that the money spent and made by their company be paid as directly as possible to Indigenous people, which means striving to employ Indigenous individuals exclusively; others believe that employing whoever is most qualified for a particular job, Indigenous or not, can mean increased profitability and, ultimately, a higher dollar amount in Indigenous pockets, even if this means non-Indigenous industry participants will have also earned some money along the way. No matter the path they have chosen, Indigenous company owners tend to think of ways to translate their involvement in the market into wider changes in industry standards, including in terms of encouraging others to redistribute wealth.

There are also different perspectives on the issue of non-Indigenous people's roles and legitimacy in the industry more generally. One non-Indigenous distributor explained to me that she tells company

representatives up front that she would not hesitate to replace their products with products that are made with a higher level of Indigenous involvement than theirs, even if it came at a cost for her business. Although she did not believe that the industry would be stronger without any non-Indigenous individuals involved at all, she also felt that it was part of her responsibility, as one of its many non-Indigenous participants, to encourage and reward increased Indigenous involvement through her business decisions. Her vision for the industry's transformation thus implies deeper Indigenous involvement but is nonetheless inclusive of non-Indigenous participants like herself. In contrast, an artist discussed with me his profound respect for a non-Indigenous company owner he worked with and even considered a friend, but said that all other things being equal, he would prefer to work with an Indigenous company. Even though he felt there was nothing wrong with the way this non-Indigenous company owner conducted his business and their relationship, he explained that in the long run he would prefer the industry to be run by Indigenous individuals. A Coast Salish company owner I interviewed took an even more radical stance. In his view, companies run by non-Indigenous individuals that purchase motifs from Indigenous artists for reproduction, but whose wares are not in any way produced by Indigenous individuals, and that do not otherwise work with Indigenous people, are extremely problematic. Referring to a non-Indigenous company owner, he stated: "The [owner's name]s of the world should not be able to participate in Indigenous art, even though they buy the designs. That's the extent of the Indianness in it, it's that [the owner] bought the design from a Native. Nowhere in that business is anything else done by a Native person."

To make matters even more complex, some of the non-Indigenous industry participants who advocate an industry that more greatly benefits its Indigenous stakeholders were specifically those whose practices were criticized by proponents of more radical change. To give but one example, a particular non-Indigenous company was widely praised as pioneering in its relationships with Indigenous artists, having significantly increased the market's connections to Indigenous people, as well as improving artists' recognition and promotion within the industry. Some of this praise came from artists who have been working with this company for years. From their perspective, the company has long been involved in changing the industry for the better. And yet critics of this company told me that artists working with it do not always receive satisfactory returns for their work in comparison

to the revenues from the products on which their work is reproduced; other critics complained that the company's reliance on products made abroad undermines the ability of others to keep their production local and still be competitive. Thus, while its owner and artists working with it see the company as instigating positive change, to its critics, the company is among those standing in the way of the industry's transformation. As this example makes clear, in the artware world, there aren't two "teams" fighting one another, one for change, the other against, but a much more complex set of formations that can at times make the field particularly hard to read.

It is thus against a complex backdrop of intertwined interests and goals that the industry participants and stakeholders I spoke to evaluate, critique, and promote certain practices, discourses, and measures over others – this even among those who have interests and goals in common. It is also with this backdrop in mind that they decide to instigate, nurture, modify, or terminate relationships with other participants in the industry. The same backdrop leads people to want this industry to develop even further, flourish, become more limited, or cease its operations altogether. Because of this complexity, it is difficult for stakeholders who want to see change in the industry to effectively make the "rubber hit the road" and set these transformations in motion in whatever direction they choose. And yet these complex interactions are nonetheless slowly but surely refashioning the industry into a form of culturally modified capitalism – a configuration that may not realize all their hopes and desires, but is nonetheless perceived as an improvement on what would exist without this kind of friction.

2

Expansion | Protection

THE ADORNMENT OF functional objects and clothing is an age-old practice among Pacific Northwest Indigenous peoples, and distributing large quantities of objects is central to their practice of potlatching. In fact, the Northwest Coast artware industry's development has arguably been greatly facilitated by the fact that, given the importance of potlatches, Pacific Northwest peoples are very familiar with the idea of producing series of items and exchanging them in large quantities. These ongoing cultural practices partly explain Indigenous people's participation in the artware market despite ever-present concerns surrounding misappropriation and unequal distributions of wealth. However, while the artware industry undoubtedly has an Indigenous precedent, the market as it currently exists is largely a product of the twentieth century and of shifting power dynamics between its Indigenous and non-Indigenous stakeholders.

In the first half of the century, just as Indigenous cultural practices were being officially restricted, some non-Indigenous academics and educators were encouraging the Canadian government to recognize Indigenous "arts," "crafts," and "motifs" as resources valuable not only to Indigenous peoples, but also to the young nation of Canada itself.[1] Thus, even while Indigenous ceremonial practices were targeted by repressive legislation – in particular through the 1884 amendment to the Indian Act, which banned the practice of potlatching – there was a push to further develop the non-Indigenous market for Indigenous objects. In the second half of the twentieth century, overt repression of Indigenous culture diminished, which meant that a range of cultural practices regained visibility after decades of having been driven underground. By then, marketers had already begun establishing Indigenous imagery as a distinctive marker of British Columbia,[2] largely without the consent or active participation of those whose images and symbols were being used. The lifting of the potlatch ban in 1951 worked to reinforce this use of Indigenous imagery, but also opened space for increased Indigenous involvement in and control over such marketing strategies. By the late twentieth century, the industry had grown considerably. Although it was still dominated by non-Indigenous stakeholders, it is around this time that it began to see a steady increase in the level of Indigenous participation and entrepreneurship.

◄ OVER
Over time, companies have increasingly worked directly with Indigenous artists, but some companies continue to showcase Northwest Coast–style images by non-Indigenous designers, as on this bathing suit and passport wallet.

Despite this heightened involvement, concerns about developing the market into a substantial source of revenue for Indigenous artists and communities have persisted to this day, with many calling into question the idea that a free, unregulated, competitive market could ever allow this to be the case.

In that regard, better protection of Indigenous cultural heritage against the misconception that it is part of the public domain and can thus be freely used is a prime concern to this day. In fact, while Indigenous people are no longer legally precluded from practising their cultures, the Canadian government has never moved to legislate against the imitation by non-Indigenous people of Indigenous arts.[3] Misappropriation of Indigenous cultural heritage, especially for profit, is increasingly considered reprehensible in the court of public opinion, but can only occasionally be brought before the Canadian court of law.[4] And yet, one of the problems most consistently discussed by the industry's stakeholders over the last century has been the need to provide greater support and protection for Indigenous artists against the appropriative practices of non-Indigenous businesses, both locally and globally. Meanwhile, various semi-industrial and industrial means of production and reproduction were presented as ways for Indigenous artists to more steadily supply the demand for affordable items. This move towards more industrialized methods spurred hopes that the art market could eventually fulfill its promise as a means of sustainable economic development for Indigenous communities, rather than only providing individual artists with sporadic supplementary income. However, industrial production has also fed into existing concerns that, in the absence of adequate protection and control, technologies of mass reproduction would mainly facilitate non-Indigenous uses of Northwest Coast imagery.

Thus, the following presentation of the artware industry's history places special emphasis on the simultaneous push for industrialization and pull of protectionism, and on the role played by Indigenous stakeholders in identifying and addressing these issues. In fact, the tension between expansion and protection is evoked with striking regularity in the discourses of most individuals and organizations involved in the Indigenous art and artware market over the last century.[5] Strikingly, some topics are discussed again and again in the archives, in particular the potential of technologies of mass reproduction and the development of authenticity labelling programs. On these subjects, the primary development over time – and one of crucial importance – is that, both in the content and in the tone of these discussions, Indigenous stakeholders are increasingly portrayed as *themselves* competent

agents of the proposed changes, as opposed to requiring "assistance" from the government and non-governmental organizations. In fact, as my research moved through the decades, the records I was studying began to include more and more Indigenous voices, and these voices seemed to be taken more and more seriously.[6] Unsurprisingly, these Indigenous stakeholders insisted from the beginning on the importance of taking part in developing the market and not losing control over it, an aspiration that is still present today with the industry's transformation into culturally modified capitalism.

The Market under the Potlatch Ban

1900s–1930s: Recognizing the Potential of Indigenous Art

The first explicit project of producing Northwest Coast art at a semi-industrial or industrial scale seems to date back at least a century. Historian Douglas Cole reports that collector George T. Emmons discovered a "Skagway 'manufactory' of Tlingit objects" as early as 1905, which could be one of the first instances of production-line organization of Northwest Coast art. Not much is known about this enterprise, except that it was "organized by an Alaska-California dealer" (who Cole believes might be B.A. Whalen of Alaska Indian Curios) and that it produced "masks, rattles, knives, pipes, and spoons."[7]

The promotion of the use of Northwest Coast forms as elements of fashion and design outside of Indigenous communities appears to have begun only about a decade later, when anthropologist Harlan I. Smith published an article in the magazine *Industrial Canada* titled "Distinctive Canadian Designs: How Manufacturers May Profit by Introducing Native Designs into Their Products." At the time, the First World War was limiting the supply to Canadian manufacturers of new designs, which they normally received from Europe. In his article, Smith proposed that "prehistoric Canadian motives," which he considered "unsurpassed in [national] distinctiveness," should be used by manufacturers to renew their design stock and develop Canadian trade.[8] Although apparently unsuccessful in convincing Canadian industrialists of the value of this opportunity, Smith continued to advocate for such uses of Indigenous designs. In 1923, he published *An Album of Prehistoric Canadian Art* under the auspices of the Department of Mines and the Victoria Memorial Museum. This album reproduced eighty-four images of museum objects, of which forty depicted figures from British Columbia (thirty-three plates for the coast, seven for the Interior). Edward

Sapir, then chief ethnologist in the Geological Survey of Canada (Division of Anthropology, Department of Mines), wrote a prefatory note to Smith's album that stated:

> Primitive motives have already yielded gratifying results in the field of industrial application though the possibilities of their utilization have as yet been barely tapped. This is due not so much to the inaccessibility of suitable material (museums and ethnological publications are crowded with valuable aesthetic suggestions) as to sheer inertia on the part of the industrial world and its failure to realize the fruitful possibilities that are inherent in so much of primitive art.

Sapir went on to invite Canadian industrialists and designers to mine "primitive" Indigenous art for inspiration, remarking that "an even greater wealth of artistic material lies ready to hand in the decorated handicrafts of the living Indians," which he noted were "readily capable of industrial utilization."[9]

In his own introduction to the *Album,* Smith reiterated the need created by the war for Canadian manufacturers to imagine new sources for designs, enjoining them to look to "prehistoric Canadian art," which had "been so little applied to modern commercial uses that almost all of it is new to the trades and useful to commercial artists." He also invited designers to consult publications by scholars such as John R. Swanton, Franz Boas, and George T. Emmons for images of "modern Indian specimens."[10] He remarked that "the designs that have been used are almost all based upon Greek, Roman, and other European art, and consequently are not distinctively Canadian." In his opinion, in order to be able to repay the country's war debt, Canada would have to "offer for export products of purely Canadian design." He further insisted on the "distinctiveness" of the designs presented in the album, stating that they cannot "be mistaken for the art of distant neighbouring regions, such as Mexico or Japan."[11]

Smith's assessment of Indigenous designs as "distinctively Canadian" disregarded the fact that many of the concerned groups' territories, including those of the Pacific Northwest, are artificially divided by the US–Canada border. Moreover, his model for the industrialization of Indigenous arts would clearly be led by non-Indigenous industrialists and designers, to their own benefit and to that of the state. Smith approached Indigenous arts from a different angle than that typical of efforts to "save" styles, techniques, and know-how that some feared were disappearing or being "corrupted" by

contact with settlers. Even though he called them prehistoric, in this instance he did not present them as relics that should be preserved by being left intact, but rather highlighted their adaptability in the hope of demonstrating their contemporary relevance, from both an economic and a nationalist point of view. Smith's call was effectively an invitation to appropriate Indigenous arts, with little consideration for the socio-economic and cultural implications such a practice might have for Indigenous people.

Smith's vision for the industrial use of Indigenous designs found one of its most fervent supporters in Alice Ravenhill, a British educator retired in Victoria. In 1927, Ravenhill received a request from the Women's Institute seeking help to adapt "suitable native tribal designs for reproduction on hooked rugs." To this end, Ravenhill reproduced designs on a variety of objects, including bags, book covers, purses, cushions, and rugs, selling them for a modest sum.[12] Around the same time, another notable resident of Victoria, Emily Carr, was also drawing attention to Northwest Coast art through textile work and other wares. Though not nearly as well-known as her paintings, a series of Carr's hooked rugs and pottery featuring Northwest Coast designs were exhibited at the 1927 *Exhibition of Canadian West Coast Art, Native and Modern* at the National Gallery of Canada, Ottawa.[13] Had these hooked rugs and wares been made by a different artist, they may very well have been rejected from an exhibition of this kind as merely "tourist art" because of the medium in which they were executed. Instead, along with Carr's paintings, they were hailed by Eric Brown, then director of the National Gallery, as "one of the most interesting features of the exhibition."[14] Commenting on Brown's claim that Northwest Coast motifs were for Canada's industry "an invaluable mine of decorative design" with the "unique quality of being entirely national in its origin and character,"[15] art historian Leslie Dawn writes that "the use of Native materials as a basis for nationally distinct commodities became an affirmation of capitalism and industry – that is, of Western economic values – rather than a potential critique. But it also assumed that the Natives, who were not cast as Canadians, owned neither their own culture nor their own lands."[16]

A newspaper review of the exhibition reiterated that "industrial leaders" should look to Northwest Coast art for "purely Canadian designs," paradoxically identifying industrialists as being "responsible for the death of the art" through their exploitative practices, while encouraging them to "profit from its demise."[17] Ironically, although the pottery and rugs presented by Carr in this 1927 exhibition foreshadowed the later use of Northwest Coast

designs in the artware industry, Carr did not support the idea that such designs be used "for ornamentation only" after having been "re-hash[ed] for the sake of decoration." In fact, she considered it an "indignity" of which she had herself been "guilty" when she had "put Indian designs on pottery where they do not belong"; a decade and a half later, she was advising, "let Indian art ... stop right there, rather than [turning it] into meaningless ornamentation."[18]

Taking quite a different stance from Carr's, in the midst of the Great Depression, Reverend George H. Raley put out another call in favour of the industrialization of Indigenous art. Raley had come to British Columbia to work as a Methodist missionary, and was the principal of the Coqualeetza Residential School from 1914 to 1935.[19] In comparison to Harlan Smith, Raley put much more emphasis on the idea that such an initiative might benefit Indigenous peoples, in addition to being in the interest of the nation. Using the patronizing language of the time, he wrote:

> Inasmuch as the Indians are the wards of the people of Canada, we are responsible for their welfare, economically as well as otherwise. The very fact that they are not free agents but living on Reserves carries with it the responsibility to provide them with a livelihood. We have a double responsibility to these, Nature's children, whom we have dispossessed of their aboriginal heritage.

Echoing Smith, Raley called Indigenous art "distinctively Canadian" and expressed an interest in what he called "Indian industries" so that Northwest Coast art could be "given a commercial value by means of a permanent market for tourists" as well as "linked with ordinary commercial industries and manufactures, and applied to many commodities of trade both ornamental and useful." Raley further argued regarding "the Indian" that:

> Until he is able to compete with the white man on equal terms and in the white man's industries, his thought should be of earning through his own peculiar and particular crafts. His opportunities for a living are becoming more restricted and he must be aroused to the possibilities of the industries of his fathers, which otherwise, although primitive and natural, will be lost to him in the near future and perhaps appropriated by other races as a means of livelihood.[20]

In other words, Raley believed that if Indigenous people were in a position to develop this industry themselves, they would be able to curtail attempts at appropriation. Indeed, Raley hoped that this industrialization of Native art would be primarily by and for Indigenous communities. He further hoped their enthusiasm to "produc[e] in such quantities as a growing market would demand" could be aroused through the prospect of adequate remuneration and the holding of "inspirational meetings" co-organized by Indian agents and "prominent chiefs" in order to garner "the cordial support and assistance of the whole community."[21] Like most other paternalist commentators on the subject, Raley also believed that this project could be achieved only with the government's active support.[22] That said, Raley did consider such initiatives not as acts of benevolence but rather as efforts that were owed to Indigenous people. In support of this idea, he cited financial reports showing that Canadians had "made thirty billion dollars ... off the country since Confederation, a country over which the Indian had undisputed right for thousands of years."[23] Still, as art historian Ronald Hawker has remarked, Raley's proposed "solution" to the poverty of Indigenous peoples was "confined by the colonial vision of First Nations people as lower-class labourers." Furthermore, his strategy depended on getting support from government bureaucrats, and thus fell short of challenging the structures of the system already in place.[24]

Indeed, Raley had trouble convincing government representatives of the benefit of supporting arts and culture in a province focused on primary industries, especially since industrial training had been one of Indian Affairs' goals since the late nineteenth century.[25] For instance, while Raley was working as an Indian residential school principal, the Indian agent for New Westminster refused to fund the teaching of "native handicrafts" in the school. This prompted Raley to write a lengthy letter reiterating his case and explaining that his use of the term "handicraft" had been "unfortunate":

> The meaning would have been obvious if I had used the term "Indian industrial arts" generally expressed to me, when applied to the Indians of the Pacific Coast, the whole range of cultural activities and industries. In other words, the washing, carding, spinning, knitting, weaving, carving, and bead work, with symbolic designs are "Indian industrial arts."

Raley argued that one of the main reasons these "industrial arts" should be "revived and continued" was that they could become "a commercial asset and

a means of livelihood to many people who, while not in danger of starvation, have to draw continuous relief from the Government of the country."[26]

It is thus not by chance that, in order to convince government officials, Raley chose to emphasize the industrial and commercial dimensions of his undertaking. He felt that what he called the "Indian problem" was essentially an economic one that progressive industrialization could help solve.[27] In this spirit, Raley helped write a resolution for the British Columbia Conference of the United Church of Canada recommending that Indian Affairs establish a "Canadian Indian Art and Handicrafts League." In Raley's view, such a league should, among other things: "save from extinction Canadian Indian arts and handicrafts"; "advise the native people to offer for sale only their best work, inasmuch as only good work, at as reasonable a price as possible, can establish a permanent market"; "foster the making of small attractive novelties and souvenirs of Indian designs as a means to capture a fair share of the tourist trade"; "by all legitimate propaganda to suggest that tourists purchase guaranteed Indian handicraft instead of spurious Oriental imitations"; "press for legislation which will protect Indian designs and artifex [sic] for commercial purposes by other than Indians"; but also – and this appears to contradict the previous point – "to interest manufacturers in Canada and abroad in the possibility of applying Indian designs ... to the decoration of luxury goods and ornamental and useful commercial commodities."[28] My research suggests that no such "league" was created by Indian Affairs at the time. However, one of Raley's admirers, educator Alice Ravenhill, would soon create a volunteer-run organization with very similar goals.

The lobbying of the government by non-Indigenous figures such as Smith and Raley (and later Ravenhill) to consider Indigenous "arts and crafts" as a valuable resource was a double-edged sword. On the positive side, they were giving the government reasons to maintain the material and visual culture of Indigenous people in public view, countering some of the erasures brought about by its assimilationist policies. However, arguing that such a resource could be used in Canada's nation-building project did not challenge the government's overall treatment of Indigenous peoples, which included repressive laws against the very practices to which these "arts and crafts" were intimately tied. This tension would continue into the next several decades.

1940s: Expanding the Market Outwards

In late 1939, Alice Ravenhill founded the Society for the Furtherance of BC Indian Arts and Crafts, in Victoria.[29] The society sought to promote the

teaching of arts and crafts to Indigenous schoolchildren, in hopes that it would increase Indigenous incomes. It also encouraged the industrialization of Indigenous designs as a means to promote Canadian identity internationally. Ravenhill outlined the goals of her newly founded society in her notes:

1) To arouse more interest in the Arts and Crafts formerly brought to great perfection by the Indian Tribes of B.C., which constitutes a valuable background to Canadian Culture.

2) The utilisation of these noteworthy designs for Commercial purposes, and to promote their use for Tourist "Souvenirs" in place of the inaccurate articles[30] now offered.

3) The encouragement in Indian Schools and among certain Tribal experts in the revival of their latent gifts of Art, Crafts, and Drama, with a view of improving their economic position, of restoring their self respect and inducing more sympathetic relations between them and their fellow Canadians.[31]

A craftswoman herself, Ravenhill was associated with the Arts and Crafts movement and worked closely with the Canadian Handicraft Guild.[32] She was also well aware of the efforts of Smith and Raley with respect to Indigenous art, and cited them both regularly in her pleas to government officials to support her society's initiatives.[33] In 1940, with support from Captain Gerald Barry (then inspector of Indian schools in British Columbia), Ravenhill was commissioned by Indian Affairs to prepare twenty large colour charts, accompanied by an explanatory handbook, to show examples of the "many forms of B.C. native arts and crafts for use in B.C. native schools."[34] Ravenhill selected the designs primarily from objects in the British Columbia Provincial Museum, with a few additions from private collections. The designs were then reproduced by Victoria artist Betty Newton, based on Ravenhill's sketches. Although Ravenhill sent the completed commission to Ottawa in early 1941, the charts' reproduction was stalled, apparently due to changes in priorities given Canada's involvement in the Second World War. Ravenhill took it upon herself to circulate them among Canadian universities, colleges, and libraries, as well as sending a few copies to the United States and England.[35] In 1944, the British Columbia Provincial Museum finally published an updated version of these charts as *A Corner Stone of Canadian Culture*.[36] The objective was to circulate the designs to Indian residential and day schools, because Ravenhill thought that

Indigenous schoolchildren's "art experience [would] be the demonstrable and initiative 'key stones' in their indigenous development," hoping that "some contagion from visual examples [would] trickle through to other subject phases of [their] education."[37] If Ravenhill was aware of the atrocities that were occurring in many of these schools across the country – mental, physical, and sexual abuse, as well as many other forms of trauma including death[38] – her correspondence with school and government officials showed no signs of such awareness. She imagined these schools to be environments in which students could receive a valuable arts education, including the graphic arts of their own people. Although she did not support cultural assimilation, her pleas often appealed to government and church officials' ideology of "modernization," arguing, "There is no reason why adaptation of crafts should not be made to modern demands if meanwhile characteristic Indian designs are utilized for their decoration."[39]

In 1942, the society sent a circular to schools across the province encouraging art education, including the "reproduction of tribal designs in needlework, knitting, weaving or rug making."[40] Acknowledging that these practices had Indigenous precedents, the circular stated that it was "desirable to acquire some insight into the past cultures ... of these people," including with respect to the "ornamentation of clothing, weapons, implements, utensils, etc." The circular also lamented that children were "adopt[ing] what they believe to be 'white man's' ideals, and need more encouragement to express their own ideas or to take pride in the former skill of their ancestors." Here too, the circular stressed that such efforts would be beneficial not only to the students and their communities, but also to Canada as a whole, arguing that it would eventually contribute to "future self-support [of Indian individuals] and to the national welfare."[41]

Some of the society's correspondents, however, were clearly concerned that Indigenous art education, even in the home economics format proposed by Ravenhill, was contrary to the assimilationist agenda of Indian Affairs. In her correspondence with government officials, Ravenhill remained consistently polite – and, at times, exaggeratedly deferential – but the friction between her and Indian Affairs is palpable, each small gesture of support for her initiatives counterbalanced by pushback against the society's aims. This was still the era of the potlatch ban, and the society's suggestion that pupils should be taught not only visual but also performative arts prompted a stern response from D.M. MacKay, then Indian commissioner for British Columbia.[42] Similarly, when Ravenhill wrote R.A. Hoey (Indian Affairs superintendent

of welfare and training) about arts and crafts education, his response was unenthusiastic. Much to Ravenhill's dismay, Hoey explained that he had recently spoken with anthropologist Diamond Jenness, and that although Jenness was interested in "promoting Indian arts and crafts" he was also:

> definitely of the opinion that our Indian day and residential schools should provide instruction in practical subjects such as boat-building, auto-mechanics, carpenter work and elementary agriculture for boys and sewing, dressmaking, crochet work, fruit preserving and elementary domestic science for girls.[43]

In addition, some schoolteachers were sceptical of their students' interest in learning Indigenous arts and crafts, while other teachers were altogether opposed to the idea. For instance, Inkameep Day School teacher and active society member Anthony Walsh wrote Ravenhill about his disappointment with the reaction of one of his colleagues:

> the new head of the Alert Bay School ... expressed great indignation ... He thought we were advocating a return to Paganism by encouraging Indian art and handicrafts. It is a tragedy that such a man is head of an Indian residential school ... If you get the opportunity of speaking with your Bishop on this matter, I hope you'll stress how important it is, that principals of Indian schools should have some understanding of present day conditions of the Indians of B.C.[44]

Thus, the society's objectives were seen as standing in conflict with those of Indian Affairs. However, as art historian Scott Watson has remarked, although the society's activities had an "emancipatory goal," they were also entangled with "more patronizing and assimilationist ideas" and some of their initiatives worked against Indigenous interests.[45] Rather than framing Indigenous artworks as the property of Indigenous people, themselves entitled to decide how to use them, the society treated the art as the public heritage of the British Dominion. For instance, the society discussed "Commercial Openings for Indian Art" in the following terms: "England also is desirous to secure original native designs from all the Dominion suitable for all forms of textiles. Specimens of B.C. art were sent in response to this invitation early in the recent war and were received with great approval as 'opening up a whole new line of art.'"[46]

Ravenhill had learned from an article in London's *Times Weekly* that English textile companies were eager to keep innovating and producing new designs despite the Second World War, so that the industry could remain competitive at war's end.[47] Ravenhill's self-congratulatory note of the "great approval" with which Indigenous designs were received in England does not consider whether English manufacturers taking advantage of such an "opening" would have sought the approval of the designs' Indigenous owners. British Columbia was clearly framed as remaining part of a colonial empire, an imperial connection made even more apparent by Ravenhill's explicit reference to West African designs published in the *Times Weekly* when arguing for the potential relevance of Northwest Coast designs to the British textile industry. Thus, even decades after British Columbia had become part of Canada, for some the Pacific Northwest remained part of a colonial imaginary that spanned territories across the world. In response to the *Times* article, Ravenhill had taken it upon herself to send reproductions of BC Indigenous designs to the Manchester Cotton Board, in hopes that textile companies would use them in their products. The board responded with interest, asking for additional coloured photographs in 1942.[48] However, as the demands of the war became more pressing, the board decided that it was no longer in a position to develop new products, and the idea to use the Northwest Coast designs sent by Ravenhill was dropped.[49]

Meanwhile, Canadian fashion designers were not waiting for the help of the society to find inspiration in the Pacific Northwest. In 1941, the Hudson's Bay Company informed Ravenhill that well-known sportswear designer Gerhard Kennedy had created a ski windbreaker with totem-pole inspired sleeves.[50] Other textile companies took the initiative of contacting the society directly. In 1944, the Montreal-based Regent Knitting Mills solicited assistance, eventually selecting four designs from a sample apparently sent by the society with Ravenhill's approval.[51] Arthur E. Pickford, honorary secretary of the society at the time, had written Ravenhill about this request, stating, "We place upon your shoulders the responsibility of deciding whether the placing of these designs in the hands of such a firm as the Regent Knitting Mills is in the best interests of the Indian [Cowichan] Sweater Industry of Vancouver Island in which our own Indians have so much at stake."[52]

Apparently, Pickford would have liked Ravenhill to limit her circulation of designs to products that would not be in direct competition with items already being made by Indigenous people themselves. In response to

Pickford, Ravenhill explained that she had thought the person who had contacted her, Jennifer L. Hobbs, was going to make personal use of the designs and that she did not know Hobbs was intending to send them to a large knitting company.[53] Thus, she seemed to set the limit elsewhere, between individual and industrial uses of the designs. Nevertheless, the society's proactive circulation of Northwest Coast images seemed to invite both kinds of uses, and the society took pride in being able to arouse interest in these Indigenous designs from various regions of the world.[54] However, Ravenhill liked to emphasize her regret that this interest seemed to be strongest outside of British Columbia.[55] She was intent on finding opportunities locally, sending images of her charts to Vancouver-based artist Jack Shadbolt, for example. Shadbolt replied with some enthusiasm, suggesting that Ravenhill get in touch with Grace Melvin, in charge of design and crafts at the Vancouver School of Art. Unlike Emily Carr (who had recently refused to join the society), Melvin was enthusiastic about the idea of asking students to create "art designs" based on "West Coast Indian motifs" for the purpose of decorating textiles.[56] In September 1945, works made by students of the school featuring such designs were showcased at the Vancouver Art Gallery. Having seen these works, Pickford was enthusiastic about what he described as "Indian Motifs as applied to Modern Goods." In his letter to the school's director, he remarked that most members of the public appeared to be of the opinion that these designs could be "blended ... into the stream of modern art developments."[57]

Initially so adamant that Indigenous designs were valuable to Canada (and, by extension, to the British Dominion), Ravenhill nevertheless ended up circulating designs to the United States. In 1942, Ravenhill sent samples of designs to artist Truman Bailey, hoping that he would find them "worthy of [his] consideration and employment" in his work for the New York company Everfast Fabric Co. Inc. The firm had previously used Quebec habitant designs in what Ravenhill considered "modern fashion," and she hoped it would be interested in doing the same with designs from the Northwest Coast.[58] In 1947, British Columbia's provincial librarian and archivist, William E. Ireland, received a request from a man named Don Adams for "suggestions of Northwest Indian patterns and designs which could be adapted to fabric designs" for the F. Schumacher Co. Inc. This was a New York textile company dubbed by Adams "the largest manufacturer and jobber of high grade drapery and upholstery materials in the United States." Adams complained that "the only Indian designs now available are those

of the Navajo and Pueblo Indians," remarking that "fabrics with [Northwest Coast] designs would be of great value to the decorators in British Columbia and the Northwest States of America for use in clubs, hotels, cafes as well as private homes."[59]

By sending design samples to such companies, the society was taking a paradoxical stance. On the one hand, the society insisted on teaching Indigenous children to create designs and manufacture objects as a means of promoting cultural and economic growth in Indigenous communities. Meanwhile, on the other hand, the society was sending examples of designs to non-Indigenous manufacturers of products that would eventually compete with the products made by Indigenous people themselves. The society cautioned that "the unique characteristics which distinguish our provincial Indian arts ... can never be reproduced by 'white' carvers and artists, however skilled in these arts."[60] At the same time, the society apparently saw no problem with non-Indigenous manufacturers *reproducing* designs created by Indigenous individuals, and even provided these designs to them. Thus, the society positioned itself as helping develop a market on behalf of Indigenous people, while making it more difficult for them to protect their art against outsiders' uses, providing a good example of what anthropologist Cori Hayden describes as "supposedly progressive practices that are actually reproducing old histories of piracy and colonialism."[61]

While apparently sympathetic to the idea of guarding some market share for Indigenous artists and the promotion of "legitimate Indian handicrafts,"[62] some of the society's policies also ended up placing more limitations on Indigenous production and creativity than on non-Indigenous appropriations of Pacific Northwest cultural heritage. For instance, in the late 1940s, the society began attaching its seal to products it considered "authentic." Enquiring about this seal and its use, Ruth M. Smith, editor of the newspaper *The Native Voice* (official organ of the Native Brotherhood of British Columbia) stressed the need for the seal also being used "to protect the Indian designs," stating that such protection was "sorely needed."[63] However, apparently the society's seal was in fact used to tag "the better pieces ... thus serving as a guarantee to the producer and setting a standard for the worker," and not to protect the designs themselves.[64] The only form of so-called protection performed by the society's tags could also be described as coercing producers to refrain from innovation: the society sometimes refused to place its tags on items using designs that it did not consider "truly Indian." For instance, "If [a basket] comes in with a rose or a butterfly, or some bird I've

never seen, I do not put the trade mark on it," explained the person in charge of marketing the works received by the society.[65] The society's authenticity label thus did little to discourage non-Indigenous producers from making Indigenous-inspired items. Instead, it attempted to discourage Indigenous producers from taking inspiration elsewhere than in what the society recognized as the repertoire of their ancestors.

The society also seemed to have a paradoxical attitude to mass production and reproduction. While it wanted to encourage the production of high-quality handmade goods, it recognized that, all in all, less expensive machine-made items tended to sell best, and thus were more likely to represent a real opportunity for economic development. For instance, in a letter to artist Nellie Jacobson of Ahousat about the kinds of items the society was interested in proposing for sale, Pickford remarked:

> It is better that you send us some of the smaller articles which will sell for a few dollars or even buttons which will sell for less. The people come and they look at the goods but unless they are rich they have not the money to spend on your best articles and they go away without buying, so we like to have a range of prices to suit everybody's purse.[66]

Thus, while the society wanted to see the production of "Indian arts and crafts" develop into a viable market, the organization worried that this might mean resorting to "factory methods of production."[67] Such an approach was contrary to its objective of encouraging Indigenous children and youth to acquire "skills and artistry" by learning their ancestors' techniques, steering clear of what they considered "cheap souvenirs."[68] This is perhaps why Ravenhill had insisted so diligently on encouraging schools to present their pupils with examples not only of objects but also of designs that could be "of commercial value" – if not directly to the pupils, perhaps to industrialists.[69] Arguably, *creating* such designs did not necessarily require students to use "factory methods of production," even if the companies that would later be encouraged to *reproduce* these designs might do exactly that.

The society's ambivalence towards Indigenous artists turning to more industrial methods of production was palpable during the 1948 Conference on Native Indian Affairs it organized with the University of British Columbia (UBC) and the British Columbia Provincial Museum. Addressing the conference's Indigenous participants in his introductory remarks, one of the organizers, anthropologist Harry Hawthorn, said, "It is from you, the Indians

of B.C.[,] that the best statement of your needs can come, and the others are gathered in the expectation of hearing this."[70] Still, during the session on "Arts and Handicrafts," the society's president, A.J. Tullis, UBC anthropologist Arthur E. Pickford, Vancouver artist Mildred Valley Thornton, and society member Mrs. J. Godman (all non-Indigenous) were invited to speak first, finally followed by Kwakwa̱ka̱'wakw artist Ellen Neel. In her now-famous speech, Neel stated, "If the art of my people is to take its rightful place alongside other Canadian art, it must be a living medium of expression." To this end, Neel asked that her people "be allowed new and modern techniques ... new and modern tools ... new and modern materials" without being accused of not being true to their culture. Neel said she saw potential for "applying this art to everyday living" by using it "to stunning effect on tapestry, textiles, sportswear and in jewellery" as well as "pieces of furniture," "public buildings," and "large restaurants and halls."[71]

The conference proceedings show that, even though Hawthorn claimed that the non-Indigenous participants were primarily there to listen to what the Indigenous participants had to say, many of them did not listen carefully to Neel's remarks. Neel delivered an ode to innovation; Mrs. J. Godman explained that she discouraged producers from exploring new designs.[72] Neel stated that she was a full-time artist and hoped more individuals would be trained to do the same; anthropologist Erna Gunther explained that she felt that "Indian art" was "a leisure time activity" and it was unreasonable for an artist to "depend on his art for his main support." Neel spoke of working as a team of carvers, using new technologies to ease and quicken production, and using designs on a variety of daily-life commodities as a means to develop the market; Indian agent H.E. Taylor warned against the perils of "mass production."[73]

In addition to being a well-recognized carver, Neel is often credited as the first artist to reproduce Northwest Coast designs for commercial purposes. In her Stanley Park studio in Vancouver, she and her family employed a line production system to create model totem poles, and she also experimented with serigraphy to reproduce her designs on textiles such as scarves.[74] One reason printing became so central in the development of the Northwest Coast art and artware market in the following years is that it is a technique that allows for multiple reproductions of two-dimensional designs at a reasonable cost and, when mastered, without reducing the graphic quality of the initial design. In many ways, Neel's approach was very much in line with what Smith, Raley, and Ravenhill had been advocating that Canadian

industrialists do. However, she was an Indigenous woman taking matters into her own hands, rather than turning over her motifs to an outside company. Although Neel's pioneering efforts were not rewarded by substantial financial success, her stance undoubtedly foreshadowed future efforts to turn a non-Indigenous-dominated Northwest Coast artware market into an Indigenous-led endeavour. Over the next decades, some of the barriers to this goal were taken down by Indigenous people's efforts to bring significant changes in Canada's overall sociopolitical climate.

The Market Post–Potlatch Ban

1950s–1960s: Acknowledging the Necessity of Protection

For arts and culture in Canada, 1951 was a pivotal year for at least two reasons. First, the ban on the potlatch was lifted through an amendment to the Indian Act. Second, the Royal Commission on the Arts, Letters and Sciences, chaired by Vincent Massey, finished conducting its nationwide investigation. The commission heard from many organizations, including the BC Indian Arts and Welfare Society and its affiliate, the Fraser Canyon Indian Arts and Crafts Society. Invited by the FCIACS to speak at the commission's hearings, Nuu-chah-nulth artist George Clutesi told the commissioners that, in his view:

> the Art of the Indians of British Columbia including the natives of the West Coast of Vancouver Island is something that ... should be kept. It should be preserved for future reference. It should be ... put where all the people can see it. It should be made so that all lay-men, together with a few people who take the trouble to delve into the means of this Art, could understand it.[75]

Clutesi's call for preservation and visibility was all the more important in that it was addressed to government representatives, after years of assimilationist laws driving Indigenous practices and cultural expression underground. These laws had previously made him wary of expressing public support for the potlatch, even as he continued to participate in potlatching himself.[76] The separation between art production and ceremony that the potlatch ban had forced on people such as Clutesi – at least while in the public eye – provides a frame of reference for his exchange with

commissioner Norman A.M. MacKenzie (then president of the University of British Columbia), in which MacKenzie sought to gauge Indigenous interest in the arts and crafts market:

> DR. MACKENZIE: Would the Indians be interested in producing or reproducing Indian Art on a commercial basis if it were saleable, or would they prefer to do it for its interest alone?
>
> MR. CLUTESI: It is just dawning in our minds – that is the Indian minds – that we must subsist on dollars. We can no longer shoot what we want in the woods. We can no longer pick what fish we want from the rivers. Therefore, it is only fair to say that he would be intensely interested if his efforts in the field of Art can be rewarded financially because he buys his bread and butter like the white brother.
>
> DR. MACKENZIE: So that if schools could be developed in which young Indians could be trained to produce these items for sale, there would be no objection to that from the point of view of the Indians?
>
> MR. CLUTESI: Absolutely none.[77]

After decades of the Indian Act's repressive legislation, Indigenous art was – at least in its public and government-sanctioned forms – coming to be seen primarily as a secular way of generating income. However, it was not yet seen as a source of economic prosperity in the form of a long-term, sustainable, market. In fact, in the Massey Commission hearings, Clutesi was highly praised for his artistic successes, but it was also noted that he made a living as a fisherman and not as an artist. The idea that a ceremonial resurgence could make it easier for artists to make a living from works commissioned for potlatching had apparently not occurred to government officials, perhaps because they believed the institution of the potlatch to be on its way out despite the recent lifting of the ban.

Up until the 1960s, the production and sale of "Indian arts and crafts" continued to be approached as a source of additional income, rather than a primary occupation. For instance, a 1955 report to the Department of Citizenship and Immigration, which at the time included Indian Affairs, written by a team of UBC researchers (including anthropologist Harry Hawthorn) noted that Indigenous people almost exclusively sought employment in industries such as fishing, logging, trapping, and farming, but that soon they would need to seek jobs in such fields as manufacturing

and services. Indeed, employment in the primary industries was declining due to mechanization and the progressive "depletion of resources."[78] The authors explained that arts and crafts already represented a source of supplementary income and had the potential to become much more, in terms of both individual employment and as a means to "foster community development."[79] The report advocated training not only in "traditional craft" but also in shop work and graphic arts, as a means for students to experiment and perhaps develop new products. The authors recommended that an instructional program "explore the possibilities of increasing the efficiency of manufacturing techniques," and even went as far as to suggest "the installation of small factories in suitable communities." However, they also cautioned that such factories could be disruptive and suggested that they be installed experimentally and under close surveillance in order to monitor any unwanted effects.[80] All in all, the report was cautiously optimistic about the idea that, if the lessened availability of resources and the mechanization of primary industries was costing jobs, then perhaps the progressive industrialization of arts and crafts production would be a suitable alternative for development. However, in a review of its own activities the next year, Indian Affairs did not seem to have taken note of these suggestions:

It has been generally recognized that under present conditions handicraft production as a full-time occupation seldom provides an adequate income to a family. Under the circumstances, it has been the policy of the Department to encourage craft projects more as a means of supplementing earnings, providing employment for elderly and physically handicapped Indians and perpetuating skills, than as a major source of employment for Indians.[81]

If the limitations of the market were "generally recognized" given the "conditions" of the time, not everyone was content that Indian Affairs did nothing to address these limitations, or even change these conditions. In 1958, the BC Indian Arts and Welfare Society helped organize a two-day Conference of Indian Business Men. Like the 1948 Conference on Native Indian Affairs, it took place on the UBC campus; also as in 1948, Ellen Neel was one of the invited speakers. In her talk, Neel spoke of the "difficulties facing the Indian in business," including having to compete with "cheap and rather shoddy imitations from abroad." She suggested that legislation

be passed to counter this, including "the levying of a tax on all articles bearing an Indian design":

> The amount of the tax could be rebated on genuine articles produced by Indian craftsmen, and the remainder of the tax proceeds could be used to help our Indian welfare and development funds. These Indian designs are popular and they deserve to be popular. They are morally the common property of the Indian people, and some of the profit from the exploitation of these designs should be used for the benefit of the Indians.

Neel also praised the society's initiative to create a "co-operative marketing agency that would dispose of Indian handicrafts at the narrowest possible margin" instead of the minimum 100 percent markup being practised by most retailers.[82]

Once again, it appears Neel's opinion was not as valuable as two invitations to speak at a conference might have suggested. Although by this time the society had supported the creation of co-operatives and other means of selling arts and crafts, the society's president, C.S. Burchill, seemed to align himself more closely with the position of Indian Affairs that these could only be a "temporary measure for supplementing income," and that the "ultimate solution to the economic problem of the Indian" was "full integration into the industrial and professional life of the Canadian community." For this reason, Burchill recommended refocusing the society's efforts on fostering a "climate of opinion that will welcome the Indian as a neighbor, as an employee, and, in the not far distant future as an employer."[83] Why this objective could not also apply to Indigenous entrepreneurship in the arts, he did not say.

The society remained in existence for over two more decades, but from this point on it played a significantly less prominent role in lobbying for the development of the market. Ironically, it was precisely during the 1960s that the arts and crafts market came to be taken more seriously as a source of employment and economic development for Indigenous communities,[84] a point that the society had been trying to make for the two previous decades. For instance, a 1966 study commissioned by the Department of Forestry suggested that a company run by and for Indigenous "craftsmen" be created under the proposed name of Canadian Indian Crafts Limited. Describing the current state of the market, the authors discussed various types of products and associated opportunities, including increased

production of what they called "adaptations," meaning "traditional Indian designs" used "on articles which are not from the Indian's culture."[85] They explained that retailers were eager for "items belonging to the white man's culture which could be sold if they were designed with Indian motifs." In order to take advantage of such opportunities, this report recommended the implementation of a craft development program so as "to provide an additional opportunity for social and economic self-development by the Canadian Indian"; importantly, it also recommended that the program should "involve Indian people in [its] operation and management," seeing "no reason at all why it cannot some day be a program requiring the advice and assistance of no white man whatsoever."[86]

Anishinaabe poet and educator Arthur Solomon was among the authors of this report, and three years later, he stated his disappointment with Indian Affairs for failing to implement its recommendations. He lamented that the market was still a "chaotic mess" and argued that this disorganization could be remedied only by "working hand in hand with the craftsmen, using their ingenuity and their initiative as the driving force."[87] Solomon believed that the recommendations of the 1966 report had largely been ignored by Indian Affairs at least in part because the report suggested organizing the market on the terms of Indigenous people, rather than those of the government. He argued, "Indian people are entitled to an opportunity on their terms which befits their dignity as human beings; they are entitled to an investment in them as the original owners of this country who have been robbed of their land and even their identity." Furthermore, he stated that art making was "the most natural and least troublesome means of economic development for these people who have almost no other way to earn money."[88] In this respect, Solomon's discourse is similar to that of some of the previously cited non-Indigenous supporters of the Indigenous art market's development, but with the crucial difference that Solomon believed that the market's potential would be realized only when Indigenous people were leading the charge, with the government as funder and facilitator only initially.

Also, according to Solomon, in 1968 approximately 80 percent of Ontario's $40 million gifts and souvenirs market had been sales of imports. To counter this, he thought it necessary to "help the craftsmen to produce high quality handmade things (not necessarily high priced) but of a quality and nature that will take the craftsmen out of the senseless competition with foreign machine made junk."[89] Indeed, competition from non-Indigenous individuals and companies was a growing concern. For instance,

an earlier *Imperial Oil Review* article had reported, "With the increasing popularity of Indian crafts, enterprising fakers have appeared," while "not all storekeepers take the trouble to point out which of their items are genuinely Indian-made." From this, the article concluded that "some form of trademark similar to the labels which identify Eskimo art would clearly benefit both the Indian artists and the buying public."[90] By then, the idea of implementing protective measures had reached the government's agenda. A report on this very topic noted that Canadian laws were failing to provide such protection. Among other things, it suggested that marks be registered under the Trade Marks Act on behalf of the Crown, and that the federal government could write legislation prohibiting both the production and the importation of imitations within Canada.[91] Though no such legislation was ever passed, the years that followed marked a new era of government involvement in the market as an instrument of both development and protection, with mostly disappointing results.

1970s: Exploring Industrialization

In 1970, the Department of Indian Affairs and Northern Development created a national Indian Arts and Crafts Program that included a centralized distribution system called the Canadian Indian Marketing Services (CIMS). Located in Ottawa, the CIMS acted as the promoter and wholesaler of products it received from across the country. The idea was that centralization would help put order and create standards in a market that was considered disorganized and unreliable. However, the CIMS was apparently not able to significantly alter the ways in which the market functioned, as similar criticism continued in the years following its creation. For instance, in 1975 the market in British Columbia was described as "chaotic," with little communication among "artists and craftsmen" and even less with retailers and customers.[92] By this time even the least optimistic commentators stood by the idea expressed in "every report on the sector" that "arts and crafts offer an attractive opportunity for Indian economic development."[93] In particular, some underlined the "vast potential for Indian participation in a number of contemporary manufacturing industries, i.e., footwear, garment, jewellery, textiles and other fields such as advertising, interior decoration, and industrial design," echoing the vision described decades earlier by Harlan Smith. "The possibilities in the future are unlimited," the same report stated, stressing that this potential should be

attainable given the demographic and cultural "resources" of the "Indian population."[94]

This overall optimism notwithstanding, it was also noted that artists were spending a lot of time producing compared to what they could reap from the sale of their works, because wholesale and retail margins rendered them unable to compete with items produced in large series.[95] In addition, artists faced harsh competition from foreign companies that produced inexpensive imitations,[96] especially given the lack of "legal protection to prevent either copying of Indian Art Handicrafts or to prevent the importation of reasonable facsimiles."[97] One report recommended legislation to "prohibit the importation and restrict domestic manufacture of non-authentic Indian products and to provide Federal Sales Tax exemption for authentically produced Arts and Crafts,"[98] a measure reminiscent of the suggestion made by Ellen Neel in the late 1950s.

The use of authenticity tags was also brought up time and time again. In the 1970s the government began using Stretched Beaver Pelt tags as official identification marks. These tags were supposed to play the role for First Nations art that the Igloo Tag did for Inuit art, as a government guarantee that pieces bearing the tags were made by "a Canadian Indian."[99] Unlike the unique Igloo Tag, the Beaver Tag existed in three different colours to designate "three levels of quality: mass-volume souvenirs, intermediate quality crafts, and one-of-a-kind art forms."[100] In order to control their use, printed tags were distributed only to organizations that had entered into a formal agreement with Indian Affairs.

Although some considered the Stretched Beaver Pelt trademark successful, and one commentator even deemed it "one of the best marketing tools developed to promote authenticity,"[101] a 1977 report judged that it was not being used as effectively as had been hoped:

> We have found Indian Arts and Crafts selling for over $200 and less than $1.00, both carrying the Beaver tag. We have seen articles of questionable quality and close to being classified as "junk articles" carrying the Beaver tag. We have seen article[s] partly, or mostly machine-made, carrying the Beaver tag. The inconsistency in the product line and its promotion is quite obvious.[102]

For some, the tag's focus on authenticity rather than on quality was a major flaw in the program's design. They argued that the lack of quality standards

gave wholesalers little reason to limit their inventory to government-approved products, remarking that many were "looking to Hong Kong and Taiwan for supplies of imitation products (although, without exception, they say they would prefer to buy in Canada if they could find a supplier who could deliver large enough quantities, at the right price)."[103] Such competition was also domestic. In the field of pottery, for instance, a company called Blue Mountain was mass-producing plates and bowls adorned with "Indian designs." Noting that many purchasers were unable to distinguish between Indigenous and non-Indigenous production, the report suggested that Indigenous producers should compete through "volume production using Indian designs." The authors argued that, in order for the market to reach its potential, "new and efficient producing units" would be required, with a focus on the development of new products that "would give the producer better margins than current products and could be produced in high quantities."[104]

The tension was growing between the need to differentiate "authentic" items from imitations, on the one hand, and the drive to identify items that could generate significant income in the market, on the other. This tension caused a progressive shift away from the fixist view of Indigenous cultures and their products as necessarily handmade and one-of-a-kind, towards an emphasis on products designed by and profiting Indigenous individuals. By the late 1970s, the push for industrialization was growing, with reports stressing that the industrial mass-produced souvenir market was the path to commercial viability, judging it likely to generate greater economic returns than the sale of handmade crafts, and much greater returns than the sale of art. However, although the market for machine-made items seemed to represent the most potential for growth, local production of such items was going to compete directly with products made in countries with lower wages and weaker labour laws. Consequently, it was advised that "in the long run ... even more mechanization will be required if Indian semi-crafts are to remain competitive."[105]

These calls for the industrialization of Indigenous production were accompanied by suggestions that some of this production be outsourced to non-Indigenous companies. For instance, it was suggested that design files be made available to designers and architects and that they be encouraged to integrate this "Indian art" in their designs for homes and offices, or that production of souvenirs be transferred "to someone else, perhaps retaining design control or taking back some royalty payments."[106] It was argued that

large unlimited series could be more easily obtained if other Canadian craftsmen and manufacturers got involved.[107] Thus, in order to develop the market further and fend off competition from overseas, Indigenous artists were being encouraged to industrialize their production processes by delegating the reproduction of their designs to Canadian industrialists, rather than developing their own companies. This showed that those reporting to the government saw the interests of Indigenous artists as directly tied to national industrial interests, as had Smith, Raley, and Ravenhill before them. Their reports were silent on how to ensure such collaborations would not only help develop a domestic industry but also significantly benefit Indigenous artists and communities.

This highlights the more general issue of the role that was being assigned to Indigenous stakeholders in governmental initiatives. For instance, from its beginning in 1970, one of the stated goals of the Indian Arts and Crafts Program, including the CIMS, was that it be "turned over to Indian ownership" within five years.[108] Over time, various reports stressed this point, some strongly advocating that the Department of Indian and Northern Affairs should maintain as minimal as possible an involvement in the CIMS's business if the transfer of control to Indigenous managers was ever to be successfully achieved.[109] However, it was only in 1978 that the Indian Arts and Crafts Program was officially turned over to the National Indian Arts and Crafts Corporation (NIACC). Also based in Ottawa, the NIACC was an Indigenous-run and government-funded organization meant to "act as wholesalers, distributors, and dealers in works of native Indian artists and craftsmen of Canada for the purpose of encouraging the development of native Indian arts, crafts and industries in Canada." The desire for development was, as usual, paired with concerns over protecting the market; thus the NIACC was also mandated to develop "trade and certification marks" for Indigenous-made works.[110] However, by the time of the transfer, Indian Affairs had terminated the operations of the CIMS. According to a later report evaluating the NIACC, the termination of the CIMS just around the time that the Indian Arts and Crafts Program was being transferred to the NIACC "seriously hampered and kinked the development of NIACC."[111]

In parallel to these developments on the national stage, Northwest Coast artists were quietly experimenting with serial reproduction in the form of silkscreen printing. As mentioned above, Ellen Neel had made a foray in this direction a decade earlier, but few of her contemporaries had followed suit. In the early 1960s, Doug Cranmer printed on paper, cotton, and burlap,

entering a royalty contract from 1964 to 1967 with a burlap bag company called Industrial Bags that reproduced his designs in exchange for royalties of 15 percent on gross sales. This arrangement between an Indigenous artist and a local company, likely the first of its kind in the Northwest Coast art market, was not particularly lucrative for either party. However, it allowed Cranmer to provide his Granville Street gallery, the Talking Stick, with affordable items that would help pay the rent, while focusing the greater part of his energy on more lucrative large-scale commissions.[112] In 1964, Kwakwaka'wakw artist Henry Speck issued twelve silkscreen prints produced by a company called BC Indian Designs Ltd., which were exhibited at the New Design Gallery in Vancouver alongside forty of his original paintings on paper. Speck has been credited as the "first Kwakwaka'wakw artist to produce a limited edition print, thus foreshadowing the important role this medium would play within the Northwest Coast art market."[113] However, as Marcia Crosby remarks, despite such public exhibits, Speck and his contemporaries had "yet to establish a sustained, commercial market for their work."[114] A Haida artist recalled that "even though there was no market" for his first series of prints, he felt seduced by the "instant gratification" of printmaking. "You pulled the squeegee once, and you had this instant print!" he explained to me, pointing out that this allowed for much more experimentation than other, more time-consuming techniques.

Although opportunities to profit monetarily from the production of multiples seemed limited at first, artists explored serial reproduction because it showed interesting potential as part of the creative process. With the creation of the Northwest Coast Indian Artists' Guild in 1977, which focused on the promotion of silkscreen printing, a technique that was initially used as a means of experimentation became increasingly treated as a "fine art" medium, with all the quality standards and prestige associated with this expression.[115] In those early days, artists usually learned to pull their own silkscreen prints, some of them hanging their freshly printed designs to dry with clothespins on lines running across the living room, and taking the prints to the stores themselves once they were ready to be sold. Eventually, an increasing number of artists came to commission master printers to produce their designs, or to work with printing companies that specialized in Indigenous and particularly Northwest Coast art, including Canadian Art Prints Inc. (established by Bill Ellis in 1964 as Canadian Native Prints), Pacific Editions Ltd. (established in 1971), and Island Art Publishers (established in the mid-1980s). Some of these companies also reproduced artists'

works on unnumbered art cards and other paper products sold as less expensive alternatives to limited edition prints, establishing a relationship between the print market and the development of the artware industry.

The company Garfinkel Publications (now operating under the name Native Northwest – Art by Native Artists), illustrates this link particularly well. Created in 1982 around a modest production of twelve postcards, the company became one of the foremost companies in the Northwest Coast artware industry. Although the company's output now goes far beyond the medium of paper, it refers to itself as an Indigenous art "publisher" and much of its merchandise displays influence from the company's experience in the field of printing. For instance, the company uses similar printing technology to reproduce designs on paper products (art cards and booklets), soft products (T-shirts and blankets), and hard products (mugs and trivets). In this regard, the 1980s were a turning point in the artware history precisely because artistic exploration of serial reproduction began to be met with interest from companies that not only wanted to corner the market for Indigenous-themed products, but also wanted to work with Indigenous artists instead of simply resorting to imitation. Arguably, the fact that many Northwest Coast artists were already deeply involved in developing the print market when artware companies began to approach them positioned artists more favourably than if images had been sent to companies before they had had a chance to experiment with serial reproduction themselves.

1980s Onwards: Reiterating the Need for Protection

In early 1982, after more than four decades, the page was turned on Ravenhill and her followers' BC Indian Arts and Welfare Society. On 1 March, during what appears to have been the society's last executive meeting, two primary points were discussed. The first point was the society's express support of "the entrenchment of aboriginal rights" in Section 35 of the Constitution Act, 1982, proclaimed in April. The second point was the members' decision to "terminate the Society as such, due to lack of interest and attendance at meetings, and the diminishing needs of the native people for our assistance."[116] Although the termination of the society was probably not scheduled to coincide with the new constitution, it is not merely coincidental that such a society, with its unmistakably paternalistic flavour (and run by people who have been described as "do-gooders"[117]), would question its relevance in the face of Section 35, which affirmed pre-existing

Aboriginal rights and title and announced (but did not in fact guarantee) drastic changes in the treatment of Aboriginal affairs by Canada's federal government. This period saw an exponential growth in the polymorphous movement of reclamation that had been developing since the early decades of the century, whereby Indigenous peoples attempted to exercise these already existing but newly acknowledged rights.[118] They did this most manifestly through participation – or, in many cases, refusal thereof – in land treaty processes (initiated provincewide in British Columbia in 1993), the repatriation of cultural belongings, and an increasing pressure to protect Indigenous cultural heritage from appropriation.[119] Interestingly, it was in this social and political climate that the production of Northwest Coast artware began to increase exponentially, continuing to raise questions about how to protect Indigenous art from misappropriation, how to increase the levels of involvement of and returns to Indigenous participants, and the extent to which the industrialization of local production could be used to push back against global competitors.

Unlike the society, the Indigenous-run NIACC remained active through the 1980s, and considered its activities more relevant than ever, seeing the arts and crafts market's potential for economic development as increasing, rather than diminishing.[120] This outlook was clearly expressed in 1983 to the Standing Committee on Indian Affairs and Northern Development by Adélard Cayer, a consultant hired by Indian Affairs to review the NIACC's management of the Indian Arts and Crafts Program.[121] Describing the sector as "rather unique," Cayer argued that "the Indian arts and crafts program was the only economic activity undertaken by people on reserve right across this country"; that "it was really the only economic development activity that had links going back to Indian culture"; and that "it was one of the few economic activities that otherwise unemployable Indian populations in isolated communities could, in fact, get involved in."[122] While these statements were erroneous on several counts – for one, they ignored the links between the country's resource economy and ancestral Indigenous activities[123] – they provided Cayer with reasons to encourage the NIACC to continue with its mission of "maximiz[ing] the socio-economic impact of the arts and crafts sector on Canadian Aboriginals."[124]

Along with the notion that developing the market further had become a necessity, the issue of protection also continued to be important. One of the long-term goals of the NIACC for the 1985–90 period was thus to develop "a comprehensive, media-based public awareness campaign to

educate consumers regarding how to distinguish between authentic and imitation Indian arts and crafts."[125] In preparation for this, the NIACC proposed to conduct thorough market research in order to determine the most appropriate avenues for such legal protection. The authors of the proposal to fund this research argued that, two decades after the release of the 1966 report to which Arthur Solomon had contributed, the situation regarding imitations "remain[ed] largely unchanged and continue[d] to debilitate the development of the Canadian Native arts and crafts industry." According to them, in the absence of any legal obligation to label goods, "small, mass-produced, totem poles can flood the Canadian market without any visible sign indicating whether or not they are authentic." Only legal avenues could protect Indigenous artists and craftspeople "from the opportunists who intrude upon their rightful market and heritage for financial gains."[126]

The research proposal was approved by the board of directors of the NIACC on 8 January 1985, but the government refused to provide the funding requested. Instead, the minister of Indian Affairs and Northern Development, David Crombie, encouraged the NIACC to simply use a "trademark campaign to certify authentic Indian arts and crafts" and rely on existing legislation to protect them "against copyright and other infringements."[127] Crombie either didn't know or chose to ignore the fact that the ministry's own Stretched Beaver Pelt Tags had been unsuccessful in that regard, and that existing laws did not adequately protect Indigenous cultural heritage. Ten years later, artists participating in the Aboriginal Artists' Project were still voicing deep concerns about the "growing number of cheaper, imitation aboriginal art [works]," arguing that these imitations made it incredibly difficult for them to compete in the gift and tourism markets.[128]

By the time the 1996 Report of the Royal Commission on Aboriginal Peoples was released, very little had changed. In its recommendations to support Indigenous businesses as part of a strategy for economic development, the report listed examples of "niche markets" worth promoting and pursuing on the specific basis that Indigenous people had "a competitive advantage arising from factors such as land claims settlements, the location and natural resources of communities, jurisdictional advantages, and cultural understanding and values." Among these niche markets were Indigenous art and clothing. The report also encouraged the creation of a "Buy Aboriginal" marketing strategy to identify and advertise "products made by Aboriginal companies and entrepreneurs,"[129] emulating federal "Buy Canadian" programs that used red maple leaf tags to encourage the purchase of

Canadian-made products. A Buy Aboriginal program – like most other recommendations of the commission[130] – was never implemented.

However, some years later, the Indigenous-run Aboriginal Tourism Association of British Columbia (AtBC) took matters into its own hands to create its "Authentic Aboriginal" program, later renamed "Authentic Indigenous." When launched in 2010, it certified tourism experiences provided by Indigenous companies, but in 2014, AtBC officially launched a sister program for Indigenous cultural products. Spearheaded by Sechelt artist and entrepreneur Shain Jackson and Kwakwaka'wakw artist and arts administrator Lou-ann Neel (Ellen Neel's granddaughter), this program was a "response to the serious concerns of Aboriginal artists about the issue of Authenticity in the Aboriginal art market." As reflected in its "Protecting Culture, Providing for People" motto, it aims to protect "the integrity of Aboriginal artworks while ensuring the resources from the sales find their way largely back to where pieces originated from, Aboriginal people and Aboriginal communities."[131] Like the Beaver Pelt Tag, AtBC's Authentic Indigenous program comprises three tiers of certification in order to include not only items that are designed, produced, and distributed by Indigenous artists, but also products where an Indigenous artist contributed the design and was fairly compensated for this work. By excluding all "inspired by" and "Native-style" products, the program aims to support Indigenous artists as well as foster good practices on the part of the companies who partner with them. The program's accompanying "Buy Authentic While You're Here" campaign aimed to make consumers more aware, so that if a company chose not to work with Indigenous artists, consumers could choose AtBC's certified products instead. Indeed, the ultimate goal was to help "redirect millions of dollars of much needed funds back to our people and communities."[132] Although it is too early to say how this initiative will affect the market in the long run, its very existence clearly shows that questions very similar to those posed over the last several decades continue to animate the Northwest Coast art and artware industry of the early twenty-first century.

A History of Balancing Expansion and Protection

In sum, the archives of the past century tell the story of the Indigenous art and artware market having great potential but being neither exploited nor protected enough. The two goals most often discussed throughout this

period – expanding the market through industrial means of production, and protecting the market from outside competition – initially appeared to be at odds. Harlan Smith, George Raley, Alice Ravenhill, and others after them established a clear division in their strategies between Indigenous one-of-a-kind handmade production and the serial reproduction of Indigenous designs by non-Indigenous companies. This division is in part why measures to protect the market – to enable it to benefit Indigenous people to the extent so many imagined it could – always seemed lacking. However, expansion and protection arguably cease to stand in unresolvable opposition, and instead become a question of careful balance, once Indigenous people play a central role in both processes and are able to bring their values to bear on this market's configuration.

In that regard, over the course of the last century, the most striking change in discourses about this market has been a stronger emphasis on the interests of Indigenous stakeholders (increasingly seen as distinct from those of the state), as well as on the importance of Indigenous involvement and leadership in this market. Another noticeable change has been a shift in emphasis from the need for further development to the need to erect better protective barriers. In the very early twentieth century, Harlan Smith said little about the need to protect Indigenous designs from appropriative practices, and even encouraged their use by non-Indigenous manufacturers in the name of Canadian national interests. In the mid-twentieth century, Ravenhill and her society did the same, going to great lengths to foster interest in Northwest Coast designs from textile companies in Canada and abroad, even as some of the society's members were growing conscious of the possible adverse effects such outside uses could have. In the mid-1980s, the NIACC continued to promote the development of the market and considered options for use of designs in factory-made products, but had also made the creation of protective legal measures one of its priorities. Most recently, AtBC's authenticity program purposefully includes products that are made by industrial means of production and reproduction, while insisting that they meet specific standards of Indigenous involvement and control. This approach recognizes that protectionist measures are of paramount importance to Indigenous artists who have participated in the expansion of the Northwest Coast artware market by using all the technological means at their disposal in order to meet the demand.

The idea that an unregulated, "free for all" market is unable to yield significant benefits to the Indigenous peoples whose cultural heritage is

being commodified has been present throughout the artware industry's development. Indigenous artists such as Ellen Neel and Arthur Solomon are far from the only ones to have argued that, if Indigenous stakeholders' interests are to be taken seriously, protective barriers are a necessary feature of the ever-expanding Northwest Coast artware industry. Most observers of late capitalism and its relationship to colonialism and other imperialist processes will not be surprised that the ongoing efforts to regulate the market have had only gradual, limited effects. But even in the absence of a full-fledged protectionist apparatus, such initiatives as authenticity labelling programs and Buy Indigenous campaigns, as well as the simple fact that arguments in favour of regulation are holding steady in the face of worldwide market liberalization, show that pressures to recognize and support Indigenous interests are shaping the artware industry. Even in this context, striking a balance between instating protectionist measures and remaining competitive remains a sizable challenge, especially given the market's growing global dimensions – precisely the issue to which we turn next.

3

Globalization | *Localization*

FROM THE EARLY days of colonization, explorers, tradesmen, and missionaries acquired objects from Indigenous peoples and brought them back to their home base, or that of their sponsors. The relationship between most of these objects and the region where they were collected was relatively straightforward: these were items made by the local peoples of the region, and as such, they represented that region and its peoples in the eyes of those who saw them in museums and private collections around the world. Even when those objects bore clear signs of intercultural exchanges – such as materials, forms, or motifs from another place – they were usually unequivocally regarded as mementos of the place where they were made. For today's Northwest Coast artware, the relationship between place of production and culture represented tends to be less straightforward. Like most other industries, the artware market is deeply entangled in the political economy of global capitalism. An item often has not one place of production, but several. However, this market is not entirely deterritorialized. Over time, artware companies have developed a niche of industrially made, Indigenous-themed products by relying simultaneously on the global reach of their suppliers and on the strong local ties of Indigenous artists. Thus, much of today's Northwest Coast artware industry combines the marketing appeal of local singularity with the economic advantage of delocalized production.

In the globalized market of household and fashion goods, what singularizes Northwest Coast artware items are the Indigenous images reproduced on them. Without these images, these products would be virtually indistinguishable from other mugs, T-shirts, blankets, and similar mass-produced objects of everyday life. Put simply, Indigenous designs help transform objects made elsewhere into products ostensibly recognizable as "local." Without overtly denying their own entanglement in global markets, Northwest Coast artware companies have a stake in maintaining the perception that their products are local first, and only secondarily global. Furthermore, instead of trying to compete directly with other decorated wares on the worldwide stage, the dominant strategy so far has been to position Northwest

◀ OVER

The commodityscape of Northwest Coast artware links the local to the global. Designed by local Indigenous artists working with Vancouver-based companies, some items are produced abroad and/or travel to faraway places as souvenirs of the Pacific Northwest.

Designs by Corey Bulpitt, Haida (flip-flops), and Bill Helin, Tsimshian (trivet).

Coast artware products as quintessential indicators of a connection to a specific place: the Northwest Coast.[1]

As anthropologist Robert J. Foster has shown, people everywhere make "worldly thing[s] part of their world" by transforming them in relationship to their specific and often culturally determined needs, values, and aesthetics.[2] In the Northwest Coast artware industry, this process of local reappropriation is aided by the transformation that occurs prior to consumption, when the flow of globally ubiquitous objects such as mugs and T-shirts is momentarily interrupted so that these items can be stamped with a distinct visual reference to the Pacific Northwest before being put back into circulation through a (primarily local) network of retail outlets. This overt branding of items produced a world away as "local" helps turn them into indexes of a particular place, making it easier for consumers to gloss over the global dimension of their coming-into-being. In part because such glossing over is so easy to do, Foster notes that it is important to trace "the movement of everyday things through diverse contexts and phases of circulation" in order to demonstrate "how such movement links geographically separate locales."[3] Drawing on Arjun Appadurai's use of the suffix "scape," Foster has coined the term "commodityscapes" to highlight the shifting values and meanings of commodities as they move through various nodes of production, distribution, and consumption.[4] Although the nonlinear paths such commodityscapes trace are undoubtedly a testament to an increasingly globalized and deterritorialized world,[5] the Northwest Coast artware industry couples such "deterritorialization" with similarly powerful processes of "reterritorialization."[6] To a degree, this plays into what Appadurai, revisiting Marx, calls "production fetishism," whereby a veneer of "locality" serves to sustain the illusion that production still takes "place" in particular sites rather than across transnational networks.[7] However, in some cases, the processes by which global wares are turned into local artware represent a deeper kind of reterritorialization, undergirded by Indigenous stakeholders' efforts to assert greater control and assume more central positions in the industry. With the industry's hub currently firmly established in the Pacific Northwest, its Indigenous stakeholders can continue to push against or, if they so choose, actively take part in creating global links between their region and other regions of the world.

As outlined in Chapter 2, whether instigated locally or globally, in domestic or international contexts, or by non-Indigenous or Indigenous companies, cultural commodification results in a tension between aspirations to expand the market and desires for its protection. Certain practices

have helped maintain the Pacific Northwest as the industry's central hub of a more globalized circuit through a careful interplay of deterritorialization and reterritorialization. In particular, Indigenous stakeholders' positions regarding the market's further globalization, which range from cautious enthusiasm to serious concern, have worked to reinforce the Northwest Coast artware industry's symbolic and material ties to the Pacific Northwest, this at a time when many other local industries are struggling to do the same with their region of origin.[8] This is another way in which the Northwest Coast artware industry exemplifies culturally modified capitalism and, more specifically, how the forces of global capitalism can be inflected by local aspirations for self-determination. While Indigenous stakeholders' efforts to assert greater control and assume more central positions in the industry have placed certain geographic limitations on where these items are made and also sold, these limitations have in turn allowed them to retain some oversight over the commodification of their cultural heritage.

A Primarily Local Marketplace

Although Northwest Coast art enjoys international recognition, as with other Indigenous arts across Canada, its distribution circuits have remained largely local. In fact, one of the primary criticisms levelled against the national Indian Arts and Crafts Program of the 1970s, which required pieces to be sent to a central warehouse in Ottawa, was that it was not adapted to the needs and interests of the different regions it was meant to serve.[9] At the time, it was estimated that approximately 70 percent of all products were sold in the province in which they were made, which undermined the relevance of a centralized system of national distribution.[10] This critique was voiced particularly strongly by the National Indian Arts and Crafts Corporation's regional branch, the Indian Arts and Crafts Society of British Columbia, which objected that shipping large quantities of Northwest Coast art to a supposedly "central" location such as Ottawa made little sense given how much of the market for Northwest Coast art is actually found in British Columbia.[11]

Considering that Northwest Coast material culture has long been exhibited in many different places around the world, it may seem surprising that the buying market would remain primarily circumscribed to the Pacific Northwest. The hundreds of thousands of objects that missionaries, Indian agents, researchers, and others took, received as gifts, or purchased when they came

to the Pacific Northwest over the course of the last three centuries have fed prominent museum and private collections of Northwest Coast material culture around the world. Artware can usually be found in the retail stores of those museums and other cultural institutions with important Northwest Coast collections and exhibitions, especially in North America.[12] However, apart from these very precise locations, which function figuratively as satellites of the Pacific Northwest thanks to the thousands of pieces held in these institutions, Northwest Coast artware has a very minimal presence east of the Pacific Coast Range. When the Northwest Coast art market is presented with pride as "international," it is in reference to individual international buyers (a good number of them from the United States), specific commissions ordered by or for government representatives and institutions (often for explicit or implicit diplomatic purposes), sales held by international auction houses (mostly focused on historical pieces), and individual artists exhibiting in art biennales. Although this effectively amounts to an international market, there is currently no truly global network of galleries presenting and selling the works of Northwest Coast artists. This limited geographic scope is especially true of artware, which represents an even more limited international market beyond the purchases of tourists visiting the Pacific Northwest.

For instance, the owner of one of the largest artware companies told me that he barely sold any products outside of Canada apart from in the United States, adding that even as close as Seattle the market was significantly more limited than in Vancouver. He did distribute some products on the east coast of Canada and the United States, and in the US Southwest, but he remarked that even there, interest existed in specific cities and in only a few select stores in each location. In his experience, the market in Europe was practically nonexistent. The sales manager of another company confirmed this observation, saying, "When it comes to west coast First Nations designs, we find it difficult to distribute them in Toronto or even in Alberta ... I don't mean that we don't sell anything at all, we do ... but not on a scale to talk about." A sales representative I met at a trade show made a similar comment, explaining that Northwest Coast designs are a "real hit" in Vancouver, but "drop off the map," so to speak, as soon as one reaches the Interior. "Tourists love them on the coast," she said "but the flocks of tourists that go to Osoyoos don't care for them." A retailer in charge of buying for a store in North Vancouver and a store in Banff explained that, in the Rockies, she found that the interest in Indigenous art in general was significantly lower, with buyers looking instead for designs on the theme of "the outdoors ... or a bear, a moose, etc."

When I asked about future developments in the industry, none of these individuals foresaw any radical geographic expansion of the popularity of Northwest Coast–themed products. Some did hope to see a little "bump" in sales as the Vancouver 2010 Olympics increased the global visibility of Indigenous arts in British Columbia, but they did not think this momentary enthusiasm would lastingly affect the scope of the market.

It may not seem particularly surprising that the geographic contours of the market for Northwest Coast artware follow quite closely those of the Pacific Northwest, since that is the region that its imagery references: whatever the figure, symbol, or abstract design, the style in which it is executed is inextricably linked to this region. However, not all regional art styles have such an isomorphic territorial overlay: imagery originating from other regions around the world has been deterritorialized to a much wider extent. To take but one particularly striking example, Paul Stoller has shown that there is a vibrant market for African-style textiles in New York City, made possible by transnational networks that link African American consumers to West African vendors, who themselves deal with Korean and Chinese wholesalers, who in turn source their product from Chinese factories.[13] To be sure, the Northwest Coast artware industry also represents a global commodityscape, especially when it comes to its places of production. But with the notable exception of the ubiquitous form of the totem pole, which has been borrowed from the Northwest Coast by producers around the world, often to recreate it in a different style,[14] Northwest Coast art has largely retained its specific cultural and geographic affiliations. While not everyone may be aware of this style's culturally and regionally distinct reference points and it has been misappropriated on many occasions, it is nevertheless not generically "exotic" or "ethnic" to the same degree as a number of other art forms. In addition, the Northwest Coast artware industry has not enlisted a diasporic network of Pacific Northwest peoples, or of any other group for that matter, to distribute Northwest Coast products more globally. Companies generally distribute their merchandise through relatively small networks of sales representatives and distributors, most of them in the Pacific Northwest. Even the Indonesia-made Northwest Coast–style masks and other carvings that have appeared on the market are primarily destined to be sold in North America, and in particular in Alaska, rather than directly from other parts of the world.[15] Northwest Coast artware has followed a much more restricted geographic path than the more global and less formal circuits of trade that have allowed other so-called ethnic products to be sold on the streets of New York, Paris,

and elsewhere.[16] This sharp contrast shows that the deterritorialization of the production of goods, especially those that are marketed for their (imagined or real) cultural and regional singularity, does not necessarily lead to a concomitant deterritorialization of their marketplace. At least in the case of Northwest Coast artware, the guardedness of local industry stakeholders against unbound globalization, seen as a threat both to their market shares and to Indigenous cultural property, has favoured processes of reterritorialization despite many companies' reliance on a global network of suppliers.

Country-of-Origin Labels and Other Indexes of Domesticity

While Northwest Coast artware is primarily sold in local retail outlets that emphasize the local specificity of Northwest Coast images, the great majority of the wares on which these images are reproduced come from places outside of the Pacific Northwest, usually elusively referred to as "China," "overseas," or "offshore." By wrapping wares that exist "over there and everywhere" in a layer of "right here and nowhere else," companies transform globally ubiquitous products into indexes of local specificity. These objects' places of production are meant to be secondary to the place of origin of the Northwest Coast images that are reproduced on them. When the place of production draws attention, the items tend to be rejected as inauthentic by those consumers who struggle to associate indigeneity with anything else than the unequivocally local. This attitude ignores a long history of Indigenous peoples using materials and goods that came from elsewhere.[17] "How could something made in China have anything to do with Indigenous cultures?" the reasoning goes, questioning how a surface transformation can turn a global commodity into a manifestation of local cultural expression. Such uneasiness partly stems from long-standing concerns that items produced by companies abroad represent unfair competition for local companies and artists. Not so long ago, most industrially produced Indigenous-themed merchandise was made without any involvement of Indigenous people at all, with designs lifted directly from books or museum objects.[18] Although such practices continue, now that more and more local companies work with Indigenous artists and several Indigenous-owned companies are taking a more central place in the market, a slightly different concern has taken centre stage. Once it has been established that it was an Indigenous artist who provided the designs, the issue becomes where the wares on which these designs are reproduced were made. Consequently, those companies that can market their products as

being made "here" have a distinct advantage over those who cannot, as most companies import wares and/or outsource a large proportion of the manufacturing process to companies based outside of Canada.

In this context, artists are often eager to point out the fact that they have chosen to work with a company that manufactures goods locally or, at the very least, within Canada. Indeed, "Made in Canada" labels reinforce the notion that the artware on which Indigenous artists' designs are reproduced is "from here"; layering Indigenous images onto Canadian-made objects helps shield their work from being erroneously discounted as an imitation simply because it was reproduced on imported goods. In expressing their preference for working with Canadian businesses, these artists variously defined these businesses as having their administration offices and/or their production factories located in Canada (usually preferring "and" but sometimes settling for "or"). However, some object that the expression "Made in Canada" misconstrues a crucial aspect of the Pacific Northwest's territoriality. One Squamish/Kwakwaka'wakw artist told me that while he favours products that are made locally, he dislikes the Made in Canada label because its wording disregards the fact that the land of his people is unceded Indigenous territory, even under Canada's own laws. To him, in the absence of a legitimate treaty, to portray his people's territory as being part of Canada is essentially to perpetuate a lie. Also, counting designs created by Indigenous artists towards the percentage of Canadian content of a product so that it can bear a Made in Canada label (more on this below) can easily be interpreted as yet another attempt to co-opt Indigenous cultural expressions on behalf of a nation-building agenda, in direct continuity with the history discussed in Chapter 2.

Their critical stances towards Canadian history and nationalism notwithstanding, a number of artists were quick to evoke the negative trope of merchandise that is "Made in China" as an unsatisfactory alternative to "Made in Canada" products. As a Musqueam artist told me about the company that reproduces her designs, "It's important that they are local, and that they are Canadian. I don't want to go to China and make my [products]." Noting that this company does produce other items in China, she said she insisted that her products be manufactured in Canada, but conceded that sometimes it seems impossible to avoid Chinese manufacture.

> You're forced because, let's face it, mostly everything we have is made in China. However, when I buy anything, I look at the label, I don't buy China. And not because I don't like China. I think it's an amazing and

beautiful and historical [country], but I just feel like, why would I want to get it from there when we should be getting it from our own people? ... I want to buy from home, you know, that's what I want.

A Tlingit/Kwakwąką'wakw artist expressed a similar preference for locally made items, all the while recognizing that being able to compete with items produced abroad is no easy feat: "*Everybody* is manufacturing in China now. And then you have people who say, 'Well, the [workers' labour] conditions are much better!' Well, I don't think so." In relation to companies who treat their workers poorly, as well as the safety and health risks consumers tend to associate with products that are made in China, one artist further remarked, "The main problem is that there is no way to control that from here. The only thing that is sure is that the products will be cheap." All the negative associations of Chinese manufacturing, combined with the notion that producing abroad necessarily means giving up some control, heightens the stakes of being able to market products as "Made in Canada." However, what such a label actually means – and the extent to which it excludes items that are at least partially produced in China – is less straightforward than it may sound.

In Canada, several pieces of legislation directly pertain to the regulation of country-of-origin claims. The Competition Act prohibits the use of "materially false or misleading representation" for the purpose of promoting a product. The Consumer Packaging and Labelling Act requires product labelling to provide "accurate and meaningful information" so that consumers can make informed decisions, and also prohibits false or misleading representations, including those related to the product's country of origin. In addition, the Textile Labelling Act similarly prohibits "false or misleading" country-of-origin claims. Together, these laws currently regulate the use of two labels as follows: "Product of Canada," which requires a minimum of 98 percent Canadian content; and "Made in Canada," which requires a minimum of 51 percent Canadian content and should be "accompanied by a qualifying statement indicating that the product contains imported content." The percentage of Canadian content is calculated on the basis of the percentage of total costs represented by Canadian goods and services. In addition, the Competition Bureau of Canada states that, for both Made in Canada and Product of Canada labels, "the last substantial transformation of the product must have occurred in Canada."[19] Companies are generally eager to use such labels, sometimes organizing their circuits of production specifically to be able to do so – importing some raw or transformed materials but ensuring that the last substantive transformation occurs in Canada,

and that the overall level of Canadian content meets the minimum requirements. Qualifying for a Made in Canada label is a reason for companies to have designs reproduced in Canada rather than abroad, even at a slightly higher production cost, especially when the product can still be sold at a reasonable retail markup. To give one simple example, if a mug produced outside of Canada is cheap enough and printing an Indigenous design on it in Canada is expensive enough (representing over 51 percent of costs), the law allows this mug to be presented as having been "Made in Canada." Especially considering the role Indigenous art has been made to play in Canada's nation-building, and the many instances in which Indigenous arts continue to be portrayed as synonymous with Canadian culture, a Made in Canada label can indeed arguably help promote certain examples of Northwest Coast artware as superior to Indigenous-themed products that do not meet the standards of the country-of-origin claim.

Companies also have other, and often less straightforward, ways of projecting Canadian origins onto their products. To start, the law permits the use of "Designed in Canada" and other labels that are unlikely to be understood as synonymous with "Made in Canada" or "Product of Canada," as long as the expression truthfully describes the product in question.[20] Despite the flexibility afforded by its acceptance of such alternative labels, the Competition Bureau of Canada stipulates that these cannot be accompanied by pictorial representations that could be misinterpreted as meaning that a product has been made in Canada when it was not:

> Depending on the context, pictorial representations (e.g., logos, pictures, or symbols such as the Canadian flag or maple leaf) may by themselves be just as forceful as an explicit "Made in Canada" written representation. Any text that attempts to qualify a pictorial representation must be sufficiently prominent to ensure that consumers notice it and understand the significance.[21]

Arguably, after a century of being presented as distinctively Canadian, Indigenous designs could very well be among the symbolic representations targeted by these guidelines. For instance, one Vancouver-based company chose Indigenous art as one of its primary themes as evidence of its own Canadian-ness, since, in the owners' view, "there was only one culture specific to Canada, that of the Native people." Similarly, another company decided to develop Northwest Coast–themed products to attract business from corporate companies that held events in Canada and wanted to purchase

merchandise they considered Canadiana. While perhaps not as evocative of Canada as a flag or a simple maple leaf – especially since the Pacific Northwest extends north and south into the United States – Northwest Coast designs have regularly been used to convey a Canadian identity, including on Canada's very currency, which reproduced Haida artist Bill Reid's work on the twenty-dollar bill. Thus, if representations that imply a country of origin must be scrutinized in order to avoid misleading representations of products as being not just "from" but "made in" a certain place, then it is worth taking a closer look at the practices of Northwest Coast artware companies and their effects on consumers' perceptions of their products. For instance, one sales representative told me that he often had to answer questions from consumers about where the products were "actually" made, as if country-of-origin labels and the *absence* of such labels were both potentially misleading.

In most cases, Canadian law does not require companies to identify the country of origin of their products.[22] In other words, there are rules regulating the identification of Canada as the country of origin, but it is also possible not to identify any country of origin at all. With the exception of textiles and a few other specialized goods, an item that is made elsewhere does not need to bear a label stating where it was made. When a Made in Canada label cannot be used, the absence of a country-of-origin label can help turn attention away from the ware's place(s) of production and more easily redirect this attention towards the cultural origin of the designs that are reproduced on it. Admittedly, some types of products, such as most textiles and ceramic kitchenware, are virtually absent from contemporary Canadian manufacturing, and it would be naïve of consumers to imagine they were made locally simply because they are branded as Canadiana. Other products, however, could reasonably have been made locally, such as wood products or metal castings. For instance, one Salish artist has very purposefully decided to work with local paper companies, but wonders, "Can [consumers] differentiate [my work] from the card that has been produced in China and yet has an Aboriginal design on it?" A similar question could be posed for pewter jewellery. At least two companies reproduce Northwest Coast designs on cast pewter jewellery in the Greater Vancouver area. A consumer might therefore assume that the Northwest Coast pewter jewellery made abroad by one of their competitors could have been made in Canada, even without an explicit claim to that effect. Especially in cases like these, in the absence of country-of-origin labels indicating otherwise, the use of Indigenous designs can implicitly reinforce consumers'

misperceptions that the products were made in Canada – and the advantage of this kind of ambiguity is apparently not lost on artware companies. Even for products that are unlikely to have been produced locally, it can be advantageous to remove official indications of this fact. For instance, a young woman who worked for a local company contracted to sandblast Indigenous designs on ceramic mugs explained to me that she was instructed to take the small Made in China sticker off each mug before she did anything else. The reason given for doing so was that the stickers could interfere with the sandblasting process. While that much is certainly true, she suspected another reason for taking them off was the negative connotations the stickers could carry with consumers, especially those who were drawn to the Indigenous designs she was reproducing rather than the mere functionality of the items on which she was reproducing them. She wondered, Even if the designs were sandblasted locally, didn't consumers deserve to know the mugs themselves were made in China? As is often the case, establishing legality seldom puts all ethical questions to rest.

The Stakes of Asserting Locality

Pushback against competition from foreign companies is an omnipresent theme in the artware market's history, and it continues to be a sticking point among its stakeholders today.[23] During my fieldwork, I cannot count the number of times I saw, or heard stories of, customers picking up an Indigenous-themed item and putting it back down, amused or bemused by the country-of-origin label they had found on it. Interestingly, these stories never concerned textiles that are "Made in Italy," even though Northwest Coast art is no more associated with Italy than with China. In contrast to the positive connotations of Made in Italy labels, in popular discourse, the expression "Made in China" has come to represent all products that are foreign and "evil," taking on such a negative connotation that some companies prefer to label their products with the more discreet "Made in PRC" (the People's Republic of China). In recent years, many of those expressing dissatisfaction with the effects of globalization on the artware industry have focused specifically on China's role as "the world's factory"; however, it is interesting to note that, for quite some time, concerns about delocalized production centred on Japan, not China.

In a 1933 letter to anthropologist W.A. Newcombe, Alice Ravenhill was already reporting efforts to curb the competition represented by Japanese

model totem poles, relaying the opinion of the treasurer of the Canadian Handicraft Guild in Vancouver that "these things are entirely destroying any market for the Natives."[24] Similarly, in a 1934 letter to the New Westminster Indian agent, George Raley wrote, "The Japanese find it worth their while to manufacture and flood the curio stores of cities in Canada with spurious imitations of the Indian totem."[25] Raley made the same point in his 1935 *Canadian Indian Art and Industries,* disapprovingly noting:

> Unfortunately, the totemic designs of the northern coast of the Pacific are being manufactured outside Canada in brass, bone, ivory and plaster, and sold to tourists as Indian curios. The Japanese in particular are developing their trade with tourists in Canada in this way, at the expense of our Canadian wards. They have imitated Indian designs, developed them commercially, flooded Canadian stores with thousands of articles and used them to increase their trade results.[26]

Some Indigenous artists voiced similar concerns. In 1953, the official organ of the Pan-American Indian League, *Indian Time,* reported that Ellen Neel was requesting protection by the Canadian government against Japanese imports:

> Thousands of Japanese-carved totem poles are being dumped in B.C. [Neel] believes native crafts should have a greater measure of government protection. She explains that native carvers are not seeking to bar these imports but consider they should bear the stamp of their place of production.[27]

Thirty years later – likely because little had been done about this issue in the interim – artists continued to feel the need for protection against Japanese-made items. For instance, a 1983 account of the National Native Indian Artists' Symposium reports that "there was a strong consensus that the Federal Government departments responsible for international trade and for consumer protection should bar Japanese reproductions of native art."[28] I am not in a position to establish with certainty whether Japan really was the primary source of such reproductions at that time[29] (or at any point after the Second World War, for that matter[30]). But in 2010, the role played by the Japanese in the market was presented to me in a much different light. Instead of being cast as producers of imitation goods exported to Canada,

they were mentioned as people who brought Northwest Coast art to Japan, usually as tourists, and very occasionally as importers. In other words, my interlocutors did not speak of competition from Japanese-made items; when they mentioned Japan at all, it was in relationship to buying Northwest Coast artware, not producing it. In contrast, the expression "Made in China" was on everybody's lips, which were usually pursed in disapproval.

However, China has not been made to simply step into the role previously held by Japan as the faraway source of products thought to be unfairly competing with locally made items. Former concerns relating to Japan had mostly to do with products imitating Northwest Coast art (e.g., plastic totem poles) that were directly imported into Canada. The more recent concerns relating to China now also include flows of plain wares (e.g., mugs, tumblers, fleece blankets) that are transformed into Northwest Coast artware by (or on behalf of) companies based in Canada thanks to embroidered, etched, or printed designs provided by Indigenous artists to these companies. In other words, those who rallied against the threat of an infiltration by "outsiders" of a market they would prefer was kept domestic are now rallying against Canadian companies taking it upon themselves to invite these "outsiders" to participate in this same market. To some, such business partnerships are insidious because local ties can obfuscate problematic global connections; to others, this scenario at least presents the significant advantage of giving the market's local "hosts" a greater say in the market's rules of engagement. In this view, deterritorialization processes instigated by companies with allegiances to Northwest Coast art's originating territory appear slightly less concerning than such processes instigated by companies who operate entirely outside of this territory, because it would be easier for the latter to ignore the "laws of the land" altogether (including those enjoining them to abide by local conceptions of property, discussed in Chapter 4, or to engage in redistribution practices, discussed in Chapter 5). In this somewhat more optimistic perspective on the effects of globalization on the artware industry, a commodityscape that is not entirely domestic could be more easily domesticated if its central hub remains local.

Other industry stakeholders are far less optimistic, feeling very strongly that what happens "over there," even when ordered from "here," is too far out of sight and out of reach to be effectively kept in check. Artists who have chosen to create their own artware companies often do so because they want to have as much control over the production process as they can. Most

of them do not operate at a scale that would make working with companies overseas worthwhile (because low prices usually come only with very high volumes), and instead work with local companies specializing in the customization of wares and clothing at a relatively small scale. Whether or not these items have been made locally, having their works reproduced nearby allowed the artists to feel more in control, reassured that their designs were at least in the hands of people they could interact with directly. For instance, one Squamish artist works with a T-shirt printing company located in the Greater Vancouver area. His choice, he explained, was predicated on the ability to "sit down with them in person":

> They see how you feel, and you communicate with them about how things should look, and you go over there and do the first layout with them, and do the colours, and that's the relationship that I want with a local company ... If I did the stuff out of town, they might do a totally different design, or different colours. That's why I chose to do it locally.

The importance he places on in-person interactions and feeling in control of the process and its final outcome resonates with this Tahltan artist's decision to work with local printers:

> It is important for me to be working with someone that has a strong sense of communication. Unfortunately, I can only speak English, so I need to work with someone who also has a strong sense of English too. That way I can make sure that I can have the most control possible, that I can get my point and my directions across as strongly as possible without having to physically pull the squeegee.

Similarly, a Salish artist prefers to work with a local printer when creating her art cards and other paper products: "I did not want to have it where I have to send something off and have it shipped to me. I definitely wanted [to have] that face to face, walking right into the business and dealing with someone, that's for sure." This choice meant that she could give instructions to the printer in person, and also easily go on site to feel the paper before selecting it, which she felt was a crucial step in her creative process. Had this artist been dealing with a company abroad or even just located outside of the Pacific Northwest, these visits would have been significantly more complicated.

Though perhaps to a lesser extent, even artists who don't have their own companies but sell or license out their designs to Vancouver artware companies (that in turn may or may not outsource production overseas) tend to feel that their own geographic proximity to these local companies affords them greater control than if they were to work directly with companies abroad. For instance, one artist explained to me that the royalty contract he signed with a Vancouver-based company stipulates his right to audit its factory, warehouse, and accounting service, to ensure that he is not being shortchanged. Although the impression I gleaned was that his relationship with them is such that he does not make active use of this clause, the ease with which he could travel to this company to conduct such audits provided him with means of control that he had lacked in the past, when an overseas company had reproduced his work without permission. "They steal and you can't do anything to stop them," he explained to me. Lacking the funds to travel to the company, gather the necessary proof of its wrongdoing, and engage in an international lawsuit, he had sent emails and letters pressuring the company to stop, which it had simply ignored. A Canadian artware company he works with had helped him at least convince local retailers to stop carrying these unauthorized reproductions. This confirmed his belief that, as an independent artist, he should privilege local business relations over global ones, even if this meant passing up potentially more lucrative deals.

Thus, concerns over having too little control over the production process, as well as risks of misappropriation, have encouraged many local stakeholders to keep the industry from "running wild" at a global scale. Local protectionist measures are not always particularly effective; calls are continually made for their reinforcement and adaptation to the realities of contemporary political economies. However, even moderately successful safeguards – such as the unwritten rule enjoining galleries to refrain from selling Indigenous-style works by non-Indigenous artists, or the pressure a local company can exert on its retailers not to sell unauthorized copies of an artist's work – can be seen as providing a more favourable context in which to counter an under-regulated global economy that treats Indigenous arts as belonging to the commons. Whereas early protectionist discourses were directed against supposedly unmistakable "Others" operating seemingly independently from any link to the Pacific Northwest, the picture is now complicated by the fact that a number of Canadian companies, some Indigenous-owned, outsource, import, export, and otherwise deterritorialize Northwest Coast artware.

The Stakes of Going Global

The arguments put forward by those industry participants who outsource their production are primarily economic. One of the main barriers to keeping production local is production costs, which affect retail prices down the line. Several company owners and retailers I spoke to noted that some consumers have the unreasonable expectation of being able to find "made-in-Canada products at made-in-China prices." As one retailer explained,

> There will always be offshore product. That is just the nature [of the business] ... The reality is that if we are actually going to do the volume [we need] and sell what we sell, we have got to ensure that we are getting the best pricing, and not all things beautiful are made in BC. And sure as heck not made in Canada!

Even so, she explained that she tried to support the economies of British Columbia and Canada by giving priority to wholesalers that are based in the province, and otherwise preferring those that are based in Canada over those that are not. Such efforts to supply consumers with made-in-Canada products are not always rewarded to the extent that retailers would like. One of them remarked:

> I get yelled at daily for things made in China. And it's like, "Okay, well then here's a two-hundred-dollar vase that's made here." But then they say, "No, I'm not paying!" ... I buy local as much as I can, but half the time the price point is just not [low enough], especially in today's economic situation.[31]

A company owner similarly described how one retailer had requested he provide Canadian-made baseball caps. He had to explain that this would raise the wholesale price to fifteen dollars from nine dollars, as a result of a higher cost for the plain cap and also because the cost of embroidering the design onto it would increase to as much as $2.75 in Canada from as low as $0.25 overseas. According to him, the preference for Canadian-made products that some distributors and consumers uphold in principle does not always translate into a viable business model in practice.

With more and more retailers claiming it is impossible to run a business effectively while excluding products made overseas, some Indigenous artists

and businesspeople have decided that they have no choice but to source these overseas products themselves. An Indigenous designer based in the Lower Mainland is among them. Committed to using her business to support not only her family but also her community by creating jobs and finding ways to "give back," she feels that it is important to challenge the double standard that makes it seem less acceptable for her as an Indigenous woman to work with Chinese companies than for her non-Indigenous competitors to do the same. From this perspective, her business model can be interpreted as an assertion of Indigenous cultural and economic sovereignty that bypasses national-colonial allegiances.[32] When customers ask why the products that she designs and distributes are made in China, she responds that it helps her ensure that a greater proportion of the revenue generated by the artware market goes to an Indigenous business, and in turn, benefits more Indigenous people. As for her Chinese business partners, she explains that over the course of her several visits to China, she has come to see their relationship as mutual support between two local people partnering up in order to prosper across cultural difference and geographic distance.

This designer isn't the only artist to have come to the conclusion that Indigenous businesses shouldn't shy away from global business relations. After developing a market for her garments in British Columbia and among Indigenous art collectors, another Northwest Coast designer says she has begun to "think globally." As part of this strategy, she now works with textile companies in both Italy and China. In doing so, she has encountered two hurdles: external criticism of this new direction, having mainly to do with working conditions in China; and her own concerns about her ability to build relationships of trust and sustain quality control when her business partners are so geographically distant. Despite these challenges, she stands by her decision to expand the horizons of her business to a more global scale. She tries to ignore the first hurdle, saying she would rather not argue with critics who know China only via biased media reports, and prefers to spend her energy on dealing with the second hurdle, through building relationships with carefully chosen business partners.

I have heard these two designers applauded for challenging the idea that the value of Indigenous products is more intrinsically tied to local production than other products, their business models presented as indicative of their entrepreneurial savvy and forward thinking. For instance, one Indigenous retailer made an exception to her policy of refusing to carry made-in-China products in order to support Indigenous businesses that wish to gain

space in that part of the market. However, these designers' business model also dismays those who feel that it places further risk on Northwest Coast cultural property by undermining the competitiveness of other Indigenous-owned companies that wish to keep their activities local, and also potentially facilitating unauthorized processes of commodification taking place abroad, out of sight until it is too late to do anything about them.

Anthropologists Jean Comaroff and John Comaroff have argued that one of the impulses of "capitalism at the millennium" has been "the distanciation from place and its sociomoral pressures." One of the things that has made such distanciation possible is the fact that "bosses live in enclaved communities a world away, beyond political or legal reach."[33] As we have seen, thinking about what they can do at their own scale, many artists prefer working with local companies precisely because they feel such distance would preclude them from exerting any sort of control over their business partners' practices. In contrast, since they are themselves the bosses who personally build relationships with companies overseas, the two Indigenous designers discussed above feel that they have as much knowledge of what happens with their artwork as if they worked with someone else's company locally. But this strategy faces a challenge from public perceptions of what Indigenous businesses should do and what Indigenous products should be.

Criticism of local companies that outsource their production to companies abroad is of course hardly confined to the Northwest Coast artware industry, since this practice is a central feature of today's capitalism. What is specific about this market, however, is the effect that the fastening of social representations of "Indigenous people" onto social representations of "local economies" has had on the propensity of the public to imagine Indigenous people themselves participating in global commodityscapes. Indigenous businesses that choose to work with Chinese companies to become more competitive in the market are constantly confronted by the intimation that, as an Indigenous business, they should refuse to contract overseas producers. As pointed out to me by the aforementioned Lower Mainland Indigenous designer, such attitudes are arguably a symptom of deeply rooted stereotypes concerning the ways in which Indigenous businesspeople engage the market, ignoring the long history of Indigenous peoples' involvement in global circuits of trade.[34]

The material and cultural forces of capitalism are always "in some measure, refracted, redeployed, domesticated, or resisted wherever they come to rest"[35] and engaging in processes of "localization" tends to be read by

anthropologists "as a nearly heroic act of refusal"[36] on the part of those who do the refracting, redeploying, domesticating, or resisting. Discussing the example of Indonesian indie pop groups in Bandung who aspire to see their music circulate worldwide, anthropologist Brent Luvaas explains that, on the ground, localization is not necessarily experienced as active refusal. To these bands hoping for international success, "the 'local' of the nation-state often feels like a trap, a barrier between Indonesia and the rest of the world."[37] When the territorial point of reference for the "local" is the nation-state of Canada, rather than partaking in localization processes that would reinforce this non-Indigenous form of territoriality, Indigenous artware producers can assert their engagement in *deterritorialization* processes as refusal of the colonial order to which they are subjected. In many ways, it is in order to further assert Aboriginal rights and title that some First Nations have engaged in negotiations directly with Chinese resource extraction companies, bypassing the federal and provincial governments.[38] An Indigenous nation deciding to override Canadian governmental processes to contract resource extraction on its territory "out" to companies overseas can be seen as lifting overbearing colonial territorialities in order to reinscribe territorial sovereignty under new terms more in tune with Indigenous interests.[39] However, in a context in which embracing globalization is one of the measuring sticks of neoliberal success, the idea that Indigenous peoples have more to lose than to gain from deterritorialization cautions some of them against such initiatives. One of the arguments levelled against globalized Indigenous entrepreneurship is the risk of having to repudiate an Indigenous specificity, especially insofar as Indigenous sovereignty continues to directly hinge on the question of territory.[40]

Contemporary consumers are sometimes imagined to have a blasé attitude towards globalization and therefore seen as generally indifferent to where their belongings were made. Whether this is true of consumers in general is beyond the scope of my research, but representatives of companies I spoke to do not think this description applies to consumers specifically looking for Indigenous items. In part, this is because the "ethical consumption" movement has rendered the flaunting of strong ties to a specific locality increasingly fashionable and profitable, especially in markets focused on culturally marked goods (e.g., art, food) or specific geographic places and spaces (e.g., eco-tourism).[41] As part of this wider resurgence of interest in local products, Northwest Coast artware companies often use indigeneity as a particularly powerful index of locality. For instance, local wild salmon

is presented in cedar boxes decorated with Northwest Coast designs, suggesting that the Pacific Northwest provenance of the fish itself is not a strong enough indication that it is indeed a "local" product.

Not only does an Indigenous design have the power to signify locality, but Indigenous-themed products also tend to be held to much higher standards of locality than their Canadiana counterparts. For instance, an acquaintance of mine who works for a well-known French luxury company once complained to a group of us gathered for dinner about some consumers' expectations that the handbags they sold would all be made in France. "We are a large multinational corporation with offices, warehouses, and stores all over the world!" she exclaimed. "Why would it matter that some of our bags are made in Portugal?" Yet, when later in our conversation I discussed my research, she pivoted on her earlier comment by explaining that, in the case of Indigenous art, she understood that consumers would place importance on local production. This person is certainly not alone in more readily associating Indigenous products with the local than with the global. For example, when prompted to provide criteria that products should meet in order to be considered "of a specific culture," several of my undergraduate students contended that place of production did not necessarily matter to them, *except* in the case of Indigenous products. Similarly, a retail manager told me that when it comes to Indigenous products, her "number-one criterion is [to] try to find items that are made in Canada, or [by] a Canadian-based company – something that has a link to Canada," noting that these are "not the easiest to find these days." To explain this priority, she evoked customers' disappointment with things that are made in China or Mexico. "They don't want that," she explained. "They want to remember it's from Canada." She went on to single out art made by Indigenous artists as "guaranteed 100 percent made in BC or made in Canada," drawing a direct relation of cause and effect between being of Indigenous ancestry and working within or near one's ancestral territory (perhaps on another Indigenous group's territory but still within the boundaries of the settler nation-state that seized it). In another instance, a gallery owner discussed a Northwest Coast jeweller who has been living in Southeast Asia for a number of years, in part because of the low cost of living there compared to Canada. The location where he lives and works, although not kept secret from buyers, is not usually put forward as a selling point for his jewellery. This reticence is not surprising in view of the prominent negative discourses about offshore production in Indigenous art, whereas non-Indigenous artists are more

easily positively cast as cosmopolitan when they make similar life choices. Not only does this underline the common tendency to oppose "indigenous" and "diasporic" forms of life,[42] it also provides another example of how representations of indigeneity have played a part in limiting the market's deterritorialization.

Local Ties in Global Times

Despite its complex commodityscape, the artware industry has a stake in remaining centred on the Pacific Northwest both symbolically and materially. Even when the reproduction of Indigenous designs does not occur within the Pacific Northwest, these marked wares almost always eventually travel through it before being placed on the market. At the very least, they are extremely likely to have once sat in packing boxes in Vancouver, Victoria, Bellingham, or Seattle warehouses before being shipped to a point of sale outside of the Pacific Northwest, most often in or near one of the region's institutional satellites. The market for Northwest Coast artware is indeed largely predicated on the industry's strong relation to its hub in the Pacific Northwest. It has made a business of reproducing designs that have for a century now been identified as distinctively Canadian, but are actually unique to this region. Indeed, they are unique to peoples who, through various forms of protectionism, have continually asserted that they consider much of their cultural expression in proprietary terms and have the right to play a central role in the markets associated with it. In this respect, the artware industry illustrates well the Comaroffs' argument that a culturally based business has to "keep its distance, and its distinctiveness" because "business based on cultural difference that succeeds in the competitive fray of global markets and does so *unmarked* by otherness, is open to the charge that it does not require, nor does it warrant, sovereign exclusion, protection, or preference."[43]

At the same time, the Northwest Coast artware industry has undeniable global dimensions: it relies on the global market of labour and goods and it sends products travelling around the world with their buyers. Some artware industry stakeholders, non-Indigenous and Indigenous, see a more direct engagement with the market's global connections as an opportunity of great economic, social, and cultural value – at least for those who willingly undertake it. Yet even the most optimistic concede that embracing globalization should not be confused with local stakeholders relinquishing control over

the market and putting into question the centrality of the Pacific Northwest to the industry's commodityscape.

There is indeed much more to Northwest Coast artware's locality than a crude branding of a product as "local" through the use of Indigenous motifs. The role played by Indigenous stakeholders in the assertion of the Pacific Northwest as the industry's primary locality should not be overlooked, as their involvement powerfully recentres the industry's territorial allegiances on the identity of those who control it rather than simply on the geography of its commodityscape. Among the Indigenous artists and entrepreneurs I spoke to, some wanted to keep the industry's global connections to a minimum, sometimes even downplaying them. In contrast, others are anxious to harness the forces of globalization to their advantage, eager to rid the field of Indigenous art and artware from what they consider to be unrealistic expectations of localization in the context of today's extremely globalized world. In both cases, the agency (or lack thereof) these Indigenous stakeholders have to shape Northwest Coast artware's commodityscape is arguably at the heart of the industry's territoriality, symbolically if not literally geographically. The industry's geographic scope is not the only thing that factors into Northwest Coast artware's ability to index locality. The identity of those who determine this geographic scope and *their* connections to these territories are just as important. It is therefore useful to look beyond where the objects are made (which more often than not is several places, anyway) to also examine the places from which their production, circulation, and consumption is orchestrated, and by whom. From that perspective, the Northwest Coast artware industry immediately appears significantly less "global" than a simple count of Made in China labels might suggest. Conversely, "Made in Canada" country-of-origin claims are not necessarily a good measure of the industry's locality, nor are they always dependable indicators of the industry's indigeneity when considered through the lens of control by Indigenous stakeholders.

In sum, the market's current configuration is shaped by the productive tension between, on the one hand, aspirations to expand the Northwest Coast artware commodityscape beyond the local and, on the other hand, desires for protection of Northwest Coast art from global competition and loss of control. Industry participants do not necessarily see expansion and protection as inherently antithetical, but instead often approach them as two elements with which they are always required to engage, inflected by the social and geographic scale at which they are willing to operate.

Decisions by Indigenous artists and company owners to move towards a greater or lesser entanglement in global networks are largely made in relation to the control that they feel is lost or gained as a result, and the effects this could have on the assertion of territorial and other forms of Indigenous sovereignty. Thus, through its stakeholders' exploration of the space created by both deterritorialization and reterritorialization processes, the industry is becoming a form of culturally modified capitalism: a market that is not immune to the forces of globalization but has nonetheless been able to uphold its local dimension by maintaining the Pacific Northwest as its central hub and continuously reasserting the ties between Northwest Coast art and its region of origin.

4

Property and Contracts | *Stewardship and Relationality*

> The culture of the new capitalism is attuned to singular effects, one-off transactions, interventions; to progress, a polity needs to draw on sustained relationships and accumulate experience.
>
> – Richard Sennett, *The Culture of the New Capitalism*

A NY ECONOMIC TRANSACTION can involve differing perspectives on what exactly is being exchanged and negotiated between parties, and on the fairness of the transaction in question. However, the ethics of certain kinds of exchanges are more controversial than others. This is particularly the case when they involve imbalances of power, or paying for what some believe is inalienable and ideally should not be treated as a commodity. Transactions related to Indigenous knowledge and cultural expression are exchanges that raise issues of both power and commodification, made even thornier by the fact that they involve negotiations across cultures. As the late anthropologist and biologist Darrell Posey once remarked, in such contexts, discussions of "what is 'just compensation' and how such benefits would be distributed opens a Pandora's Box."[1] It is arguably much easier to posit the need for such "just compensation" on moral grounds than to assign specific criteria and characteristics to this expression in relation to each given situation, let alone in a cross-cultural context. In addition, the different conceptions of what constitutes "fair" distribution of wealth and power that are in play are not always made explicit, especially when the most dominant of these models is widely taken for granted.[2] For instance, the expression "business is business" – which is regularly used to justify a contractual agreement or business practice as standard despite it being considered inequitable by one or more of the involved parties – signals a blanket acceptance of predominant norms that are, more often than not, archetypically capitalist.

In contrast, the assessment of a particular transaction as "fair" or "unfair" is always contingent on context and process, including the parties' acceptance or contestation of dominant values and practices.[3] And the fairness of a business model cannot be evaluated solely based on the features of the

◀ OVER

By emphasizing their responsibility towards their families and communities, Indigenous-owned artware companies are changing the industry's configuration, reinforcing Pacific Northwest values and ways of life.

Designs by the late Joe Becker, Musqueam (mug), and Shain Jackson, Sechelt (earrings).

individual relationships and punctual transactions that characterize it. Such an assessment is also always dependent on the socially and culturally consti-tuted frames of reference – including those reflected in a society's laws, notions of property, and ethical norms – within which relationships are pursued, developed, and, in some cases, terminated. As anthropologist Peter Luetchford puts it, each society harbours its own "morally-informed notions of the proper purpose of economic activity, political ideas about how the economy works and how different contributions are assessed and rewards divided."[4] Therefore, when economic exchanges involve systemic imbalances of power as well as cultural difference – as is often the case between the Northwest Coast artware industry's Indigenous and non-Indigenous participants – there can be dis-agreements about what "just compensation," "fair payment," or "ethical business" really mean. Beyond the specifics of each contract signed by companies and artists, the ethics of the artware industry are evaluated by its participants and stakeholders very differently depending on whether the primary frame of reference is a capitalist or an Indigenous understanding of property, and whether the main focus is on punctual exchanges or on the development of relationships over the long term.

"Just Compensation," beyond the Issue of Misappropriation

In the artware industry, moral evaluations of economic transactions often go beyond what is prescribed by Canadian law or what might be considered standard business practices in the world of graphic and product design. When a company is accused of not having paid "enough" for an image, this may not mean that the price it paid for the artist's work was below market value (less than freelance design rates, for instance). Even a company paying more than what would be considered standard in the design world is not necessarily shielded from criticism. Relationships between artists and artware companies are governed by much more than signed contracts, exchanges of money, and a straightforward "business is business" mentality. Still, the agreements they negotiate in relation to the use of Northwest Coast images are one of the most basic and frequent transactions to occur in the artware industry. Understanding the tensions that surround artist remuneration can therefore provide a baseline for broader discussions of the ethics and economics of this market. Examining in more detail the nature of these transactions and the relationships they reflect will help illuminate the debates that animate the industry, beyond the more obvious concerns surrounding commodification-as-appropriation.

Much has been written about the complex politics of misappropriation, that is, the act of taking inspiration from, and in some cases outright copying, culturally significant elements without collaborating with or seeking permission from the people who developed them generation after generation, and using these elements outside of their context in a way that threatens this people's way of life and/or livelihood.[5] In the artware industry and in countless other fields of business, cultural misappropriation is common practice. Many use Indigenous images without any form of attribution or consent, often copying them from books, museum objects, or the Internet, wrongly believing that they are in the public domain, things to which "simultaneously/alternatively, everyone and no one might have a claim."[6] Pressed to explain what has led them to do this, most will draw on one or more of the following arguments: (a) they were told that Indigenous art is regarded as collective property, which they interpreted as meaning that these works are the property of no one in particular instead of the property of a specific group of people; (b) they believe Indigenous art is "national heritage" and as such can be used by any citizen regardless of ancestry; (c) they know that the creators of the works they used passed away long enough ago that these images are considered free of rights under their country's law; (d) they have seen works reproduced elsewhere without an artist attribution, leading them to think that no one has claimed or could claim them as their own; (e) they believe that works that are shown in public spaces escape intellectual property (IP) laws by virtue of having become iconic.[7] As incorrect or unfounded as these arguments may be, especially from an Indigenous perspective, Canadian and international IP laws (and popular understandings of these laws) have generally been ineffective in protecting Indigenous cultural expressions and knowledge from misappropriation.[8] In relation to this, anthropologist Jennifer Kramer remarks there has been an "explosion of property language used by and for Indigenous peoples at the same time that some property categories are being exposed as inappropriate for representing Indigenous perspectives."[9] Arguably there are only "illusory benefits to Indigenous peoples of employing European-based property concepts and terms," because these "never accurately or productively represent Native ideas of possession and stewardship." Still, Kramer notes, the language of property is regularly deployed by Indigenous people as a means to "fight appropriation and secure greater control over the proliferation of others claiming their designs, stories, songs, etc."[10] This

is certainly true in the Northwest Coast artware industry, where concerns run high about the effects of commodification on the ability of Northwest Coast peoples to protect their cultural heritage.

My own research having focused primarily on artware companies that work directly with Indigenous artists, my analysis focuses on uses of Indigenous images that are not usually considered straightforward misappropriation (in the sense of taking without any consideration whatsoever for property rights as recognized in both Indigenous and non-Indigenous frameworks). That said, the question of misappropriation is not altogether pushed out of the picture simply because artists have consented to, and are paid for, the sale or use of their works. Misappropriation can be understood not only as an act of taking what is not one's own, but also as inappropriate modes of making something one's own, that is, asserting ownership over something under rules that are inconsistent with the rules under which ownership was assigned in the first place. Eliminating the first kind of misappropriation does not necessarily mean evacuating the second: buying the rights to an image from someone is better than stealing it from them, but does little to appease those who believe such an image was never meant to be owned by the seller in the first place. On the Northwest Coast, as creators, artists may feel entitled to sell their works but, as members of a family, clan, or nation, often find that it is not considered their prerogative alone to decide when it is appropriate, and often seek guidance or even permission from those who have the knowledge and authority to do so within their family or community. Many artists I spoke to recognize their embeddedness in a larger network of stewardship: they seek to be appropriately compensated for their work as individuals making a living in the creative economy, but also feel a responsibility to ensure their community receives recognition or even tangible benefits from their personal activities in the artware industry.

This additional layer of complexity is in great part why, despite my focus on artware companies that work directly with Indigenous artists (as opposed to companies that simply copy or imitate the style of Northwest Coast art), the danger of misappropriation figured prominently in my conversations with industry stakeholders, as did the ethics of cultural commodification more broadly. These discussions usually opened with the question of whether artists were fairly paid by the companies that use their images, and very often moved on to the relationships between Indigenous and non-Indigenous stakeholders in general. A contract between an artist and an artware company may not legally bind anyone else but them, and yet there are usually more than individual

interests on the negotiation table, whether or not they are explicitly articulated in the moment. The fairness of contracts negotiated between artists and companies is often not simply a question of business having been conducted fairly, but also a question of equity in the ways Indigenous and non-Indigenous peoples treat what they are exchanging and, by extension, each other. As Cori Hayden has argued with respect to bioprospecting contracts, which raise strikingly similar questions to the issues of cultural commodification,[11] "One of the central paradoxes of [benefit-sharing] agreements is that benefit-sharing provisions, offered by their proponents as a form of redistribution of wealth and technology, or even as an ethical act, only make more explicit the historically entrenched gaps in power of the actors involved."[12] Thus, while the issue of just compensation at the level of individual artists deserves to be addressed, it almost inevitably leads to discussions about the implications of cultural commodification at a more collective and relational level.

Artist Remuneration Explained

While much of the criticism of artware companies I heard was focused on the issue of imbalances in the distribution of profits, a number of artists pointed out that money is not the only thing that matters to them when evaluating the quality of their relationship with a company. Several artists commented that one of the benefits of having their work reproduced on artware was to make their name better known in the Northwest Coast art market. For instance, a Tsimshian artist made the following comment about the benefits of working with a particular artware company:

> I understood from the beginning that I was getting paid more than just money with these pieces that I was selling the rights to reproduce ... In my opinion, I'm getting more than money off of this. I'm also getting advertising. I understand how much it would cost for my products to get out there the way that [the company] puts them out if I paid for it myself ... That's a lot of money to consider spending on your own if you don't want this so-called "white man" to get rich off of you. Like I said, I think at the same time that [the company] is making money, I'm getting exposure and that is just as valuable of a payment for me as it would be financially.

This artist was not the only one to point out that having work reproduced on artware was a means of promotion for artists, especially early on in their

career. A gallery owner explained that he has occasionally encouraged artists who are at the start of their career to work with artware companies.

> If you are a new artist, ... unless you are an extremely good speaker when you go in and you can sell yourself to these dealers, it's difficult to break through. If you go to a company that is producing cards and that gallery now sells your cards, when you walk in and say your name, they'll say, "Oh, I know you, you made these cards." It's giving you that foot in the door ... That's why I encourage some of the young artists to go ahead and work with a company like that because it just puts your name out there. Even if you haven't met those dealers, if they know your name, it gives you a huge advantage.

The same gallery owner stressed that if artists considered artware primarily a means to publicize their work, they would be less disappointed or frustrated by the difference between what they make and what the company makes. In this sense, although artware in and of itself is seldom a sufficient means of subsistence, it can be seen as a way to gain name recognition in order for artists to advance their career and be able to make a living from selling their individual artworks.

Some artists are ambivalent about this approach, pointing out that the promise of exposure can seem empty, or even dangerous at times. As one artist's wife told me, "You can die of exposure, you know!" pointing to the idea that overexposure as a so-called commercial artist could have detrimental effects on an artist's career. The importance of finding a balance between getting known through artware and getting known as an artist was expressed by a Coast Salish artist:

> It's sort of strange because even though it's a really commercial means for having my name out there as a contemporary Northwest Coast artist, it's almost like my name precedes me, like people are aware of who I am even before we've met, so that's ... I don't know exactly how to feel about that. I know that my work has been published on T-shirts and cards that are distributed all over British Columbia and different parts of North America, so I always try to view that from a humble perspective because I'm aware of financially how much I made from what's being published and distributed, but also because I'm aware that it's commercial.

But no matter an artist's stance on the benefits and perils of artware as a form of advertising, it can easily be framed as an economic benefit in that the exposure is supposed to lead to future monetary gains. In that regard, one Haida artist treated artware as a means to "buy time" when working on a larger project that will only pay in the long run. However, he stressed that this was only possible if his time spent on creating artware designs was remunerated well enough.

Thus, before continuing, it is necessary to describe typical agreements between artists and companies, so as to more aptly examine the various angles through which industry participants and stakeholders evaluate these transactions' ethics. Artists are seldom if ever on companies' payrolls as employees, working as in-house designers. Instead, their position is similar to that of freelance designers: they are remunerated for each image or project, usually without any contractual obligation on either side to continue working together afterwards. As long as they do work together, artists are typically paid by the company one of two ways:

1. Flat fees with which the company purchases the image copyright from the artist; in this scenario, the company becomes the image's owner.
2. Royalties that the company pays in exchange for using an image to which the artist keeps the rights; in this scenario, the artist is the owner and licensor of the image, and the company its licensee.

On a few occasions, I have heard these two systems discussed as if they were one and the same, especially by retailers who were careful to point out that they only carried the products of companies that paid "royalties" to artists, even though their store carried merchandise produced by companies that in fact purchase images outright with a flat fee. Equating the two arrangements in this way suggests that artists being paid one way or another should be enough to allay any unease related to misappropriation, on these retailers' part and on the part of their customers. However, the two systems are not interchangeable, and the preferences of artists (and of companies) for one or the other system of payment reveal much more than a concern for money alone, as each system also reflects a different kind of relationship-building.

Still, numbers – whether dollar amounts or royalty percentages – do play a role in how the fairness of these transactions is assessed. In that regard, the mode of payment alone – flat fee or royalty – does not determine artists' level of remuneration, nor their satisfaction with this remuneration. It is

difficult to paint a precise picture of practices across the industry: many participants were reluctant to share the details of their own contracts, and even when speaking generally, were unable to point to what one might call "industry standards." What is clear is that the amount ultimately paid out to an artist can differ substantially from one image and one artist to another. For instance, royalty percentages vary greatly from one artist and company to the next. One company owner explained to me that he set a percentage based on what "felt right" to him, while another turned to me, the researcher, wondering if I had discovered such a standard by speaking to her competitors. Although I did ask artists and companies for specific percentages, their responses were often individually vague and overall wide-ranging. One artist said he didn't remember what the percentage was, but joked that he knew he "could not retire on it," while another was happy to report that his royalties were "a really good deal, a deal that no one else can get" but did not feel comfortable giving me a number. Some more precise royalty percentages were shared with me based on cost of production (7 percent, 10 percent, 15 percent, and up), and on wholesale price (3 percent, 5 percent, 6 percent, 7 percent, 10 percent, 20 percent, and up). However, given that wholesalers' margins also vary (I was given the approximation of anywhere between 20 percent and 60 percent of the wholesale price on average, depending on the kind of item), these figures are not directly comparable. One store employee told me that the standard royalty for products developed with museums was between 7 percent and 10 percent of production cost. However, the many other figures I was given suggest that this range is not yet the norm industry-wide. Also, several companies explained that they preferred to pay all their artists either the same or at least very similar percentages so as not to create a hierarchy among them, while others stated that well-known artists tended to be paid higher percentages because products bearing their artwork could be more easily sold. As with royalty percentages, very few precise numbers as to flat fee payments were shared with me, and those ranged from a particularly low amount of twenty-five dollars to over five thousand dollars. Several figures were in the hundreds of dollars, a few others in the thousands of dollars, and I also heard vague statements such as that an artist received a sum "equivalent to the price of a painting."

Especially given these wide-ranging numbers, neither method of payment has an inherent monetary advantage for an artist, and there is no real consensus among artists as to which system is more advantageous. Receiving a fixed amount up front can be more lucrative than counting on the progressive

returns of royalties, especially if an image does poorly on the market; in contrast, that same set amount will seem too little if the image performs well and royalties would have yielded more revenue over time. In other words, just compensation as measured in dollars received by both parties largely depends on the specifics of each contract, as well as the success of the products on which the images are reproduced. Although many artists are now requesting to be paid royalties, I have met artists who have been in the artware business for years, and are content both with flat fees as a form of payment and with the amount they receive for their images. They liked that the total amount was known and paid to them up front rather than dependent on how well the product performed, paid in fractions over time. A Haida artist who usually works with a company that pays flat fees explained that under a royalty agreement with a different company, he had received a grand total of fifty dollars over a period of two years, a sum that pales in comparison to the flat fee he normally receives for a similar image. Conversely, a number of artists paid through a flat fee, once they saw the products lined up in store after store, began to feel that the amount they had obtained was not as good a deal as they had initially thought. Without necessarily feeling that the company had purposefully tricked them into signing away more than they had intended, they wished they had foreseen the breadth of the uses they were agreeing to.[13]

Being able to evaluate the fairness of a contract – even in simple monetary terms – assumes that both parties are on the same page as to what exactly is being remunerated. Indeed, one of the questions surrounding the remuneration of artists is whether they are being paid in relation to the amount of work their image represents, the quality of that image, the value the image adds to the product, the value their name adds to it, or a combination of some or all of the above. Beyond the technical legality of what is stipulated in their contracts, how industry participants discuss artist remuneration easily shifts from the quality of an image to the time spent creating it, from production costs to profit margins, from cultural heritage to intellectual property, and so on. Slippages between these various spheres of value are frequent, leading to different, and in some cases conflicting, assessments of what just compensation looks like.

For instance, several industry participants pointed out to me that a company may have to thoroughly rework an artist's design. They contrasted artists delivering a rough paper sketch or recovering an image from an old stash of drawings with artists who delivered polished designs, in some cases

already digitized, as well as artists who were much more heavily involved in the product development process. Both artists and companies used such comparisons to argue that labour and effort was key in evaluating the fairness of the benefits reaped by each party.[14] The more extensively artists were involved in the process the greater returns they should expect, they argued, as such involvement required more work and more professionalism on their part. For instance, an artist assessed the arrangement he had with a T-shirt company: "He [the company owner] gets paid more because he's the one doing the work. He's the one getting the bigger percentage, because all I'm doing is doing the design." Others made similar analyses, such as when I asked an artist if he felt that the percentage he was paid was fair and he replied "yes," explaining:

> Just about everything that I've done is off of works that I had already created, so I mean ... In a lot of cases they're sold-out print editions, so there's no work on my part. You hand them the design, you email it to them, I don't do anything physical, and then they are able to work with that, and then I get royalties from it. So I think it's kind of a good situation.

A Northwest Coast fashion designer similarly explained that, beyond individuals' position in the market and the quality of their images, the royalties they are able to obtain depend on the kind of work they are prepared to deliver. She explained that as part of her contract with an artware company, she was involved in most decisions and had approval on everything related to product design. She noted that, given this deep involvement, she had also had a say in terms of marketing, from packaging to setting retail prices. In contrast, she evoked a situation in which an artist draws a design on a paper napkin and leaves it up to the company to make the drawing usable for reproduction, as well as develop and market the product. She said she would not be surprised if the royalties paid to the artist in such a scenario were lower than the ones she receives given her own participation at every stage of the process. To her, it made sense that the amount of work delivered by artists should be a factor in their compensation.

However, not all artists agree that the amount of labour involved should be the primary factor in determining the appropriate level of remuneration. For instance, an artist described his experience being paid a fee of five hundred dollars for an image, to his satisfaction at first and to his

disappointment later on. It had taken him a few hours to create the work in question, he explained, and so the fee had seemed very reasonable. Later, he learned that the products on which the image had been used had generated approximately sixty thousand dollars in sales. Notwithstanding the company's investment in producing the objects, this figure made him feel that his payment was not as fair as he had initially thought. His change of heart highlights the distinction between fairly remunerated labour and fairly redistributed profit. There is a difference between being paid proportionally to the time spent working on a design, and being paid proportionally to the value this work generates. In the case of images applied to objects specifically in order to distinguish them from other similar products, as Northwest Coast images do in the artware industry, the value contributed to the item by each party is not merely the sum of their respective labour and expended costs. It also derives from their respective contributions to the product's ability to spark interest in the buying public. This value may not seem easy to measure in monetary terms, but companies do take that very aspect into consideration when deciding whether to add an image to a blank product. Taking the example of an embroidered scarf, one company owner explained:

> Everything really is, sadly, often governed by cost, because a Native embroidery is often very detailed, with such a high number of stitch count. You could be adding a five-dollar cost to a product that costs two dollars, and making it very expensive ... Suddenly you've got a scarf that might normally sell for five dollars, you put a Native design on it and it sells for twenty, because you've also got the royalty and the embroidery costs. So, often things like price point do govern what we do.[15]

In this scenario, embroidering an image onto the scarf is only "worth it" for the company and its retailer if consumers are as willing to pay twenty dollars for a scarf with a Northwest Coast image on it as they are to pay five dollars for a plain scarf, that is, if they consider that the image increases the value of the scarf fourfold. It might be argued, in that case, that the artist should be paid in relation not only to the labour required to create the image, but in relation to how much the image they created enhances the perceived value of the item in the eyes of the consumer. However, this "added value" was made possible because the company was able to front the costs associated with reproducing the image, which arguably warrants some return

on this investment. But, as is clear from the language in which it is couched, this discussion is framed in capitalist terms that do not take into consideration the fact that the very thing that is at the heart of the commodification process – put simply, an instance of Northwest Coast cultural expression – is also governed by Indigenous property regimes.

Eurocentric IP Laws versus Northwest Coast Indigenous Legal Regimes

> In European art, I can buy a bear [design], I can buy a fish, I can buy a maple leaf, and there's never going to be an issue how I buy that design, how much money I made off of it, but with the First Nations, we've constructed it [differently]. Is [paying royalties] any more or less ethical than buying the art outright as we would with someone who made a flower or a maple leaf? I don't know, I think that's a good discussion. We happen to [pay royalties], but whether it's the best program, ask the artist. Maybe the artist would prefer a front payment and that's it.
>
> – A non-Indigenous artware company owner

The cross-cultural dimension of the transactions that are at the heart of companies' relationships with Northwest Coast artists are sometimes downplayed to place emphasis on personal preferences. And yet, to suggest that individuals' divergent perceptions of "just compensation" fully explain the underlying tensions that traverse the artware industry would be to misunderstand the roots of the tensions that surround transactions involving cultural commodification. The company owner quoted above says that when she buys what she calls "European art" (an image of a bear, fish, or maple leaf), neither the means she uses to purchase it nor how much she profits from its use are likely to receive much scrutiny; "with the First Nations," she remarks, she does feel scrutinized in relation to the way she conducts business, and in particular how she pays for the images she uses. However, the heightened scrutiny she experiences and the preference of the artists she works with for royalty payments is arguably not as arbitrary as she implies. The dynamics of current relationships between Indigenous and non-Indigenous peoples are informed not only by a particularly fraught history and the mistrust it has caused, but also by fundamental differences between Canadian laws and Indigenous laws,[16] and those of Northwest

Coast societies in particular. Both have direct implications for the artware industry and the ethics of the transactions that take place between artists and companies. Let's begin with the differences in legal regimes before returning to the issue of trust.

Northwest Coast Legal Regimes: A Primer

In the words of Haida lawyer gii-dahl-guud-sliiaay (Terri-Lynn Williams-Davidson), "Given the wide cultural diversity among First Nations, it is difficult to give a single definition of cultural property from a First Nations perspective." However, Indigenous conceptions of cultural property generally differ from those reflected in Canadian intellectual property laws, including due to the fact that Northwest Coast people "recognize that cultural objects possess their own spirits and the creator of these objets is only a medium through which our ancestors speak."[17] As anthropologist Jennifer Kramer remarks, the notion of "possessive individualism" according to which objects can be "sold and alienated from their owners as commodities" is the basis of most European-derived copyright laws. Under Canadian IP laws, for instance, living artists automatically hold the copyright to their work as individuals until fifty years after their death. Artists can choose to sell this copyright, or particular use rights through royalty agreements, to another person or legal entity such as a private company. In contrast, Kramer notes, "many Indigenous peoples espouse the view that their possessions are inalienable; they are merely the stewards of objects that cannot be divorced from social identity." On the Northwest Coast, representations of figures, crests, stories, and other forms of cultural expression are often held collectively, usually within particular clans, lineages, and families.[18] In some cases, specific individuals embody particular names and are afforded the rights and privileges associated with this position, including responsibilities related to the care of various forms of intangible and tangible heritage. When their responsibilities are passed on to the next generation, the transfer occurs according to complex systems of inheritance that do not leave the transmission process up to that person. As pointed out by anthropologist Cara Krmpotich regarding the Haida, alienable possessions such as cars, clothing, and household appliances can be bought and sold by individuals, but they are regarded as secondary to inalienable possessions such as crests and stories, which are highly valued and tied to lineage or kin.[19] In short, Canadian IP laws are designed to protect an idea as expressed by an

individual through a fixed form (such as an artwork, a photo, or a song), and allow its creator to decide, as an individual, what to do with it. In contrast, Northwest Coast laws are concerned with assigning stewards to both the idea and its various forms of expression, which do not stand alone but rather are linked to a system of interconnected ideas and collective responsibilities. Krmpotich explains that outsiders, including institutions such as museums – and, one would assume, artware companies – "rarely occupy a social position that would, according to Haida cultural protocol, sanction them to be the possessors, caretakers, or handlers of lineage property."[20]

Another point of difference between these two perspectives concerns the societal status of artists. European societies nowadays tend to value artists as those whose role is to "break the rules"; on the Northwest Coast, as pointed out by Snuneymuxw/Nuu-chah-nulth lawyer Douglas White, the role of artists has been "nothing less than to assist in the formulation and expression of the philosophical and normative foundations underlying sovereignty and constitution of Indigenous nations."[21] In other words, in Northwest Coast societies, artists are meant to work alongside lawmakers, not against them. They are still afforded creative freedom in terms of aesthetics, style, and innovation; however, their work also serves a legal purpose by publicly expressing rights, privileges, and responsibilities as assigned by law and asserted through customary protocols.

As noted by historian Susan Roy, Northwest Coast peoples have long been drawing "upon indigenous prescriptive rules, performative traditions, and Western display conventions centred on objects and the visual in order to produce meaning for non-Aboriginal audiences," including making Indigenous laws known to them.[22] For instance, the Coast Salish associate certain people within each community to specific ancestral figures, stories, and names, and these specific connections are required in order to access certain parts of the territory and its resources. While Coast Salish artists often keep the deep spiritual significance of their works private, they often signal their "connections to family ancestry, lineage, and history" in their works, including those sold to outsiders.[23] Similarly, Douglas White argues that Nuu-chah-nulth ceremonial curtains or *Kiitsaksuu-ilthim* "reflect and contribute to the formation of the Indigenous legal systems and cosmology articulated through potlatches," including "laws similar in substance to intellectual property" that "address the ownership and use of names, songs, and depictions of certain beings and the right to tell stories." Thus particular

thunderbirds "have nests in specific territories, and the right to depict them is owned and controlled by specific families as part of their basic identity."[24] As detailed by Tsimshian scholar Mique'l Dangeli, among Sm'algyax-speaking peoples, some rights and responsibilities are communally inherited, while others can be taken on by individuals. A person can become intimately connected to *nax nox* (supernatural powers, spirits, masks, dances, and songs) through revelatory encounters with them, which are validated and continuously reinforced by public witnessing of this connection, such as during potlatches. This highly protocolary process grants individuals the right, and places on them the responsibility, to bring these *nax nox* to life through their performances and creations. According to Tsimshian epistemology, these tangible manifestations of *nax nox* as created and performed by their stewards are essentially ceremonial beings,[25] which means they are not usually subject to the kind of commodification that is conducted in the artware industry. However, legal and ceremonial transfers of names and privileges require the distribution of items that are often adorned with family crests and figures, and these alienable goods serve to bind "participants in relations of recognition of and respect for each others' hereditary privileges."[26] Tlingit anthropologist Nora Dauenhauer describes a similar approach to Tlingit concepts of ownership and the notion of *at.óow* (prized possessions) as reflected in artistic production and circulation:

> Our people acquire works of art with this in mind: that our coming generations will benefit from them, that our grandchildren will have them when we are gone, and that they will use them the way we used them when we were alive. When grandparents pass away, a chosen individual or group is given the piece or collection of art that was in the stewardship of the grandparent. The steward's role is to take care of it, to keep it from going to another clan, and to prevent its being lost, traded, or sold.[27]

Given all of the above – which merely brushes the surface of Northwest Coast Indigenous laws – it may be surprising that so many Northwest Coast artists willingly engage in the sale of copyright and use-rights of their works in the artware industry. Many do limit their non-ceremonial works to the representation of generic rather than specific figures and stories, and steer clear of commodifying what they know their community considers sacred and inalienable, especially if it will be reproduced and circulated outside of the community on myriads of alienable goods. Other artists seem much

less concerned with respecting customary laws. In some cases, they do not know them well in the first place, while in other cases they choose to ignore them and prioritize Eurocentric laws instead. As White remarks:

> Canadian law has always been explicitly engaged in, and at the forefront and foundation of, the ongoing colonial project to dispossess them of their sovereignty, laws, lands, waters, cosmology, worldview, identity, and voice. Because art is so deeply embedded in all of these aspects of Northwest Coast society, it, too, has been impacted.[28]

So too has the social role and position of Northwest Coast artists been affected; they often feel they have little choice but to conform to Canadian IP laws if they are to make a living from their work. In 1993, a group of Chilkat weavers gathered in Hoonah, Alaska, issued a public statement that pointed to this very conundrum, simultaneously asserting their rights and privileges in accordance with Indigenous laws and acknowledging artists' economic realities. "We will educate our people on the traditional laws of ownership which govern certain items," they stated, adding that "the use of traditional art to enhance the artist's economic well being must be balanced with traditional use and ownership."[29] As it stands, a balance between artists' economic interests and industry participants' observance of Indigenous laws as promoted by these weavers twenty-five years ago has yet to be truly struck. However, Indigenous stakeholders have been working hard to make Indigenous laws better understood and implemented within the industry. Their efforts have affected the ways in which the ethics of artists and companies' transactions are assessed, and represent another way this market is becoming an example of culturally modified capitalism.

The Importance of Trust

The quality of the relationships artists and companies enjoy is a key factor in the wide-ranging attitudes among artists towards flat fees and royalties, and a direct reflection of their just as wide-ranging levels of trust vis-à-vis the companies they work with. No matter the type of contract, trust is a key component of how artists and companies decide which system of payment to adopt, and their satisfaction with it as time passes. Generally speaking, the relationships that were described to me in the most positive terms, whether involving flat fees or royalties, had been built over years of

business conducted jointly, sometimes having begun as a friendship or developing into one over time. For instance, one Nuu-chah-nulth artist has a joint business venture with a glass company that is run by one of his close friends. This artist's common-law partner described it in the following terms: "With our friend – because he's such a good friend – he basically just pays [my partner] royalties, and this might seem naïve, but we take his word for it. He'll say, 'I went to a festival and sold twenty of your pieces,' and half the time we'll just take [an amount equivalent to royalties] back in glass jewellery." As implied by this description, a royalty arrangement requires artists either to trust that it is being honoured or to have the means to ensure that it is. Since artists are paid per number of items produced or sold, they have to know, or at least believe, that these numbers are being both accurately counted and honestly accounted for. Some are clearly not worried, such as an artist who commented rather nonchalantly on the information he received in the mail with his royalty cheques: "They give me a breakdown ... of which [products] are selling, and how good the quantities of sales are and everything, so I get a rough idea of that, but I haven't really kept track." Not everyone is as trusting. Another Nuu-chah-nulth artist explained that he could not be bothered with anything but a flat fee. Otherwise, he explained, he would have to eternally "chase [the company] down" to get his royalty payments, something he was not prepared to do. One Musqueam artist argued that when an artist is paid royalties, "you have to depend on the honesty of the person that you are dealing with" since "you would have to travel far and wide to check up on [a company's] sales, in order to track your design!" After several bad experiences, including one with a marketing representative who sent him neither royalties nor the records to support his claims he did not owe any, one Tsimshian artist decided to sign only contracts explicitly giving him access to company records and facilities.

In relation to such checkups, a gallery owner suggested that it is much easier for artists to trust companies when royalty payments are made on production rather than on sales. While sales numbers are mediated by retailers, each company controls how many objects it produces. If the accounting becomes contentious, calculations based on production are more immediate and potentially easier to verify than calculations based on sales. He explained:

> There are companies out there where they may produce a hundred thousand products with an artist's design on it, but they don't pay until they've

sold that product, and my belief is that the minute that the artist's design is printed, the royalties should be made at that time. On production, not on sales ... Otherwise, the artist really doesn't have control, and the trust that they have to have on the company selling their work is huge ... If the royalties are paid on production, then it's easy. I can walk into your warehouse at any time: if you have ten thousand mugs, I know I was paid for those ten thousand mugs.

Even this scenario does not assume good faith as the basis of the relationship, but rather anticipates the need artists may feel to check up on the company, in order to eventually build and maintain such trust. All in all, the notion that an artist may want to audit a company's books and even physically count items in its warehouse goes to show how little trust some of these companies enjoy, at least at first.

Indeed, one company opted for flat fees after royalty payments had created tensions in its relationships with artists. The owner was regularly confronted with accusations from artists who thought that the payments they were receiving did not accurately reflect the books. He hoped that paying flat fees would give these artists a sense of increased transparency because everything was on the table from the start: artists would know exactly what they would get, negotiated and fully paid up front. In some sense, this company was trading an immediate and certain payment in exchange for the assurance that artists would not come back to claim they were owed more money. However, for the artists, knowing precisely how much they will earn and earning it immediately usually comes at the price of relinquishing copyright. To some, this is a reasonable and acceptable deal. There are artists who have a very clear understanding of their options and the ability to negotiate as they see fit, who choose to work with companies who pay flat fees and even vouch for them. One such artist pointed out that the company owner he works with, and who pays him flat fees, is a "very respectful and honourable" person, one of the very few people he has continuously worked with over his two-decade-long career. He trusted his images would be treated well and giving up copyright didn't make him anxious. Others were more ambivalent, stating they were quite happy with flat fees even though "in a perfect world" they might prefer "being paid with royalties, instead of being paid a one-time flat fee for the copyright," as one artist put it.

Among the most openly critical of flat fees were artists who said they had signed a contract without having fully understood its implications,

either due to inexperience or pressed by sheer necessity. One artist's very first experience in the artware industry was selling an image to a company for the particularly meagre sum of twenty-five dollars, not realizing that the company was acquiring the rights to it and intended to reproduce it on a wide range of products. He felt that he had fallen victim to his own naïveté as well as the company's taking advantage of the same; from that point on he never sold copyright to his work again, no matter the amount offered. While this example is extreme (most artists who sell copyright do so knowingly, and are usually paid substantially more), other artists expressed similar frustration with the amounts they received and, even more, their inability to go back on their decision to give up copyright. These experiences have led some to associate flat fees with abuse, such as one Tahltan artist who stated, "I think royalties are the best as far as dealing with the artist. Flat fees, I think, take advantage of people who are not in the best position at times, and I think that's really negative. That's really, really negative."

This comment implies that only artists who don't really understand the nature of flat fee agreements or who don't have the means to negotiate to keep copyright would ever choose to sign it away. To artists with this view, the sale of copyright is at the very crux of the artware industry's ethics, because no matter how fair an agreement may seem to an individual artist, giving up copyright also has collective implications. "They signed [copyright] away ... they lose control. And it makes it hard on others," one Haida artist explained, urging artists to avoid agreeing to contracts that could be detrimental not only to themselves but also to their peers. From this artist's perspective, selling copyright sends the industry the wrong message about the nature of artists' work: each artist who accepts a flat fee is in a sense giving companies the go-ahead to treat Northwest Coast cultural expressions as outright commodities, rather than as expressions of inalienable rights and privileges. One artist's reflections on his first experience in the artware industry, detailed below, further illustrates this point.

Collective Implications

On the advice of a colleague, a young up-and-coming artist had approached an artware company with a particular image he thought would look good on T-shirts and caps, assuming he would receive royalties at a later time. Only upon closer inspection of the contract he had signed did he understand

that he had already received his one-time flat fee. He recognized that the company hadn't hidden anything during the negotiations, but was still frustrated that such a contract would have been placed before him in the first place. "I didn't think about it in the long run, you know," he said. In addition to how much he made (or, rather, did not make) from the deal, what bothered him was not having kept control over how the image would be used and on what items. As he saw the image being reproduced on an increasing number of objects without having had a say, he grew to feel that signing the copyright away had been a mistake, stating, "Today, I wouldn't go and sell anything of such to any company." Retrospectively, he would have had felt much more comfortable had he licensed the image to the company instead, explaining, "Of course I feel it's only right that the artist gets royalties or collects payments from each individual sale that the product is used on. Why? Because art isn't just art, it's a lifestyle, *it's a way of life* where it comes from. You know, it's been practised for ten thousand years easy!" While a flat fee paid in exchange for a transfer of copyright operates to disconnect the image from where it came and from the steward in charge of its care, royalty payments restate this connection again and again as the image continues to be used. Thus, while royalties are the product of a Eurocentric IP system, they are nonetheless better suited than flat fees to enabling artists to uphold Northwest Coast legal regimes and the stipulation that their works are inalienable expressions of the cultural heritage of which they are not the owners but rather the caretakers on behalf of their family, clan, or community.[30] There are historical precedents to outsiders being asked to pay in exchange for the ability to use a lineage's resources. For instance, in the late nineteenth and early twentieth centuries, some Tlingit began to ask non-Indigenous fishermen to seek permission from clan elders and pay them for the right to access and fish in their ancestral fishing sites.[31] Similarly, for many Northwest Coast artists, their participation in the artware industry not only reflects an individual pursuit but also engages their responsibility towards the group and lineage to which they belong. They understand that the stakes of cultural commodification go far beyond being fairly remunerated as individuals, and know that their personal interests are intertwined with collective ones. The needs of a single community member or of a particular family do not always align with the interests of the community as a whole, which may not carry much weight when it comes to individual or family property but assuredly does when decisions also affect the fate of a community's cultural heritage more broadly. This fact enjoins

artists to do what they can to consider each transaction in terms of its longer-term and further-reaching consequences.

This discussion points to interesting parallels between the transactions that occur between artists and artware companies and the negotiation of treaties between Indigenous and non-Indigenous governments. In the artware market, the notion of just compensation is tied not only to money, but also to issues of risk and control similar to the questions of uncertainty and sovereignty that are at the heart of treaty processes. Contracts between artists and companies as to specific Northwest Coast images do not settle the question of rights to making or using Northwest Coast art in general, just as mutual respect between two individuals does not constitute a treaty between sovereign peoples. In that regard, commenting on the common comparison between contracts and treaties, Anishinaabe scholar Aaron Mills argues that "contract ... doesn't link us together. It's a chain that binds us apart and anchors us in perpetuity and with certainty to division."[32] Still, the ways in which industry stakeholders discuss interpersonal relationships between artists and artware companies raise economic and ethical issues beyond the money and respect (or lack thereof) that circulate between them as individuals, and those issues are similar to those raised in the context of treaty negotiations and implementation. What seems like a "good deal" in the moment may have less equitable results over time, especially if the contract precludes later adjustments in order to maintain the spirit of the agreement in the face of changing conditions.

While it is arguably up to each party to understand the terms to which they are agreeing, Canadian history offers a number of historical precedents for radically differing interpretations of agreements between Indigenous and non-Indigenous parties, as well as failures to implement them. Anthropologist Michael Asch has powerfully demonstrated that this is the case for many treaties negotiated with Indigenous leaders in other parts of Canada on behalf of the Crown.[33] Furthermore, law professor Michael Coyle argues that there currently exists no legal framework "for the enforcement of historical treaty rights that more fully reflects ... that treaties were built across significant differences in world view, normative orders, and undoubtedly, expectations about the future of the parties' relationship."[34] This history, combined with the fact that there are entire regions for which treaties were never negotiated in the first place (including most of British Columbia), means distrust continues to play an important role in Indigenous and non-Indigenous relations; such distrust colours many Northwest Coast artists'

relationship with artware companies, at least until several more punctual transactions lead them to consider these might eventually become mutually beneficial partnerships.

In that respect, monetary considerations aside, one of the main points of contention among the artware industry's stakeholders concerns with whom the rights to the image and control over its use ultimately rest. As we have seen, this issue is at the heart of some artists' and other stakeholders' uneasiness with flat fees. Although the stakes are far lower, the defiance they express vis-à-vis flat fees echoes similar concerns about treaties that include, or have been interpreted as including, the extinguishment of Aboriginal rights and title.[35] The fact that flat fees generally accompany a transfer of copyright and "settle" the deal once and for all can even be interpreted as a desire by the involved parties to attain a sense of certainty both on who owns what, and on who owes what to whom – not unlike the certainty Canada is seeking to establish in British Columbia's ongoing treaty process, or the way Canadian courts have tended to regard historical treaties.[36] This does not in any way mean that artware companies that pay flat fees are inherently less trustworthy than those who pay royalties. The point is that flat fees are sometimes the arrangement of choice in order to address immediate issues of trust and eliminate the need for recurring negotiations, rather than because this system is deemed the most adequate and culturally appropriate mode of compensation for the use of Northwest Coast images. Realistically, those artists who struggle to make a living from their work, as respectful of Northwest Coast legal regimes and supportive of Indigenous sovereignty as they may wish to be, may well be wary of having to wait for indeterminate royalty payments and, given the chance, may opt for the certainty of a flat fee. But the financial uncertainty associated with royalty agreements could be greatly diminished if artists were paid advances, followed by subsequent payments if and when additional royalties begin to accrue. Advances on royalties would guarantee artists the amount they feel makes the arrangement worth it for them no matter what happens next, as well as the amount they would receive if and when royalties exceed this up-front payment.

While advances on royalties are relatively common practice in the design world, they seem to be only seldom issued to artists in the Northwest Coast artware industry. At the time of my fieldwork, one company owner did have a similar – though informal – system in place. He explained that the flat fee is negotiated on the basis of expected sales for products bearing

that image, which can be tricky to predict. If the sales turn out to be significantly above the projected numbers, or if an unexpected opportunity for the use of the image comes up, then he might make an additional payment so that the artist does not feel the company alone benefited from this unforeseen success. When I asked whether such additional payments were written into the contracts with the artists, he said no, that he did this based on a moral obligation and his sincere desire to keep his relationships with artists as good as possible. While artists are likely to appreciate a company going above and beyond what is stipulated in a signed contract, the absence of a legal obligation means the extra payment is essentially a courtesy on the part of the owner. Artists have to count on the goodwill of the companies with which they work, equipped with morally charged arguments and the quality of their interpersonal relationship as the primary means to mobilize this goodwill in their favour. In other words, they have to believe that the company has their interests at heart or, better yet, that the interests of the company are directly tied to theirs. This is arguably, in essence, what treaty relationships were meant to be. As Coyle explains, "Historical land treaties were intended to create an enduring relationship that would not lead to the impoverishment of either party" and indeed to ensure that "the future of their peoples could be secured in the face of inevitable changes to come."[37] So too with relationships in the artware industry: companies often strenuously contest the suggestion that their arrangements with Indigenous artists are exploitative, arguing that their goal is to contribute to the wealth of Indigenous individuals and communities. If these arrangements are meant to be fair, and are struck in a spirit of accountability and reciprocity, shouldn't the objective then be to ensure that the future of all parties is secured, including through ongoing renewals as their respective circumstances change?[38] As Anishinaabe scholar Aimée Craft writes, it is in that spirit that treaty relationships are meant to "morph and evolve over time" because they are "constantly fostered, re-defined, re-examined, and re-negotiated" and "must be tended, fuelled, nurtured, or simmered."[39] That said, as described throughout this chapter, although some artists and companies may hope for a mutually beneficial long-term partnership built on accountability and reciprocity, many begin by aiming more modestly for a one-time equitable transaction – that is, something much closer to a contract than to a treaty-like relationship.

Both artists and companies have made deliberate efforts to move past such distrust and cautious ambitions, in part through a push for royalty

agreements over flat fees. The following gallery owner's description of how he chose to partner up with an artist to develop a collection of glassware exemplifies such reasoning:

> If I was ever to produce anything for the market, I was going to want to make sure that it was done in a partnership with the artist. [An artist] brought me the designs, and originally he wanted to sell them to me for $750 each, and I could do whatever I wanted to do with them forever. And I said ... "If I sell a million vases, I win and you lose as an artist. If I sell zero vases, you win and I lose. If we're partners, we should work together, and if we sell a million vases, we both win, and if we sell zero vases, we both lose." There's no point pulling on separate ends of the stick; we should be on the same side and pull on the same side.

In other words, with flat fees, the more the company "wins," the more the artist may feel they are "losing out." With royalties, the two parties' interests are more closely aligned: when the product is successful, both parties win; when it is not, both parties lose.[40]

Although the accuracy of royalty payments can raise suspicions, one advantage of royalty agreements is that they usually apply for a limited term, which means they can be periodically re-examined in relation to changing circumstances, just as treaties were arguably meant to be.[41] With terms of usually one or two years and sometimes limited applications, artists sometimes later ask for a higher percentage or negotiate a different scope of application, depending on how much they have progressed and the plans they have for their career by the time of the renewal. Artists and companies can also decide not to continue working together at all after the end of the term. As one Tsimshian artist put it, at the end of a term, "[If] I don't like them, I just say, 'Forget it!'" precluding the continued use of an image by the company in the future. This is the advantage of agreements that have to be renewed by both parties to endure, as opposed to contracts in which copyright is signed over once and for all, and which are not meant to be revisited.

Artware company owners do not deny that their relationships with artists can break down from time to time – sometimes irreparably, other times temporarily. Quite understandably, during interviews they seldom volunteered such "breakup" stories without being prompted; in contrast, they much more proactively shared stories of positive working relationships,

sometimes even encouraging me to contact the artist in question so that I could hear both sides of what they considered a success story. However, even these positive relationships raised interesting questions as to the difference between a fair transaction and a true collaboration, and between a satisfactory series of contracts and a treaty-like partnership.

Collaboration and Relationality in the Artware Market

One of the main concerns I have heard voiced about the artware industry relates to situations where artists feel that they are not in a position to negotiate with artware producers, both for monetary and other benefits, and with respect to how their designs will be used. As previously discussed, this lack of influence is felt to apply particularly when the artist needs immediate income, or when there is a real or perceived power differential in favour of the company. In such cases, the concern is that some producers might take advantage of the situation to pay less than market price, or might not involve the artist in further discussion once the design has been purchased.[42]

Yet the common assumption that non-Indigenous companies always have the upper hand over Indigenous artists does not always hold true. Some artists do have leverage and use it to ensure the relationship develops on the terms they deem appropriate, which go far beyond the issue of payment. When these negotiations occur on relatively level playing fields, the parties also discuss such things as choices of objects, materials, colours, and layout, for instance. When taken together by the artist and the company, these decisions are more likely to be hard-fought – which is not necessarily to say that they will be based in conflict, but only that both parties are able to defend their positions. In fact, rearrangements of power arguably occur precisely through such "frictions of collaboration":[43] when parties with potentially divergent interests create movement using points of contact to exert pressure on one another. In other words, if "one of the key ethical principles" of collaboration is "that both sides should be able to define and gain the benefits they deem appropriate," in art historian Ruth Phillips's estimation,[44] then collaborations are unlikely to progress entirely without friction. Without resulting in open conflict, such friction can slow down decision-making processes, make apparent socio-cultural differences, and require the development of new protocols. Absence of such friction is thus not necessarily a good indicator that a process is collaborative, nor does it

always announce any significant shifts in the power dynamics at play. As John Sutton Lutz has argued about the word "dialogue," it "does not mean that both parties speak from the same position of power," because "'dialogue' is sometimes no more than 'double talk.'"[45] Similarly, the word "collaboration" sometimes merely signals that more than one person worked on a project.

This point was made clear to me during an interview with a Kwakw̱a̱ka̱'wakw artist. In addition to selling works in several well-known galleries, he has created designs for a variety of products, and two examples stood out to me. In the first case, he described a very smooth process and a positive outcome: a gallery owner suggested he create images for a specific kind of product he wanted to sell. The artist drew up a few sketches, from which the gallery owner made a selection, and they agreed on royalty payments. A few pieces were produced; when those sold, they agreed to have new ones made, and so on. In the second case, the process was much less smooth. A designer asked him to work on a project with her, which he agreed to do, thinking it could be an interesting experience. When he showed her the image he had created, she suggested changes that he felt went against the design principles of Northwest Coast art, as well as his own personal style, leading to some back-and-forth until they could agree on a design. Shortly after the product was finished, they found themselves arguing about how the pieces' authorship was presented on his website. He also expressed some frustration about the payments he received for this work. They have not worked together since. After hearing these two stories, I asked if he thought the word "collaboration" would accurately describe the first example above. He answered no, that he saw it more as a business partnership in which each had done their part, and each reaped benefits from their prenegotiated agreement. He said that his experience of the second example – the experience he chose not to renew – was what he would call "a collaboration." The design process had been more dialogical, and in the end the pieces had been attributed to "[name of designer] with [name of artist]."

I was at first surprised by this answer because I expected the artist to associate the more conciliatory process with collaboration rather than the more conflictual of the two. I now think his distinction between what he would call "business partnerships" and "collaborations" is useful in demonstrating that a straightforward, conciliatory process with a positive outcome does not necessarily equal a collaboration. It might instead signal a different

kind of engagement where there is very little to negotiate and thus nothing to potentially disagree on. This is not to say that all collaborations are conflictual, but that non-conflictual relationships are not all collaborations. However, I am quite certain that when I asked producers and artists to discuss their experiences of "collaboration," none of them were under the impression that I was asking them to focus on the disagreements and points of contention that may have arisen along the way. I would even speculate that when they wanted to portray their relationships as collaborative, they emphasized the smooth segments of the road, not its rough patches. This underlines the promotional dimension of portraying relationships as collaborative, because the term conjures up images of cordiality, equality, and fairness. Of course, not all companies are described by Indigenous artists as employing collaborative methods. For instance, a Kwakwaka'wakw/ Tlingit artist I spoke to contrasted "a real collaboration in product development" with situations where "people are taking First Nations art and saying they are collaborating, and they are not really ... They are getting all of the recognition for it [even though] it was the artist who created the beauty of the piece." In her view, a collaboration is "different than selling a design to somebody": it includes creating designs, co-developing the product (down to the details of colour palette, shapes, and sizes), and being remunerated for both. However, there are still many fewer examples of this kind of relationship than of artware companies that work with artists following a much less involved process.

Some store managers strive to support positive relationships between artists and companies, such as one shop that has a policy to sell only "ethically selected merchandise," defined as items deemed accurate and respectful of Indigenous cultures and purchased directly from artists or from companies working with Indigenous artists, as well as products developed by the shop's staff with artists who were paid royalties. The policy precludes the store from carrying products in which Indigenous artists have not had a hand, but still allows for very different degrees of artist involvement and a wide range of relationships, as exemplified by two types of products the shop did carry.

The first example concerns the products of a large Vancouver artware company. The artists who work with this company and with whom I spoke described a rather simple process: they offered designs to the company, signed the rights over in exchange for a fee, and the company then developed a variety of products with each design. A number of these artists were

clearly accustomed to and comfortable with having only a consultative role during the product development phase after their design had been selected, and felt it was normal not to have a say in what happened with their images once they had sold their copyright to the company. Several artists said that if they did not like the way their images were reproduced, they had told the company owner, who had usually rectified the problem if at all still possible. This showed a willingness on the company's part to ensure reproductions were executed in a way that artists considered satisfactory even when, legally speaking, they had little hold left on the design process. When such back-and-forth occurred, it usually took place after the copyright had been sold, when mock-ups or samples of the product were presented by the company to the artist. Due to the timing of this consultation, any changes could generally only consist of slight adjustments rather than a more thorough redesign. In addition, given the terms of their contracts, these last-minute adjustments are more of a courtesy to the artists than an obligation on the company's part. In some cases, artists became aware of details they would have wanted to change only after a product was put on the market – too late, they felt, for anything to be done. For instance, a gallery owner told me about an artist who noticed that a section of his design had been modified in such a way that it suggested he did not command Northwest Coast design principles (a distortion that probably occurred during the digital vectorizing process). He saw this only after the product had reached the shelves of retail stores, and he felt his reputation as an artist had already been compromised. The gallery owner who told me the story, showing me the offending product and pointing out the design flaws as he did, said this artist was likely to request a greater role in the product development process from then on, if he ever worked with that company again. The fact that other artists had been happy to work within the system already in place does not make the design process collaborative – it only shows that arrangements that are not collaborative can sometimes be cordial and satisfactory to both parties involved, and sometimes lead to conflict and disappointment.

The second example concerns products the shop developed with a well-established Northwest Coast artist. Rather than directly applying a previously existing design onto a variety of objects, this artist created images to fit each specific new product. The shop first approached him to design T-shirts. For this, he created and proposed several designs, took part in discussions about which ones would work and sell best, and showed the

team how to change the structure of a design so it would show on different colours of T-shirt, down to such details as choosing the correct shade of white for printing. He explained to me that he did not always have the final word in these discussions but that, although he would have done certain things differently, he respected the decisions that were made and felt there was no point in engaging in endless arguments over them. Later, they developed a line of kitchenware, which was an even more involved process. For instance, the artist designed three different versions of a single product before one met his own approval and that of the shop manager. He then spent time experimenting with various reproduction techniques until he found one that worked reasonably well. This creative process took many hours of production, as well as meetings with shop staff to work out various aspects of the product along the way. The artist estimated that six thousand items would have to be sold in order for him to recover his hours through royalty payments. That said, as he explained to me, his interest in having such a high level of involvement in the development of these products was never primarily monetary. Among his other interests were, first, his desire to develop a body of work to which he could maintain the rights while earning returns through a royalty system; second, his desire to learn and explore new techniques and new ways of looking at design for his own artistic growth; and third, his desire to raise the artware industry's standards both in terms of quality and in terms of Indigenous involvement. In turn, from the shop's perspective, the artist's deep involvement in the process meant being able to create products of particularly high quality – though, as it turned out, ones that did not yield particularly high profits. With these products, the shop was primarily hoping to provide the market with an aspirational model of collaborative product development. Although its staff do not directly monitor other artware companies' relationships with artists – nor does it exclude from its shelves less collaboratively created products such as those described in the first example – it did succeed in promoting a greater involvement of Indigenous artists in the industry. Several company owners and artists described the shop to me as a market trendsetter, and many pride themselves on this shop carrying their merchandise, even making a point to mention it on their website or in newspaper articles featuring their products.

However, there are a few reasons why companies and artists may decide against a collaborative approach, not the least of which is that collaboration can be costly both in time and money. Not all artists hope to make their

involvement with artware producers worthwhile beyond a punctual business arrangement that helps get their work out to a wider audience. Some of them are happy to let artware companies develop products using their designs while they dedicate their own time and energy to other projects they value more. From the point of view of artware companies, collaboratively developed products are not particularly likely to result in bigger profit margins, as the range of price points for such products as mugs and T-shirts remains relatively narrow. Companies may hope that engaging in collaborative processes will bring other, non-monetary benefits. For instance, in the Northwest Coast art world, the reputation of a company is constantly subject to re-evaluation in relation to its practices, in particular those related to relationships with artists. Referring to products as the result of collaboration can improve this reputation, in particular among those retailers and consumers who are concerned about supporting artists and/or purchasing works that they consider authentic because of the involvement of these artists.

To be sure, one of the ways companies promote these products is by publicizing their practices as collaborative. Like what has happened in the field of museum anthropology, as the idea of collaboration gained currency, more and more companies have started emphasizing their partnerships with Indigenous artists, whether or not they explicitly call them collaborations. For instance, one company states on its website, "Ultimately, we are grateful to the artists who continue to commit to our aspiration to have their work recognized. Without their talent and energy, none of this would be possible and we thank them with the utmost respect." This company also solicits submissions from artists, explaining that "our goal is to support Native art and culture and we strive to be a vehicle for artists to make their art accessible to a wider audience."[46] The web page on which one of its competitors presents its own "featured artists" explains that the company "has developed strong working relationships with a number of Canadian artists reflecting the great diversity of our country. A royalty is paid to all First Nations artists." This company's description of products featuring designs by specific artists states that the art is "reproduced in collaboration with the artist and royalties are paid to the artist on each item sold."[47] One fashion designer's website declares that it developed one of its collections "in collaboration with [a] world renowned Haida Artist."[48] An Ontario-based company explains that it "partnered with some very talented Canadian Native Artists to ... expose more people internationally to the beauty and diversity of Canadian art," explaining that the company includes artist biographies with

its products so that these artists' work can be "recognized in the rest of the world."[49] Some companies are less explicit when describing their relationships with artists. For instance, one states that it is "working with ... Pacific Coast native artists," while another says that its designs were "commissioned" from a Northwest Coast artist.[50] Even so, the inclusion of this information suggests that, when artists are involved, it is in the interest of companies to make it known using the vocabulary of collaboration, partnerships, and other indicators of mutually beneficial relationships.

The above examples are arguably a strong indication that working with Indigenous artists is slowly becoming a moral imperative – and a marketable practice – in the industry. But the language of labels and other marketing materials makes it difficult to differentiate products in terms of the level of involvement of artists and the kinds of benefits they receive in exchange. Of the various companies cited above, some fully co-develop products with artists and some simply apply designs to their wares; some pay royalties and some pay flat fees; some have been working with the same artists for years and some have worked with an artist on only one product. In all cases, the language used suggests more or less explicitly that the relationships in question are conciliatory and beneficial to both parties. Discourses suggesting otherwise would admittedly be unlikely to appear in promotional material; however, having a business relationship considered successful by both parties does not always mean that there has been a collaboration, given that various modes of engagement satisfy different needs.

There are also Indigenous-owned and -operated businesses, and individual artists who choose to create their own businesses, hiring non-Indigenous labour for certain tasks or paying other companies to make the products they design and distribute. These business relationships were not described to me as "collaborations" by their Indigenous owners, which suggests that they have less to gain from using this language than do non-Indigenous businesses. Another non-collaborative form of engagement that is nonetheless considered satisfactory by the parties involved is when, as described earlier, artists prefer to remain only superficially involved in the product development process for lack of time or interest beyond the creation of their own design. In principle, the existence of opportunities to willingly engage in non-collaborative relationships does not necessarily work against the equitable treatment of Indigenous artists in the artware industry. But in order for this to be true in practice, the difference between various kinds and levels of engagement between Indigenous and non-Indigenous industry participants would need to be made

more obvious. Otherwise, all relationships – equitable and not – can be equally rewarded by the possibility of being marketed as collaborative. Once words like "collaboration" or "partnership" become used almost indiscriminately, it becomes nearly impossible to know whether they gloss over unequal power dynamics: cynics are free to imagine that they do, while optimists can continue to imagine that they do not.

In the Northwest Coast artware industry, relationships between companies and artists are informed by deeper histories than the "here and now" of punctual transactions, and indicate wider power dynamics than those of interpersonal interactions. Keeping this in mind helps in understanding why agreements aren't always considered satisfactory, and why some may be labelled "unfair" or worse, "exploitative," even when they correspond to what would be expected in many other markets. Some see such reactions as stemming from unjustified Indigenous exceptionalism, arguing that Indigenous artists should not be treated any differently from their non-Indigenous peers. However, building this industry – which relies directly on the commodification of Indigenous cultural heritage – on culturally sustainable and economically equitable grounds is a high-stakes enterprise for both Indigenous peoples and for Indigenous/non-Indigenous relations more broadly. These high stakes have arguably led to progressive modifications of the capitalist way of doing business through various disruptions of what is otherwise and elsewhere considered "business as usual."

Beyond One-Time Exchanges: Building Future Relationalities

> If we attend only to the balance sheets of royalties paid and products gone to market, we miss a great deal in terms of how relationships, power, participation, and inequality are being structured here. The product is the fetishized anchor for a process that does create "value," labor, monetary transactions, and capital accumulation, but just as importantly, it is a site of promise, hope, fear, and speculation that itself sets new relationships in motion.
>
> – Cori Hayden, *When Nature Goes Public*

Whether it is "nature" or "culture" that is the object of commodification, numbers never paint a complete picture of the relationships in play. As argued by anthropologist Cori Hayden, it is crucially important to also pay

attention to power dynamics and their effect on how these relationships evolve over time. In that sense, the engagement of Indigenous artists and communities in the artware industry can be considered in light of what we know about how treaties – and the kind of future they promised – were understood when they were first negotiated.

Anthropologist Michael Asch remarks that relationships between Indigenous and non-Indigenous peoples in settler-colonial contexts tend to be framed in one of two ways:

1. an "I-It" relation of "Self and Oppositional Other" in which the Self has a will to be free to act politically without reference to the Other, against which it is struggling for freedom;
2. an "I-Thou" relation of "Self and Relational Other," in which the Self has a will to be free to act politically but in reference to the Other, with which it has the responsibility to seek a political relationship.[51]

Asch remarks that, in the context of treaty negotiations, the Canadian government has tended to adopt an "I-It" approach, whereas he believes that "I-Thou" relationships offer the greatest potential for the creation of partnerships that permit living together and sharing resources without extinguishing Aboriginal rights and title.[52] The treaties currently part of the British Columbia treaty negotiation process are presented by the BC Treaty Commission as being mutually beneficial to "First Nations and their neighbours,"[53] but the reluctance of many First Nations to move forward in these negotiations shows their serious doubts that this process is truly as balanced as it is claimed.

In 1998, the Union of British Columbia Indian Chiefs (UBCIC) voiced its opposition to the BC treaty process on the grounds that the ultimate objective of the Crown was to generate once-and-for-all, contract-like agreements. Under Grand Chief Stewart Phillip's leadership, the UBCIC felt that the government sought to achieve "certainty" by precluding renegotiations of agreements in court even "if the Indigenous group in the future do not think that the Agreement was a fair deal."[54] Such agreements, the UBCIC argued, effectively extinguish Aboriginal rights and title. According to Secwepemc leader and activist Arthur Manuel, the BC treaty process has been conducted under the premise that "the final result had to be 'certainty' as defined by a 'modified' rights framework that extinguished Aboriginal title and all of the rights not specifically described in the agreement."[55] And

yet, as a Nisga'a treaty negotiator explained to anthropologist Carole Black-burn, the Royal Proclamation of 1763, upon which the constitutional imperative of treaty negotiation is based, was meant to be about "entering into a relationship."[56]

Since the beginning of the treaty negotiations in 1993, only a handful of First Nations have signed final agreements. Among those that have, there are varying views as to the consequences of having done so, in particular with respect to the finality of these agreements. For instance, Toquaht legal scholar Johnny Mack describes the Maa-nulth First Nations Final Agreement (MFA), signed in 2007, as "stipulating that the MFA is a certain, final, and comprehensive resolution of Aboriginal Right Claims. There is no turning back to renegotiate."[57] Mack sees this objective of achieving "certainty" as antithetical to the totemic tradition of his people. In his community, "for every new relationship disclosed or shift in authority, new totems are carved and placed beside older decaying totems that are returning themselves to the earth and leaving space for newer ones." He further explains:

> As Maa-nulth people, we have a longstanding tradition of carving totem poles. These poles play a cohesive role in our communities, and are understood as sacred and symbolic tangible representations of the histories that have created our present world. These totems would be carved in honour of the *hawilth* (hereditary chiefs) and would symbolize the stories that authorize authority. They would also bind the chief to principles of generosity and respect – principles we understand as necessary to maintain the delicate balances of the world. These poles would be ceremonially erected outside of the leader's longhouse, and would be explained to the community. Songs would be sung about the event, and the totem's story would be reflected back to the community. The totem would live out a natural life, decaying with the elements and making room for new totems to represent the stories of later *hawilth* and *ha'houlthee* (their chiefly ter-ritory). This process allowed the principles and values associated with the totem to evolve, not freezing at any particular historical point, while still being responsible to and respectful of the histories that produced them.[58]

Although the stakes surrounding the remuneration of artists for their designs by artware companies are not comparable in magnitude to those related to the negotiation of treaties between First Nations and Canadian governments, the stakes are similar in nature. Relationships between artists

and companies in the Northwest Coast artware industry can be expressed in terms of "Self and Oppositional Other" or "Self and Relational Other," in part depending on whether they are focused on setting fixed contractual terms or creating partnerships. Much like treaties, some business relationships tend to create a separation between the interests and properties of the parties involved, while others bind the parties together and call for ongoing dialogue. Of course, artists understandably dislike being in positions of subordination vis-à-vis companies, and flat fees are well suited to maintaining a certain kind of independence. However, they are not designed to be the building blocks of long-term partnerships: whether or not the artist and the company intend to continue working together, technically, each flat fee paid signals the end of any obligation of the company towards the artist, and vice versa. Royalties, on the other hand, entwine artists' and companies' interests, all the while maintaining a certain level of independence for each party within a partnership that is designed to be re-examined on a regular basis. In this sense, they are closer to the totem tradition described by Mack, in which relationships are regulated by specific overarching values and principles, but must be established and re-established as time goes by, accounting for changes in the order of things rather than being fixed in time.

Thus, beyond the mode of payment and what kind of property regime it is based on, it is important to also look to the kind of relationality that is reflected in the ways companies and artists work together. In that regard, the vocabulary of collaboration present in the industry's marketing material is not only indicative of the ways in which artists and companies are trying to work together "in a good way"; it is also a part of what Tsimshian/Haida art historian Marcia Crosby called the "new political climate of political partnership" of the 1990s, in which:

> provincial ministries and administrators of many public institutions (schools, universities and museums) used the concept of "partnership" to negotiate new program and policy changes with First Nations. While the term "partnership" suggests that all of the stakeholders have similar goals and rationales, the fact is, no true partnership can take place where a federal or provincial institution is owned and administratively operated by Canadian government staff.[59]

Whether true partnerships are impossible when undertaken at the governmental level, as Crosby suggests, is an important question beyond the scope

of my research. Regardless, in the two decades since this statement, the words "partnership" and "collaboration" have enjoyed widespread use by those who want to imply mutually beneficial relationships, avoiding less celebratory alternatives such as "negotiation" or "transaction," for example. This usage is particularly evident in governmental, academic, and corporate discourses that seek to convey an improvement in the relationships between Indigenous and non-Indigenous peoples.[60]

In a sense, this rhetoric functions like the idea that Canada is founded on "'positive,' 'generous' and 'tolerant' treatment ... of Native people"; as demonstrated by Eva Mackey, this idea tends to both "hide inequalities and oppression" and contribute to a "mythology" of "innocence."[61] Although, in some ways, the constant reiteration of the idea that relationships are improving does reinforce an ideal for which it is possible to reach, such rhetoric can also undermine these very efforts by giving the false impression that this ideal has already been realized. In Canada, such narratives of inclusion, while apparently in line with the principles of generosity and respect mentioned by Mack, have long served to mask processes of dispossession and appropriation.[62] Arguably, despite all the benefits to which more collaborative relationships between artists and artware companies could lead, an overzealous and unchecked use of the language of collaboration risks serving similar masking purposes.

From this standpoint, when evaluating the ethics of a company's business model, both the property regime and the type of relationality that is reflected in artists' mode of payment are at least as important as the dollar amount they receive. This helps explain why paying royalties is increasingly being put forth as a "best practice": they are more closely aligned with Northwest Coast models of property stewardship than flat fees, and are therefore less likely to be likened to misappropriation under local Indigenous property regimes. Furthermore, every time a royalty agreement is up for renewal, artists and companies have the opportunity to evaluate the relationship that undergirds this agreement and decide whether, how, and under what conditions to consolidate it. To be sure, artists who receive royalties are not necessarily making more money than artists who are paid flat fees, and not all artists are in a position to walk away from renewing a royalty contract that they consider unfair. Nonetheless, in the context of the artware industry's gradual transformation into a kind of culturally modified capitalism, it is not surprising to see royalties gain ground on flat fees: both are part of the capitalist panoply of contracts, but royalties more closely reflect local

Indigenous views of property and relationality. In addition, when artists and companies envisage their negotiations as tracing a path towards sustained reciprocal relationships rather than as mere preambles to one-off transactions, they challenge contemporary capitalism's obsession with the present and with self-contained interactions[63] by imagining a mutually beneficial future informed by lessons learned through common past experiences.

Mique'l Askren's and Mike Dangeli's Engagement Feast
August 29th 2009

5

Accumulation | *Redistribution*

You can be all about business, but the other side of it is, What do you give back to the community?

– Indigenous designer and artware company owner

In North American society, people who are considered successful and attempt to have a positive impact on the lives of people around them – a professional hockey player who donates large amounts of money to a children's hospital, or a movie star who regularly volunteers as a United Nations ambassador – tend to receive high praise and be seen as selfless and generous. If these same people did not engage in any kind of community work, some might disparage them as too individualistic, but they would not suddenly be deemed unsuccessful. In the Northwest Coast artware industry, however, positive assessments of someone's personal trajectory and practices are almost exclusively reserved for those whose achievements are seen to have contributed to the betterment of Indigenous peoples' collective situation from an economic, social, cultural, or political standpoint. The injunction to "give back to the community" is so pervasive in the industry that failure to do so exposes participants to sharp criticism and can translate into discernable reputational losses. This injunction is related to the central role of reciprocity and redistribution in Pacific Northwest society: much as in the potlatch economy, social status in the Northwest Coast artware industry is not tied simply to the ability to accumulate, but also to the willingness to meet one's obligations to redistribute.

To be clear, industry participants, including Indigenous ones, are concerned with what they can personally gain from making or selling artware. None of the dozens of individuals I spoke to during my research pretended that money and career advancement had nothing to do with their participation in the artware industry. One day, a particularly community-minded Indigenous artware company owner was insisting on the importance of "giving back" and his responsibility to contribute to the cultural and economic vitality of his

◀ OVER

On the Northwest Coast, the ceremonial distribution of goods to witnesses and guests is a central feature of Indigenous law and economics. Artware items are frequently among these items.

Crest design by Mike Dangeli, Nisga'a, Tlingit, Tsetsaut, and Tsimshian, in honour of his engagement to his wife, Mique'l Dangeli.

people. Suddenly, in the middle of his impassioned speech, he paused, looked at me, and said, "Just to be clear: there is nothing wrong with an Aboriginal person making money." While this remark can be read as a response to the widespread trope of a supposed antithetical relation between indigeneity and wealth,[1] he also wanted to make sure I understood that tending to community responsibilities did not negate the possibility of personal wealth and success. Indeed, this outlook is consistent with the Indigenous economic systems of the Pacific Northwest. One must accumulate in order to later be able to engage in the mass giveaways that occur during potlatches. And as historian David Arnold notes, Northwest Coast societies seek to balance "individualism with social solidarity, wealth accumulation with reciprocity, localism with intervillage kinship, and competitiveness with cooperation."[2] Wealth redistribution does not lead to the flattening of hierarchies, but on the contrary plays an important role in the validation of social status.

Similarly, in the artware industry, redistribution is not a generous or selfless act of benevolence; it is the fulfillment of an obligation and a mechanism for the validation of one's social standing. Redistribution practices mean the artware industry helps sustain the Indigenous communities on whose cultural expressions it draws, beyond merely sustaining the livelihood of individual industry participants. Those who engage in such redistribution benefit by reinforcing their status through these practices, which can in turn improve their reputational capital in a world where trust is a sought-out currency.

"Giving Back": A Just Return on Investment?

In my fieldwork, the importance of "giving back" was a recurrent and impassioned topic, especially for the industry's Indigenous stakeholders. Many of them considered imbalanced wealth accumulation to the benefit of certain individuals (non-Indigenous company owners in particular, but not exclusively) to be inherently unfair – akin to what geographer David Harvey calls "accumulation by dispossession"[3] – and advocated for an industry in which Indigenous stakeholders would be on the receiving end of systematic and significant redistribution practices on the part of Indigenous and non-Indigenous industry participants. This proposal was usually presented to me as a step towards restoring the rightful order of things. Put simply, the industry is directly indebted to Pacific Northwest peoples, since its very existence is founded in the specificity of the cultural expressions they have developed over thousands of years. Since

the industry has been "taking" from them, it follows that it should be "giving back" to them as well.

At first glance, this reasoning fits well within a capitalist framework. According to economist Matthew Bishop, capitalism is based on "the idea that owners of capital have property rights that entitle them to earn a profit as a reward for putting their capital at risk in some form of economic activity."[4] If profit rewards owners of capital for risk, then it is easy to argue that Indigenous peoples are entitled to the benefits yielded by taking risks with their cultural resources by way of commodification. From this standpoint, redirecting more of the industry's profits towards Indigenous communities merely pays their fair share of returns for investing their resources and bearing the risks related to these resources' exploitation. Furthermore, from such a standard capitalist point of view, shareholders should receive returns proportionally to their respective initial investments. In the artware industry, measuring the relative contribution of various "investors," in both symbolic and monetary terms, is tricky. It is difficult to assess the relative returns warranted by the investment of economic capital by the company, and the investment of cultural capital by the artists and their communities. Both investments are needed for artware to exist. Without the initial investment of the artware company, there would be no wares on which to reproduce the work of the artists, while without the artists' work, there would be no artware but only wares. In other words, at the scale of the industry as a whole, artware company owners – those who fund artware production and have invested in the development of the industry, whether or not they are of Indigenous descent – are not the only ones putting their resources at risk; the cultural resources of Indigenous peoples are also a major investment being made into the industry. The value of cultural resources may be difficult to measure in monetary terms but is difficult to deny, if only because the Northwest Coast artware industry would not exist without them.

In this light, the pressure put on companies to find ways to give back can be seen as a way to instate Indigenous peoples as collective investors, entitling them to receive rewards from the Northwest Coast artware industry beyond what specific individuals receive in exchange for their artwork. Thus, even though redistribution as practised in the Pacific Northwest is not in and of itself a feature of the capitalist model, it can be translated into capitalist terms.[5] This relatively easy translation helps explain why a number of companies, in the artware industry and beyond, are at least in theory receptive to the injunction to give back and do not necessarily see it as a departure from the capitalist model. But this narrow reading of the injunction to give

back to the community does not account for the fact that Indigenous stake-holders are also beholden to this obligation, despite being members of the communities in question. It could be argued that, when participating in the artware industry, Indigenous individuals of Pacific Northwest descent are merely drawing on something that already belongs to them or they have permission to use, and that it would be nonsensical to ask them to give back to themselves. Yet Indigenous industry participants are also expected to show that they are tending to their responsibilities by giving back to the community. In addition to underlining the differences in regimes of property and relationality discussed in the previous chapter, this obligation points to the deeper social significance of redistribution in the Pacific Northwest, which cannot be collapsed into the payment of dividends that are owed, as could be framed in strictly capitalist terms. One must look beyond a strictly trans-actional explanation and consider the culturally specific role of reciprocity and redistribution in Pacific Northwest societies.

Reciprocity and Redistribution in the Pacific Northwest

> For Northwest Coast peoples, a potlatch is a special and temporary space within which essential frameworks of meaning are animated and operationalized. These powerful spaces are articulated and formed to enable some specific transformation of individuals, families, and nations or to mark a significant event. An individual can come of age or become a chief or wife or husband or receive a seat in the longhouse. Families assert and pass on rights and prerogatives. Nations express and give voice to their identities, proclaim their leaders, tell their histories, and form alliances with other nations. Ancestors are present. Likewise, supernatural beings appear. In this way, the potlatch is a sacred space within which temporal and cosmological boundaries are transcended. Art is an essential element in the creation and articulation of this space and the events, rituals, and transformations that take place within it.
>
> – Douglas White, Snuneymuxw and Nuu-chah-nulth lawyer, "'Where Mere Words Failed': Northwest Coast Art and the Law"

Over a century and a half of research in the Pacific Northwest offers a great number of different descriptions and interpretations of the potlatch. One aspect of this institution that has garnered the interest of academics around the world

is also of particular interest here: the large quantities of goods exchanged between potlatch hosts and guests. While a comprehensive review of this literature could be the object of an entire book in its own right, a brief overview of some of these competing analyses will shed light on how outsiders have understood the *raison d'être* of potlatches and the mass giveaways they entail.[6]

One of the most influential anthropological analyses of the potlatch was offered in the late nineteenth century by Franz Boas, who stated that, in Kwakwaka'wakw society, "acquiring rank" was done by "the distribution of property." He wrote, "Possession of wealth is considered honourable, and it is the endeavour of each Indian to acquire a fortune. But it is not as much the possession of wealth as the ability to give great festivals which makes wealth a desirable object to the Indian."[7] Based on the tenet that wealth is amassed primarily for the purpose of later redistribution that, in turn, bestows status on the giver, Marcel Mauss famously argued about the Pacific Northwest that "nowhere else is the prestige of an individual as closely bound up with expenditure, and with the duty of returning with interest gifts received in such a way that the creditor becomes the debtor."[8]

Subsequent analyses contested these interpretations that the potlatch constitutes an interest-bearing system of credit and debt. For instance, anthropologist Homer G. Barnett argued in the 1930s that the goods distributed are not loans to the guests, but rather "payment for services rendered" by the attendees as witnesses, or payments "in return for the ... benefits of labor and ceremonial prerogative." The host calls witnesses to recognize his status and reputation, and his expenditure should be in accordance with "the status he holds or presumes to acquire."[9] In that sense, potlatch gifts are customary and culturally approved expressions of esteem for self and other, and the validation of the host's status requires that witnesses consider that the distribution of potlatch gifts appropriately reflects their and the host's respective ranks. Echoing Barnett several decades later, anthropologist Marjorie Halpin also emphasized the importance of witnesses in the Haida potlatch, stating that in a potlatch, "the crucial distinction is the giving of wealth by the hosts to the guests in payment for the latter's witnessing the transfer of honorific names and crests from one generation to the next."[10]

Other scholars explained wealth distribution from a different angle, including that of ecological subsistence management. For instance, Wayne Suttles wrote in the early 1960s that the function of the Coast Salish potlatch derives from the combination of the individual drive for high status through the manipulation of wealth and the social need for solidarity with

respect to the satisfaction of subsistence needs. He argued that the Coast Salish used redistribution as a mechanism to manage local and seasonal variations in the availability of food.[11] In other words, the most important function of the Coast Salish potlatch was the redistribution of wealth, which enabled intergroup cooperation to continue as it cyclically restored the "purchasing power" of its partnering communities.[12] A few years later, Philip Drucker and Robert F. Heizer refuted Suttles's idea that potlatching is a "food-for-wealth" exchange system put in place to accommodate local economies to fluctuation in natural resources. Against the cultural ecology model, they argued that the potlatch had developed gradually as a mechanism to reinforce certain elements of social organization such as marriage, relationships between affinal kin, inheritance of rights, and mortuary rites in honour of deceased chiefs. Although Drucker and Heizer contended that status could not be gained but only validated through potlatching, they argued that potlatches offered hosts the opportunity "to make their name good" by having their status authenticated by those in attendance, and chiefs in particular.[13]

Based on his fieldwork with the Tsimshian in the 1990s, Christopher Roth offered a slightly different analysis of the role played by gift exchanges. Revisiting Mauss's notion that gift economies bind communities in networks of debt, Roth argues that Tsimshian social reproduction is located in a symbolic order maintained by both the paying of witnesses and the retention of inalienable wealth. According to Roth, goods offered to feast guests are not gifts but "payments for witnessing and validating the ceremonial renewal of the potlatch hosts' status, wealth, and legitimacy."[14] Thus, the location of the impulse to reciprocate is not in the gift itself, as argued by Mauss, but in the responsibility to testify that a name or a transfer of property is legitimate and has been feasted properly.

In broad strokes, beyond analytical divergences and differences related to culture and time period, these various interpretations of the potlatch all point to the idea that, in the Pacific Northwest, accumulation of wealth is carried out primarily for the purpose of later redistribution, which is necessary to the legitimization of one's property and status. Giveaways are not a means of social equalization, but rather a mechanism to support social structures, including hierarchical ones. Reciprocal gift exchanges in Pacific Northwest societies are not geared towards maintaining a balance between what has been given and what has been received by each individual or group involved. Instead, proprietary responsibilities related to songs, territories,

names, and other intangible forms of wealth, which are all indicative of status, are bestowed and validated through public exchanges.

By and large, and although the institution has not been immune to wider dynamics of cultural change, this overarching interpretation is consistent with contemporary Indigenous testimonies about the potlatch and the role redistribution plays in the region's social, spiritual, political, legal, and economic systems. For instance, Haida elder Flossie Lambly explained that it was crucial for potlatches to occur in front of witnesses since this was what made the transactions legal: "Because [we] had no written language. Whatever [we] did, [we] did in front of witnesses to prove that it was done."[15] Discussing the name and corresponding button blanket he gave Joe David when he adopted him during his 1983 potlatch, Haida artist Robert Davidson also explained, "When you give a name, you have this doing where you make a statement with confidence which holds true with all the people who are there ... You have to validate the name and the blanket." About the button blanket he received from David on that same occasion, Davidson further explained, "It's a beautiful design. But in the old way, he has to validate it in his own village, the fact that he gave me a blanket. I don't feel right using it until it's validated."[16] The importance Davidson places on such acts of validation echoes Gitxsan elder Margaret Heit's assertion that public distribution of gifts and money is a crucial step in the transfer of property: "Payment to those who helped make the blanket would be done at a feast. At this feast, the blanket would be officially placed on the owner. He would call out the names of those who made it and publicly make payment. The owner would give out money and gifts at this time to validate his new button blanket."[17]

Furthermore, as described by Kwakwaka'wakw anthropologist and curator Gloria Cranmer-Webster, gifts received during Kwakwaka'wakw potlatches should reflect the rank of those receiving them: "Chiefs and their wives, chief's widows, and those who have come from far away must receive more than ordinary people ... Special gifts, such as silver bracelets, may be given to those who have contributed in a significant way."[18] In other words, what is received during a potlatch must be validated not by just any set of witnesses, but by specific witnesses, and the status of these witnesses should be reflected in what *they* receive for acting as such. Until such validation has occurred in ways that satisfy local protocols, it is improper to bring items out and claim the status that is associated with them as if they already belonged to those who received them. This is well illustrated by Heiltsuk

artist and cultural expert David Gladstone's account of his own reluctance to bring out some of his regalia:

> Some of the button blankets I own have already been validated by the families who commissioned and paid for them and presented them to me in public at a potlatch ... I have several blankets and several articles of regalia that I haven't shown because I haven't given a potlatch in Bella Bella to validate them. I will bring them out and announce what was paid for them and whom it was paid to, when I have my potlatch.[19]

Especially when addressing themselves to non-expert audiences, Northwest Coast artists often like to point out that such an obligation to publicly redistribute wealth in order to validate one's status stands in opposition to the Western belief that lavish expenditure and acquisition of goods are in and of themselves a marker of status. For instance, in lessLIE's 2006 piece *Words of Wealth,* a framed serigraph print inspired by a spindle whorl is surrounded by a text in which the artist positions himself and the Coast Salish culture he comes from in stark contrast with what he considers to be a Western consumerist ideology:

> As a contemporary Coast Salish artist who has relatively non-materialistic values, it is a contention of mine that the environmentally, socially and politically destructive consumer culture of Canada is the antithesis of traditional Coast Salish values. In traditional Coast Salish culture, wealth is not conspicuous consumption of the superficial status symbols of cars and clothes, etc. Wealth is not how much you can spend and accumulate. Although, through acculturation, the consumer culture of Canada has become inextricably interwoven with Coast Salish culture, it should not be overlooked that the consumer culture of Canada is antithetical to the potlatching traditions of Coast Salish culture.[20]

Similarly, commenting on his installation *1884–1951,* in which a pile of Starbucks-like coffee cups made out of copper are seemingly discarded on a Hudson's Bay blanket, Laich-kwil-tach artist Sonny Assu explained that he wanted to draw attention to the ways in which "two dramatically different societies disseminate wealth":

> On one hand, you have the Potlatch Society, where they, traditionally, would save their wealth, hoard their wealth, only to give it all away. [Your]

wealth as a person in a Potlatch society was based upon how much you gave away ... Where, in our contemporary Western Society, ... we collect our wealth, we save our wealth, we keep our wealth, and we display that wealth in the things we buy [and keep for ourselves].[21]

Beyond the payment of debts or dividends, the difference in relative importance of accumulation and redistribution in Pacific Northwest and Western societies stands at the core of the obligation that is placed on artware companies to engage in redistribution. From an Indigenous standpoint, refusing to do so is to fail to validate the status these companies may have felt they acquired through wealth accumulation. It is not just that their reputation in the artware industry is diminished because they might be considered "bad" (unethical) companies, but also that their reputation as "good" (well-performing) companies does not stand until it has been publicly validated. The name of a company can be "made good" – to use Drucker and Heizer's expression[22] – only through public acts of redistribution. As entities that operate in a context that largely favours Western worldviews, artware companies may not care about their status as reflected in a potlatch-like system of prestige. The activities of companies that do not work with Indigenous artists do not depend on connections with Indigenous individuals and communities. But for companies that do work with Indigenous artists, their reputational capital among Indigenous peoples is crucial; being known as a company that doesn't give back to the community can seriously hamper artists' desire to be associated with them. Moreover, with the rise of ethical consumption and a growing thirst for cultural authenticity, consumers increasingly value the knowledge that Indigenous people were involved in the creation of an Indigenous-themed product, rendering positive relationships with Indigenous artists and communities all the more important. Thus, as working with Indigenous artists slowly grows closer to becoming the norm, more companies find themselves drawn into the Indigenous status system and the redistribution practices that undergird it.

Redistribution in the Artware Industry

Artware and Potlatching

Although anthropologists have debated the particular social function that is attributed to potlatch goods, and this function can vary depending on

the cultural group and time period, it is a common feature of potlatches that series of the same or very similar items are given away in large quantities to those present, which requires long hours of work and massive shopping sprees.[23] Whether they are considered gifts or payments, the items distributed to potlatch witnesses and guests today span a wide array of goods that are the contemporary equivalents to the stacks of foodstuffs, columns of silver bracelets, and piles of wool blankets commonly pictured in late nineteenth century and early twentieth century photography.[24] In some cases, alongside locally harvested foods, blankets, jewellery, unmarked comforters, towels, cookware, and plastic containers,[25] one can find the artware items that are at the centre of this book. These can be made or customized specifically for the event – mugs, T-shirts, or tote bags with specific crests, feast names, and dates, for instance[26] – or simply chosen from the already available products distributed by artware companies. Thus, although the artware industry is typically imagined to produce souvenirs that allow non-Indigenous tourists to hold on to a material token of their experiences of travel, this industry also provides potlatch items that can later function as mnemonic indexes for the witnesses of specific transfers of property and responsibilities.[27] In turn, even though artware products are more often sold as commodities than they are distributed as potlatch gifts, the fact that some companies' products circulate in potlatches contributes to both economically supporting and socially justifying the existence of this industry. Given that Pacific Northwest peoples integrate artware items into an institution as important to them as the potlatch, this market cannot be framed as an entirely non-Indigenous imposition on Indigenous peoples. This is yet another way in which the artware market is slowly being transformed by Indigenous stakeholders' efforts to create a form of cultural commodification they can consider getting behind instead of fighting against.

Thus, before delving into the parallels between potlatches and the obligation of artware companies to "give back," it is important to discuss this even more direct relationship between the artware market and potlatching. For instance, an artist who was hoping to one day create his own artware company explained: "In order to have a potlatch, you have to have money: you have to pay your singers, you have to pay the artists who will do your masks, you have to pay the man who composes your songs." He wanted his business to cater to the specific needs of potlatch hosts, producing items suitable for redistribution and using revenue made from selling products to outsiders

to fund his own feasts. Thus he envisioned a company that would doubly contribute to the perpetuation of this important institution.

As this artist pointed out, holding a feast or a potlatch can be very expensive, easily costing tens of thousands of dollars. The items distributed to guests represent one of the costs falling on the shoulders of the hosts. As Tseshaht (Nuu-chah-nulth) artist and author George Clutesi wrote, before a potlatch "the principal and his councillors began to plan and to accumulate various articles that he would give away – sea-otter robes; whaling canoes, sleek sea-otter and fur-seal hunting canoes and the smaller fishing and utility canoes ... Then there were smaller articles such as cooking utensils and chattels of many kind."[28] Similarly, Haida artist and elder Florence Davidson recalled: "The families would all work together on *watleth* [potlatch]. When they had gathered enough things for it, they invited all the opposite clan to the *watleth*. Sometimes feasting would go on for ten days and nights. They gave away piles upon piles of wool blankets, to everyone from the opposite side."[29] Commenting on the potlatches held in Alert Bay in recent decades, Kwakwa̱ka̱'wakw scholar Gloria Cranmer-Webster explained, "During the months of preparation, family members are busy accumulating the goods to be given away. The big house in Alert Bay holds almost 700 people, which gives you some idea of how much is needed to ensure that no guest leaves empty-handed."[30] Whereas previously much of the wealth distributed could be drawn directly from the territories to which the hosts have rights, access to these territories and their resources has in many cases become limited if not denied by governmental policies, private property, and conservation laws. Nevertheless, goods like eulachon grease, seaweed, salmon, and cedar items are still distributed in potlatches. In fact, hosts go to great lengths to make this possible even if they live in urban centres, taking time off from work to travel to their home territories. Discussing eulachon grease in particular, Cranmer-Webster remarked in the 1990s that "a gallon sells for about a hundred dollars, so that the distribution of such a valuable commodity greatly enhances the stature of the potlatch-giver."[31] However, store-bought goods are also popular potlatch gifts, and it can take years for hosts to save up the money needed for these mass purchases, not to mention all the other expenses and required payments. In addition to mobilizing volunteers to help with preparations,[32] hosts may seek donations in kind, in particular from individuals who are within a lineage that has an obligation to contribute. As the artist mentioned above explained, artware items can be among those contributions: "Say my great-uncle, a big chief,

has a big potlatch, [I'd say,] 'Hey Uncle, take this X amount of items, you can give it away, use it, that's my contribution to your feast.'"

From time to time, artware companies are asked to make custom products with designs created by a person who is hosting a potlatch or someone in this person's family. The production of these custom potlatch gifts bears a lot of similarity to producing custom corporate products and "name dropping" (when the name of the client company is added to an existing product design). In fact, an explicit parallel between potlatching and corporate gift giving was made in an article about Haida artist Clarence Mills's relationship with the Vancouver-based corporation BC Bearing:

> Many of the gifts given by [CEO] Wendy McDonald on behalf of BC Bearing bear [Mills's] artwork. "It's called potlatching according to Native tradition," says Mills of BC Bearing's tradition of gifting miniature totem poles, coasters, key chains and limited-edition prints to corporate alliances, visiting dignitaries and BC Bearing staff. "To potlatch is to give away, bringing honour to your family in the process," says Mills, noting the parallel between First Nation chiefs who potlatch and CEOs – chiefs in their own right – who potlatch.[33]

Whether or not this parallel holds true from a socio-legal standpoint, from the point of view of logistics, at least, companies accustomed to producing custom corporate gifts can easily produce custom potlatch gifts.[34] In the case of these custom items, the host or someone in the host's family places an advance order, but artists will also stock up on regular items featuring their designs in order to be ready to supply their kin and others in the community with gift items. While artists usually receive no more than a few free samples of merchandise in addition to their payment, some ask to be paid in kind or to be able to purchase items at wholesale prices in anticipation of requests to contribute to upcoming potlatches. For instance, a Musqueam weaver I spoke to explained that she purchases blankets from the company that reproduces her weavings at a discount equivalent to the royalty payment she usually receives. She wanted to directly provide her band office and other customers with blankets, rather than sending them to purchase these gifts at a retail store or from the company itself. In turn, the company was quite happy to see this weaver supply this particular market, preferring to restrict their own wholesaling activities to corporate gift giving, a practice with which they are much more familiar than with potlatching.

While corporate gift giving and potlatching are not truly one and the same, these practices bear just enough surface similarities for artware companies to understand the idea of purchasing large quantities of items only to give them away. Just as it would cut prices for a corporate customer with a large order, a company may sell its products to a potlatch host at a discount. But providing lower prices on the specific basis that the products will be used in a potlatch can also be a way for companies to show their understanding of the importance for Pacific Northwest peoples of carrying out these mass redistributions, even in the face of economic hardship. Several artists stressed that companies needed to understand and support artists' involvement in potlatching. For instance, it was key to one Tsimshian artist's decision to work with a specific company:

> I was interested in [the company] reproducing my images on products that could be used in potlatches as gifts, something that is accessible to Native people to order in quantity. That was also very much a fundamental reason as to why I was dealing with [the owner] because I understood from him that he was wholly open to supplying potlatches. That was important to me.

For most companies, potlatch-related sales are peripheral to their own growth, which is largely predicated on selling single items to non-Indigenous consumers. But for artware companies presenting themselves as dedicated to supporting Indigenous peoples and cultures, finding ways to support the potlatch economy can be seen as an integral part of their business ethos, doing the business of artware while supporting the business of potlatching, and vice versa – precisely what culturally modified capitalism is about. That said, as a Squamish/Kwakwaka'wakw artist explained to me, the cultural significance of potlatching is not understood equally by all companies: a company can be aware that its products are distributed in potlatches but not "necessarily realize what that means in a strong way," he said. Yet such an understanding can make a world of difference in terms of a company's compliance with the obligation to give back.

"Giving Back" in the Artware Industry

Marshall Sahlins defines three basic forms of reciprocity: (1) generalized, when that which is given comes with the expectation of later counter-exchanges,

but the time, quantity, and quality of this obligation is indefinite and not necessarily individualized; (2) balanced, when the exchange is simultaneous and symmetrical; and (3) negative, when each party is driven to maximize gain and, ultimately, wants to "get something for nothing with impunity."[35] As Chapter 4 clearly shows, the artware industry is shaped by participants' concerns about balanced reciprocity (such as when a company pays an artist for designs to the satisfaction of both parties) and negative reciprocity (such as when one party profits at the expense of the other). But generalized reciprocity also plays an important role in the way the industry operates, as injunctions to give back – not to specific individuals and not at a specific moment in time, but in ways that benefit Indigenous communities at large and in the long run – have become increasingly common and better acknowledged. Debates about what constitutes fair payment, or the difference between balanced and negative reciprocity, are common in any market, including capitalist ones; but the importance of "giving back" in the artware industry, while not unheard of within a capitalist approach, is more specifically consistent with the ethos of generalized reciprocity that characterizes the potlatch economy and enables the validation of one's status within the community.[36] Of course, Indigenous people are not the only ones who can consolidate their social position through gifts and community engagements. Many politicians, athletes, movie stars, artists, and entrepreneurs engage in philanthropic activity, some of which is described as "giving back to the community." Such philanthropy can certainly heighten the esteem in which they are held in the public eye. However, there are significant differences between gestures of generosity that someone chooses to make and redistribution practices that fulfill an obligation and follow a set of protocols.

In order to understand the difference between the principles that govern philanthropic gestures and those of generalized reciprocity in the Pacific Northwest, some emphasis must be placed on the word "back" in the injunction to "give back." The responsibility borne by participants in the artware industry is not to assist an "other" who is at arm's length; it is rather to feed wealth back into what is conceptualized as its original source, whether this source is described in general terms as Indigenous peoples, cultures, or communities, or with reference to a specific nation, village, or relational network. Indigenous individuals and businesses may tend to adhere to the notion of reciprocity because, in the Pacific Northwest, this responsibility comes with being part of an Indigenous community.

Conversely, business people who are not Indigenous, and thus have no claims to this form of cultural belonging, might not be concerned by such obligations as they are not tied into this system of reciprocal responsibility. For this reason, practices of redistribution by these non-Indigenous companies could be read as a sign of goodwill and benevolence on their part – in other words, as philanthropic acts similar to those promoted (and publicized) in today's corporate world more generally. However, this reading overlooks the fact that the industry's Indigenous stakeholders consider such practices as "normal": even if quantitatively they are on the exceptional side, qualitatively they correspond to proper behaviour by non-Indigenous industry participants. In fact, I was constantly told by Indigenous individuals that non-Indigenous companies were obliged to redistribute, even when they do not know, care, or act as if they are so obliged. Much of the animosity I encountered against non-Indigenous artware companies was levied against them not because of their chosen field of activity per se, but because they were seen to have failed to sufficiently give back. Some participants were more radically opposed to non-Indigenous participation in the market, preferring there be nothing to give back because nothing had been taken in the first place. For instance, after I had described contributions made by non-Indigenous companies as "some kind of back-and-forth, some give and take," one artist replied, only half-joking, "It would be better if it was just all 'give,' no 'take.'"

On some level, the responsibility of non-Indigenous companies not to "take" at all, or at least to "give back" when they do, might be seen as associated with the broader responsibility attributed to settler society for many of the ills suffered by Indigenous peoples. However, there is more than so-called white guilt in the social responsibility non-Indigenous artware companies have towards the Indigenous stakeholders of the artware industry. No matter the economic, social, cultural, or political intentions behind the decision to create a business around the reproduction of Northwest Coast art, that decision effectively pulls these businesses into the Pacific Northwest system of generalized reciprocity. As discussed in Chapter 4, what might normally constitute fair business is not considered a form of giving back: to pay market price for a design plays by the rules of balanced reciprocity but does not demonstrate understanding of the ties to a system of generalized reciprocity that are created by such transactions, beyond their interpersonal dimension. The culturally specific logic of this system of reciprocity is what creates the expectation that companies will

engage in practices of redistribution. Although such redistribution is not as common as such an expectation might suggest, this fact only galvanizes pressures that it be fulfilled.

In a conversation I had with a Sechelt artist and entrepreneur, he discussed his disappointment with the lack of support certain retail stores showed towards his company, pointing to certain expected behaviours on the part of those who draw on Indigenous resources to run their business. He explained that when he asked a store manager why she would not carry his products, she put it bluntly: Why would she want to put his products in the store if they would take up shelf room and result in four times less return for the shop than other items made in China? While, from a business standpoint, he appreciated her honesty, he could not agree with the world-view her thinking reflected. What shocked him even more was that the store is attached to an institution that not only attracts tourists with Indigenous art, but also sits on unceded Coast Salish territory. In his view, such stores should "naturally" support businesses like his. And yet, in his experience, few institutions acknowledge this responsibility and take it seriously. Still, he and others like him were not disposed to overly praise those who do fulfill their obligations as if they deserve special recognition for doing so, when in fact they are simply abiding by the principles of a system of exchange in which they chose to participate when deciding to produce Northwest Coast artware in the first place. This was explained to me on a number of occasions, but he made it especially clear. When I mentioned a few non-Indigenous companies that contribute funds to Indigenous youth organizations, he flatly replied, "That's the way it should be."

Essentially, this perspective is consistent with the view that there is nothing redemptive about contributing to the well-being of Indigenous individuals, businesses, and communities when partaking in the commodification of Indigenous culture. Instead of originating from a place of either compassion or guilt, such contributions are seen as compliance with the social responsibilities that come with engaging in the local Indigenous economy and social organization. From this point of view, a non-Indigenous company contributing to an Indigenous youth fund is neither benevolence nor support nor a compensation or apology for capitalizing on the cultural resources of a group to which it does not belong; rather, it is an acknowledgment and a demonstration of respect towards the source from which it derives its success and from which it has carved its niche market. As such, "giving back" is obligatory and thus an expected fulfillment of a responsibility. Those

on the receiving end of such redistribution practices have nothing to be thankful for, just something to be satisfied with. It is, as he stated, "the way it should be."

Several individuals explained to me that they were wary of small or punctual "donations," and felt the injunction of reciprocity called for more substantial, longer-term contributions. For instance, a Squamish designer I spoke to, herself highly committed to practices of redistribution, has high expectations of non-Indigenous companies. "What I'm thinking is that these companies could put aside 10 percent of that money and select somewhere where they donate it. Whether it's to Emily Carr art school where they encourage First Nations to go to school there, and enjoy the arts, whether it's sports, whether it's entrepreneurial training ... *Then* I'd be pretty damn happy."

As evident in her statement, not only are companies enjoined to find ways to redistribute, such redistributions are expected to be specifically directed to Indigenous stakeholders, further underlining the significance of the "back" in "giving back." Such redistribution cannot be conceptualized as classic philanthropy, where donors are at liberty to choose a cause to which they want to contribute solely based on their personal sensibilities. She speaks of companies "selecting" where they want to "donate" but also makes it clear that this choice should be made within a particular pool of options, all of which would have a direct impact on the well-being of Indigenous peoples specifically. In this sense, she is not suggesting companies provide aid to whomever they want to "help," but rather that companies be accountable to the people with whom they are bound in reciprocal relationships.

Giving Back More Than Money

At a basic but essential level, the obligation that binds artware industry participants to redistribute finds expression in the idea – most often expressed by the artware industry's Indigenous stakeholders but also on occasion by non-Indigenous stakeholders – that this market should provide concrete means for Indigenous communities not only to subsist, but to thrive. Far from novel, this idea was promoted by the early proponents of the development of the market a century ago, as discussed in Chapter 2. Artware companies that are either Indigenous-owned or work with Indigenous artists are seen as contributing to this goal, albeit at markedly varied levels depending on the company.

Not all artists who approach artware companies do so from vulnerable economic positions, far from it, but many do tie their decision to work in artware at least in part to paying their bills, whether a mortgage on an expensive house in Kitsilano (one of Vancouver's wealthier neighbourhoods) or a modest phone bill. That is, making artware is part of many artists' livelihoods. However, there remains a difference between a company that helps provide the conditions for the immediate survival of an individual and one that commits significant resources to the long-term economic prosperity of communities. Also, if in the first case hard cash may be what is needed most, in the second case, the most important contributions may take less tangible forms, such as volunteering time, sharing knowledge, providing training, or, in the case of an Indigenous artist or company, demonstrating community leadership. In this sense, it is important not to overstate the strictly economic dimension of the injunction to give back.

Some early academic commentators on the potlatch, including Boas, focused their attention on the material and even monetary nature of potlatch exchanges, in some cases translating them into capitalist terms of debts owed and loans repaid so as to render them easier to understand by a non-Indigenous audience.[37] But potlatches involve the exchange of both tangible and intangible forms of wealth. For instance, the late Heiltsuk artist David Gladstone explained the relationship between taking on a new name and being given a button blanket:

> I received names from the same people who gave blankets. Sometimes, it was names, and sometimes it was knowledge that they gave me. They also trusted me with songs for the use of their descendants. The blanket is a symbol – a visible, tangible symbol of the giver's esteem for the recipient. The name is another gift. It's intangible, but highly valued by us. When people give you a name, it's a mark of their esteem for you. The blankets are in the same category.[38]

The importance of exchanging both tangible and intangible wealth, as underlined here by Gladstone, provides a window into why monetary payments are only one aspect of how companies can fulfill their responsibility to give back. Furthermore, upholding this responsibility monetarily and otherwise is seen as a direct manifestation of respect. A company that gives back is not only one that pays its dues, so to speak; it is also one that shows its esteem for those on the receiving end of its redistributive practices.

Recent developments in one non-Indigenous artware company illustrate how growing concerns for communities have been progressively taking hold among some industry participants. Following several decades of growth, this company has for some time been considered one of the leaders in the industry. Like many non-Indigenous companies, it is criticized by those who believe it makes profits on the back of Indigenous culture. At the same time, the company is also praised for having raised the profile of Northwest Coast art and setting a precedent in the early days of the industry for exclusively working with Indigenous artists rather than using copied or imitative designs by non-Indigenous artists. The owner explained to me that since he created his company, many of the artists he had worked with over the years had had successful careers, Northwest Coast art had become much more widely celebrated, and a number of companies had begun working with Indigenous artists when previously they did not. Realizing the extent of the changes that had occurred in the industry since the early days of his business, he began to feel that it was time to take on new initiatives. This realization led to a campaign to promote education and literacy, particularly among Indigenous children.

A few years ago, the owner noticed the lack of Indigenous-themed educational material and resources, and wanted to address that by creating a series of board books. Initially unsure about the response these books would garner from the educational community, he was surprised but pleased that educators and teachers called to say how enthusiastic they were about using them in their classes. Based on this positive response, the company decided to create a more comprehensive program of educational products. For instance, the company began creating bookmarks and posters promoting literacy, which it distributed for free. Also, it partnered with a community organization that focuses on early childhood education to give away several hundred books as part of a program in support of Indigenous families facing economic hardship. The company's plan was to sell the products in gift stores as well as through educational networks, while continuing to distribute them free of charge to organizations focusing on Indigenous education. Discussing why he would take on such an endeavour, the company owner explained that while on a personal level he still enjoyed product development, he felt it did not make sense to keep augmenting his company's collections indefinitely without serving any other purpose than adding pages to its catalogue. This new line of products, he explained, reflected a real need to create what he called "culturally connected" learning resources that he hoped would help further Indigenous children's education.

This shift in his practices could be seen as serving a well-crafted rebranding strategy in the face of growing criticism, not to mention that free products can also serve as advertisements for products that are for sale. However, the development of these new products and their distribution for free to Indigenous organizations can still be a sincere attempt to fulfill the company's obligation to give back. In other words, such initiatives are not necessarily only one thing: they can simultaneously help improve the image of a company and help fulfill an obligation of redistribution. Initiatives like these are seldom rooted solely in personal awareness of an undesirable situation and the aspiration for social change. They also respond to increasingly strongly articulated social expectation, most notably by Indigenous stakeholders, that a company that derives its success from Indigenous cultural heritage must in one way or the other contribute to the social, cultural, and economic development of Indigenous communities.

Some companies have gone as far as placing such contributions at the very core of their policies. For instance, Indigenous-owned and -operated artware company Spirit Works Ltd. details its approach on its website as follows:

> Spirit Works is an Aboriginal owned, operated, and staffed company focused on the creation and distribution of authentic Aboriginal products ... Spirit Works is a company not just focused on the bottom line. We at Spirit Works believe in community. [We believe] that the passing down of knowledge is an obligation ... [as is] protecting our heritage and our environment ... Although it is much less profitable to conduct business in the manner we've chosen, Spirit Works would not gain the approval of our communities and Elders otherwise.[39]

As this statement attests, Spirit Works seeks to position environmental, economic, social, and cultural well-being at the heart of its business model. Such a holistic approach surely entails costs – economic and non-economic – that could be difficult to bear for a small company, at the time still in the early years of its development. These various commitments are both the company's strength – what can help set it apart from the many other companies in the market – and one of its challenges – placing limits on what the company can do in order to grow. While this business model isn't necessarily at odds with capitalism per se, it operates within a culturally modified version of it. Importantly, as the company states above, by striving to honour

its various commitments it can obtain the blessing of elders and other community members.

Cause Marketing and Pacific Northwest Principles of Reciprocity

Outside of the artware industry, examples of business models that combine the bottom line with social purpose – as well as criticisms of some such initiatives as mere corporate window-dressing – abound. In general, the idea that companies can chase profits while championing various causes is very much present among multinational corporations that are considered flagships of neoliberal capitalism (take Coca-Cola's Living Positively program, for instance). This may suggest that the practices such as those described above in the artware industry are not the result of context-specific pressures on the part of local peoples trying to protect and further their interests, but just one more example of a current trend in the corporate world. However, the obligation to give back plays out in the Northwest Coast artware industry in ways that are culturally specific, and distinguishes redistribution practices from the increasingly popular marketing strategy of "cause marketing."

In a capitalist system, businesses typically divide their profits among the owners, reinvest them in the growth of the company, or pay them out to shareholders. Many companies also redirect at least a small portion of their profits to supporting various groups and causes, which may be directly related to the company's activities or more disconnected from them.[40] In some cases, things are set up in such a way that consumers are only vaguely or punctually aware of the companies' causes of choice. For instance, if a particular company is a sponsor of the Race for the Cure against breast cancer organized by the Susan G. Komen foundation, consumers who participate in this race may or may not notice its sponsorship, and may or may not find it to be a good reason to continue or start buying its products. In other cases, consumers are more directly called upon to actively support a cause through their own purchasing habits. For example, products in the Pink Ribbon program are identifiable by their particular shade of pink and accompanying pink ribbon logo. This branding makes consumers aware that a portion of the proceeds from the sale of these products will be used for breast cancer research. In such cases – when the consumer directly associates buying a product with personally supporting a cause – we can talk specifically of cause marketing.[41] Instead of merely seeing a company

in a positive light because it supports a particular cause, consumers are made to feel that they can buy products in order to themselves support this cause.

As philosopher Slavoj Žižek notes, this kind of direct integration of charitable deeds and consumptive activity is becoming a central feature of the economy. In what Žižek calls the "postmodern" spirit of capitalism,[42] corporations have become increasingly good at selling, along with their products, "a good night's sleep" by embedding in the very act of consumption one's redemption from being consumerist. In Žižek's view, this kind of capitalism sells the idea that private property can be used to alleviate the ills that have arisen from the institution of private property. This phenomenon has also given rise to the idea of corporate social responsibility (CSR), which speaks "the argot of altruism" while being "portrayed to shareholders as sound fiduciary practice: a credit to company reputation" that ultimately also "feeds the bottom line."[43] In sum, CSR practices such as cause marketing are ways in which businesses associate selling their goods with doing good.

Some of the redistribution practices that occur in the Northwest Coast artware industry roughly correspond to what Lisa Ann Richey and Stefano Ponte call "engaged" and "proximate" CSR: practices that are directly tied to the way the company runs its business, and are meant to affect the communities in or with which the company operates.[44] The kinds of redistribution practices described so far in this chapter are indeed designed to affect the people who are directly concerned by a company's activities, while encouraging the consumption of the company's products and improving its reputation. Furthermore, artware companies' "giving back" could be seen as cause marketing in that these companies are associating their products to the "cause" of Indigenous peoples' well-being. These practices offer the hope that it is possible to participate in cultural commodification while countering one of the perils of "Ethnicity Inc.," namely the sharpening of "the line of division between enrichment and exclusion."[45] In other words, redistribution practices in the artware industry are an example of the current trend that makes companies that want to be considered ethical resort to cause marketing and other practices such as fair trade and eco-friendly labelling. Cause marketing is indeed largely predicated on the idea that profits can be generated by tapping into what Catherine S. Dolan calls "the new morality of consumption," which draws consumers to goods they believe are associated with good causes and enjoins them to stay away from those they see as symptomatic of the ills of the contemporary world.[46]

At first glance, Northwest Coast artware companies that give back are practising a form of cause marketing in that they can make consumers feel that buying their artware is "doing good by shopping well."[47] However, in classic "causumerist" culture, enhancing a company's image through cause marketing relies heavily on affecting consumers' opinions and perceptions. In contrast, in the artware industry, consumers are generally not the ones being called to witness the companies' practices of redistribution in order to publicly validate companies' status as good or ethical businesses. Rather, it is the industry's Indigenous stakeholders who must bear witness to a company's redistribution practices in order for these to establish its status and legitimize its reputation in the industry. Artware companies may hope that consumers will feel good about buying their products if they think their purchases support Indigenous artists and communities, but these consumers are not the ones who have the power to make their name good. Instead, it is the Indigenous artists and communities to whom companies are bound by obligations of reciprocity that serve as the primary witnesses of their redistribution practices and are in a position to validate (or not) the positive reputation they can gain from giving back.

And the stakes of such validation are high. As described in Chapter 1, the Northwest Coast artware industry is traversed by feelings of distrust, and thus also by continual efforts to seek protection against the abuses of others, as well as generate more trust between the various parties involved. As demonstrated in Chapter 2, this market grew amid, and even despite, persistent concerns that abuses were taking place and would continue to take place unless better protections were implemented. Trust is thus evidently not an a priori feature of this industry. In fact, lack of trust is the backdrop against which individuals in the industry approach and engage (or neither approach nor engage) each other, more or less suspicious of the other's business approach and ethics depending on what they have heard and from whom. In this sense, the *circulation of criticism* (and to a lesser extent, the circulation of praise), whether publicly or privately expressed, is one of the platforms through which the market is subjected to a certain kind of social control. This control is in part possible because the industry is small enough that its key participants know or at least know of each other.[48] While this network does not necessarily include the industry's stakeholders at large, many Indigenous stakeholders know at least one of the artists who work with a particular company, or at the very least know someone who does, whether because this artist is well-known, or because they are related through

kinship ties, friendships, or professional networks. Consequently, criticism tends to circulate quickly among the industry's Indigenous stakeholders – much more quickly than it does among consumers.

Furthermore, the stakes of such criticism are higher when it circulates among Indigenous stakeholders than among consumers at large, even particularly critical ones. Controversies related to cultural appropriation are regularly discussed in the media and have been sparking outrage in an increasingly significant segment of the population. But even as far as those consumers are concerned, a company that pays Indigenous artists for their work is difficult to fault because it is already an exception to the expected norm of misguided inspiration, outright imitation, or, at best, botched collaboration. A story about a company that pays Indigenous artists but fails to give back at a more collective scale is likely to have much less traction among the general public. As stated at the beginning of this chapter, in North American society, redistributions of wealth are not considered obligatory – only praiseworthy. Although some consumers might refrain from purchasing artware products from a company that was criticized for not giving back to the community, losing the support of Indigenous stakeholders would have a much bigger impact on a company's reputation and ability to consolidate its standing in the industry. In turn, artists who have good relationships with the companies they work with are ideally positioned to bear witness to their redistribution practices or, when they see fit, to encourage them to step up to the plate of their reciprocal responsibilities towards Indigenous communities.

The limited wager companies seem to place on the impact of consumer awareness and approval of their reputation, in particular compared to the importance of Indigenous stakeholders' opinions, was confirmed to me in various ways. Product labels do sometimes mention royalties being paid to artists, or bear the logo of an organization to which the company gives a portion of its profits, and at least one company posts about its community engagements on social media from time to time. In fact, in the years since conducting my fieldwork, I noticed that, as the idea of giving back to the community gains momentum in consumer culture in general and in the artware industry in particular, there are more and more examples of packaging that associate buying artware with a good cause. Even so, most Northwest Coast artware companies' marketing materials reserve a relatively discreet space for the ways in which they give back. In many cases, this may be because they do very little of it, but even so, discretion about something

that could garner consumer support arguably shows that boasting about such practices without also having community support could very easily backfire, especially since on the Northwest Coast, gestures considered too self-aggrandizing for one's status can be met with cultural disapproval.[49] Whether or not artware companies are right in this assessment, their belief that consumers seldom buy Northwest Coast artware because they think such purchases also mean buying into the "cause" of Indigenous peoples' well-being provides important clues as to the true identity of the witnesses whose attention they are trying to garner. Two examples will help illustrate this point.

The first example concerns a Vancouver fashion designer's line of clothing. Her first collaborator was an established Haida artist for whom she had previously worked as an assistant. When I spoke to her, she was hoping to expand the line and was thinking about possibly working with other artists. She explained to me that, when approaching new artists, she made sure to tell them that the company takes "five dollars or so from each [item] that immediately goes into our donation back to the Aboriginal Friendship Society." She clearly believed that this commitment could help her foster positive relationships with the Indigenous artists with whom she hoped to work, or else she would not think it was important to mention upon meeting them.

The second example concerns a company owner who developed a line of fashion accessories in collaboration with an Indigenous designer. At first, the owner wasn't exactly sure how to proceed, wondering about the Indigenous "style of doing business," as she put it.

> I was very concerned about how I would be received ... I've never worked with First Nations individuals before, and I wasn't sure about the style of doing business and I didn't want to be seen as taking advantage of the culture. So that's where I started looking at integrating a charity that would give back to the First Nation culture, and [the artist] really liked that too.

While the solution she found to the risk of being "seen as taking advantage of the culture" could be filed under classic cause marketing, it was not anonymous consumers' opinions on this issue that worried her most. When I asked if she thought her products' association with an organization

supporting First Nations played a part in buyers' decision to purchase her accessories, she replied:

> I think it's a small part of it, a very small part of it. But you know, it has allowed us certainly to catch the Assembly of First Nations' attention, and credibility, so there is definitely benefit to it, but I don't think buyers take it because of that, no, and I don't think consumers buy anything because of that.

The Assembly of First Nations (AFN) had invited her to present and sell her products at their Christmas event, and she felt strongly that her company's effort to give back had enhanced its credibility in the eyes of the AFN and offered an advantage far greater than consumer approval: the reputational capital of a company that began tending to its responsibility towards Indigenous stakeholders as soon as it made the decision to use Indigenous imagery, rather than as a response to pressures to do so after the fact.

As these examples make clear, artware companies that engage in practices of redistribution are primarily concerned with how their activities will be received by Indigenous industry participants and Indigenous stakeholders, and only secondarily with consumers' perception of the same. While some Northwest Coast artware products are packaged with references to the company's support of Indigenous communities, this attractive wrapping primarily exists to be witnessed by Indigenous stakeholders rather than by masses of consumers. Although redistributing funds to Indigenous organizations and programs is arguably a form of cause marketing, the reasons for which companies carry out such practices are also consistent with the Pacific Northwest "style of doing business," as the previously cited company owner put it. In particular, they mesh well with the practice of calling upon witnesses according to rank so that they can oversee the acts of redistribution that are required in order to validate one's status in the potlatch economy. Thus, in the Northwest Coast artware industry, successfully enjoining companies to give back to the community hinges less upon convincing them of consumers' sensitivity to good causes, and more on the reputational capital they can garner from catching the attention of Indigenous witnesses, who are able to recognize these practices of redistribution as due participation in the Pacific Northwest system of generalized reciprocity.

"Giving Back" as Indigenous Protocol

As we have seen, there can be a direct relationship between the business of making artware and the business of potlatching: artware items can be potlatch gifts, and some artware companies treat potlatch hosts similarly to wholesalers by offering them discounts and customizing goods for their feasts. But there is more. Companies' status in the artware industry is also directly tied to the fulfillment of a potlatch-like obligation to engage in publicly witnessed acts of redistribution. The decision to draw on Indigenous cultural resources comes with an engagement to respect Pacific Northwest property regimes and protocols. Thus, artware companies are expected to engage in practices of redistribution similar to those conducted during potlatches, thereby acknowledging that their economic activities have pulled them into a local system of generalized reciprocity. They cannot merely pay the individuals who directly contribute to the creation of their products; they must also distribute "gifts" to other Indigenous stakeholders.

In sum, when artware companies are expected to give back, it not only makes sense for these companies to give back to Indigenous communities rather than give to a cause of their choice; it also makes sense for this redistribution to be witnessed first by Indigenous stakeholders, and only secondarily by the (largely non-Indigenous) consuming public. A company whose compliance with the obligation to redistribute was not appropriately witnessed will be seen as thinking itself above or at least beyond the reach of the local protocols dictating that it seek not only balanced reciprocity with individual artists, but also generalized reciprocity with Indigenous stakeholders at large. This emphasis on giving back meshes well with today's consumer culture, which values green, fair trade, and other forms of "ethical consumption." But although cause marketing is undeniably a growing trend in the artware industry, as in most markets, so far it does not primarily aim to provide "a good night's sleep" to its consumers. Instead, it is a means for companies to signal their desire to fulfill their responsibility towards those who created the cultural resources upon which they draw. There is evidence that more and more companies are realizing that their reputations will suffer if they focus on wealth accumulation without also participating in the system of generalized reciprocity that requires them to redistribute some of this wealth. Even though companies that give back are by no means the norm, Indigenous stakeholders consider their redistribution practices to be normal in that they correspond to an expected behaviour in the context of a potlatch

economy. The injunction to give back to the community is thus a feature of the artware industry's transformation into culturally modified capitalism: it not only resonates with the rise of corporate social responsibility in a capitalist system that still uses accumulation as its primary measure of success, but also places artware companies squarely within a Pacific Northwest Indigenous economic system in which one's status is directly tied to publicly sanctioned acts of redistribution.

CONCLUSION

Indigenous Sovereignty and the Sustainability
of Culturally Modified Capitalism

ANTHROPOLOGY'S MAJOR CONTRIBUTION to the study of political economies has been its acknowledgment of the tension between the determination of capitalism and the cultural freedom of anthropological "subjects." Whether focusing on historical or contemporary examples, anthropological studies of capitalism often argue against the view that the worldwide advance of capitalism has led to the repression of practices inconsistent with its internal logic, and consequently to the destruction of pre-existing local economic systems, a view that obscures the fact that capitalism rarely if ever manifests itself in the form of a pure economic model.[1] As Jean Comaroff and John Comaroff have argued, capitalism is always "refracted, redeployed, domesticated, or resisted" in the local contexts where it operates.[2] Furthermore, contrary to the notion that non-European peoples encountered capitalism only with the most recent developments of globalization, they have been interacting with it for several centuries now.[3] Ethnographic work has helped show that the fear of global cultural homogenization is largely unfounded due to the ability of peoples around the world to make their worldviews bear on the capitalist model, as they have done time and time again.[4] Given the resilience demonstrated by the Indigenous peoples of the Pacific Northwest in the face of disease, theft, and violence,[5] it comes as no surprise that a market based on one of their distinctive forms of expression like the Northwest Coast artware industry would be met with resistance against cultural assimilation and economic exploitation. This resistance, however, is not directed against the idea of an economy centred on the production and distribution of large quantities of objects.

Indeed, the adornment of objects of everyday life, as well as the production and distribution of objects in large series, is neither foreign nor new to the Indigenous peoples of the Pacific Northwest. These age-old practices are integral to one of the region's most important institutions, the potlatch. Therefore, while the Northwest Coast artware industry undeniably grew out of the spread of a capitalist organization of the economy to the Pacific Northwest, it grew in a context rife with local precedents on which Indigenous

◀ OVER

Intensive and extensive resource extraction has made it increasingly difficult to find trees suitable for building longhouses, house posts, and totem poles. When logging companies occasionally set logs aside for the purpose of being carved by Indigenous artists, it is often framed as a "donation" but can also be understood as the fulfillment of an obligation towards those from whose territory the log was harvested.

peoples could draw to make sense of this market. That said, for the better part of this industry's history, the capitalist model that it has followed and the settler-colonial context in which it has operated has made it difficult for Indigenous people to turn the existence of this market to their own ends, let alone take its reins into their own hands. The industrialization of Northwest Coast art was promoted over the course of a century as potentially good for both the Canadian economy and the well-being of Indigenous peoples, despite concerns that it would benefit the former more than the latter. Thus a yearning for this market to be increasingly controlled by Indigenous peoples has shaped and continues to significantly shape the discourses and practices I witnessed from various stakeholders during my fieldwork.

Contrasting with hopes for such improvements, there are also concerns that, due to globalization, local stakeholders are increasingly at risk of losing their grip on how the industry is run. In this respect, the Northwest Coast art and artware market is an example of a commodityscape entwined in global connections that nonetheless continues to be tightly bound to the local hub from which it initially derived its specificity. Despite various deterritorialization processes, the Pacific Northwest continues to be the territory from which local industry participants exert control over certain aspects of the market. This includes placing limits on the unauthorized reproduction and circulation of Northwest Coast designs, which have long been a problem in this market and beyond.

One manifestation of these efforts is that, even though most Northwest Coast artware companies are non-Indigenous-owned and -operated, these companies increasingly face a moral imperative to work directly with Indigenous artists. These relationships in turn inextricably entwine economics and ethics, and transactions negotiated between individual industry participants occur with the backdrop of more collective stakes. As a result, the fairness of the arrangements struck between artists and artware companies tends to be evaluated in terms of not only what is being exchanged from a technical-legal standpoint – whether it be considered art, labour, or cultural property – but also what kind of relationship between Indigenous and non-Indigenous peoples these exchanges represent. Debates about the morality of the artware industry's current configuration tend to reach beyond whether participants abide by Canadian laws and work with market-defined prices. Furthermore, because so many companies describe their relationships with artists as "collaborations" – mirroring the rhetoric used to describe relationships between Indigenous and non-Indigenous peoples more generally (although

the rhetoric of "reconciliation" has now begun to take over) – it has become increasingly difficult to differentiate businesses that challenge colonial power dynamics through more equal and equitable partnerships from businesses that simply reproduce the imbalanced relationships that usually flourish in colonial contexts. As argued by anthropologist Cori Hayden in relation to the politics of bioprospecting and benefit-sharing agreements with local communities, "the near hegemonic status of 'community participation' in sustainable development initiatives should not be taken as a transparent indicator of systemic shifts in the way development is both imagined and managed."[6] In other words, the fact that Indigenous people are being invited to the negotiation table does not signal as big a sea change as some might imagine. There are thus parallels between negotiations as they occur in the artware industry and as they unfold in relation to issues of Indigenous sovereignty more generally. In both cases, such negotiations are arduous because the political frameworks and socio-legal standards under which they are supposed to take place need to be radically overhauled in order to reflect the worldviews and interests of the Indigenous parties involved.[7]

One way change has manifested in the artware industry is in the injunction that companies should adopt practices that directly support the perpetuation of Indigenous expression and ways of life in the Pacific Northwest. It may appear paradoxical that such a responsibility be assigned to an essentially capitalist market, since it was in the name of this very economic model – among other justifications – that the practice of potlatching was criminalized under federal law for sixty-seven years, severely affecting Northwest Coast political, social, and cultural life. But as the example of the artware industry shows, the relationship between capitalism and potlatching is more complex than one of unilateral destruction. Far from catering only to the tourist market, the artware industry also produces potlatch goods, and a number of artists fund their contributions to potlatches through the sale of their work to galleries and artware companies. More importantly, the artware industry has been increasingly shaped by the expectation that its participants, Indigenous and non-Indigenous alike, find ways to give back to the industry's (other) Indigenous stakeholders in a way that mirrors redistribution in the potlatch economy. Deriving its specificity from the use of Northwest Coast art to singularize otherwise ubiquitous wares, the industry and all its participants are pulled into this local system of generalized reciprocity. Beyond finding agreeable arrangements with their direct business partners, artware companies are expected to make redistribution part of their overall business model. In turn, the fulfillment of this

expectation is a way for companies to improve their reputation in the market. A good reputation allows companies to publicize their commitment to supporting Pacific Northwest peoples in their willingness to derive economic and other forms of capital from cultural resources, such as their art,[8] so long as these communities also maintain the ability to manage the risks that inevitably come with cultural commodification.

Commenting on what they call the era of "Ethnicity Inc.," Jean Comaroff and John Comaroff have argued that "while the commodification of identity is frequently taken as prima facie evidence of the cheapening of substance, the matter has never been quite so straightforward."[9] In the Northwest Coast artware industry, the relationship between commodification and the "cheapening of substance" is anything but straightforward, as I have endeavoured to show throughout this book. Each argument suggesting otherwise invites a counter-argument. The idea that Northwest Coast art has been devalued by undergoing processes of serialization can be countered by the observation that serialization has long been an important mode of artistic exploration for Northwest Coast artists. To the suggestion that the large-scale distribution of mass-produced goods points to a decline in the importance of Pacific Northwest Coast ways of life, it can be objected that the availability of such goods has facilitated the holding of expensive and crucially important potlatch ceremonies in the face of extreme economic hardship. The argument that Indigenous identities are lessened by the use of industrial materials and technologies fails to take into consideration the fact that artware items, which are produced with these materials and technologies, play an important role not only in everyday expressions of cultural identity but also in the payment of witnesses to the transfer of names, titles, songs, and other forms of intangible wealth. Thus many of the processes that accompany cultural commodification have served to reinforce and perpetuate important aspects of Pacific Northwest Indigenous cultures, demonstrating that cultural commodification and cultural perpetuation are not necessarily always at odds.

Still, the commodification of things cultural often involves quantification, standardization, and destruction, even as it also leads to qualification, singularization, and preservation. The artware industry treats Northwest Coast art as a resource – something that is drawn upon and extracted for use, but also requires promotion and protection if it is to be renewed in order to remain available for exploitation, like the other resources upon which the industry draws, such as labour, capital, and raw materials. The very idea of "cultural resources" that need to be "managed" attests to the fact that capitalism, and what anthropologist James G. Carrier calls "the language of the

Market" in the West, provide the frame of reference for how things are valued and treated.[10] And yet Northwest Coast art is not just another resource among many used by this industry, for several reasons. First, although Indigenous motifs alone do not make the Northwest Coast artware industry, they do occupy a central place in this market, as they distinguish the industry and its products from all others with the same functionality. Second, many of those I spoke to consider that the value of these designs cannot be quantified, even though the commodification process suggests otherwise by attributing them a price. So although Northwest Coast art is treated as a resource in that it is used in order to create wealth, its intrinsic value is also regarded as exceeding this particular kind of utility.

There is a palpable tension between these images' economic value and their other dimensions – social, political, legal, spiritual, and cultural. This tension shifts the stakes of images' use for the purposes of artware production from rendering this industry commercially viable to the benefit of all directly involved, to ensuring this market directly supports culturally sustainable Indigenous communities. Such an industry inevitably raises concerns about how far the commodification of cultural heritage can extend before that heritage becomes adversely and possibly irreversibly affected.[11] Although some would like this market to be developed to its fullest potential, others would rather place limits on this development as a safeguard against the real and perceived dangers of hyper-commodification. Industry participants and others are concerned that monetary value should not overpower the other social, political, legal, spiritual, and cultural values in the name of which Northwest Coast art has been and continues to be produced. In fact, much of the specificity of the Northwest Coast artware industry's current configuration stems precisely from this concern, held over decades now, by both the industry's opponents and also by some of its proponents. I have described a yearning for a new and improved industry that benefits Indigenous stakeholders more than it currently does. In many ways, this yearning expresses the desire that Northwest Coast art be used as a resource only to the extent that the economic wealth it yields feeds into, rather than takes away from, the ways of life of the Indigenous peoples who developed what is also a non-economic form of wealth in the first place. The politically and morally charged debates that animate the Northwest Coast artware industry, and to which this book has spoken, can in great part be attributed to the undeniable complexity of this hope and to the importance of the stakes to which it is associated.

What adds to this complexity and raises these stakes further is that developments in the artware industry are folded into much larger issues of

sovereignty. The arts, broadly defined, are just one of many fields in which Indigenous peoples are fighting for their rights. As Aleut/Yup'ik anthropologist Alexis Bunten put it, they are using the "political clout acquired through the accumulation of large amounts of capital to support self-determination through a strategy to 'beat the systems in power at their own game.'"[12] As pointed out by Cori Hayden, some Indigenous activists are "refusing to be 'museumified,'" arguing that money generated from the exploitation of their communities' resources should not be earmarked by others for their so-called preservation against further losses, but should instead be channelled "to help those communities participate in the world in ways that they themselves might choose."[13] Thus Indigenous peoples are not simply aiming to destroy certain power relations – using the master's tools to deconstruct the master's house of colonialism, if you will – in order to better preserve their values and practices. They are also aiming to use these tools to construct new relationships and imagine new ways of living as Indigenous peoples, in the hopes of progressively building more sovereign societies. Productive tensions between these two strategies have arguably led the artware industry to become a form of culturally modified capitalism, drawing wealth from a non-Indigenous market structure in order to reinforce Indigenous values and worldviews and gain more independence from this market's non-Indigenous stakeholders. Assuming that the ultimate goal is to durably re-establish Indigenous sovereignty – in the world of artware and beyond – the sustainability of such a model needs to be more closely examined. As Bunten argues about Indigenous capitalisms, "Toggling back and forth between the dialectics of internal value systems and those that drive dominant political economies, Indigenous corporations can provide new pathways for nation-building and self-determination, but they could also be harbingers of partial or total subsumption."[14] In short, the question remains, Is it reasonable to pin hopes for a brighter, more prosperous, more culturally rooted, and more politically sovereign future for Indigenous peoples on a phenomenon such as culturally modified capitalism? Given that it serves to perpetuate both Northwest Coast cultural heritage (by helping sustain artists and communities, and increasingly putting control in Indigenous hands), *and* capitalism (by giving it a more familiar face and therefore reducing the impact of the criticisms levelled against it), how sustainable can culturally modified capitalism realistically be for Indigenous communities, especially if the end goal is sovereignty?

Some commentators are openly sceptical of the idea that cultural commodification of any kind can represent a sustainable path forwards for

Indigenous peoples. For example, Jean Comaroff and John Comaroff seem to take this stance regarding what they call an "all too concrete reality":

> In many desperately poor parts of the world, the attenuation of other modes of producing incomes has left the sale of cultural products, and of the simulacra of ethnicized selfhood, one of the only viable means of survival. Whether or not this is turned, imaginatively, into an act of positive choice, into a positive assertion of identity – let alone into a sustainable basis of communal life – is another matter entirely.[15]

The Comaroffs sound cautious, and even somewhat cynical, about the idea that economic development centred on cultural products could form the basis of a better future for marginalized communities. They are certainly not alone, especially given the cultural and economic exploitation peoples around the world have experienced in the name of capitalism. However, others believe that working within one of capitalism's iterations has been unavoidable for some time now, and although some Northwest Coast industry participants did express ambivalent feelings regarding their participation in capitalism as a system, very few voiced outright rejection of this economic model as a whole. A number of Indigenous industry participants emphasized the importance of acquiring certain kinds of business skills and cultivating their entrepreneurial spirit, embracing rather than rejecting some of the practices and values central to capitalism. I am therefore cautious not to misread their criticisms of the artware industry's current configuration as an overt, direct, and unequivocal form of resistance to and push against capitalism as a whole. There are of course many Pacific Northwest Indigenous individuals who do overtly reject capitalism and forcefully decry its effects on their communities. Such voices are particularly well represented among those who oppose the extraction of natural resources from their territories, as anyone paying attention to social movements against pipelines, mines, hydroelectric dams, and other forms of resource extraction would immediately realize. But having focused my research on people who are in one way or another involved in the artware industry, none of those with whom I spoke formulated their discomforts and dissatisfaction with how this industry functions as a stand against capitalism as such, and so I am not in a position to describe the positions of those who oppose this market's existence primarily on anti-capitalist terms.[16]

Among those I did speak to as part of my research, the industry stakeholders who pressure artware companies to modify their practices from mainstream business standards are not focused on doing away with capitalism altogether. Rather they seek to find ways of "doing business" in the capitalist sense while "doing business" as understood in the Pacific Northwest Indigenous sense. Their objective may not be to end all forms of cultural commodification, but they do strive to eventually assert sovereignty over how their cultural resources are used, for what purpose, and to whose benefit. In summary, the artware industry as a form of culturally modified capitalism is being born out of Indigenous stakeholders' efforts to progressively transform the features of a market they recognize as capitalist so as to help perpetuate Indigenous values and ways of life that are not considered characteristic of capitalist societies. In order to consider the extent to which culturally modified capitalism represents a sustainable path towards Indigenous sovereignty in the long run, this phenomenon must be repositioned in the broader context of contemporary capitalisms.

The expression "culturally modified capitalism" does not simply refer to the modification by "culture" of a so-called natural economic system or order. If that were the case, like most of the other kinds of capitalism that can be observed around the world, the artware industry would simply fall under what Daniel Miller calls "organic capitalism" in the sense that its norms and procedures have more to do with historical developments than the abstract model or ideal of capitalism as an economic system.[17] Similarly, culturally modified capitalism has affinities with, but cannot be reduced to, what Slavoj Žižek calls "cultural" or "postmodern capitalism" – an economic system where the market provides not just goods but also experiences, including that of thinking it is possible to alleviate the poverty of "Others" through individual consumerist acts.[18] Culturally modified capitalism does appeal to the kind of "compassionate consumption" that is so central to contemporary market relations,[19] but that alone is not what drives its transformation into an economic model that better serves the needs of Indigenous peoples. Also, the artware industry bears similarities with what John Sutton Lutz described as the "moditional economy" of Indigenous labour in British Columbia's industry until the 1970s, which was neither "traditional" nor "modern," but instead was a "new, distinctive economy" in which Indigenous peoples could choose "independence over any one of wage labour, state support, or 'living off the land.'"[20]

However, culturally modified capitalism isn't simply a hybrid of differing economic models that the Canadian government once considered incompatible,[21] nor is it merely an example of what Partridge and Uquillas, writing for the World Bank, describe as "ethnodevelopment," that is, projects that are "defined by and controlled by the indigenous peoples themselves as they seek better lives in the face of increasing poverty and social disintegration."[22] Such projects seek to improve the collective situation of local communities through initiatives that respect "the evolving cultural self-identity of indigenous people,"[23] but ultimately tend to focus primarily on socioeconomic well-being or development as measured through such indicators as median income, formal education, and health statistics. In contrast, culturally modified capitalism isn't about measuring the effects of capitalist businesses on Indigenous peoples' well-being as defined by international organizations, but on Indigenous peoples' ability to harness a capitalist market to their own, culturally specific, ends.

Indigenous participants in the Northwest Coast artware industry are arguably participating in an example of what Bunten calls "Indigenous capitalism," which she defines as "a strategy employed by Indigenous communities to take part in national and international level political economies while negotiating and asserting self-determination."[24] Given that the field remains dominated by non-Indigenous stakeholders, this expression hardly applies to the artware industry as a whole. Furthermore, capitalist markets need not be modified by *Indigenous* values and practices to become a form of culturally modified capitalism – similar modifications to the capitalist system can arguably occur by way of any group's cultural values and practices. As well, not all Indigenous capitalisms assume the form of culturally modified capitalism: some are simply capitalist, full stop. What is specific about the idea of culturally modified capitalism is not that the norms and procedures of such a market are being shaped by local values and practices, but that this is done *expressly* as a means to perpetuate the cultures and ways of life to which these values and practices are central.

Briefly restating the epistemological roots of the concept as a nod to the designation of "culturally modified tree" (CMT) will hopefully make this even clearer. A CMT is a tree that bears the marks of having been altered by Indigenous uses of the forest, including the harvesting of wood planks and bark. In British Columbia, CMTs are considered a form of heritage and are protected from logging by the BC Heritage Conservation Act. The designation conveys a sense that the cultural value of the tree exceeds its

value as a natural resource. Ironically, a tree is identified as a CMT and therefore protected from logging precisely because it was once used as a resource by the Indigenous people who harvested materials from it. However, the outright logging of a tree is quite a different use than harvesting methods that purposely keep a tree alive. This difference between a system in which harvesting a resource destroys it and a system in which harvesting is conducted so as to preserve the resource in question is, in a sense, akin to the difference between what capitalism is often feared to do and the hopes some place in what I call culturally modified capitalism. But the many challenges in the protection of heritage and resources do not end with such things as the designation of CMTs. The protection of one CMT does little for the preservation of the forest surrounding it, which, if logged, can compromise the preservation of the spared CMT. Similarly, discussing the Northwest Coast artware industry's transformation into culturally modified capitalism is not meant to suggest that this market is turning into an economic model without problems of resource exploitation and depletion – far from it. The values and practices that are currently being championed to improve the market's contributions to Indigenous communities are as much the expression of an awareness of the persistence of these problems as an attempt at their resolution. Just as the designation of "culturally modified tree" was created to protect certain trees, culturally modified capitalism might also be interpreted as describing a system that seeks to preserve capitalism. This holds true to the extent that, for some, only under the condition of certain modifications by local values and practices does the artware industry become the kind of capitalist enterprise that is deemed worth developing rather than curtailing. However, the CMT designation seeks not only to preserve the tree as a tangible object, but also the intangible cultural heritage it embodies. In the case of the Northwest Coast artware market, the cultural modification of capitalism emerges from a desire to harness mass production, distribution, and consumption for the purpose of perpetuating Indigenous cultural heritage and ways of life. Paradoxically, these are the very kinds of intangible wealth that are often seen as being endangered by the processes of commodification that epitomize capitalism, that system in which virtually anything can have a price. Therein lie the tensions that run through culturally modified capitalism: How can heritage be used as a resource and at the same time be perpetuated rather than depleted? How can *expending* heritage to produce tangible economic resources be a means to preserve it, while also *expanding* it as an intangible form of wealth? As we have seen, these are

the questions that have informed the artware industry's development for over a century, and to which this book only offers partial answers.

To conclude, it is useful to consider the words of Kwakwa̱ka̱'wakw anthropologist Gloria Cranmer-Webster, commenting on the changes that were brought to the institution of the potlatch by way of her people's responses to the cultural, legal-political, and economic colonialism they have endured:

> If my ancestors from two hundred years ago were able to be with us today, I often wonder what they would think of a contemporary potlatch. Would they be able to recognize what we do as being related to what they did? Would they pity us for having lost so much, or be proud that we are still here? I think that after recovering from the shock of seeing so many changes, not only in the potlatch but in all aspects of our lives, they would tell us that under the circumstances, we are not doing too badly. They would also urge us to keep on strengthening what we have, if we are to survive and continue having our good times.[25]

A similar line of reasoning can be applied to the artware industry and the relationship between cultural commodification and a sustainable, sovereign future for Indigenous communities. Capitalism is part of the world in which Pacific Northwest peoples live, and a key component of the context in which they seek to perpetuate their cultures and ways of life in all their dynamism. Still, some will argue that any participation in the artware industry, even in the form of culturally modified capitalism, is counterproductive to the fight for Indigenous sovereignty because this market ultimately remains entrenched in settler-colonial laws, political institutions, social structures, and economic systems. And yet, it is not difficult, as Cranmer-Webster does, to imagine Indigenous Northwest Coast ancestors feeling that, under the circumstances, it is a powerful show of ingenuity and resilience that their descendants are finding ways to divert capitalist means of production, distribution, and consumption towards a prosperous future for their cultures and ways of life. In a world that is still overwhelmingly hostile to such an objective, sustainable improvements on this front are unlikely to come solely from engaging in market relations, as culturally modified as they may be; but such forms of engagements with capitalism are perhaps Anna Tsing's "rubber hitting the road" – friction that helps alter existing power dynamics as Indigenous peoples strengthen their position to set wheels in motion towards more radical and durable forms of sovereignty.

Notes

Acknowledgments

1 I should also note that although I have credited the Indigenous artists whose designs are presented in the illustrations, this is not meant to imply that these artists were necessarily also among the research participants. The items in these photographs were acquired during my fieldwork, and are presented here as examples of what artware can be.

Introduction

1 Eighth Generation, "The Art of Giving Back – Your Input Needed!," 20 June 2017, https://eighthgeneration.com/blogs/blog/survey-how-you-think-the-first-inspired-natives-grant-should-be-awarded.
2 Harlan I. Smith, "Distinctive Canadian Designs: How Canadian Manufacturers May Profit by Introducing Native Designs into Their Products," *Industrial Canada* 17 (September 1917): 2.
3 Jean Comaroff and John L. Comaroff, *Ethnicity, Inc.* (Chicago: University of Chicago Press, 2009).
4 Michael F. Brown, "Heritage as Property," in *Property in Question: Value Transformation in the Global Economy*, ed. Katherine Verdery and Caroline Humphrey (Oxford: Berg, 2004), 49–68; Jennifer Kramer, "Fighting with Property: The Double-Edged Character of Ownership," in *Native Art of the Northwest Coast: A History of Changing Ideas*, ed. Charlotte Townsend-Gault, Jennifer Kramer, and Ki-ke-in (Vancouver: UBC Press, 2013), 720–56; Eugenia Kisin, "Unsettling the Contemporary: Critical Indigeneity and Resources in Art," *Settler Colonial Studies* 3, 2 (2013): 141–56.
5 Robert Shepherd, "Commodification, Culture and Tourism," *Tourist Studies* 2, 2 (2002): 183–201; Jessica R. Cattelino, "Casino Roots: The Cultural Production of Twentieth-Century Seminole Economic Development," in *Native Pathways: American Indian Culture and Economic Development in the Twentieth Century*, ed. Brian C. Hosmer and Colleen M. O'Neill (Boulder: University Press of Colorado, 2004), 66–90; Robert Layton and Gillian Wallace, "Is Culture a Commodity?," in *Ethics and Archaeology*, ed. Chris Scarre and Geoffrey Scarre (Cambridge: Cambridge University Press, 2006), 46–68; Alexis Celeste Bunten, "Sharing

Culture or Selling Out? Developing the Commodified Persona in the Heritage Industry,"
American Ethnologist 35, 3 (2008): 380–95.

6 See Darrell A. Posey and Graham Dutfield, *Beyond Intellectual Property: Toward Traditional Resource Rights for Indigenous Peoples and Local Communities* (Ottawa: International Development Research Centre, 1996); Sarah A. Laird, ed., *Biodiversity and Traditional Knowledge: Equitable Partnerships in Practice* (London: Earthscan Publications Ltd., 2002); Cori Hayden, *When Nature Goes Public: The Making and Unmaking of Bioprospecting in Mexico* (Princeton, NJ: Princeton University Press, 2003); Shane Greene, "Indigenous People Incorporated? Culture as Politics, Culture as Property in Pharmaceutical Bioprospecting," *Current Anthropology* 45, 2 (2004): 211–37; Saskia Vermeylen, "Contextualizing 'Fair' and 'Equitable': The San's Reflections on the Hoodia Benefit-Sharing Agreement," *Local Environment* 12, 4 (2007): 423–36; Rachel Wynberg, Doris Schroeder, and Roger Chennells, *Indigenous Peoples, Consent and Benefit Sharing Lessons from the San-Hoodia Case* (Dordrecht, Netherlands: Springer, 2009).

7 George P. Nicholas and Kelly P. Bannister, "Copyrighting the Past? Emerging Intellectual Property Rights Issues in Archaeology," *Current Anthropology* 45, 3 (2004): 327–50.

8 Barney G. Glaser and Anselm L. Strauss, *The Discovery of Grounded Theory: Strategies for Qualitative Research*, Observations (Chicago: Aldine, 1967).

9 Wayne Suttles, ed., *Handbook of North American Indians: Northwest Coast* (Washington, DC: Government Printing Office, 1978).

10 Townsend-Gault, Kramer, and Ki-ke-in, *Native Art of the Northwest Coast.*

11 Franz Boas, *Primitive Art* (New York: Dover, 1955); Claude Lévi-Strauss, *The Way of the Masks* (Seattle: University of Washington Press, 1988); Mique'l Dangeli, "Dancing Our Stone Mask out of Confinement: A Twenty-First-Century Tsimshian Epistemology," in *Objects of Exchange: Social and Material Transformation on the Late Nineteenth-Century Northwest Coast*, ed. Aaron Glass (New York: Bard Graduate Center, 2011), 37–47; Robin R. Gray, "Ts'msyen Revolution: The Poetics and Politics of Reclaiming" (PhD diss., University of Massachusetts – Amherst, 2015), http://scholarworks.umass.edu/dissertations_2/437; Alexis Celeste Bunten, "Commodities of Authenticity: When Native People Consume Their Own 'Tourist Art,'" in *Exploring World Art*, ed. Eric Venbrux, Pamela Sheffield Rosi, and Robert L. Welsch (Long Grove, IL: Waveland Press, 2006), 317–36.

12 Gloria Cranmer-Webster, "The Contemporary Potlatch," in *Chiefly Feasts: The Enduring Kwakiutl Potlatch*, ed. Aldona Jonaitis (Seattle: University of Washington Press, 1992), 227–48.

13 Unfortunately, four groups of British Columbia's Pacific Northwest, the Wuikinuxv, the Nuxalk, the Nisga'a, and the Gitxsan, are not represented among my interviewees, although I did have conversations with artists from the two latter groups.

14 Environics Institute, *Urban Aboriginal Peoples Study: Vancouver Report* (Toronto: Environics Institute, 2011).

15 Although there are now several-generation Indigenous urbanites living in Metro Vancouver, this does not necessarily mean lack of connections to friends and relatives living on reserves or other rural areas, in or near their ancestral territories. To give but one example, 'Namgis artist Doug Cranmer moved back and forth between Vancouver and his home town of Alert Bay for years before returning to the bay in 1976 after close to two decades spent primarily in and around Vancouver. See Jennifer Kramer, *Kesu': The Art and Life of Doug Cranmer* (Vancouver, BC: Douglas and McIntyre, 2012).

16 Judith Ostrowitz, *Privileging the Past: Reconstructing History in Northwest Coast Art* (Seattle: University of Washington Press, 1999), 3.

17 Bill Holm, *Northwest Coast Indian Art: An Analysis of Form*, Burke Museum Monograph 1 (Vancouver, BC: Douglas and McIntyre, 1965).

18 Michael Kew, *Sculpture and Engraving of the Central Coast Salish Indians*, Museum Note 9 (Vancouver: UBC Museum of Anthropology, 1980); Cathi Wherry and Andrea N. Walsh,

"Transporters: Contemporary Salish Art," in *Transporters = Łecsilen: Contemporary Salish Art* (Victoria, BC: Art Gallery of Greater Victoria, 2007), 8–56.

19 When discussing the work of particular artists, I have referred to the specific nation(s) of those artists unless I felt it might jeopardize their request to keep their identity confidential.

20 Townsend-Gault, Kramer, and Ki-ke-in, *Native Art of the Northwest Coast*; Marie Mauzé, "Aux invisibles frontières du songe et du réel – Lévi-Strauss et les surréalistes: La 'découverte' de l'art de la Côte Nord-Ouest," in *Cahier de l'Herne 82, Claude Lévi-Strauss*, ed. Michel Izard (Paris: Editions de l'Herne, 2004), 152–61.

21 Michael Dawson, *Selling British Columbia: Tourism and Consumer Culture, 1890–1970* (Vancouver: UBC Press, 2004).

22 Ronald William Hawker, *Tales of Ghosts: First Nations Art in British Columbia, 1922–61* (Vancouver: UBC Press, 2003); Leslie Allan Dawn, *National Visions, National Blindness: Canadian Art and Identities in the 1920s* (Vancouver: UBC Press, 2006).

23 Jennifer Kramer, *Switchbacks: Art, Ownership, and Nuxalk National Identity* (Vancouver: UBC Press, 2006).

24 Marie Battiste and James Youngblood Henderson, *Protecting Indigenous Knowledge and Heritage: A Global Challenge* (Saskatoon, SK: Purich, 2000); Sarah A. Laird and Rachel Wynberg, *Access and Benefit-Sharing in Practice: Trends in Partnerships across Sectors* (Montreal: Secretariat of the Convention on Biological Diversity, 2008); Catherine E. Bell and Robert K. Paterson, *Protection of First Nations Cultural Heritage: Laws, Policy, and Reform* (Vancouver: UBC Press, 2009).

25 Hayden, *When Nature Goes Public*, 4; B. Lynne Milgram, "Recommunitizing Practice, Refashioning Capital: Artisans and Entrepreneurship in a Philippine Textile Industry," in *Textile Economies: Power and Value from the Local to the Transnational*, ed. Walter E. Little and Patricia Ann McAnany, Society for Economic Anthropology Monographs 29 (Lanham, MD: AltaMira Press, 2011), 239; Cattelino, "Casino Roots," 73; Jason Antrosio and Rudolf Josef Colloredo-Mansfeld, *Fast, Easy, and in Cash: Artisan Hardship and Hope in the Global Economy* (Chicago: University of Chicago Press, 2015), 33.

26 David Arnold, "Work and Culture in Southeastern Alaska: Tlingits and the Salmon Fisheries," in *Native Pathways: American Indian Culture and Economic Development in the Twentieth Century*, ed. Brian C. Hosmer and Colleen M. O'Neill (Boulder: University Press of Colorado, 2004), 157–58.

27 I am indebted to my friend Adriane Lake for suggesting this term during one of our conversations about my work.

28 Solen Roth, "Argillite, Faux-Argillite and Black Plastic: The Political Economy of Simulating a Quintessential Haida Substance," *Journal of Material Culture* 20, 3 (2015): 299–312.

29 Ibid.

30 In that respect, some consider Haida argillite carvings to have been the earliest form of Northwest Coast "tourist art" because they were presented for sale to outsiders. However, today few would object to the idea that argillite carvings are art. See Carole N. Kaufmann, "Changes in Haida Indian Argillite Carvings, 1820 to 1910 (PhD diss., University of California Los Angeles, 1969); Leslie Drew and Douglas Wilson, *Argillite: Art of the Haida* (North Vancouver, BC: Hancock House, 1980); Peter L. Macnair and Alan L. Hoover, *The Magic Leaves: A History of Haida Argillite Carving* (Victoria: BC Ministry of Provincial Secretary and Government Services, 1984).

31 For exceptions, see Charlotte Townsend-Gault, "Circulating Aboriginality," *Journal of Material Culture* 9, 2 (2004): 183–202; Scott Watson, "Two Bears," in *Bill Reid and Beyond: Expanding on Modern Native Art*, ed. Karen Duffek and Charlotte Townsend-Gault (Vancouver, BC: Douglas and McIntyre, 2004), 209–24; Aaron Glass, "Crests on Cotton: 'Souvenir' T-Shirts

and the Materiality of Remembrance among the Kwakwaka'wakw of British Columbia," *Museum Anthropology* 31, 1 (2008): 1–18.

32 See Daniel Miller, *Capitalism: An Ethnographic Approach* (Oxford: Berg, 1997).

33 Mark Granovetter, "Economic Action and Social Structure: The Problem of Embeddedness," *American Journal of Sociology* 91, 3 (1985): 481–510.

34 See, for instance, Daromir Rudnyckyj, "Spiritual Economies: Islam and Neoliberalism in Contemporary Indonesia," *Cultural Anthropology* 24, 1 (2009): 104–41; Antrosio and Colloredo-Mansfeld, *Fast, Easy, and in Cash.*

35 Miller, *Capitalism*, 37.

36 Luc Boltanski and Eve Chiapello, *The New Spirit of Capitalism* (London: Verso, 2005).

37 Michael Blim, "Capitalisms in Late Modernity," *Annual Review of Anthropology* 29 (2000): 25–38.

38 Peter Luetchford, "Economic Anthropology and Ethics," in *A Handbook of Economic Anthropology*, ed. James G. Carrier (Cheltenham, UK: Edward Elgar, 2005), 391, 392.

39 Charles R. Menzies and Caroline F. Butler, "Returning to Selective Fishing through Indigenous Fisheries Knowledge: The Example of K'moda, Gitxaala Territory," *American Indian Quarterly* 31, 3 (2007): 442, 463nn31–32. Historian David Arnold has similarly argued that "characteristics usually associated with capitalism – innovation, individualism, ambition, and competitiveness – were also traits revered by Tlingit society, as long as they were balanced by ethics of cooperation and social responsibility." Arnold, "Work and Culture in Southeastern Alaska," 175.

40 William Roseberry, "Political Economy," *Annual Review of Anthropology* 17 (1988): 174.

41 BC Ministry of Small Business, Tourism and Culture, *Culturally Modified Trees of British Columbia*, version 2.0, 2001, https://www.for.gov.bc.ca/hfd/pubs/docs/mr/mr091.htm.

42 This expression refers to the book by Philip Drucker and Robert F. Heizer, *To Make My Name Good: A Reexamination of the Southern Kwakiutl Potlatch* (Berkeley: University of California Press, 1967).

43 Miller, *Capitalism*; Robert J. Foster, *Coca-Globalization: Following Soft Drinks from New York to New Guinea* (New York: Palgrave Macmillan, 2008); Alexis Celeste Bunten, "A Call for Attention to Indigenous Capitalisms," *New Proposals: Journal of Marxism and Interdisciplinary Inquiry* 5, 1 (2011): 60–71.

44 Mariza G.S. Peirano, "When Anthropology Is at Home: The Different Contexts of a Single Discipline," *Annual Review of Anthropology* 27 (1998): 105–28.

45 In addition to numerous informal conversations ranging from a few minutes to several hours, I conducted fifty-one formal interviews varying from approximately thirty minutes to two and a half hours in length. Some included more than one person at a time, for a total of fifty-four interviewees. They included artists, artware company owners, artware sales representatives, current and former gallery owners, retail store managers, fashion designers, artware designers, and art collectors. Twenty-one were women, and thirty-three were men. Twenty-eight were of Indigenous descent, and twenty-six were non-Indigenous.

46 James Clifford, *Routes: Travel and Translation in the Late Twentieth Century* (Cambridge, MA: Harvard University Press, 1997), 54.

47 Once, on my way out from an art sale, I bumped into an artist and company owner whom I had previously interviewed. He asked me how my research was coming along, and how many people I thought I would end up interviewing. When I answered "about fifty," he gave me a somewhat bewildered look: "Huh! So you'll probably have talked to a bunch of people that I've never even talked to, then!"

48 In reference to Bronislaw Malinowski's approach to fieldwork; see Clifford, *Routes*, 60.

49 Kath Weston, "'Real Anthropology' and Other Nostalgias," in *Ethnographica Moralia: Experiments in Interpretive Anthropology*, ed. E. Neni K. Panourgia and George E. Marcus (New York: Fordham University Press, 2008), 136.

50 These concerns greatly influenced my decision not to use names in this book, unless referring to published materials or public information.

51 Michel Foucault, *The Archaeology of Knowledge* (London: Tavistock, 1972).

52 See Shi Xu, *A Cultural Approach to Discourse* (Basingstoke, UK: Palgrave MacMillan, 2009); Jan Blommaert and Chris Bulcaen, "Critical Discourse Analysis," *Annual Review of Anthropology* 29 (2000): 447–66.

53 Blommaert and Bulcaen, "Critical Discourse Analysis," 449.

54 This is in part why the (aptly named) Truth and Reconciliation Commission's hearings that took place in the 1990s in South Africa about apartheid or, more recently, in Canada about the residential school system, have been criticized for letting some confound the act of listening to past traumatic stories with taking action for future societal change. See, for instance, Marlene Brant Castellano, Linda Archibald, and Mike DeGagné, *From Truth to Reconciliation: Transforming the Legacy of Residential Schools* (Ottawa: Aboriginal Healing Foundation, 2008); Matt James, "A Carnival of Truth? Knowledge, Ignorance and the Canadian Truth and Reconciliation Commission," *International Journal of Transitional Justice* 6, 2 (2012): 182–204.

55 Gayatri Chakravorty Spivak, "Can the Subaltern Speak?," in *Marxism and the Interpretation of Culture*, ed. Nelson Carry and Lawrence Grossberg (Urbana: University of Illinois Press, 1988), 271–313.

56 Michael Coyle and John Borrows, eds., *The Right Relationship: Reimagining the Implementation of Historical Treaties* (Toronto: University of Toronto Press, 2017); Carole Blackburn, "Searching for Guarantees in the Midst of Uncertainty: Negotiating Aboriginal Rights and Title in British Columbia," *American Anthropologist* 107, 4 (2005): 586–96; Johnny Camille Mack, "Thickening Totems and Thinning Imperialism" (master's thesis, University of Victoria, 2009), https://dspace.library.uvic.ca//handle/1828/2830.

57 Zoe Todd, "Relationships," Theorizing the Contemporary, *Cultural Anthropology* website, 21 January 2016, https://culanth.org/fieldsights/799-relationships.

Chapter 1: A Controversial Industry

1 J.R. Miller, *Skyscrapers Hide the Heavens: A History of Indian-White Relations in Canada*, 3rd ed. (Toronto: University of Toronto Press, 2000); John S. Lutz, *Makúk: A New History of Aboriginal-White Relations* (Vancouver: UBC Press, 2008); Michael Coyle and John Borrows, eds., *The Right Relationship: Reimagining the Implementation of Historical Treaties* (Toronto: University of Toronto Press, 2017).

2 See Carole Blackburn, "Searching for Guarantees in the Midst of Uncertainty: Negotiating Aboriginal Rights and Title in British Columbia," *American Anthropologist* 107, 4 (2005): 586–96; Arthur Manuel and Nicole Schabus, "Indigenous Peoples at the Margin of the Global Economy: A Violation of International Human Rights and International Trade Law," *Chapman Law Review* 8 (2005): 229–52.

3 Franz Boas, as quoted in Lutz, *Makúk*, 192; see also Eva Mackey, *The House of Difference: Cultural Politics and National Identity in Canada*, Anthropological Horizons 23 (Toronto: University of Toronto Press, 2002), 25.

4 David Arnold, "Work and Culture in Southeastern Alaska: Tlingits and the Salmon Fisheries," in *Native Pathways: American Indian Culture and Economic Development in the Twentieth Century*, ed. Brian C. Hosmer and Colleen M. O'Neill (Boulder: University Press of Colorado, 2004), 157–58; Charles R. Menzies and Caroline F. Butler, "The Indigenous Foundation of the Resource Economy of BC's North Coast," *Labour/Le Travail* 61 (2008): 131–49.

5 Following the Supreme Court of Canada decision in *Haida Nation v. British Columbia (Minister of Forests)* in 2004, the Crown has an obligation to consult with First Nations, Inuit, and Métis communities and accommodate their interests in the context of projects

that could affect Aboriginal rights and title. Whether such consultation should be undertaken solely by the Crown or could be conducted by corporations, as well as what constitutes meaningful consultation, continues to be hotly debated in and out of court.

6 Jennifer Kramer, *Switchbacks: Art, Ownership, and Nuxalk National Identity* (Vancouver: UBC Press, 2006), 23.

7 Darrell A. Posey, "Intellectual Property Rights and Just Compensation for Indigenous Knowledge," *Anthropology Today* 6, 4 (1990): 13–16; Michael F. Brown, "Heritage as Property," in *Property in Question: Value Transformation in the Global Economy*, ed. Katherine Verdery and Caroline Humphrey (Oxford: Berg, 2004), 49–68; George P. Nicholas and Kelly P. Bannister, "Copyrighting the Past? Emerging Intellectual Property Rights Issues in Archaeology," *Current Anthropology* 45, 3 (2004): 327–50.

8 At least initially, Indigenous artists usually decide to participate as a way to earn income, make themselves known, and be able to give affordable goods adorned with their work; when they abstain, it is often due to concerns they might be unfairly exploited, or that it could harm their standing in the art world. Indigenous business owners are usually more explicit in their intent to create competition for non-Indigenous owners and set new standards for Indigenous control and involvement in the industry.

9 On the concept of social location, see, for example, Karen Dugger, "Social Location and Gender-Role Attitudes: A Comparison of Black and White Women," *Gender and Society* 2, 4 (1988): 425–48.

10 Rachel Simon-Kumar and Catherine Kingfisher, "Beyond Transformation and Regulation: Productive Tensions and the Analytics of Inclusion," *Politics and Policy* 39, 2 (2011): 271–94.

11 A "culturalist" interpretation is one in which cultural background is taken to be the primary cause of divergences in practices and views, above all else. See Patrick Chabal and Jean-Pascal Daloz, *Culture Troubles: Politics and the Interpretation of Meaning* (Chicago: University of Chicago Press, 2006), 171.

12 Jean Comaroff and John L. Comaroff, *Ethnicity, Inc.* (Chicago: University of Chicago Press, 2009), 51. This inseparability is one reason a number of industry participants and stakeholders hold the view that the industry's focus on Northwest Coast culture should automatically warrant various forms of direct and indirect benefits for Northwest Coast communities, as discussed in Chapter 5. This argument draws not only on the idea that Northwest Coast peoples "have a stake" in the artware industry, but also on the fact that they hold rights to their cultural heritage. From this perspective, it could be argued that the term "rightsholders" might be more appropriate than "stakeholders." However, on the Northwest Coast, property rights to the representation of figures, crests, stories, and other forms of cultural expression are not necessarily, or even usually, held collectively at the scale of nations or communities, let alone the entire network of Northwest Coast peoples. Instead, such rights are usually held within particular clans, lineages, and families, and in some cases by individuals who embody particular names, until the name and its associated rights are passed on to the next generation. Individual artists can represent in their own original way those crests or stories to which they have rights in relation to their status and lineage, but would not normally be able to transfer rights to those depictions without following their communities' protocols. In contrast, under Canadian law, artists automatically hold the copyright to their work as individuals, and can usually transfer copyright to other people or entities as they please. In the artware industry, some images become the property of a specific artware company when their copyright is sold by the artist, making that company the official "rightsholder" to the image, at least from the point of view of Canadian law, if not from the point of view of Indigenous law (unless proper protocols have been followed). Therefore, at the scale of the artware industry as a whole, the term "stakeholder" more

appropriately points to all those who have a stake in industry participants' activities, beyond the property rights of individuals or subgroups as delineated by Indigenous or non-Indigenous laws.

13 Donald defines "ethical relationality" as "an ecological understanding of human relationality that does not deny difference, but rather seeks to more deeply understand how our different histories and experiences position us in relation to each other." Dwayne Donald, "Forts, Curriculum, and Indigenous Metissage: Imagining Decolonization of Aboriginal-Canadian Relations in Educational Contexts," *First Nations Perspectives* 2, 1 (2009): 6.

14 Mackey, *House of Difference*, 75.

15 Commenting on the denial of support for the Indigenous art market by the Indian Affairs Branch in the 1960s, Ojibway intellectual and activist Art Solomon expressed similar sentiments: "I have met some good people in Indian Affairs but they were in positions where they could do very little of real value, they always gave me their good wishes. I fed my dog on good wishes once when I was a boy; and he died." Arthur Solomon, "Craft Development, Human Development, Community Development," p. 1, 29 May 1969, MG 28-I 222, Canadian Craftsmen Association fonds, 1964–77, vol. 16, Library and Archives Canada.

16 A similar observation applies to the trust invested, or not, in non-Indigenous researchers by the people they work with. Even when initiated on the basis of overlaps in the objectives of the parties involved, divergent interests also significantly shape these relationships, and this combination of convergences and divergences is one source of friction in the worlds of both research and artware.

17 Howard S. Becker, *Art Worlds* (Berkeley: University of California Press, 1982), 1.

18 Ibid., 35, emphasis mine.

19 For instance, there is a line of clothing based exclusively on designs by Haida artist Freda Diesing, and Kwakwaka'wakw artist Tony Hunt also has a line of apparel to his name. Haida artist Robert Davidson was mentioned by several people as someone who is able to hold his own in negotiations with artware companies, thanks to his long experience and international stature.

20 Anna Tsing, *Friction: An Ethnography of Global Connection* (Princeton, NJ: Princeton University Press), 6.

21 Ibid., 5, 6. I have modified Tsing's metaphor slightly. She writes that "a wheel *turns* because of its encounter with the surface of the road," but this metaphor is inaccurate: it is not that the wheel turns *because* of its contact with a surface, it is that a turning wheel goes nowhere until it engages with a surface.

Chapter 2: Expansion | Protection

1 Ronald William Hawker, *Tales of Ghosts: First Nations Art in British Columbia, 1922–61* (Vancouver: UBC Press, 2003); Leslie Allan Dawn, *National Visions, National Blindness: Canadian Art and Identities in the 1920s* (Vancouver: UBC Press, 2006).

2 Michael Dawson, *Selling British Columbia: Tourism and Consumer Culture, 1890–1970* (Vancouver: UBC Press, 2004).

3 In the United States, the Indian Arts and Crafts Act, first signed into law in 1935, makes it illegal to sell or display items as Native American when they are not actually the products of members or organizations of a federally recognized tribe. While the act has been criticized for colonial policing of Indigenous identity as well as poor implementation, its truth-in-advertising approach is meant to protect Indigenous-made items from unfair competition from imitations and Indigenous-style works. See Robert Fay Schrader, *The Indian Arts and Crafts Board: An Aspect of New Deal Indian Policy* (Albuquerque, NM: Olympic Marketing, 1983); Jennifer McLerran, *A New Deal for Native Art: Indian Arts and Federal Policy, 1933–1943* (Tucson: University of Arizona Press, 2009).

4 Marie Battiste and James Youngblood Henderson, *Protecting Indigenous Knowledge and Heritage: A Global Challenge* (Saskatoon, SK: Purich, 2000); Catherine E. Bell and Val Napoleon, eds., *First Nations Cultural Heritage and Law: Case Studies, Voices, and Perspectives* (Vancouver: UBC Press, 2008); Catherine E. Bell and Robert K. Paterson, *Protection of First Nations Cultural Heritage: Laws, Policy, and Reform* (Vancouver: UBC Press, 2009).

5 With the exception of a few quotes drawn from interviews I conducted during my fieldwork, the sources from which I draw in this chapter consist primarily of correspondence and reports I found in fonds related to government policies and organizations directly involved in the development of the Native Northwest Coast artware industry, including with respect to Indigenous education and training, support for artists, and Indigenous art labelling programs. (For a complete list of the fonds I was able to consult, see the archival sources listed in the bibliography.)

6 This greater Indigenous presence in the records is at least partly because, over time, Indigenous individuals played increasingly important roles in the management of government-supported programs, non-governmental organizations made efforts to develop their Indigenous membership, and Indigenous organizations gained prominence in the field. Their voices' increased presence does not necessarily reflect a surge in their mobilization in these matters; rather, their opinions and initiatives became part of archival records once they became involved in the kinds of organizations that deposit their files in provincial, federal, and other archives. In this respect, the account I provide and the leitmotifs I have identified largely pertain to the socio-political bureaucracy of the Indigenous art and artware market's development, and do not reflect other on-the-ground initiatives in which Indigenous stakeholders may have taken part.

7 Douglas Cole, *Captured Heritage: The Scramble for Northwest Coast Artifacts* (Vancouver, BC: Douglas and McIntyre, 1985), 294.

8 Harlan I. Smith, "Distinctive Canadian Designs: How Canadian Manufacturers May Profit by Introducing Native Designs into Their Products," *Industrial Canada* 17 (September 1917): 730.

9 Edward Sapir, "Prefatory Note," in *An Album of Prehistoric Canadian Art*, by Harlan I. Smith, Victoria Memorial Museum Bulletin 37 (Ottawa: Department of Mines, 1923), iii.

10 Harlan I. Smith, *An Album of Prehistoric Canadian Art*, Victoria Memorial Museum Bulletin 37 (Ottawa: Department of Mines, 1923), 1, 6.

11 Ibid., 1, 3.

12 In this task of seeking Indigenous designs suitable for reproduction, Ravenhill asked for assistance from ethnologist W.A. Newcombe, son of anthropologist and museum object collector C.F. Newcombe. See Alice Ravenhill, "Highlights in over Twenty Years' Service for the Uplift of the Native Tribes of British Columbia (copy of Material Collected July 1948 by C.B.C. and Sent to Toronto)," 2, 1948, Alice Ravenhill fonds [microform], UBC Library Rare Books and Special Collections.

13 National Gallery of Canada, *Exhibition of Canadian West Coast Art, Native and Modern* (Ottawa: National Gallery, 1927); Dawn, *National Visions, National Blindness*, 248.

14 National Gallery of Canada, *Exhibition of Canadian West Coast Art*, 2.

15 Ibid.

16 Dawn, *National Visions, National Blindness*, 257.

17 Ibid., 264–65.

18 Emily Carr, letter to Alice Ravenhill, 14 March 1942, microfilm A01661, MS-2720, BC Indian Arts and Welfare Society fonds, 1940–54 (Correspondence), BC Archives (hereafter cited as BCIAWS fonds). It was in this spirit that, in 1942, Carr declined Alice Ravenhill's offer to make her the honorary president of the Society for the Furtherance of Indian Arts and Crafts, much to Ravenhill's disappointment as she felt Carr's decision was based on a

"complete misunderstanding of [the society's] aims." Alice Ravenhill, letter to Mrs. Thornton, 26 March 1942, microfilm A01661, BCIAWS fonds.

19 Paige Raibmon, "'A New Understanding of Things Indian': George Raley's Negotiation of the Residential School Experience," *BC Studies* 110 (1996): 69–96; Hawker, *Tales of Ghosts*, 66–81.

20 George H. Raley, *Canadian Indian Art and Industries: An Economic Problem of To-Day* (London: G. Bell, 1935), 991, 993, 995.

21 Ibid.

22 George H. Raley, "Canadian Indian Art and Industries. An Economic Problem of Today (Draft)," n.d., H/D/R13: Raley, George Henry (1863–1958), vol. R13.3: Industries and handicrafts, articles, reports, etc., BC Archives.

23 George H. Raley, "Additional Facts RE Canadian Indian Art and Handicrafts," May 1935, ibid.

24 Hawker, *Tales of Ghosts*, 75.

25 Ibid., 76.

26 George H. Raley, letter to Mr A. O'N. Daunt, Indian Agent, New Westminster, BC, 3 May 1934, H/D/R13: Raley, George Henry (1863–1958), vol. R13.3: Industries and handicrafts, articles, reports, etc., BC Archives.

27 Raley, "Canadian Indian Art and Industries (Draft)."

28 Raley, "Additional Facts RE Canadian Indian Art and Handicrafts."

29 The society was renamed the BC Indian Arts and Welfare Society in 1946.

30 It is unclear what types of item Ravenhill deemed "inaccurate," possibly those suggesting outside influence in terms of iconography or technique, or imitations by non-Indigenous makers. In any case, this term foreshadows the society's later concern for authenticating the items it sold by way of an official tag.

31 SFIAC, "The Society for the Furtherance of Indian Arts and Crafts," n.d., Alice Ravenhill fonds [microform], UBC Library Rare Books and Special Collections.

32 On the Arts and Crafts movement, see Eileen Boris, *Art and Labor: Ruskin, Morris, and the Craftsman Ideal in America* (Philadelphia: Temple University Press, 1986); on the Canadian Handicrafts Guild, see Ellen Easton McLeod, *In Good Hands: The Women of the Canadian Handicrafts Guild* (Montreal and Kingston: McGill-Queens University Press, 1999).

33 Alice Ravenhill, letter to Anthony Walsh, 5 December 1940, Alice Ravenhill fonds [microform], UBC Library Rare Books and Special Collections.

34 Ravenhill, "Highlights in over Twenty Years' Service," 4.

35 Ibid., 5.

36 Alice Ravenhill, *A Corner Stone of Canadian Culture: An Outline of the Arts and Crafts of the Indian Tribes of British Columbia*, Occasional Papers of the British Columbia Provincial Museum 5 (Victoria: British Columbia Provincial Museum, 1944).

37 Alice Ravenhill, letter to Anthony Walsh, 3 August 1940, Alice Ravenhill fonds [microform], UBC Library Rare Books and Special Collections.

38 Truth and Reconciliation Commission of Canada, *Final Report of the Truth and Reconciliation Commission of Canada*, vol. 1: *Summary: Honouring the Truth, Reconciling for the Future* (Toronto: Lorimer, 2015).

39 Alice Ravenhill, letter to Reverend Alex R. Simpson, 29 October 1942, microfilm A01661, BCIAWS fonds.

40 BC Indian Arts and Welfare Society, "Sample Letter for the Principals of Indian Day and Residential Schools," October 1942, microfilm A01661, BCIAWS fonds.

41 Society for Indian Arts and Crafts, "Suggestions on the Encouragement of Arts and Crafts in the Indian Schools of British Columbia," 1, 2, 1942, microfilm A01661, BCIAWS fonds.

42 D.M. MacKay, letter to Alice Ravenhill, 24 September 1942, microfilm A01661, BCIAWS fonds.

43 R.A. Hoey, letter to Alice Ravenhill, 21 October 1941, MS-1116, Society for the Furtherance of Indian Arts and Crafts fonds, vol. 1, file 5, BC Archives.

44 Anthony Walsh, letter to Alice Ravenhill, 9 April 1948, Alice Ravenhill fonds [microform], UBC Library Rare Books and Special Collections. On Walsh, see Thomas Fleming, Lisa Smith, and Helen Raptis, "An Accidental Teacher: Anthony Walsh and the Aboriginal Day Schools at Six Mile Creek and Inkameep, British Columbia, 1929–1942," *Historical Studies in Education/Revue d'histoire de l'éducation* 19, 1 (2007): 1–24.

45 Scott Watson, "Two Bears," in *Bill Reid and Beyond: Expanding on Modern Native Art*, ed. Karen Duffek and Charlotte Townsend-Gault (Vancouver, BC: Douglas and McIntyre, 2004), 211.

46 BC Indian Arts and Welfare Society, "Addressed to the Royal Commission of Senators and Members of the House of Commons Appointed to Inquire Into All Phases of the Affairs of Canadian Indians in May and October, 1946," 7, 1946, Alice Ravenhill fonds [microform], UBC Library Rare Books and Special Collections.

47 "New Styles in the Cotton Industry: Evidence of Lancashire's War-Time Enterprise," *Times Weekly*, 6 August 1941, clipping, MS-1116, Society for the Furtherance of Indian Arts and Crafts fonds, vol. 2, file 5, BC Archives.

48 Alice Ravenhill, letter to Cleveland Bell, Colour, Design and Style Centre, Cotton Board, 15 April 1942, microfilm A01661, BCIAWS fonds.

49 Alice Ravenhill, letter to Mrs. Thornton, 11 November 1941, microfilm A01661, BCIAWS fonds.

50 Clifford F. Wilson, letter to Alice Ravenhill, BCIAWS, 30 December 1941, microfilm A01661, BCIAWS fonds.

51 These designs were described as the "Kwakiutl Beaver and Raven" and the "Haida Whale and Mythic Raven." Jennifer M.L. Hobbs, letter to A.E. Pickford, SFIAC, 19 October 1944, microfilm A01661, BCIAWS fonds.

52 Arthur E. Pickford, letter to Alice Ravenhill, 20 October 1944, microfilm A01661, BCIAWS fonds.

53 Alice Ravenhill, letter to A.E. Pickford, 21 October 1944, MS-1116, Society for the Furtherance of Indian Arts and Crafts fonds, vol. 1, file 11, BC Archives.

54 BC Indian Arts and Welfare Society, "Brief Prepared for the Royal Commission on National Development in the Arts, Letters and Sciences," n.d. 1951, 5, RG 33-28, Royal Commission on National Development in the Arts, Letters and Sciences, reel C-2000 (vol. 5, brief 54), Library and Archives Canada.

55 In a 1947 newspaper article about the society's efforts to send designs to various textile companies, an "eastern Canadian designer" was quoted saying, "British Columbians were passing up $1,000,000 industry by ignoring the Indian's ability for designing." (This reference comes from a newspaper clipping that unfortunately does not indicate the name of the author nor the full name of the newspaper.) "Indian Designs Interest Large New York Firm," clipping, *Times*, 17 October 1947, MS-1116, Society for the Furtherance of Indian Arts and Crafts fonds, vol. 2, file 4, BC Archives.

56 Grace Melvin, letter to Alice Ravenhill, 20 January 1942, microfilm A01661, BCIAWS fonds.

57 Arthur E. Pickford, letter to Mr Chas. H. Scott, Vancouver School of Art, June 15, 1946, microfilm A01661, BCIAWS fonds.

58 Alice Ravenhill, letter to Truman Bailey, Everfast Fabric Co. Inc., 4 August 1942, microfilm A01661, BCIAWS fonds.

59 Don Adams, letter to Provincial Libraries (Victoria, BC), 23 September 1947, microfilm A01662, BCIAWS fonds.

60 BC Indian Arts and Welfare Society, "Addressed to the Royal Commission," 8.

61 Cori Hayden, *When Nature Goes Public: The Making and Unmaking of Bioprospecting in Mexico* (Princeton, NJ: Princeton University Press, 2003), 35.

62 Willard E. Ireland, letter to H.D. Baker, Manager, Vancouver Tourist Association, microfilm A01662, BCIAWS fonds.

63 Ruth M. Smith, letter to Ellen Hart, Honorary Secretary, BCIAWS, 9 December 1947, microfilm A01662, BCIAWS fonds. This letter quotes Ravenhill's description of the seal: "one of the North West Coast Chief's highly valued 'coppers' accurately copied in form with a native 'eye' in place occupied by each Chief; crest to suggest the Society's look into the future when we see the reestablishment of our fellow Canadians in their rightful position."

64 Ellen Hart, letter to Mrs. Ian Cameron, President, Junior League of Vancouver, 22 January 1948, microfilm A01662, BCIAWS fonds.

65 BC Indian Arts and Welfare Society, *Report of Conference on Native Indian Affairs at Acadia Camp: University of British Columbia, Vancouver, B.C., April 1, 2 and 3, 1948, Sponsored by the B.C. Indian Arts and Welfare Society, Provincial Museum, Victoria, B.C.* (Victoria: BC Indian Arts and Welfare Society, 1948), 15.

66 Arthur E. Pickford, letter to Mrs Nellie Jacobson, 14 May 1946, microfilm A01661, BCIAWS fonds.

67 Ellen Hart, letter to the Chairman of the Vancouver Parks Commission, 30 June 1948, microfilm A01662, BCIAWS fonds.

68 Ibid.

69 For example, Alice Ravenhill, letter to Professor Topping, 3 December 1941, microfilm A01661, BCIAWS fonds.

70 BC Indian Arts and Welfare Society, *Report of Conference on Native Indian Affairs at Acadia Camp*, 1.

71 Ibid., 13, 14.

72 One conference participant did point out this difference of approach between Neel and Godman, stating that the society's "definition of authentic art would stop at a particular time, whereas according to Mrs. Neel's statement it must be living in order to be art. Can it not move up the present time and have other forms included in it?" Ibid., 18.

73 Ibid., 17.

74 Edwin S. Hall, Margaret B. Blackman, and Vincent Rickard, *Northwest Coast Indian Graphics* (University of Washington Press, 1981), 50.

75 Fraser Canyon Indian Arts and Crafts Society, "Fraser Canyon Indian Arts and Crafts Society Hearing Transcript," n.d. 1951, 48, RG 33-28, Royal Commission on National Development in the Arts, Letters and Sciences, reel C-2008 (vol. 19, brief 210), Library and Archives Canada. In 1943, George Clutesi had been asked to become an honorary member of the Society for the Furtherance of BC Indian Arts and Crafts, an offer which he accepted.

76 Douglas White, "'Where Mere Words Failed': Northwest Coast Art and the Law," in *Native Art of the Northwest Coast: A History of Changing Ideas*, ed. Charlotte Townsend-Gault, Jennifer Kramer, and Ki-ke-in (Vancouver: UBC Press, 2013), 633–76.

77 Fraser Canyon Indian Arts and Crafts Society, "Fraser Canyon Indian Arts and Crafts Society Hearing Transcript," 50–51.

78 This report was later published as a book: Harry B. Hawthorn, Cyril S. Belshaw, and Stuart Jamieson, *The Indians of British Columbia: A Study of Contemporary Social Adjustment* (Toronto: University of Toronto Press, 1958), 84.

79 Ibid., 257.

80 Ibid., 267.

81 Department of Citizenship and Immigration, Indian Affairs Branch, "A Review of Activities 1948–1958," 1959, MS-2837, Adam Beattie papers, 1945–73, vol. 1, file 11, BC Archives.

82 BC Indian Arts and Welfare Society, *Report of the Second Decennial Conference on Native Indian Affairs at the Library, University of British Columbia, Vancouver, B.C., April 1st and 2nd, 1958: A Conference of Indian Business Men* (Victoria: BC Indian Arts and Welfare Society, 1958), 13, 14.

83 BC Indian Arts and Welfare Society, "B.C. Indian Arts and Welfare Society. Summary of Activities in 1958," 5, 1958, MS 2837: Adam Beattie Papers, vol. 1, file 8, BC Archives.

84 NIACC, "Operational Plan and Budget 1985/86 National Indian Arts and Crafts Corporation," 1985, MG 30-D 387, Modest Cmoc fonds [NIACC], vol. 11, file 6, Library and Archives Canada (hereafter cited as Modest Cmoc fonds).

85 Canadian Consociates Limited, "'Canadian Indian Crafts Limited': A Proposed Program for Developing Indian Arts and Crafts in Canada," submitted to the Agricultural Rehabilitation and Development Act, Department of Forestry, Ottawa, Ontario (Toronto, Ontario, June 1966), 9, Modest Cmoc fonds, vol. 6, file 4.

86 Ibid., 22, 66, 68.

87 Arthur Solomon, "Craft Development, Human Development, Community Development," 5, 7, 29 May 1969, MG 28-I 222, Canadian Craftsmen Association fonds, 1964–77, vol. 16, Library and Archives Canada.

88 Ibid., 5

89 Ibid., 7.

90 Renate Wilson and Thelma Dickman, "They're Giving the Culture back to the Indians: International Art Collectors Are Making B.C. Indians as 'In' as Eskimos," *Imperial Oil Review*, April 1964, 18.

91 A.A. Fatouros, *Legal Protection of Eskimo and Indian Arts and Crafts: A Preliminary Report* (Ottawa: Department of Northern Affairs and National Resources, 1966).

92 Indian Arts and Crafts Development Board (BC), "British Columbia Region Indian Craftsmen's Assistance Program, 1975–1981," August 1975, 8–9, Modest Cmoc fonds, vol. 6, file 8.

93 Department of Supply and Services, Bureau of Management Consulting, "Evaluating the Indian Arts and Crafts Program: 1975–1977 and the Future," 12, April 1978, MG 28-I 274, Canadian Crafts Council, vol. 57, file 6: Legislation and Programs, National Indian Northern Affairs Policy, 1978–80, Library and Archives Canada.

94 Indian Arts and Crafts Development Board (BC), "British Columbia Region Indian Craftsmen's Assistance Program, 1975–1981," 8–9.

95 Department of Supply and Services, Bureau of Management Consulting, "Canadian Indian Marketing Services," 19, 1975, Modest Cmoc fonds, vol. 6, file 9. One report put the average wholesaler margin at 33 percent, and retail margins at an average additional 100 percent. Woods, Gordon & Co., "NIACC National Marketing Service. Phase I Market Survey," 38, September 1978, Modest Cmoc fonds, vol. 8, file 15.

96 Bureau of Management Consulting, "Evaluating the Indian Arts and Crafts Program: 1975–1977 and the Future," 40.

97 Bureau of Management Consulting, "Canadian Indian Marketing Services," 19.

98 Ibid.

99 "Indian Arts and Crafts Development Program," 45, 1976, Modest Cmoc fonds, vol. 6, file 18.

100 Karen Duffek, "'Authenticity' and the Contemporary Northwest Coast Indian Art Market," *BC Studies* 57 (1983): 100.

101 "Indian Arts and Crafts Development Program," 46.

102 Department of Supply and Services, Bureau of Management Consulting, "Indian Arts and Crafts NIACC Wholesaler's Market Research Survey," 60, July 1977, Modest Cmoc fonds, vol. 7, file 6.

103 Woods, Gordon & Co., "NIACC National Marketing Service. Phase I Market Survey," 30, 33. The same report included complaints from retailers that the use of the Beaver Tag on poor-quality goods damaged perceptions of the tag as a guarantor of authenticity, seemingly conflating the issue of quality with that of the maker's identity. The authors suggested that this explained why alternative tags were proliferating despite the advantages of a nationally recognized tag. For instance, some of the National Indian Arts and Crafts Corporation's regional corporations created their own tags. The Indian Arts and Crafts Society of British Columbia, for instance, developed its own certification, available in the form of tags and as a jewellery stamp.

104 Ibid., 19, 58.

105 Bureau of Management Consulting, "Approaches to Marketing Strategies for Indian Arts and Crafts," xii, 6. Interestingly, souvenirs and "machine-made crafts" were not originally within the scope of the commissioned report, but the authors included them on the grounds that this segment of the market "is substantial and not to be overlooked while developing options for the future." Ibid., 38.

106 Ibid., 128, 125.

107 Woods, Gordon & Co., "NIACC National Marketing Service. Phase I Market Survey," 61.

108 Department of Supply and Services Bureau of Management Consulting, "Draft – Arts and Crafts Evaluation, 1975–1976," 4, 1976, Modest Cmoc fonds, vol. 6, file 10.

109 This view was still being reiterated years later in a 1984 letter to the president of NIACC from Adélard Cayer (of Adélard Enterprises Limited, the consulting firm that had reviewed NIACC for the year 1981–82). Adélard Cayer, letter to Marilyn John (NIACC), "NIACC Corporate Structure and Planning Framework," 19 November 1984, Modest Cmoc fonds, vol. 10, file 1.

110 "Indian Arts and Crafts Development Program," 7.

111 House of Commons, "Minutes of Proceedings and Evidence of the Standing Committee on Indian Affairs and Northern Development, Respecting: Main Estimates 1983–84: Vote 1 – Administration Program under Indian Affairs and Northern Development," 9, 25 May 1983, Modest Cmoc fonds, vol. 9, file 15.

112 Jennifer Kramer, *Kesu': The Art and Life of Doug Cranmer* (Vancouver, BC: Douglas and McIntyre, 2012), 43.

113 Derek Simpkins Gallery of Tribal Art, *Chief Henry Speck: An Exhibition of Paintings, c. 1958–1964* (Vancouver, BC: Gallery of Tribal Art, 1995).

114 Karen Duffek and Marcia Crosby, *Projections: The Paintings of Henry Speck, Udzi'stalis*, Exhibition catalogue (Vancouver: UBC Museum of Anthropology and Satellite Gallery, 2012).

115 Canadian Indian Marketing Services, *Northwest Coast Indian Artists Guild: 1977 Graphics Collection* (Ottawa: Canadian Indian Marketing Services, 1977); Canadian Indian Marketing Services, *Northwest Coast Indian Artists Guild: 1978 Graphics Collection* (Ottawa: Canadian Indian Marketing Services, 1978).

116 BC Indian Arts Society, "Executive Meeting March 1 1982," March 1982, MS 2720 – Parker, G. Macrina, file 3, BC Archives. The Constitution Act, 1982 is the act through which the Constitution was patriated to Canada from the United Kingdom. The process included the inscription of amendments to the Constitution, including Section 35, which affirms Aboriginal and treaty rights in Canada.

117 Scott Watson, "Art/Craft in the Early Twentieth Century," in Townsend-Gault, Kramer, and Ki-ke-in, *Native Art of the Northwest Coast*, 351.

118 James R. Miller, *Skyscrapers Hide the Heavens: A History of Indian-White Relations in Canada*, 3rd ed. (Toronto: University of Toronto Press, 2000), 211–35; John S. Lutz, *Makúk: A New History of Aboriginal-White Relations* (Vancouver: UBC Press, 2008), 289–91.

119 See Rosemary J. Coombe, *The Cultural Life of Intellectual Properties: Authorship, Appropriation and the Law* (Durham, NC: Duke University Press, 1998); Michael F. Brown, *Who Owns Native Culture?* (Cambridge, MA: Harvard University Press, 2003).

120 NIACC, "Operational Plan and Budget 1985/86 National Indian Arts and Crafts Corporation," 3.

121 See also Adélard Enterprises Ltd., *Annual Report for National Office of the National Indian Arts and Crafts Corporation for the Year 1981–1982* (NIACC, 1982), Modest Cmoc fonds, vol. 9, file 11.

122 House of Commons, "Minutes of Proceedings and Evidence of the Standing Committee on Indian Affairs and Northern Development. Respecting: Main Estimates 1983–84: Vote 1 – Administration Program under Indian Affairs and Northern Development," 7–8.

123 Charles R. Menzies and Caroline F. Butler, "The Indigenous Foundation of the Resource Economy of BC's North Coast," *Labour/Le Travail* 61 (2008): 131–49.

124 NIACC, "Together Towards the Future: A Corporate Overview," 6, December 1984, Modest Cmoc fonds, vol. 10, file 14.

125 NIACC, "Operational Plan and Budget 1985/86 National Indian Arts and Crafts Corporation."

126 NIACC, "Proposal to Develop a Blueprint for Legal Action for the Protection of Authentic Canadian Indian Arts and Crafts Against Imitations," 2, 3, November 1984, Modest Cmoc fonds, vol. 9, file 7 .

127 David Crombie, letter to Modest Cmoc, Director of Operations (NIACC), 7 October 1985, Modest Cmoc fonds, vol. 10, file 2.

128 British Columbia Ministry of Small Business, Tourism and Culture, *Aboriginal Artists' Project: Artist Needs and Market Assessment* (Victoria: The Ministry of Small Business, Tourism and Culture, 1995), 13, 14. The Aboriginal Artists' Project was "a cooperative effort between B.C. aboriginal artists, aboriginal organizations, representatives of the industry, B.C. Trade Development Corporation, and the Ministry of Small Business, Tourism and Culture," that sought to "encourage ongoing dialogue amongst industry participants," including "aboriginal organizations, trade organizations, retailers, wholesalers, suppliers, and most importantly, aboriginal artists." Ibid., 5.

129 Canada, *Report of the Royal Commission on Aboriginal Peoples* (Ottawa: Minister of Supply and Services, 1996), 869.

130 Alan Cairns, *Citizens Plus: Aboriginal Peoples and the Canadian State* (Vancouver: UBC Press, 2000); Miller, *Skyscrapers Hide the Heavens,* 384–89; Lutz, *Makúk,* 298.

131 Aboriginal Tourism Association of British Columbia, "Authentic Aboriginal Artisan Certification Program – Aboriginal Tourism BC," accessed 18 July 2012, http://www.authenticaboriginal. com/y/#home. At first named "Authentic Aboriginal," the program was renamed "Authentic Indigenous" (prompting a URL change to http://www.authenticindigenous.com). Its motto was also later changed to "Speaking Truth, Protecting Cultures, Providing for People."

132 Ibid.

Chapter 3: Globalization | Localization

1 For a discussion of how certain materials sometimes become the "quintessential substances" of specific communities, see Elizabeth Ferry, "Inalienable Commodities: The Production and Circulation of Silver and Patrimony in a Mexican Mining Cooperative," *Cultural Anthropology* 17, 3 (2002): 331–58; Solen Roth, "Argillite, Faux-Argillite and Black Plastic: The Political Economy of Simulating a Quintessential Haida Substance," *Journal of Material Culture* 20, 3 (2015): 299–312.

2 Robert J. Foster, *Coca-Globalization: Following Soft Drinks from New York to New Guinea* (New York: Palgrave Macmillan, 2008), 5.

3 Robert J. Foster, "Tracking Globalization: Commodities and Value in Motion," in *Handbook of Material Culture*, ed. Chris Tilley, Webb Keane, Susan Kuechler, Mike Rowlands, and Patricia Spyer (Thousand Oaks, CA: Sage, 2006), 285.

4 Ibid., 289. Arjun Appadurai uses the suffix "scape" to describe "the fluid, irregular shapes" of the various "landscapes" (ethnoscapes, mediascapes, technoscapes, finanscapes, and ideoscapes) that make up our "imagined worlds." He contends that these "scapes" are not "objectively given relations which look the same from every angle of vision, but rather that they are deeply perspectival constructs, inflected very much by the historical, linguistic and political situatedness of different sorts of actors." Arjun Appadurai, *Modernity at Large: Cultural Dimensions of Globalization* (Minneapolis: University of Minnesota Press, 1996), 33.

5 Appadurai, *Modernity at Large*, 52, 178–99.

6 On deterritorialization and reterritorialization, see Gilles Deleuze and Félix Guattari, *A Thousand Plateaus: Capitalism and Schizophrenia* (Minneapolis: University of Minnesota Press, 1987).

7 Appadurai, *Modernity at Large*, 42.

8 Jennifer S. Esperanza, "Outsourcing Otherness: Crafting and Marketing Culture in the Global Handicrafts Market," in *Hidden Hands in the Market: Ethnographies of Fair Trade, Ethical Consumption, and Corporate Social Responsibility*, ed. Geert De Neve, Peter Luetchford, Jeffrey Pratt, and Donald C. Wood, Research in Economic Anthropology 28 (Bingley, UK: JAI Press, 2008), 71–95; Joan Weibel-Orlando, "Made in Italy: Metaphors for Merchandising Textiles in a Global Economy," in *Textile Economies: Power and Value from the Local to the Transnational*, ed. Walter E. Little and Patricia Ann McAnany, Society for Economic Anthropology Monographs 29 (Lanham, MD: AltaMira Press, 2011), 263–84.

9 Department of Supply and Services, Bureau of Management Consulting, "Evaluating the Indian Arts and Crafts Program: 1975–1977 and the Future," 48, April 1978, MG28 I274, Canadian Crafts Council, vol. 57, file 6: Legislation and Programs, National Indian Northern Affairs Policy, 1978–1980, Library and Archives Canada.

10 Woods, Gordon & Co., "NIACC National Marketing Service. Phase I Market Survey," 36, September 1978, MG 30-D 387, Modest Cmoc fonds [NIACC], vol. 8, file 15, Library and Archives Canada.

11 Bureau of Management Consulting, "Evaluating the Indian Arts and Crafts Program," 48.

12 For instance, during my travels I have found Northwest Coast artware for sale at the National Museum of the American Indian in Washington, DC, and New York, the American Museum of Natural History in New York, the Fenimore Art Museum in Cooperstown, the Museum of Contemporary Native Art in Santa Fe, the National Gallery of Canada and the Canadian Museum of History in Gatineau, and the McCord Museum in Montreal.

13 Paul Stoller, *Money Has No Smell: The Africanization of New York City* (Chicago: University of Chicago Press, 2002).

14 Aldona Jonaitis and Aaron Glass, *The Totem Pole: An Intercultural History* (Seattle: University of Washington Press, 2010); Michael Hall and Pat Glascock, *Carvings and Commerce: Model Totem Poles, 1880–2010* (Saskatoon, SK: Mendel Art Gallery, 2011).

15 Anthropologist Jennifer S. Esperanza's study of the mass-production of "ethnic art" by Balinese handicrafts producers to sell to non-Balinese intermediaries includes examples of Northwest Coast–style carvings. See Jennifer S. Esperanza, "Outsourcing Otherness: Crafting and Marketing Culture in the Global Handicrafts Market," in *Hidden Hands in the Market: Ethnographies of Fair Trade, Ethical Consumption, and Corporate Social Responsibility*, ed. Geert De Neve et al., Research in Economic Anthropology 28 (Bingley, UK: JAI Press, 2008), 71–95. For an artistic commentary on the sale of Indonesian-made Northwest Coast–style masks in Alaska, see Tlingit/Aleut artist Nicholas Galanin's series *The Imaginary Indian* (2009) and *The Curtis Legacy* (2009).

16 As sales through internet platforms such as eBay become more common, it is likely that items labeled "Northwest Coast art" will increasingly be sold from outside North America,

whether they are imitations made elsewhere or items that were purchased in the region and later resold online by their owners.

17 Much of what is today considered "classic" Northwest Coast material culture includes materials that are not local to the Pacific Northwest. To take but one example, button blankets have long been adorned with abalone shells traded from California or with plastic buttons that were industrially produced in China. See Doreen Jensen and Polly Sargent, *Robes of Power: Totem Poles on Cloth*, UBC Museum of Anthropology Note 17 (Vancouver: UBC Press, 1986).

18 While both Canadian and foreign companies copied designs in this way, the pushback tended to focus mainly on the actions of foreign companies – "over there" – perhaps because effective ways of stopping them – "from here" – seemed more elusive.

19 Competition Bureau of Canada, "Enforcement Guidelines – 'Product of Canada' and 'Made in Canada' Claims," 22 December 2009, http://www.competitionbureau.gc.ca/eic/site/cb-bc. nsf/eng/03169.html, accessed 11 November 11 2011.

20 For instance, one shop created a label referencing the British Columbian origins of some of their products as part of its effort to signal that it was shifting away from the "heavy-heavy-heavy produced offshore" as the manager put it. This label does not refer to a legally defined category, but the store's objective is to try to better "reflect the BC experience" by promoting products made locally, and therefore refrains from using it on products that are merely distributed by a company based in British Columbia.

21 Competition Bureau of Canada, "Enforcement Guidelines – 'Product of Canada' and 'Made in Canada' Claims."

22 Ibid.

23 For instance, a few months before the Vancouver 2010 Winter Olympics, a controversy arose regarding the fact that no official Olympic Indigenous-themed merchandise was created by Indigenous companies, and much of it was not produced in Canada. See "Native Artisan Raps VANOC's 'Authentic' Aboriginal Art," CBC News, 25 December 2009, http://www. cbc.ca/news/canada/british-columbia/native-artisan-raps-vanoc-s-authentic-aboriginal -art-1.837734.

24 Alice Ravenhill, letter to W.A. Newcombe, 23 April 1933, microfilm A01753, MS-1077, Newcombe family fonds, vol. 14, folder 95, BC Archives. As discussed in Chapter 2, there is certainly irony in the fact that, although Ravenhill was relaying this concern about the effects of Japanese imports on the Indigenous art market, she would later publish *A Corner Stone of Canadian Culture* in the hope that it would, in addition to teaching Indigenous schoolchildren about Northwest Coast design, help renew the design stock of Commonwealth industrial companies such as the Manchester Cotton Mills.

25 George Raley, letter to Mr. A. O'N. Daunt, Indian Agent, New Westminster, BC, 3 May 1934, H/D/R13: Raley, George Henry (1863–1958), vol. R13.3: Industries and handicrafts, articles, reports, etc., BC Archives.

26 George H. Raley, *Canadian Indian Art and Industries: An Economic Problem of To-Day* (London: G. Bell, 1935), 999. Raley's sources are unclear, but his description of these Japanese-made items is typical of other references to them, which rarely if ever mention the names of specific individuals, companies, or locations in Japan that were producing these imitations.

27 "Ellen Neel," *Indian Time* 2, 6 (Spring 1953): 2.

28 Carole Farber and Joan Ryan, "National Native Indian Artists' Symposium, August 25–30 1983" (Hazelton, BC, 1983), 13.

29 Art historian Ronald Hawker remarks that the "influx of imitation products from Japan" was a "frequently cited problem in the 1930s" but this could have been at least in part the effect of an "increasing fear of eastern Asia, as Japan continued to expand." Ronald William Hawker, "Welfare Politics, Late Salvage, and Indigenous (In)Visibility," in *Native Art of the*

Northwest Coast: A History of Changing Ideas, ed. Charlotte Townsend-Gault, Jennifer Kramer, and Ki-ke-in (Vancouver: UBC Press, 2013), 394.

30 H.D. Baker, manager of the Vancouver Tourist Association, believed Japanese totem poles fell out of favour after the Second World War. H.D. Baker, letter to Willard E. Ireland, Corresponding Secretary, BCIAWS, 18 February 1949, MS-2720, microfilm A01662, BC Indian Arts and Welfare Society fonds, 1943–54, BC Archives.

31 The unfavourable economic situation she was referring to was the financial crisis that began in 2008 and was still ongoing during my fieldwork.

32 For a discussion of the relationship between sovereignty and commodification, see Alexis Celeste Bunten, "Sharing Culture or Selling Out? Developing the Commodified Persona in the Heritage Industry," *American Ethnologist* 35, 3 (2008): 380–95; Jessica R. Cattelino, "The Double Bind of American Indian Need-Based Sovereignty," *Cultural Anthropology* 25, 2 (2010): 235–62.

33 Jean Comaroff and John L. Comaroff, eds., *Millennial Capitalism and the Culture of Neoliberalism* (Durham, NC: Duke University Press, 2001), 13.

34 See, for example, Eric R. Wolf, *Europe and the People without History* (Berkeley: University of California Press, 1982); Nicholas Thomas, *Entangled Objects: Exchange, Material Culture, and Colonialism in the Pacific* (Cambridge, MA: Harvard University Press, 1991).

35 Comaroff and Comaroff, *Millennial Capitalism*, 14.

36 Brent Luvaas, "Dislocating Sounds: The Deterritorialization of Indonesian Indie Pop," *Cultural Anthropology* 24, 2 (2009): 248.

37 Ibid.

38 First Nations Leadership Council and Asia Pacific Foundation Canada, "First Nations and China: Transforming Relationships," 9 August 2011, https://www.asiapacific.ca/sites/default/files/filefield/chinastrategy_final.pdf; Eugenia Kisin, "Unsettling the Contemporary: Critical Indigeneity and Resources in Art," *Settler Colonial Studies* 3, 2 (2013): 141–56.

39 See, for instance, Calvin Helin, *Dances with Dependency: Out of Poverty through Self-Reliance* (Woodland Hills, CA: Ravencrest, 2008).

40 Ingrid Barnsley and Roland Bleiker, "Self-Determination: From Decolonization to Deterritorialization," *Global Change, Peace and Security* 20, 2 (2008): 121–36.

41 James G. Carrier, "Ethical Consumption," *Anthropology Today* 23, 4 (2007): 1–2; Geert De Neve, Peter Luetchford, Jeffrey Pratt, and Donald C. Wood, eds., *Hidden Hands in the Market: Ethnographies of Fair Trade, Ethical Consumption, and Corporate Social Responsibility*, Research in Economic Anthropology 28 (Bingley, UK: JAI Press, 2008); James G. Carrier, "Think Locally, Act Globally: The Political Economy of Ethical Consumption," in De Neve et al., *Hidden Hands in the Market*, 31–51.

42 James Clifford, "Varieties of Indigenous Experience: Diasporas, Homelands, Sovereignties," in *Indigenous Experience Today*, ed. Marisol de la Cadena and Orin Starn (Oxford: Berg, 2007), 199.

43 Jean Comaroff and John L. Comaroff, *Ethnicity, Inc.* (Chicago: University of Chicago Press, 2009), 73–74.

Chapter 4: Property and Contracts | Stewardship and Relationality

1 Darrell Posey, "Intellectual Property Rights and Just Compensation for Indigenous Knowledge," *Anthropology Today* 6, 4 (1990): 15. Darrell Posey was one of the main organizers of the 1988 International Congress of Ethnobiology in Belém that led to the Declaration of Belém, which outlines principles for the protection of Indigenous ethnobiological knowledge and the compensation of Indigenous peoples for corporations' uses of this knowledge.

2 Rachel Wynberg, "Rhetoric, Realism and Benefit-Sharing," *Journal of World Intellectual Property* 7, 6 (2004): 851–76; Saskia Vermeylen, "Contextualizing 'Fair' and 'Equitable': The San's Reflections on the Hoodia Benefit-Sharing Agreement," *Local Environment* 12, 4 (2007): 423–36.

3 Philip L. Kohl, "Making the Past Profitable in an Age of Globalization and National Ownership: Contradictions and Considerations," in *Marketing Heritage: Archaeology and the Consumption of the Past*, ed. Uzi Baram and Yorke Rowan (Plymouth, UK: AltaMira Press, 2004), 301.

4 Peter Luetchford, "Economic Anthropology and Ethics," in *A Handbook of Economic Anthropology*, ed. James G. Carrier (Cheltenham, UK: Edward Elgar, 2005), 396.

5 See, for example, Bruce H. Ziff and Pratima V. Rao, eds., *Borrowed Power: Essays on Cultural Appropriation* (New Brunswick, NJ: Rutgers University Press, 1997); Michael F. Brown, *Who Owns Native Culture?* (Cambridge, MA: Harvard University Press, 2003); James O. Young and Conrad G. Brunk, eds., *The Ethics of Cultural Appropriation* (Chichester, UK: Wiley-Blackwell, 2009).

6 Cori Hayden, *When Nature Goes Public: The Making and Unmaking of Bioprospecting in Mexico* (Princeton, NJ: Princeton University Press, 2003), 45.

7 Reproductions of the totem poles that are located in Vancouver's Stanley Park in all sizes, shapes, and materials – as miniatures, photographs, logos, etc. – are a good example of this notion that works presented as public art necessarily enter the public domain.

8 On this topic, see for instance, Marie Battiste and James Youngblood Henderson, *Protecting Indigenous Knowledge and Heritage: A Global Challenge* (Saskatoon, SK: Purich, 2000); Catherine E. Bell and Robert K. Paterson, *Protection of First Nations Cultural Heritage: Laws, Policy, and Reform* (Vancouver: UBC Press, 2009).

9 Jennifer Kramer, "Fighting with Property: The Double-Edged Character of Ownership," in *Native Art of the Northwest Coast: A History of Changing Ideas*, ed. Charlotte Townsend-Gault, Jennifer Kramer, and Ki-ke-in (Vancouver: UBC Press, 2013), 730.

10 Ibid., 721, 722.

11 George P. Nicholas and Kelly P. Bannister, "Copyrighting the Past? Emerging Intellectual Property Rights Issues in Archaeology," *Current Anthropology* 45, 3 (2004): 327–50.

12 Hayden, *When Nature Goes Public*, 4.

13 In this respect, there are parallels with the idea of "free and informed consent" that is used in the language of research ethics. On the premise that there is often an imbalance of power between those conducting the research and its participants, researchers are considered responsible for outlining potential risks and advantages to these participants, who cannot be assumed to have all the information or understanding of the workings of the research process required to appropriately anticipate them. Similarly, artware companies could be considered responsible for making sure artists, especially inexperienced ones, know what they are buying into and/or signing away, and that they do so freely, rather than under pressure or duress.

14 Cori Hayden describes a very similar type of reasoning with respect to bioprospecting benefit-sharing agreements: "In most cases, prospecting contracts reward their interlocutors – whether indigenous communities, biodiversity-rich governments, or research institution – for their distinctive but still fairly 'raw' contributions to product development (manifested in their labor, knowledge, or provision of plant material itself). In some situations, source institutions negotiate differential returns according to the relationship between the inputs and the eventual outputs – thus, they receive higher royalty payments for specimens that lead directly to a marketable product, and lower returns if the participating company has to work harder to squeeze a marketable product out of the chemical compounds sent their way." Hayden, *When Nature Goes Public*, 40.

15 In this example, a scarf that costs $2, with a 20 percent wholesale margin (for a $2.40 wholesale price) and a retail markup of a little over twice that amount, would have a retail price of around $5.30. If the same $2 scarf is embroidered at the cost of $5, plus a 10 percent royalty payment of 70 cents, the total cost is $7.70. With a 20 percent wholesale margin (for a $9.24 wholesale price) and with that same markup, it would have a retail price just over $20.

16 On the limits of copyright in particular, see Jane Anderson and Kimberly Christen, "'Chuck a Copyright on It': Dilemmas of Digital Return and the Possibilities for Traditional Knowledge Licenses and Labels," *Museum Anthropology Review* 7, 1–2 (2013): 105–26.

17 Terri-Lynn Williams, "Cultural Perpetuation: Repatriation of First Nations Cultural Heritage," special issue, *University of British Columbia Law Review* (1995): 185.

18 Kramer, "Fighting with Property," 727–28.

19 Cara Krmpotich, *The Force of Family: Repatriation, Kinship, and Memory on Haida Gwaii* (Toronto: University of Toronto Press, 2014), 109. See also Williams, "Cultural Perpetuation," 186.

20 Krmpotich, *The Force of Family*, 110. To help address this issue, anthropologist Kim Christen and law professor Jane Anderson are heading an initiative called Local Contexts to develop licences and labels that better align with Indigenous notions of property and stewardship, giving the option to "institutions and/or individuals who continue to hold the copyright in [Indigenous] material ... to abandon their copyright and transfer it to the source community," acknowledging that "they should never have been the 'owners' and the decision-makers for this material in the first place." Anderson and Christen, "'Chuck a Copyright on It,'" 113.

21 Douglas White, "'Where Mere Words Failed': Northwest Coast Art and the Law," in Townsend-Gault, Kramer, and Ki-ke-in, *Native Art of the Northwest Coast,* 638.

22 Susan Roy, *These Mysterious People: Shaping History and Archaeology in a Northwest Coast Community* (Montreal and Kingston: McGill-Queen's University Press, 2010), 80.

23 Ibid., 79.

24 White, "'Where Mere Words Failed,'" 639, 640.

25 Mique'l Dangeli, "Dancing Our Stone Mask out of Confinement: A Twenty-First-Century Tsimshian Epistemology," in *Objects of Exchange: Social and Material Transformation on the Late Nineteenth-Century Northwest Coast,* ed. Aaron Glass (New York: Bard Graduate Center, 2011), 40, 39, 37.

26 Christopher F. Roth, "Goods, Names, and Selves: Rethinking the Tsimshian Potlatch," *American Ethnologist* 29, 1 (2002), 131.

27 Nora Marks Dauenhauer, "Tlingit At.óow: Traditions and Concepts," in *The Spirit Within,* ed. Steven C. Brown (Seattle, WA: Seattle Art Museum, 1995), 21.

28 White, "'Where Mere Words Failed,'" 643.

29 Cited in Kramer, "Fighting with Property," 745. The weavers were Ann Smith, Donna Cranmer, Clarissa Hudson, and Ernestine Hanlon, and their statement was included in the press release for Barbara Cranmer's film *Gwishalaayt: The Spirit Wraps around You* (2001).

30 For ethnographically grounded discussions of how intellectual property laws compare to Indigenous conceptions of property elsewhere in the world, see Marilyn Strathern, "The Patent and the Malanggan," *Theory, Culture and Society* 18, 4 (2001): 1–26; Haidy Geismar, "Copyright in Context: Carvings, Carvers, and Commodities in Vanuatu," *American Ethnologist* 32, 3 (2005): 437–59.

31 David Arnold, "Work and Culture in Southeastern Alaska: Tlingits and the Salmon Fisheries," in *Native Pathways: American Indian Culture and Economic Development in the Twentieth Century,* ed. Brian C. Hosmer and Colleen M. O'Neill (Boulder: University Press of Colorado, 2004), 167. This example provides an interesting parallel with the issue of intellectual property and Indigenous art. As Arnold explains, these requests for payments were only occasionally honoured since most non-Indigenous fishers considered waterways to be common property,

much as Indigenous cultural expression tends to be treated as public domain. See also Nicholas and Bannister, "Copyrighting the Past?"

32 Aaron Mills, "What Is a Treaty? On Contract and Mutual Aid," in *The Right Relationship: Reimagining the Implementation of Historical Treaties*, ed. Michael Coyle and John Borrows (Toronto: University of Toronto Press, 2017), 215. See also Alan Ojiig Corbière, "The Underlying Importance of Wampum Belts," YouTube video posted by Chippewas of Rama First Nation, 30 March 2015, https://www.youtube.com/watch?v=wb-RftTCQ_8.

33 Michael Asch, *On Being Here to Stay: Treaties and Aboriginal Rights in Canada* (Toronto: University of Toronto Press, 2014).

34 Michael Coyle, "As Long as the Sun Shines: Recognizing That Treaties Were Intended to Last," in Coyle and Borrows, *The Right Relationship,* 53.

35 Asch, *On Being Here to Stay,* 10–34. See also Arthur Manuel and Grand Chief Ronald M. Derrickson, *Unsettling Canada: A National Wake-Up Call* (Toronto: Between the Lines, 2015), 90.

36 See Mills, "What Is a Treaty?"; Coyle, "As Long as the Sun Shines."

37 Coyle, "As Long as the Sun Shines," 64, 61.

38 Ibid., 61–62.

39 Aimée Craft, *Breathing Life into the Stone Fort Treaty: An Anishinabe Understanding of Treaty One* (Saskatoon, SK: Purich, 2013), 113.

40 This reasoning is reminiscent of Aaron Mills's argument that, while contracts have been presented as an instrument that "saves us from being used as a means to others' ends," they are in fact "precisely the way of thinking about our relationship which ... necessitates that we all lose." Instead, Mills proposes that relationships be built according to the Anishinaabe vision that "we are and always have been interdependent" and that "we can all win." Mills, "What Is a Treaty?," 214.

41 Writing about historical treaties, Michael Coyle argues that "this obligation to renew the treaty arrangement is an ongoing one, just as the treaty partnership is ongoing and further changes in circumstances are inevitable." Coyle, "As Long as the Sun Shines," 61–62.

42 These concerns are very similar to those expressed about the nature of relationships developed under the label of "collaboration" in museums, where imbalances of power can affect decision processes during a project and the distribution of the resulting benefits, despite the objective of working as equal partners. See Miriam Kahn, "Not Really Pacific Voices: Politics of Representation in Collaborative Museum Exhibits," *Museum Anthropology* 24, 1 (2000): 57–74; Ann McMullen, "The Currency of Consultation and Collaboration," *Museum Anthropology Review* 2, 2 (2008): 54–87; Martha Black, "Collaborations: A Historical Perspective," in Townsend-Gault, Kramer, and Ki-ke-in, *Native Art of the Northwest Coast,* 785–827.

43 Anna Tsing, *Friction: An Ethnography of Global Connection* (Princeton, NJ: Princeton University Press, 2005), 249.

44 Ruth B. Phillips, "Re-Placing Objects: Historical Practices for the Second Museum Age," *Canadian Historical Review* 86, 1 (2005): 159.

45 John S. Lutz, *Makúk: A New History of Aboriginal-White Relations* (Vancouver: UBC Press, 2008), 298.

46 Native Northwest, accessed 28 August 2012, http://www.nativenorthwest.com.

47 Panabo Sales, "Featured Artists," accessed 28 August 2012, http://www.panabosales.com/featured-artists. See, for example, Panabo Sales, "B. Helin Chilkat Apron Red | Panabo Sales," accessed 28 August 2012, http://www.panabosales.com/catalog/products/bbq-aprons/b-helin-chilkat-apron-red.

48 Chloë Angus Design, accessed 28 August 2012, http://chloeangus.moonfruit.com.

49 Oscardo, "Welcome to Oscardo Inc.," accessed 28 August 2012, https://www.oscardo.com/artists.jsp.

50 Frederick Design, "Home," accessed 28 August 2012, http://www.frederick-design-pewter. com/index.html; Claudia Alan Inc., "First Nations Eyewear & Native American Fashion | BC, Canada," accessed 28 August 2012, http://www.claudiaalan.com/aya-pacific-northwest-eyewear.

51 Asch, "Indigenous Self-Determination," 205–6.

52 Ibid. Similarly, John Sutton Lutz sees potential in a return to *makúk* – simply put, Indigenous forms of exchange – through dialogue engaged from a "place of creative understanding." Lutz, *Makúk*, 298–99.

53 The BC Treaty Commission website claims that: (1) "treaties will pump *billions of dollars into the BC economy*"; (2) "the *financial benefits to First Nations* could be *as high as $10 billion*"; (3) "those capital and investment dollars will make the biggest impact where the money is needed most – *in the hands of First Nations and their neighbours throughout the province*"; and (4) *when a First Nation prospers* with a modern-day treaty *the whole region prospers.*" BC Treaty Commission, "BC Treaty Commission," accessed 2 August 2012, http://www.bctreaty. ca, emphasis mine.

54 Union of British Columbia Indian Chiefs, *Certainty: Canada's Struggle to Extinguish Indigenous Title*, 1998, https://www.ubcic.bc.ca/ubcic_publications.htm.

55 Manuel and Derrickson, *Unsettling Canada.*

56 Carole Blackburn, "Searching for Guarantees in the Midst of Uncertainty: Negotiating Aboriginal Rights and Title in British Columbia," *American Anthropologist* 107, 4 (2005): 590.

57 Johnny Camille Mack, "Thickening Totems and Thinning Imperialism" (master's thesis, University of Victoria, 2009), https://dspace.library.uvic.ca//handle/1828/2830, 34.

58 Ibid., 7, 128–29.

59 Marcia Crosby, *Nations in Urban Landscapes: Faye HeavyShield, Shelley Niro, Eric Robertson* (Vancouver, BC: Contemporary Art Gallery, 1997), 27–28.

60 Some Canadian examples of such discourses include the political collaboration of the Green Party and the Serpent River First Nations (https://greenparty.ca/media-release/2011-05-01/ green-party-supports-collaboration-address-aboriginal-issues, accessed 17 August 2011); Ontario's Far North Act, 2010, promoting collaboration between First Nations and resource companies (http://www.blaney.com/sites/default/files/Far-North-Act.pdf, accessed 17 August 2011); the Royal Bank of Canada's *Aboriginal Partnership Report* (http://www.rbcroyalbank. com/commercial/aboriginal/pdf/rbc-aboriginal-mou-2009-e.pdf, accessed 17 August 2011); and VANOC's partnerships and collaborations with the Four Host First Nations (http:// www.linkbc.ca/torc/downs1/4AboriginalParticipationandCollaboration.pdf, accessed 17 August 2011).

61 Eva Mackey, *The House of Difference: Cultural Politics and National Identity in Canada*, Anthropological Horizons 23 (Toronto: University of Toronto Press, 2002), 26.

62 Ibid., 92.

63 On contemporary capitalism's focus on the very short term, see Richard Sennett, *The Culture of the New Capitalism* (New Haven, CT: Yale University Press, 2007).

Chapter 5: Accumulation | Redistribution

1 See Jessica R. Cattelino, "The Double Bind of American Indian Need-Based Sovereignty," *Cultural Anthropology* 25, 2 (2010): 237; Audra Simpson, *Mohawk Interruptus: Political Life across the Borders of Settler States* (Durham, NC: Duke University Press, 2014), 127.

2 David Arnold, "Work and Culture in Southeastern Alaska: Tlingits and the Salmon Fisheries," in *Native Pathways: American Indian Culture and Economic Development in the Twentieth Century*, ed. Brian C. Hosmer and Colleen M. O'Neill (Boulder: University Press of Colorado, 2004), 175.

3 David Harvey, *A Brief History of Neoliberalism* (Oxford: Oxford University Press, 2007).

4 Matthew Bishop, *Essential Economics* (London: Economist in Association with Profile Books, 2004), 44–45.

5 On the topic of gifts and capitalism, see, for instance, Daniel Miller, "Alienable Gifts and Inalienable Commodities," in *The Empire of Things: Regimes of Value and Material Culture*, ed. Fred Myers (Santa Fe, NM: SAR Press, 2001), 91–115; Dinah Rajak, "'I Am the Conscience of the Company': Responsibility and the Gift in a Transnational Mining Corporation," in *Economics and Morality: Anthropological Approaches*, ed. Katherine E. Browne and B. Lynne Milgram, Society for Economic Anthropology Monographs 26 (Lanham, MD: AltaMira Press, 2009), 211–33; Kyung-Nan Koh, "Representing Corporate Social Responsibility, Branding the Commodity as Gift, and Reconfiguring the Corporation as 'Super-'Person," *Signs and Society* 3, S1 (2015): S151–73.

6 Admittedly, by discussing the potlatch in such general terms, this overview cannot do justice to the differences among cultural groups or time periods; as a way to indicate these differences, the group and date to which each analysis or testimony pertains will be clearly stated.

7 Franz Boas and George Hunt, *The Social Organization and the Secret Societies of the Kwakiutl Indians* (Washington, DC: Government Printing Office, 1897), 341, 342.

8 Marcel Mauss, *The Gift: Forms and Functions of Exchange in Archaic Societies* (New York: W.W. Norton, 1967), 36.

9 Homer G. Barnett, "The Nature of the Potlatch," *American Anthropologist*, n.s., 40, 3 (1938): 352, 354.

10 Marjorie Halpin, foreword to *A Haida Potlatch*, by Ulli Steltzer (Seattle: University of Washington Press, 1984), viii.

11 Wayne Suttles, "Affinal Ties, Subsistence, and Prestige among the Coast Salish," *American Anthropologist*, n.s., 62, 2 (1960): 296–305.

12 Stuart Piddocke later extended Suttles's hypothesis to the Southern Kwakiutl, and Andrew P. Vayda extended it to the Northwest Coast as a whole. See Stuart Piddocke, "The Potlatch System of the Southern Kwakiutl: A New Perspective," *Southwestern Journal of Anthropology* 21, 3 (1965): 244–64; Andrew P. Vayda, "Division of Anthropology: A Re-Examination of Northwest Coast Economic Systems," *Transactions of the New York Academy of Sciences*, 2nd ser., 23, 7 (1961): 618–24.

13 Philip Drucker and Robert F. Heizer, *To Make My Name Good: A Reexamination of the Southern Kwakiutl Potlatch* (Berkeley: University of California Press, 1967), 8–9.

14 Christopher F. Roth, "Goods, Names, and Selves: Rethinking the Tsimshian Potlatch," *American Ethnologist* 29, 1 (2002): 126.

15 Quoted in Doreen Jensen and Polly Sargent, *Robes of Power: Totem Poles on Cloth*, UBC Museum of Anthropology Note 17 (Vancouver: UBC Press, 1986), 56.

16 Quoted ibid., 21, 22.

17 Quoted ibid., 16.

18 Gloria Cranmer-Webster, "The Contemporary Potlatch," in *Chiefly Feasts: The Enduring Kwakiutl Potlatch*, ed. Aldona Jonaitis (Seattle: University of Washington Press, 1992), 246.

19 Quoted in Jensen and Sargent, *Robes of Power*, 42.

20 lessLIE, artist statement, http://www.alcheringa-gallery.com/words-of-wealth-print.html, accessed 20 March 2018.

21 Interview with Sonny Assu by Crystal Baxley, "Sonny Assu – Laich-Kwil-Tach (Kwakwaka'wakw)," Spring 2011, http://contemporarynativeartists.tumblr.com/post/6030123932/sonny-assu-laich-kwil-tach-kwakwakawakw.

22 Drucker and Heizer, *To Make My Name Good*.

23 Cranmer-Webster, "The Contemporary Potlatch," 229. Some supermarkets or department stores located near First Nations communities are becoming accustomed to being informed

of upcoming feasts and ceremonies so that they can stock up in time for the mass purchases that will be made for these events.

24 For Kwakwa̱ka̱'wakw examples of such images, see figures 2.15 2.48, 2.53, 3.12, 3.23, 3.24, and 3.35 in Aldona Jonaitis, ed., *Chiefly Feasts: The Enduring Kwakiutl Potlatch* (Seattle: University of Washington Press, 1991). For examples of very similar images taken in contemporary potlatches, see figure 5.19, ibid., and photographs of a 1981 potlatch held in Masset by Robert Davidson, in Steltzer, *A Haida Potlatch*, 73–74.

25 Cranmer-Webster, "The Contemporary Potlatch," 229. Christopher Roth lists the potlatch gifts he received in a 1996 Wolf-clan feast in Kistumkalum as follows: "one souvenir cloth calendar, three tea towels, four drinking glasses, one bottle of bath salts, one wax candle, two plastic baggies of dried seaweed, two chocolate bars, one pair of socks, three ballpoint pens including two souvenir pens with the date and particulars of the feast printed on the side, one pencil, one elastic hair tie, one plastic water bottle, one uninflated black party balloon ... and one specially printed school folder featuring a Northwest Coast design." Roth, "Goods, Names, and Selves," 131.

26 Aaron Glass, "Crests on Cotton: 'Souvenir' T-Shirts and the Materiality of Remembrance among the Kwakwaka'wakw of British Columbia," *Museum Anthropology* 31, 1 (2008): 1–18.

27 Ibid.

28 George Clutesi, *Potlatch* (Sidney, BC: Gray's, 1969), 10.

29 Cited by Dorothy Grant, "Sculpting on Cloth," in Jensen and Sargent, *Robes of Power*, 61.

30 Cranmer-Webster, "The Contemporary Potlatch," 229.

31 Ibid.

32 Ibid., 232.

33 Tiffany Sloan, "Corporate Potlatching. Meet BC Bearing's Acclaimed 'Corporate Artist,'" *BCB Communicator*, 2009, 8.

34 Another parallel between potlatching and corporate expenditure was drawn in relation to the Vancouver 2010 Winter Olympics, which some dubbed "the world's biggest potlatch." See VANOC, *The World's Biggest Potlatch: Aboriginal Participation in the Vancouver 2010 Olympic and Paralympic Games* (Vancouver, BC: VANOC, 2010); Fiona Morrow, "Vancouver to Host 'the World's Biggest Potlatch,'" *Globe and Mail*, 3 February 2009, https://www.theglobeandmail.com/arts/vancouver-to-host-the-worlds-biggest-potlatch/article22510131/.

35 Marshall Sahlins, *Stone Age Economics* (Chicago: Aldine-Atherton, 1972), 193–94.

36 The obligation of reciprocity is predicated on guests performing as witnesses for their hosts and on their need to have the hosts be witnesses at their own future potlatches. Christopher Roth argues that this reciprocity is generalized rather than balanced because the composition of the attendance varies from one potlatch to the next, as does the value of what is exchanged. Although the presence of specific individuals is expected, the overall responsibility to attend and witness is borne collectively. Instead of simultaneous and equivalent returns, the obligation of redistribution is expected to be carried out over time and across the various groups participating in the potlatch economy. See Roth, "Goods, Names, and Selves," 125.

37 Jennifer Kramer, "Fighting with Property: The Double-Edged Character of Ownership," in Townsend-Gault, Kramer, and Ki-ke-in, *Native Art of the Northwest Coast*, 724.

38 Quoted in Jensen and Sargent, *Robes of Power*, 40.

39 Spirit Works, "About Us," accessed 21 July 2016, http://www.authenticaboriginalproducts.ca/about-us/.

40 Lisa Ann Richey and Stefano Ponte, *Brand Aid: Shopping Well to Save the World* (Minneapolis: University of Minnesota Press, 2011), 121–76.

41 For critiques of the Pink Ribbon campaign as one that "capitalizes on hope" without addressing the fundamental causes of breast cancer, see Samantha King, *Pink Ribbons, Inc.: Breast Cancer and the Politics of Philanthropy* (Minneapolis: University of Minnesota Press,

2008); Kris Frieswick, "Sick of Pink," *Boston Globe*, 4 October 2009; Léa Pool, *Pink Ribbons, Inc.*, documentary (2012).

42 Slavoj Žižek, *First as Tragedy, Then as Farce* (London: Verso, 2009), 51–65. Žižek also uses the expression "cultural capitalism." I do not use this expression here so as not to create confusion with the concept of culturally modified capitalism, which meshes well with but cannot be reduced to "cultural capitalism" as described by Žižek.

43 Jean Comaroff and John L. Comaroff, *Ethnicity, Inc.* (Chicago: University of Chicago Press, 2009), 129.

44 Richey and Ponte, *Brand Aid*, 121–76. In contrast, "disengaged" and "distant" CSR practices usually associate goods with a cause disconnected from the activities of the company that produces them or the place where they are produced. The RED products promoted by Bono and other celebrities to fight HIV/AIDS in Africa are a good example of this kind of CSR, or what Richey and Ponte call "Brand Aid" (p. 129).

45 Comaroff and Comaroff, *Ethnicity, Inc.*, 143.

46 Catherine S. Dolan, "Virtue at the Checkout Till: Salvation Economics in Kenyan Flower Fields," in Browne and Milgram, *Economics and Morality*, 167. For a more detailed and comprehensive discussion of morality and economics, from fair trade to corporate social responsibility, see Browne and Milgram, *Economics and Morality*.

47 Richey and Ponte, *Brand Aid*, 151–75.

48 Based on the products that are sold in Vancouver, my estimate is that, Canada-wide, a little over forty artware companies (including fashion designers) carry at least one line of products referencing Northwest Coast art. About half of these companies are based in British Columbia. Approximately fifteen of these companies are non-Indigenous companies that work with Indigenous artists. The latter are the focus of this chapter.

49 Cara Krmpotich, *The Force of Family: Repatriation, Kinship, and Memory on Haida Gwaii* (Toronto: University of Toronto Press, 2014), 111–12.

Conclusion

1 For a review of many of these works, see Michael Blim, "Capitalisms in Late Modernity," *Annual Review of Anthropology* 29 (2000): 25–38; James G. Carrier, "Exchange," in *Handbook of Material Culture*, ed. Christopher Tilley, Webb Keane, Susanne Kuechler, Mike Rowlands, and Patricia Spyer (London: Sage, 2006), 373–83.

2 Jean Comaroff and John L. Comaroff, eds., *Millennial Capitalism and the Culture of Neoliberalism* (Durham, NC: Duke University Press, 2001), 14.

3 Eric R. Wolf, *Europe and the People without History* (Berkeley: University of California Press, 1982).

4 Nicholas Thomas, *Entangled Objects: Exchange, Material Culture, and Colonialism in the Pacific* (Cambridge, MA: Harvard University Press, 1991); Jocelyn Linnekin, "Fine Mats and Money: Contending Exchange Paradigms in Colonial Samoa," *Anthropological Quarterly* 64, 1 (1991): 1–13; Marshall Sahlins, "Cosmologies of Capitalism: The Trans-Pacific Sector of 'The World System,'" in *Culture/Power/History: A Reader in Contemporary Social Theory*, ed. Nicholas B. Dirks, Geoff Eley, and Sherry B. Ortner (Princeton, NJ: Princeton University Press, 1994), 412–55; Alexis Celeste Bunten, "A Call for Attention to Indigenous Capitalisms," *New Proposals: Journal of Marxism and Interdisciplinary Inquiry* 5, 1 (2011): 60–71; Jessica R. Cattelino, "The Double Bind of American Indian Need-Based Sovereignty," *Cultural Anthropology* 25, 2 (2010): 235–62.

5 Douglas Cole and Ira Chaikin, *An Iron Hand upon the People: The Law Against the Potlatch on the Northwest Coast* (Vancouver, BC: Douglas and McIntyre, 1990); Ian Gill, *All That We Say Is Ours: Guujaaw and the Reawakening of the Haida Nation* (Vancouver, BC: Douglas

and McIntyre, 2009); Arthur J. Ray, *An Illustrated History of Canada's Native People: I Have Lived Here since the World Began*, rev. ed. (Toronto: Key Porter Books, 2010).

6 Cori Hayden, *When Nature Goes Public: The Making and Unmaking of Bioprospecting in Mexico* (Princeton, NJ: Princeton University Press, 2003), 61.

7 Regarding how adopting different socio-legal standards might affect the implementation of historical treaties, see Michael Coyle and John Borrows, *The Right Relationship: Reimagining the Implementation of Historical Treaties* (Toronto: University of Toronto Press, 2017).

8 For a discussion of the framing of "art" as a "resource," see Eugenia Kisin, "Unsettling the Contemporary: Critical Indigeneity and Resources in Art," *Settler Colonial Studies* 3, 2 (2013): 141–56.

9 Jean Comaroff and John L. Comaroff, *Ethnicity, Inc.* (Chicago: University of Chicago Press, 2009), 28.

10 See James G. Carrier, "Introduction," in *Meanings of the Market: The Free Market in Western Culture*, ed. James G. Carrier (Oxford: Bloomsbury Academic, 1997), 47–55.

11 Interestingly, concerns about the commodification of cultural heritage are almost as frequently voiced by non-Indigenous observers as by Indigenous people themselves. As Jessica Cattelino has observed, "In the casino era, American Indians once again encounter the economic politics of settler colonialism, in which it is only a short step from wondering whether Indians with gaming are losing their culture to skepticism over whether indigenous people with economic power can and should remain legitimately indigenous and sovereign." Cattelino, "American Indian Need-Based Sovereignty," 248.

12 Bunten, "Call for Attention to Indigenous Capitalisms," 67.

13 Hayden, *When Nature Goes Public,* 35.

14 Bunten, "Call for Attention to Indigenous Capitalisms," 67.

15 Comaroff and Comaroff, *Ethnicity, Inc.,* 139.

16 The system against which many did speak openly was colonialism. Although it is arguably closely intertwined with capitalism, this connection was not often made explicit by those who critiqued the artware industry as too colonial and not Indigenous enough.

17 Daniel Miller, *Capitalism: An Ethnographic Approach* (Oxford: Berg, 1997), 55.

18 Slavoj Žižek, *First as Tragedy, Then as Farce* (London: Verso, 2009), 52–54.

19 Lisa Ann Richey and Stefano Ponte, *Brand Aid: Shopping Well to Save the World* (Minneapolis: University of Minnesota Press, 2011).

20 John S. Lutz, *Makúk: A New History of Aboriginal-White Relations* (Vancouver: UBC Press, 2008), 305.

21 Cole and Chaikin, *An Iron Hand*; Douglas White, "'Where Mere Words Failed': Northwest Coast Art and the Law," in *Native Art of the Northwest Coast: A History of Changing Ideas*, ed. Charlotte Townsend-Gault, Jennifer Kramer, and Ki-ke-in (Vancouver: UBC Press, 2013), 633–76.

22 William L. Partridge, Jorge E. Uquillas, and Kathryn Johns, "Including the Excluded: Ethnodevelopment in Latin America," Paper presented at the Annual World Bank Conference on Development in Latin America and the Caribbean, Bogotá, Colombia, 30 June–2 July 1996, http://documents.worldbank.org/curated/en/98143146877039776o/Including-the-excluded-ethnodevelopment-in-Latin-America, 5.

23 Ibid., 8.

24 Bunten, "Call for Attention to Indigenous Capitalisms," 61.

25 Gloria Cranmer-Webster, "The Contemporary Potlatch," in *Chiefly Feasts: The Enduring Kwakiutl Potlatch*, ed. Aldona Jonaitis (Seattle: University of Washington Press, 1992), 248.

Bibliography

Archival Sources

British Columbia Archives, Victoria

F/1/R19	Alice Ravenhill fonds
GR-0111	BC Provincial Museum correspondence inward, 1897–1970
GR-1661	Records of the Deputy Provincial Secretary, 1954–83
GR-1731	Lieutenant Governor files, 1958–78
H/D/R13	George Henry Raley fonds
MS-0964	Llewellyn Bullock-Webster fonds
MS-1077	Newcombe family fonds
MS-1116	Society for the Furtherance of British Columbia Indian Arts and Crafts fonds
MS-2629; MS-2799	Anthony Walsh fonds
MS-2720	British Columbia Indian Arts and Welfare Society (BCIAWS) fonds, 1940–54
MS-2760	G. Macrina Parker collection
MS-2837	Adam Beattie papers, 1945–73

Library and Archives Canada, Ottawa

MG28-I 222 (R4667-0-5-E)	Canadian Craftsmen Association fonds, 1964–77
MG30-D 387 (R9331-0-X-E)	Modest Cmoc fonds
RG10-B-3-e-xiv	Economic development – Project assignment – Canadian Indian Marketing Services – Headquarters
RG33-28 (R1107-0-0-E)	Royal Commission on National Development in the Arts, Letters and Sciences, 1946–51

University of British Columbia Library Rare Books and
Special Collections, Vancouver
Alice Ravenhill fonds

University of British Columbia Museum of Anthropology
Library and Archives, Vancouver
Audrey Hawthorn fonds

Other Sources

Anderson, Jane, and Kimberly Christen. "'Chuck a Copyright on It': Dilemmas of Digital Return and the Possibilities for Traditional Knowledge Licenses and Labels." *Museum Anthropology Review* 7, 1–2 (2013): 105–26.

Antrosio, Jason, and Rudolf Josef Colloredo-Mansfeld. *Fast, Easy, and in Cash: Artisan Hardship and Hope in the Global Economy.* Chicago: University of Chicago Press, 2015. https://doi.org/10.7208/chicago/9780226302751.001.0001.

Appadurai, Arjun. *Modernity at Large: Cultural Dimensions of Globalization.* Minneapolis: University of Minnesota Press, 1996.

Arnold, David. "Work and Culture in Southeastern Alaska: Tlingits and the Salmon Fisheries." In *Native Pathways: American Indian Culture and Economic Development in the Twentieth Century,* ed. Brian C. Hosmer and Colleen M. O'Neill, 156–83. Boulder: University Press of Colorado, 2004.

Asch, Michael. "Indigenous Self-Determination and Applied Anthropology in Canada: Finding a Place to Stand." *Anthropologica* 43, 2 (2001): 201–7. https://doi.org/10.2307/25606035.

–. *On Being Here to Stay: Treaties and Aboriginal Rights in Canada.* Toronto: University of Toronto Press, 2014.

Barnett, Homer G. "The Nature of the Potlatch." *American Anthropologist,* n.s., 40, 3 (1938): 349–58.

Barnsley, Ingrid, and Roland Bleiker. "Self-Determination: From Decolonization to Deterritorialization." *Global Change, Peace and Security* 20, 2 (2008): 121–36. https://doi.org/10.1080/14781150802079797.

Battiste, Marie, and James Youngblood Henderson. *Protecting Indigenous Knowledge and Heritage: A Global Challenge.* Saskatoon, SK: Purich, 2000.

BC Indian Arts and Welfare Society. *Report of Conference on Native Indian Affairs at Acadia Camp: University of British Columbia, Vancouver, B.C., April 1, 2 and 3, 1948, Sponsored by the B.C. Indian Arts and Welfare Society, Provincial Museum, Victoria, B.C.* Victoria: BC Indian Arts and Welfare Society, 1948.

–. *Report of the Second Decennial Conference on Native Indian Affairs at the Library, University of British Columbia, Vancouver, B.C., April 1st and 2nd, 1958: A Conference of Indian Business Men.* Victoria, BC: BC Indian Arts and Welfare Society, 1958.

BC Ministry of Small Business, Tourism and Culture. *Culturally Modified Trees of British Columbia.* Version 2.0, 2001. https://www.for.gov.bc.ca/hfd/pubs/docs/mr/mr091.htm

Becker, Howard S. *Art Worlds.* Berkeley: University of California Press, 1982.

Bell, Catherine E., and Val Napoleon, eds. *First Nations Cultural Heritage and Law: Case Studies, Voices, and Perspectives.* Vancouver: UBC Press, 2008.

Bell, Catherine E., and Robert K. Paterson. *Protection of First Nations Cultural Heritage: Laws, Policy, and Reform.* Vancouver: UBC Press, 2009.

Bishop, Matthew. *Essential Economics.* London: Economist in Association with Profile Books, 2004.

Black, Martha. "Collaborations: A Historical Perspective." In Townsend-Gault, Kramer, and Ki-ke-in, *Native Art of the Northwest Coast*, 785–827.

Blackburn, Carole. "Searching for Guarantees in the Midst of Uncertainty: Negotiating Aboriginal Rights and Title in British Columbia." *American Anthropologist* 107, 4 (2005): 586–96. https://doi.org/10.1525/aa.2005.107.4.586.

Blim, Michael. "Capitalisms in Late Modernity." *Annual Review of Anthropology* 29 (2000): 25–38. https://doi.org/10.1146/annurev.anthro.29.1.25.

Blommaert, Jan, and Chris Bulcaen. "Critical Discourse Analysis." *Annual Review of Anthropology* 29 (2000): 447–66. https://doi.org/10.1146/annurev.anthro.29.1.447.

Boas, Franz. *Primitive Art*. New York: Dover, 1955.

Boas, Franz, and George Hunt. *The Social Organization and the Secret Societies of the Kwakiutl Indians*. Washington, DC: Government Printing Office, 1897.

Boltanski, Luc, and Eve Chiapello. *The New Spirit of Capitalism*. London: Verso, 2005.

Boris, Eileen. *Art and Labor: Ruskin, Morris, and the Craftsman Ideal in America*. Philadelphia: Temple University Press, 1986.

British Columbia. Ministry of Small Business, Tourism, and Culture. *Aboriginal Artists' Project: Artist Needs and Market Assessment*. Victoria: The Ministry of Small Business, Tourism, and Culture, 1995.

Brown, Michael F. "Heritage as Property." In *Property in Question: Value Transformation in the Global Economy*, ed. Katherine Verdery and Caroline Humphrey, 49–68. Oxford: Berg, 2004.

–. *Who Owns Native Culture?* Cambridge, MA: Harvard University Press, 2003.

Browne, Katherine E., and B. Lynne Milgram, eds. *Economics and Morality: Anthropological Approaches*. Plymouth, UK: AltaMira Press, 2009.

Bunten, Alexis Celeste. "A Call for Attention to Indigenous Capitalisms." *New Proposals: Journal of Marxism and Interdisciplinary Inquiry* 5, 1 (2011): 60–71.

–. "Commodities of Authenticity: When Native People Consume Their Own 'Tourist Art.'" In *Exploring World Art*, ed. Eric Venbrux, Pamela Sheffield Rosi, and Robert L. Welsch, 317–36. Long Grove, IL: Waveland Press, 2006.

–. "Sharing Culture or Selling Out? Developing the Commodified Persona in the Heritage Industry." *American Ethnologist* 35, 3 (2008): 380–95. https://doi.org/10.1111/j.1548-1425.2008.00041.x.

Cairns, Alan. *Citizens Plus: Aboriginal Peoples and the Canadian State*. Vancouver: UBC Press, 2000.

Canada. *Report of the Royal Commission on Aboriginal Peoples*. Ottawa: Minister of Supply and Services, 1996.

Canadian Broadcasting Corporation. "Native Artisan Raps VANOC's 'Authentic' Aboriginal Art." 25 December 2009. http://www.cbc.ca/news/canada/british-columbia/native-artisan-raps-vanoc-s-authentic-aboriginal-art-1.837734.

Canadian Indian Marketing Services. *Northwest Coast Indian Artists Guild: 1977 Graphics Collection*. Ottawa: Canadian Indian Marketing Services, 1977.

–. *Northwest Coast Indian Artists Guild: 1978 Graphics Collection*. Ottawa: Canadian Indian Marketing Services, 1978.

Carrier, James G. "Ethical Consumption." *Anthropology Today* 23, 4 (2007): 1–2. https://doi.org/10.1111/j.1467-8322.2007.00520.x.

–. "Exchange." In *Handbook of Material Culture*, ed. Christopher Tilley, Webb Keane, Susanne Kuechler, Mike Rowlands, and Patricia Spyer, 373–83. London: Sage, 2006. https://doi.org/10.4135/9781848607972.n25.

–. "Introduction." In *Meanings of the Market: The Free Market in Western Culture*, ed. James. G. Carrier, 1–68. Oxford: Bloomsbury Academic, 1997.

–. "Think Locally, Act Globally: The Political Economy of Ethical Consumption." In De Neve et al., *Hidden Hands in the Market*, 31–51. https://doi.org/10.1016/S0190-1281(08)28002-9.

Castellano, Marlene Brant, Linda Archibald, and Mike DeGagné. *From Truth to Reconciliation: Transforming the Legacy of Residential Schools*. Ottawa: Aboriginal Healing Foundation, 2008.

Cattelino, Jessica R. "Casino Roots: The Cultural Production of Twentieth-Century Seminole Economic Development." In *Native Pathways: American Indian Culture and Economic Development in the Twentieth Century*, ed. Brian C. Hosmer and Colleen M. O'Neill, 66–90. Boulder: University Press of Colorado, 2004.

–. "The Double Bind of American Indian Need-Based Sovereignty." *Cultural Anthropology* 25, 2 (2010): 235–62. https://doi.org/10.1111/j.1548-1360.2010.01058.x.

Chabal, Patrick, and Jean-Pascal Daloz. *Culture Troubles: Politics and the Interpretation of Meaning*. Chicago: University of Chicago Press, 2006.

Clifford, James. *Routes: Travel and Translation in the Late Twentieth Century*. Cambridge, MA: Harvard University Press, 1997.

–. "Varieties of Indigenous Experience: Diasporas, Homelands, Sovereignties." In *Indigenous Experience Today*, ed. Marisol de la Cadena and Orin Starn, 197–223. Oxford: Berg, 2007.

Clutesi, George. *Potlatch*. Sidney, BC: Gray's, 1969.

Cole, Douglas. *Captured Heritage: The Scramble for Northwest Coast Artifacts*. Vancouver, BC: Douglas and McIntyre, 1985.

Cole, Douglas, and Ira Chaikin. *An Iron Hand upon the People: The Law Against the Potlatch on the Northwest Coast*. Vancouver, BC: Douglas and McIntyre, 1990.

Comaroff, Jean, and John L. Comaroff. *Ethnicity, Inc*. Chicago: University of Chicago Press, 2009. https://doi.org/10.7208/chicago/9780226114736.001.0001.

–, eds. *Millennial Capitalism and the Culture of Neoliberalism*. Durham, NC: Duke University Press, 2001.

Coombe, Rosemary J. *The Cultural Life of Intellectual Properties: Authorship, Appropriation and the Law*. Post-Contemporary Interventions. Durham, NC: Duke University Press, 1998. https://doi.org/10.1215/9780822382492.

Corbière, Alan Ojiig. "The Underlying Importance of Wampum Belts." YouTube video posted by Chippewas of Rama First Nation, 30 March 2015. https://www.youtube.com/watch?v=wb-RftTCQ_8.

Coyle, Michael. "As Long as the Sun Shines: Recognizing That Treaties Were Intended to Last." In Coyle and Borrows, *The Right Relationship*, 36–69.

Coyle, Michael, and John Borrows, eds. *The Right Relationship: Reimagining the Implementation of Historical Treaties*. Toronto: University of Toronto Press, 2017.

Craft, Aimée. *Breathing Life into the Stone Fort Treaty: An Anishinabe Understanding of Treaty One*. Saskatoon, SK: Purich, 2013.

Cranmer-Webster, Gloria. "The Contemporary Potlatch." In *Chiefly Feasts: The Enduring Kwakiutl Potlatch*, ed. Aldona Jonaitis, 227–48. Seattle: University of Washington Press, 1992.

Crosby, Marcia. *Nations in Urban Landscapes: Faye HeavyShield, Shelley Niro, Eric Robertson*. Vancouver, BC: Contemporary Art Gallery, 1997.

Dangeli, Mique'l. "Dancing Our Stone Mask out of Confinement: A Twenty-First-Century Tsimshian Epistemology." In *Objects of Exchange: Social and Material Transformation on the Late Nineteenth-Century Northwest Coast*, ed. Aaron Glass, 37–47. New York: Bard Graduate Center, 2011.

Dauenhauer, Nora Marks. "Tlingit At.óow: Traditions and Concepts." In *The Spirit Within*, ed. Steven C. Brown, 21–29. Seattle, WA: Seattle Art Museum, 1995.

Dawn, Leslie Allan. *National Visions, National Blindness: Canadian Art and Identities in the 1920s*. Vancouver: UBC Press, 2006.

Dawson, Michael. *Selling British Columbia: Tourism and Consumer Culture, 1890–1970*. Vancouver: UBC Press, 2004.

De Neve, Geert, Peter Luetchford, Jeffrey Pratt, and Donald C. Wood, eds. *Hidden Hands in the Market: Ethnographies of Fair Trade, Ethical Consumption, and Corporate Social Responsibility*. Research in Economic Anthropology 28. Bingley, UK: JAI Press, 2008.

Deleuze, Gilles, and Félix Guattari. *A Thousand Plateaus: Capitalism and Schizophrenia*. Minneapolis: University of Minnesota Press, 1987.

Derek Simpkins Gallery of Tribal Art. *Chief Henry Speck: An Exhibition of Paintings, c. 1958–1964*. Vancouver, BC: Gallery of Tribal Art, 1995.

Dolan, Catherine S. "Virtue at the Checkout Till: Salvation Economics in Kenyan Flower Fields." In Browne and Milgram, *Economics and Morality*, 167–85.

Donald, Dwayne. "Forts, Curriculum, and Ethical Relationality." *First Nations Perspectives* 2, 1 (2009): 1–24.

Drew, Leslie, and Douglas Wilson. *Argillite, Art of the Haida*. North Vancouver, BC: Hancock House, 1980.

Drucker, Philip, and Robert F. Heizer. *To Make My Name Good: A Reexamination of the Southern Kwakiutl Potlatch*. Berkeley: University of California Press, 1967.

Duffek, Karen. "'Authenticity' and the Contemporary Northwest Coast Indian Art Market." *BC Studies* 57 (1983): 99–111.

Duffek, Karen, and Marcia Crosby. *Projections: The Paintings of Henry Speck, Udzi'stalis*. Exhibition catalogue. Vancouver: UBC Museum of Anthropology and the Satellite Gallery, 2012.

Dugger, Karen. "Social Location and Gender-Role Attitudes: A Comparison of Black and White Women." *Gender and Society* 2, 4 (1988): 425–48. https://doi.org/10.1177/089124388002004002.

Eighth Generation. "The Art of Giving Back – Your Input Needed!" 20 June 2017. https://eighthgeneration.com/blogs/blog/survey-how-you-think-the-first-inspired-natives-grant-should-be-awarded.

"Ellen Neel." *Indian Time* 2, 6 (Spring 1953): 2.

Environics Institute. *Urban Aboriginal Peoples Study: Vancouver Report*. Toronto: Environics Institute, 2011.

Esperanza, Jennifer S. "Outsourcing Otherness: Crafting and Marketing Culture in the Global Handicrafts Market." In De Neve et al., *Hidden Hands in the Market*, 71–95. https://doi.org/10.1016/S0190-1281(08)28004-2.

Farber, Carole, and Joan Ryan. "National Native Indian Artists' Symposium, August 25–30 1983." Hazelton, BC, 1983.

Fatouros, A.A. *Legal Protection of Eskimo and Indian Arts and Crafts: A Preliminary Report*. Ottawa: Department of Northern Affairs and National Resources, 1966.

Ferry, Elizabeth. "Inalienable Commodities: The Production and Circulation of Silver and Patrimony in a Mexican Mining Cooperative." *Cultural Anthropology* 17, 3 (2002): 331–58. https://doi.org/10.1525/can.2002.17.3.331.

First Nations Leadership Council and Asia Pacific Foundation Canada. "First Nations and China: Transforming Relationships." 9 August 2011. https://www.asiapacific.ca/sites/default/files/filefield/chinastrategy_final.pdf.

Fleming, Thomas, Lisa Smith, and Helen Raptis. "An Accidental Teacher: Anthony Walsh and the Aboriginal Day Schools at Six Mile Creek and Inkameep, British Columbia,

1929–1942." *Historical Studies in Education/Revue d'histoire de l'éducation* 19, 1 (2007): 1–24.

Foster, Robert J. *Coca-Globalization: Following Soft Drinks from New York to New Guinea.* New York: Palgrave Macmillan, 2008. https://doi.org/10.1057/9780230610170.

–. "Tracking Globalization: Commodities and Value in Motion." In *Handbook of Material Culture*, ed. Christopher Tilley, Webb Keane, Susan Kuechler, Mike Rowlands, and Patricia Spyer, 285–302. Thousand Oaks, CA: Sage, 2006.

Foucault, Michel. *The Archaeology of Knowledge.* London: Tavistock, 1972.

Frieswick, Kris. "Sick of Pink." *Boston Globe*, 4 October 2009.

Geismar, Haidy. "Copyright in Context: Carvings, Carvers, and Commodities in Vanuatu." *American Ethnologist* 32, 3 (2005): 437–59. https://doi.org/10.1525/ae.2005.32.3.437.

Gell, Alfred. *Art and Agency: An Anthropological Theory.* Oxford: Clarendon Press, 1998.

Gill, Ian. *All That We Say Is Ours: Guujaaw and the Reawakening of the Haida Nation.* Vancouver, BC: Douglas and McIntyre, 2009.

Glaser, Barney G., and Anselm L. Strauss. *The Discovery of Grounded Theory: Strategies for Qualitative Research.* Chicago: Aldine, 1967.

Glass, Aaron. "Crests on Cotton: 'Souvenir' T-Shirts and the Materiality of Remembrance among the Kwakwaka'wakw of British Columbia." *Museum Anthropology* 31, 1 (2008): 1–18. https://doi.org/10.1111/j.1548-1379.2008.00001.x.

Granovetter, Mark. "Economic Action and Social Structure: The Problem of Embeddedness." *American Journal of Sociology* 91, 3 (1985): 481–510. https://doi.org/10.1086/228311.

Grant, Dorothy. "Sculpting on Cloth." In Jensen and Sargent, *Robes of Power*, 60–62.

Gray, Robin R. "Ts'msyen Revolution: The Poetics and Politics of Reclaiming." PhD diss., University of Massachusetts – Amherst, 2015. http://scholarworks.umass.edu/dissertations_2/437.

Greene, Shane. "Indigenous People Incorporated? Culture as Politics, Culture as Property in Pharmaceutical Bioprospecting." *Current Anthropology* 45, 2 (2004): 211–37. https://doi.org/10.1086/381047.

Hall, Edwin S., Margaret B. Blackman, and Vincent Rickard. *Northwest Coast Indian Graphics.* Seattle: University of Washington Press, 1981.

Hall, Michael, and Pat Glascock. *Carvings and Commerce: Model Totem Poles, 1880–2010.* Saskatoon, SK: Mendel Art Gallery, in association with University of Washington Press, 2011.

Halpin, Marjorie. Foreword to *A Haida Potlatch*, by Ulli Steltzer, vii–x. Seattle: University of Washington Press, 1984.

Harvey, David. *A Brief History of Neoliberalism.* Oxford: Oxford University Press, 2007.

Hawker, Ronald William. *Tales of Ghosts: First Nations Art in British Columbia, 1922–61.* Vancouver: UBC Press, 2003.

–. "Welfare Politics, Late Salvage, and Indigenous (In)Visibility." In Townsend-Gault, Kramer, and Ki-ke-in, *Native Art of the Northwest Coast*, 379–403.

Hawthorn, Harry B., Cyril S. Belshaw, and Stuart Jamieson. *The Indians of British Columbia: A Study of Contemporary Social Adjustment.* Toronto: University of Toronto Press, 1958.

Hayden, Cori. *When Nature Goes Public: The Making and Unmaking of Bioprospecting in Mexico.* Princeton, NJ: Princeton University Press, 2003.

Helin, Calvin. *Dances with Dependency: Out of Poverty through Self-Reliance.* Woodland Hills, CA: Ravencrest, 2008.

Holm, Bill. *Northwest Coast Indian Art: An Analysis of Form.* Burke Museum Monograph 1. Vancouver, BC: Douglas and McIntyre, 1965.

James, Matt. "A Carnival of Truth? Knowledge, Ignorance and the Canadian Truth and Reconciliation Commission." *International Journal of Transitional Justice* 6, 2 (2012): 182–204. https://doi.org/10.1093/ijtj/ijs010.

Jensen, Doreen, and Polly Sargent. *Robes of Power: Totem Poles on Cloth*. UBC Museum of Anthropology Note 17. Vancouver: UBC Press, 1986.

Jonaitis, Aldona, ed. *Chiefly Feasts: The Enduring Kwakiutl Potlatch*. Seattle: University of Washington Press, 1991.

Jonaitis, Aldona, and Aaron Glass. *The Totem Pole: An Intercultural History*. Seattle: University of Washington Press, 2010.

Kahn, Miriam. "Not Really Pacific Voices: Politics of Representation in Collaborative Museum Exhibits." *Museum Anthropology* 24, 1 (2000): 57–74. https://doi.org/10.1525/mua.2000.24.1.57.

Kaufmann, Carole N. "Changes in Haida Indian Argillite Carvings, 1820 to 1910." PhD diss., University of California Los Angeles, 1969.

Kew, Michael. *Sculpture and Engraving of the Central Coast Salish Indians*. Museum Note 9. Vancouver: UBC Museum of Anthropology, 1980.

King, Samantha. *Pink Ribbons, Inc.: Breast Cancer and the Politics of Philanthropy.* Minneapolis: University of Minnesota Press, 2008.

Kisin, Eugenia. "Unsettling the Contemporary: Critical Indigeneity and Resources in Art." *Settler Colonial Studies* 3, 2 (2013): 141–56. https://doi.org/10.1080/2201473X.2013.781927.

Koh, Kyung-Nan. "Representing Corporate Social Responsibility, Branding the Commodity as Gift, and Reconfiguring the Corporation as 'Super-'Person." *Signs and Society* 3, S1 (2015): S151–73. https://doi.org/10.1086/679603.

Kohl, Philip L. "Making the Past Profitable in an Age of Globalization and National Ownership: Contradictions and Considerations." In *Marketing Heritage: Archaeology and the Consumption of the Past*, ed. Uzi Baram and Yorke Rowan, 295–301. Plymouth, UK: AltaMira Press, 2004.

Kramer, Jennifer. "Fighting with Property: The Double-Edged Character of Ownership." In Townsend-Gault, Kramer, and Ki-ke-in, *Native Art of the Northwest Coast*, 720–56.

–. *Kesu': The Art and Life of Doug Cranmer*. Vancouver, BC: Douglas and McIntyre, 2012.

–. *Switchbacks: Art, Ownership, and Nuxalk National Identity*. Vancouver: UBC Press, 2006.

Krmpotich, Cara. *The Force of Family: Repatriation, Kinship, and Memory on Haida Gwaii*. Toronto: University of Toronto Press, 2014.

Laird, Sarah A., ed. *Biodiversity and Traditional Knowledge: Equitable Partnerships in Practice*. London: Earthscan Publications, 2002.

Laird, Sarah A., and Rachel Wynberg. *Access and Benefit-Sharing in Practice: Trends in Partnerships across Sectors*. Montreal: Secretariat of the Convention on Biological Diversity, 2008.

Layton, Robert, and Gillian Wallace. "Is Culture a Commodity?" In *Ethics and Archaeology*, ed. Chris Scarre and Geoffrey Scarre, 46–68. Cambridge: Cambridge University Press, 2006. https://doi.org/10.1017/CBO9780511817656.004.

Lévi-Strauss, Claude. *The Way of the Masks*. Seattle: University of Washington Press, 1988.

Linnekin, Jocelyn. "Fine Mats and Money: Contending Exchange Paradigms in Colonial Samoa." *Anthropological Quarterly* 64, 1 (1991): 1–13. https://doi.org/10.2307/3317832.

Luetchford, Peter. "Economic Anthropology and Ethics." In *A Handbook of Economic Anthropology*, ed. James G. Carrier, 390–404. Cheltenham, UK: Edward Elgar, 2005. https://doi.org/10.4337/9781845423469.00040.

Lutz, John S. *Makúk: A New History of Aboriginal-White Relations*. Vancouver: UBC Press, 2008.

Luvaas, Brent. "Dislocating Sounds: The Deterritorialization of Indonesian Indie Pop." *Cultural Anthropology* 24, 2 (2009): 246–79. https://doi.org/10.1111/j.1548-1360.2009.01131.x.

Mack, Johnny Camille. "Thickening Totems and Thinning Imperialism." Master's thesis, University of Victoria, 2009. https://dspace.library.uvic.ca/handle/1828/2830.

Mackey, Eva. *The House of Difference: Cultural Politics and National Identity in Canada*. Anthropological Horizons 23. Toronto: University of Toronto Press, 2002.

Macnair, Peter L., and Alan L. Hoover. *The Magic Leaves: A History of Haida Argillite Carving.* Victoria: BC Ministry of Provincial Secretary and Government Services, 1984.

Manuel, Arthur, and Ronald M. Derrickson. *Unsettling Canada: A National Wake-Up Call.* Toronto: Between the Lines, 2015.

Manuel, Arthur, and Nicole Schabus. "Indigenous Peoples at the Margin of the Global Economy: A Violation of International Human Rights and International Trade Law." *Chapman Law Review* 8 (2005): 222–52.

Mauss, Marcel. *The Gift: Forms and Functions of Exchange in Archaic Societies.* New York: W.W. Norton, 1967.

Mauzé, Marie. "Aux invisibles frontières du songe et du réel – Lévi-Strauss et les surréalistes: La 'découverte' de l'art de la Côte Nord-Ouest." In *Cahier de l'Herne 82, Claude Lévi-Strauss,* ed. Michel Izard, 152–61. Paris: Editions de l'Herne, 2004.

McLeod, Ellen Easton. *In Good Hands: The Women of the Canadian Handicrafts Guild.* Montreal and Kingston: McGill-Queens University Press, 1999.

McLerran, Jennifer. *A New Deal for Native Art: Indian Arts and Federal Policy, 1933–1943.* Tucson: University of Arizona Press, 2009.

McMullen, Ann. "The Currency of Consultation and Collaboration." *Museum Anthropology Review* 2, 2 (2008): 54–87.

Menzies, Charles R., and Caroline F. Butler. "The Indigenous Foundation of the Resource Economy of BC's North Coast." *Labour/Le Travail* 61 (2008): 131–49.

–. "Returning to Selective Fishing through Indigenous Fisheries Knowledge: The Example of K'moda, Gitxaala Territory." *American Indian Quarterly* 31, 3 (2007): 441–64.

Milgram, B. Lynne. "Recommunitizing Practice, Refashioning Capital: Artisans and Entrepreneurship in a Philippine Textile Industry." In *Textile Economies: Power and Value from the Local to the Transnational,* ed. Walter E. Little and Patricia Ann McAnany, 223–43. Society for Economic Anthropology Monographs 29. Lanham, MD: AltaMira Press, 2011.

Miller, Daniel. "Alienable Gifts and Inalienable Commodities." In *The Empire of Things: Regimes of Value and Material Culture,* ed. Fred Myers, 91–115. Santa Fe, NM: SAR Press, 2001.

–. *Capitalism: An Ethnographic Approach.* Oxford: Berg, 1997.

Miller, James R. *Skyscrapers Hide the Heavens: A History of Indian-White Relations in Canada.* 3rd ed. Toronto: University of Toronto Press, 2000.

Mills, Aaron. "What Is a Treaty? On Contract and Mutual Aid." In Coyle and Borrows, *The Right Relationship,* 208–47.

Morrow, Fiona. "Vancouver to Host 'the World's Biggest Potlatch.'" *Globe and Mail,* 3 February 2009, https://www.theglobeandmail.com/arts/vancouver-to-host-the-worlds-biggest-potlatch/article22510131/.

National Gallery of Canada. *Exhibition of Canadian West Coast Art, Native and Modern.* Ottawa: National Gallery, 1927.

Nicholas, George P., and Kelly P. Bannister. "Copyrighting the Past? Emerging Intellectual Property Rights Issues in Archaeology." *Current Anthropology* 45, 3 (2004): 327–50. https://doi.org/10.1086/382251.

Ostrowitz, Judith. *Privileging the Past: Reconstructing History in Northwest Coast Art.* Seattle: University of Washington Press, 1999.

Partridge, William L., Jorge E. Uquillas, and Kathryn Johns. "Including the Excluded : Ethnodevelopment in Latin America." Paper presented at the Annual World Bank Conference on Development in Latin America and the Caribbean, Bogotá, Colombia, 30 June–2 July 1996, http://documents.worldbank.org/curated/en/981431468770397760/pdf/272020IncludingotheoExcludedo1public1.pdf.

Peirano, Mariza G.S. "When Anthropology Is at Home: The Different Contexts of a Single Discipline." *Annual Review of Anthropology* 27 (1998): 105–28. https://doi.org/10.1146/annurev.anthro.27.1.105.

Phillips, Ruth B. "Re-Placing Objects: Historical Practices for the Second Museum Age." *Canadian Historical Review* 86, 1 (2005): 83–110. https://doi.org/10.3138/CHR/86.1.83.

Piddocke, Stuart. "The Potlatch System of the Southern Kwakiutl: A New Perspective." *Southwestern Journal of Anthropology* 21, 3 (1965): 244–64. https://doi.org/10.1086/soutjanth.21.3.3629231.

Pool, Léa. *Pink Ribbons, Inc.* Documentary, 2012.

Posey, Darrell A. "Intellectual Property Rights and Just Compensation for Indigenous Knowledge." *Anthropology Today* 6, 4 (1990): 13–16. https://doi.org/10.2307/3032735.

Posey, Darrell A., and Graham Dutfield. *Beyond Intellectual Property: Toward Traditional Resource Rights for Indigenous Peoples and Local Communities.* Ottawa: International Development Research Centre, 1996.

Raibmon, Paige. "'A New Understanding of Things Indian': George Raley's Negotiation of the Residential School Experience." *BC Studies* 110 (1996): 69–96.

Rajak, Dinah. "'I Am the Conscience of the Company': Responsibility and the Gift in a Transnational Mining Corporation." In Browne and Milgram, *Economics and Morality: Anthropological Approaches,* 211–33.

Raley, George H. *Canadian Indian Art and Industries: An Economic Problem of To-Day.* London: G. Bell, 1935.

Ravenhill, Alice. *A Corner Stone of Canadian Culture: An Outline of the Arts and Crafts of the Indian Tribes of British Columbia.* Occasional Papers of the British Columbia Provincial Museum 5. Victoria: British Columbia Provincial Museum, 1944.

Ray, Arthur J. *An Illustrated History of Canada's Native People: I Have Lived Here since the World Began.* Rev. ed. Toronto: Key Porter Books, 2010.

Richey, Lisa Ann, and Stefano Ponte. *Brand Aid: Shopping Well to Save the World.* Minneapolis: University of Minnesota Press, 2011.

Roseberry, William. "Political Economy." *Annual Review of Anthropology* 17 (1988): 161–85. https://doi.org/10.1146/annurev.an.17.100188.001113.

Roth, Christopher F. "Goods, Names, and Selves: Rethinking the Tsimshian Potlatch." *American Ethnologist* 29, 1 (2002): 123–50. https://doi.org/10.1525/ae.2002.29.1.123.

Roth, Solen. "Argillite, Faux-Argillite and Black Plastic: The Political Economy of Simulating a Quintessential Haida Substance." *Journal of Material Culture* 20, 3 (2015): 299–312. https://doi.org/10.1177/1359183515581631.

Roy, Susan. *These Mysterious People: Shaping History and Archaeology in a Northwest Coast Community.* Montreal and Kingston: McGill-Queen's University Press, 2010.

Rudnyckyj, Daromir. "Spiritual Economies: Islam and Neoliberalism in Contemporary Indonesia." *Cultural Anthropology* 24, 1 (2009): 104–41. https://doi.org/10.1111/j.1548-1360.2009.00028.x.

Sahlins, Marshall. "Cosmologies of Capitalism: The Trans-Pacific Sector of 'The World System.'" In *Culture/Power/History: A Reader in Contemporary Social Theory,* ed. Nicholas B. Dirks, Geoff Eley, and Sherry B. Ortner, 412–55. Princeton, NJ: Princeton University Press, 1994.

–. *Stone Age Economics.* Chicago: Aldine-Atherton, 1972.

Sapir, Edward. "Prefatory Note." In *An Album of Prehistoric Canadian Art,* by Harlan I. Smith, iii. Victoria Memorial Museum Bulletin 37. Ottawa: Department of Mines, 1923.

Schrader, Robert Fay. *The Indian Arts and Crafts Board: An Aspect of New Deal Indian Policy.* Albuquerque, NM: Olympic Marketing, 1983.

Sennett, Richard. *The Culture of the New Capitalism*. New Haven, CT: Yale University Press, 2007.

Shepherd, Robert. "Commodification, Culture and Tourism." *Tourist Studies* 2, 2 (2002): 183–201. https://doi.org/10.1177/146879702761936653.

Simon-Kumar, Rachel, and Catherine Kingfisher. "Beyond Transformation and Regulation: Productive Tensions and the Analytics of Inclusion." *Politics and Policy* 39, 2 (2011): 271–94. https://doi.org/10.1111/j.1747-1346.2011.00291.x.

Simpson, Audra. *Mohawk Interruptus: Political Life across the Borders of Settler States*. Durham, NC: Duke University Press, 2014. https://doi.org/10.1215/9780822376781.

Sloan, Tiffany. "Corporate Potlatching. Meet BC Bearing's Acclaimed 'Corporate Artist.'" *BCB Communicator* (2009): 8–9.

Smith, Harlan I. *An Album of Prehistoric Canadian Art*. Victoria Memorial Museum Bulletin 37. Ottawa: Department of Mines, 1923.

–. "Distinctive Canadian Designs: How Canadian Manufacturers May Profit by Introducing Native Designs into Their Products." *Industrial Canada* 17 (September 1917): 729–33.

Spivak, Gayatri Chakravorty. "Can the Subaltern Speak?" In *Marxism and the Interpretation of Culture*, ed. Nelson Carry and Lawrence Grossberg, 271–313. Urbana: University of Illinois Press, 1988.

Steltzer, Ulli. *A Haida Potlatch*. Seattle: University of Washington Press, 1984.

Stoller, Paul. *Money Has No Smell: The Africanization of New York City*. Chicago: University of Chicago Press, 2002. https://doi.org/10.7208/chicago/9780226775265.001.0001.

Strathern, Marilyn. "The Patent and the Malanggan." *Theory, Culture and Society* 18, 4 (2001): 1–26. https://doi.org/10.1177/02632760122051850.

Suttles, Wayne. "Affinal Ties, Subsistence, and Prestige among the Coast Salish." *American Anthropologist*, n.s., 62, 2 (1960): 296–305. https://doi.org/10.1525/aa.1960.62.2.02a00080.

–, ed. *Handbook of North American Indians: Northwest Coast*. Washington, DC: Government Printing Office, 1978.

Thomas, Nicholas. *Entangled Objects: Exchange, Material Culture, and Colonialism in the Pacific*. Cambridge, MA: Harvard University Press, 1991.

Todd, Zoe. "Relationships." Theorizing the Contemporary, *Cultural Anthropology* website, 21 January 2016. https://culanth.org/fieldsights/799-relationships.

Townsend-Gault, Charlotte. "Circulating Aboriginality." *Journal of Material Culture* 9, 2 (2004): 183–202. https://doi.org/10.1177/1359183504044372.

Townsend-Gault, Charlotte, Jennifer Kramer, and Ki-ke-in, eds. *Native Art of the Northwest Coast: A History of Changing Ideas*. Vancouver: UBC Press, 2013.

Truth and Reconciliation Commission of Canada. *Final Report of the Truth and Reconciliation Commission of Canada*. Vol. 1: *Summary: Honouring the Truth, Reconciling for the Future*. Toronto: Lorimer, 2015.

Tsing, Anna. *Friction: An Ethnography of Global Connection*. Princeton, NJ: Princeton University Press, 2005.

Union of British Columbia Indian Chiefs. *Certainty: Canada's Struggle to Extinguish Indigenous Title*. 1998. https://www.ubcic.bc.ca/ubcic_publications.htm.

VANOC. *The World's Biggest Potlatch: Aboriginal Participation in the Vancouver 2010 Olympic and Paralympic Games*. Vancouver, BC: VANOC, 2010.

Vayda, Andrew P. "Division of Anthropology: A Re-Examination of Northwest Coast Economic Systems." *Transactions of the New York Academy of Sciences*, 2nd ser., 23, 7 (1961): 618–24. https://doi.org/10.1111/j.2164-0947.1961.tb01395.x.

Vermeylen, Saskia. "Contextualizing 'Fair' and 'Equitable': The San's Reflections on the Hoodia Benefit-Sharing Agreement." *Local Environment* 12, 4 (2007): 423–36. https://doi.org/10.1080/13549830701495252.

Watson, Scott. "Art/Craft in the Early Twentieth Century." In Townsend-Gault, Kramer, and Ki-ke-in, *Native Art of the Northwest Coast*, 348–78.

–. "Two Bears." In *Bill Reid and Beyond: Expanding on Modern Native Art*, ed. Karen Duffek and Charlotte Townsend-Gault, 209–24. Vancouver, BC: Douglas and McIntyre, 2004.

Weibel-Orlando, Joan. "Made in Italy: Metaphors for Merchandising Textiles in a Global Economy." In *Textile Economies: Power and Value from the Local to the Transnational*, ed. Walter E. Little and Patricia Ann McAnany, 263–84. Society for Economic Anthropology Monographs 29. Lanham, MD: AltaMira Press, 2011.

Weston, Kath. "'Real Anthropology' and Other Nostalgias." In *Ethnographica Moralia: Experiments in Interpretive Anthropology*, ed. E. Neni K. Panourgia and George E. Marcus, 126–37. New York: Fordham University Press, 2008.

Wherry, Cathi, and Andrea N. Walsh. "Transporters: Contemporary Salish Art." In *Transporters = Łecsilen: Contemporary Salish Art*, 8–56. Victoria, BC: Art Gallery of Greater Victoria, 2007.

White, Douglas. "'Where Mere Words Failed': Northwest Coast Art and the Law." In Townsend-Gault, Kramer, and Ki-ke-in, *Native Art of the Northwest Coast*, 633–76.

Williams, Terri-Lynn. "Cultural Perpetuation: Repatriation of First Nations Cultural Heritage." Special issue, *University of British Columbia Law Review* (1995): 183–201.

Wilson, Renate, and Thelma Dickman. "They're Giving the Culture back to the Indians: International Art Collectors Are Making B.C. Indians as 'In' as Eskimos." *Imperial Oil Review* 48, 2 (April 1964): 14–18.

Wolf, Eric R. *Europe and the People Without History*. Berkeley: University of California Press, 1982.

Wynberg, Rachel. "Rhetoric, Realism and Benefit-Sharing." *Journal of World Intellectual Property* 7, 6 (2004): 851–76. https://doi.org/10.1111/j.1747-1796.2004.tb00231.x.

Wynberg, Rachel, Doris Schroeder, and Roger Chennells. *Indigenous Peoples, Consent and Benefit Sharing Lessons from the San-Hoodia Case*. Dordrecht, Netherlands: Springer, 2009.

Xu, Shi. *A Cultural Approach to Discourse*. Basingstoke, UK: Palgrave MacMillan, 2009.

Young, James O., and Conrad G. Brunk, eds. *The Ethics of Cultural Appropriation*. Chichester, UK: Wiley-Blackwell, 2009. https://doi.org/10.1002/9781444311099.

Ziff, Bruce H., and Pratima V. Rao, eds. *Borrowed Power: Essays on Cultural Appropriation*. New Brunswick, NJ: Rutgers University Press, 1997.

Žižek, Slavoj. *First as Tragedy, Then as Farce*. London: Verso, 2009.

Index

California, 5, 40, 190*n*17
Canada: changes in socio-political climate of, 54, 64–65; and colonialism, 20–21, 43, 49–50, 54, 78, 90, 131; and consumer culture, 141; economy, identity, and Indigenous arts, 3, 7, 38–42, 45–47, 62, 78–81, 87, 91, 165; made in, vs made elsewhere, 60–61, 68, 77–93, 190*n*23. *See also* Canadian government; nationalism and Indigenous arts and culture
Canadian Art Prints Inc. (formerly Canadian Native Prints), 63
Canadian government: involvement in developing and protecting the Indigenous art market, 38–40, 44–47, 54–55, 58–62, 65–66, 75, 83, 182*nn*5–6; negotiations with, 17–18, 20, 116, 128–30; and policies affecting access to the land, 144
Canadian Handicraft Guild, 46, 83
Canadian Indian Art and Handicraft League, 45
Canadian Indian Marketing Services (CIMS), 59, 62, 186*n*95
Canadian Museum of History (formerly Canadian Museum of Civilization), 189*n*12
Canadiana, 81, 91
canoes, 144
capitalism: characteristics of, 178*n*39; and colonialism, 42, 69; culture and spirit of, 10, 96, 155; direct expressions of opposition to, 170; as an economic model and system, 10–12, 136, 151–54, 161, 164, 166, 169; and fairness, 96–97, 147; and globalization, 72, 74, 89–90; Indigenous, 172; language of, 167–68; and local contexts and cultures, 5, 8, 10–12, 14, 17, 89–90, 164–73; and its obsession with the present, 132; "organic" and "postmodern," 171. *See also* culturally modified capitalism
Carr, Emily, 42–43, 50, 150, 182*n*18
Carrier, James G., 167
carving, 44, 51, 53, 76, 177*n*30, 189*n*15; of totem poles, 83, 129, 164(i)
Cattelino, Jessica R., 8, 199*n*11

cause marketing, 154–60; as corporate window-dressing, 154; definition of, 154–55
causumerism, 156–57
Cayer, Adélard, 65, 187*n*109
cedar, 3, 9, 91, 144; bark, 2(i), 12
ceramics, 3, 9, 42–43, 61, 81–82
ceremony and ceremonial practices, 6, 15, 129; and artware companies, 2, 167; and gifts/payments during potlatches, 134(i), 138–39; and intellectual property, 109–10; repression of, 38, 54–55
certainty and uncertainty, 20, 116–17, 128–29
chiefs, 44, 128–29, 137–40, 144–45, 185*n*63
Chilkat, 111
China, made in, 76–93, 149, 190*n*17
circulation of criticism, 16–17, 134, 156–57
clans, 99, 108, 110, 115, 144, 180*n*12
Clifford, James, 14
Clutesi, George, 54–55, 144, 185*n*75
Coast Mountains, 5
Coast Salish. *See* Salish
Coca-Cola, 154
Cole, Douglas, 40
collaboration, 21, 26, 62, 120–21, 157; absence of, 98; conciliatory vs conflictual, 121–26; costs and profitability, 124–25; and design process, 123–24; frictions of, 120–21; and marketing, 125–27, 130; rhetoric of, 125–27, 131, 165; vs partnerships, 121–22, 127
collections. *See* art collectors; museum collections
Colloredo-Mansfeld, Rudolf J., 8
colonialism: and Canada's position in the British Dominion, 48–49; and capitalism, 10, 69, 199*n*16; and cultural change, 41–42, 174; and dispossession, 13, 25, 51, 111; and the exploitation of Indigenous natural and cultural resources, 12, 20; fight against and critiques of, 78, 169, 181*n*3, 199*n*16; and imbalances of power, 23, 166; and international business relationships, 88, 90; and responsibilities towards Indigenous communities, 44, 148. *See also* settler colonialism

Crosby, Marcia, 63, 130–31
Crown (the), 59, 116, 128, 179*n*5
cultural affiliation, 21, 24. *See also* identity
cultural appropriation: and the artware
 industry, 12–13, 28, 38(i), 38–43,
 49–51, 102; and commodification,
 4, 23, 97; and concepts of property,
 98–99; definition of, 98; and
 dispossession, 131; fight and protection
 against, 4, 39, 56–68, 83, 98–99, 153, 165,
 181*n*3, 190*n*18; and Native-style products
 made abroad, 61, 76, 83–84, 189*nn*15–16;
 public debates about, 157
cultural commodification, 4; benefits for
 Indigenous communities, 68–69;
 control over processes of, 73–74, 171;
 and cultural perpetuation, 167, 173; as
 exploitation, 11–12; and fairness, 96–100,
 107, 127; and intellectual property, 110,
 114–15; and nationalism, 42; and
 responsibilities toward communities,
 149, 155; and risk, 89, 136, 167–68;
 support and critiques of, 21–24, 143,
 199*n*11; and sustainability, 127, 168–70,
 174; as a threat vs as a prospect, 8, 155,
 167–68, 173; as a way to make a living,
 30. *See also* culture as a resource
cultural difference: as the focus of a
 business, 92; and interpretations of
 treaties, 116; working across, 25, 88,
 96–97, 120. *See also* culturalism
cultural heritage: commodification of (*see*
 cultural commodification); and
 intellectual property, 115; protection of,
 172–73; tangible and intangible, 108, 173
 (*see also* wealth: intangible forms of)
cultural homogenization, 164
cultural perpetuation; and the artware
 industry, 13, 144, 166; and capitalism, 5,
 14, 169–71; and commodification, 4,
 7–8, 173
cultural property. *See* property: cultural
cultural resources. *See* culture as a resource
culturalism, 21–22, 24–25, 180*n*11
culturally modified capitalism, 146, 153; as
 the "culture-washing" of capitalism, 12;
 definition of, 5, 11–13, 172; and local
 people's agency, 14, 74; and the
 preservation of capitalism, 173; and
 sovereignty, 169–71, 174; vs Indigenous

capitalism, 172; vs organic and
 postmodern capitalism, 171; ways the
 artware industry is becoming an
 example of, 13, 22, 35, 40, 94, 111, 131,
 161, 169, 171
culturally modified tree (CMT), 2(i),
 11–12, 172–73
culture as a resource: encouragements to
 treat, 38, 59–60; nurturing vs exploiting,
 2, 8; responsibilities when treating
 another group's, 149, 160; and risk, 4,
 136, 167; stakes of treating, 22–23, 45
customization, 85, 143, 145, 160

dances, 110
Dangeli, Mike, 134(i)
Dangeli, Mique'l, 6, 110, 134(i)
Dauenhauer, Nora M., 110
David, Joe, 140
Davidson, Florence, 144
Davidson, Robert, 9, 140, 181*n*19, 197*n*24
Dawn, Leslie A., 42
debt: of the artware industry vis-à-vis
 Pacific Northwest peoples, 135; and
 credit in potlatching, 138–39,
 142, 151
Declaration of Belém, 191*n*1
Deleuze, Gilles, 189*n*6
Department of Citizenship and
 Immigration, 55
Department of Forestry, 57
Department of Indian Affairs and
 Northern Development, 44–48, 52,
 55–60, 62, 65–66, 181*n*15
Department of Mines, 40–41
deterritorialization and reterritorialization,
 72–77, 84, 86, 90–94, 165
dialogue, 121, 130, 195*n*52
diaspora, 76, 92
Diesing, Freda, 181*n*19
discrimination, 24–25. *See also* racism;
 stereotypes
discursive practices, 16–17, 22
dispossession, 13, 42–44, 58, 131; and ability
 to make a living, 55, 98; and
 accumulation, 135; and Canada's
 "history of theft," 8, 21, 25–26, 164;
 and the law, 111
distribution: circuits in the artware
 industry, 67, 74–76, 101, 152–53;

fishing and fisheries, 8, 55, 115, 144, 193*n*31

flat fees: and artist independence, 130; paid to artists to acquire the rights to their designs, 27, 102–7, 114–15, 126, 131; and trust, 111–13, 117–19; vs royalties, 102–4, 107, 111–19, 126. *See also* copyright; intellectual property (IP)

food, 8, 139, 143–44

formline design, 7

Foster, Robert J., 73

Foucault, Michel, 16

Four Host First Nations, 195*n*60

Fraser Canyon Indian Arts and Crafts Society, 54, 185*n*75

friction, 12–13, 22–23, 30–31, 35, 47, 174; and collaboration, 120–22; as defined by Anna Tsing, 31; in research relationships, 181*n*16

friendship, 23, 28, 34, 111–12, 156–57

Galanin, Nicholas, 189*n*15

galleries. *See* art galleries

Garfinkel Publications. *See* Native Northwest – Art by Native Artists

Gastown (Vancouver, BC), 3, 9

Geismar, Haidy, 193*n*30

generosity, 129, 131, 134–35; vs fulfilling an obligation, 135, 147–48

Geological Survey of Canada, 41

gift shops, 9, 152

gifts, 9, 74, 147, 196*n*5; corporate, 145–46; market, 58, 66 (*see also* gift shops); potlatch, 10, 38, 110, 134(i), 138–45, 151, 160, 197*n*25

gii-dahl-guud-sliiaay. *See* Williams-Davidson, Terri-Lynn

Gitxsan, 140, 176*n*13

giving back: and cause marketing, 154–59; to the community, 2, 14, 88, 134–37, 142, 147–53, 157; to Indigenous stakeholders, 150, 166; as respecting an Indigenous protocol, 160–61; as a responsibility and obligation, 143, 146–54

Gladstone, David, 141, 151

glass, 9, 112, 119

globalization: and the artware market, 13, 72(i), 72–77, 84, 87–94, 165; and capitalism, 12, 72, 164; and cultural homogenization, 164; pushback and

protection against, 13, 39, 65, 69, 73–74, 77, 82, 86, 90. *See also* commodityscape; deterritorialization and reterritorialization; localization and delocalization

Godman, J., 53, 185*n*72

Granville Island (Vancouver, BC), 9

Gray, Robin R., 6

Greater Vancouver. *See* Vancouver (BC)

Gunther, Erna, 53

ha'houlthee (chiefly territory, Nuu-chah-nulth), 129

Haida, 6; argillite carvings, 177*n*30, 188*n*1; artists, 63, 72(i), 81, 102–4, 114, 125, 158, 181*n*19; conceptions of property, 108–9; design, 49, 184*n*51; Nation and duty to consult, 179*n*5; potlatching, 138, 140, 144, 145, 197*n*24

Haisla, 6

Halpin, Marjorie, 138

handicrafts. *See* crafts

Hanlon, Ernestine, 193*n*29

Harvey, David, 135

hawilth (hereditary chiefs, Nuu-chah-nulth), 129

Hawker, Ronald W., 44, 190*n*29

Hawthorn, Harry B., 52–53, 55

Hayden, Cori: on bioprospecting agreements and negotiations, 8, 100, 127, 166, 192*n*14; on Indigenous self-determination, 169; on the reproduction of colonial histories, 51

Heiltsuk, 6, 140, 151

Heit, Margaret, 140

Heizer, Robert F., 139, 142

Helin, Bill, 20(i), 72(i), 194*n*47

Hobbs, Jennifer M.L., 50

Hoey, R.A., 47–48

Holm, Bill, 7

honesty, 112–14, 149

hope: vis-à-vis culturally modified capitalism, 35, 169, 173; vis-à-vis the Indigenous art market and artware industry, 39, 46, 53, 127, 155, 165, 168

Hudson, Clarissa, 193*n*29

Hudson's Bay Company, 49; blanket, 141

Hunt, Tony, 9, 181*n*19

Phillip, Ruth B., 120
Phillip, Stewart, 128
Pickford, Arthur E., 49–50, 52–53, 184*n*51
Piddocke, Stuart, 196*n*12
Pink Ribbon campaign against breast
cancer, 154, 197*n*41
plastic, 9, 84, 143, 190*n*17, 197*n*25
Point, Susan, 9
political economy, 72, 86, 164, 169, 172
Ponte, Stefano, 155, 198*n*44
Posey, Darrell, 96, 191*n*1
potlatch gifts and goods, 38, 110, 134(i),
138–46, 164, 197*n*25; artware as, 10,
143–46, 160, 166; shopping for, 143,
197*n*23
potlatching: academic studies of, 6,
137–40, 151; and art, 137; and the artware
industry, 2, 143–46, 159–60, 166–67;
definition of, 137; differences among
NWC cultural groups, 196*n*6; and the
effects of colonialism and capitalism,
166, 174; as "food-for-wealth" exchange,
138; government banning of, 38, 47, 54,
166; and Indigenous laws, 109; as an
institution central to NWC societies, 6,
38, 164, 166; and money, 140–41, 143–44,
151; ongoing practice of, 6, 38, 54–55, 110,
140, 145–46, 174; parallel with corporate
gift giving, 145–46, 197*n*34; and
redistribution, 14, 134–35, 138–42, 146–47,
166; and witnessing, 110, 138–41, 159
pottery. *See* ceramics
poverty, 8, 30, 44, 146, 152, 167, 170–72
power: abuses of, 24–25, 33, 114, 156;
balance/imbalance, 24, 26–33, 96–97,
100, 121, 127–28, 130, 166, 192*n*13,
194*n*42; and capital, 169; entrenched
dynamics of, 23, 100, 127, 174;
rearrangements of, 31, 38, 120–21,
127–28, 166, 169, 174
pride: and cultural commodification, 4, 23;
to have products in a particular store,
124; and international recognition,
50, 75; and the perpetuation of culture,
47, 174
prints and printing, 9, 63–64, 80, 84–85,
197*n*25; silkscreen, 62–63, 141, 145; on
textiles, 53, 85
privileges. *See* rights: and privileges or
prerogatives

product and production fetishism, 73, 127
product development, 49, 56, 61, 152–53,
192*n*14; artist involvement in, 104–5,
120–24, 126
productive tensions, 21, 93, 169
profit: distribution in the art market and
artware industry, 29, 32–33, 61, 100,
104–6, 118; gained from capitalizing on
Indigenous culture, 24, 39–40, 42, 57,
107, 147, 152, 158; as a motive, 11, 63,
86, 102, 115, 124, 134, 149, 153–54;
redistribution to a cause, 154–55, 157–58;
as a return on investment, 8, 136; as a
reward for taking risks, 136
profitability, 2, 33, 90, 124–25, 153
property: collective, 57, 98–99, 108–10, 115,
180*n*12; cultural, 42, 77, 89, 108, 165; and
Indigenous art and cultural expression,
48, 57, 92, 111; Indigenous regimes of, 5,
13, 84, 97–98, 107, 109–11, 131–32, 160,
180*n*12, 193*n*20; language of, 4, 98;
private, 11–12, 136, 144, 155;
redistribution and transfer of, during
potlatches, 137–40, 167; Western vs
Indigenous concepts of, 97–99, 130–31,
137. *See also* intellectual property (IP);
stewardship
protectionism: and competition from
imitations and outsiders, 13, 39, 51, 62,
68–69, 83; and globalization, 13, 86,
92–93. *See also* expansionism
protocols, 109–10, 120, 140, 147, 160,
180*n*12
public domain. *See under* intellectual
property (IP)
Pueblo, 51

quality: control, 63, 88; of images being
reproduced, 53, 104–5; of products, 25,
45, 52, 58, 60, 124, 187*n*103
Quebec habitant designs, 50

racism, 21, 24–25. *See also* stereotypes
Raley, George H., 43–46, 53, 62, 68, 83,
190*n*26
rank. *See* status
Ravenhill, Alice: and ambiguous
relationship with cultural appropriation,
49–51, 82, 190*n*24; and authenticity
seals, 183*n*30, 185*n*63; and Emily Carr,

182*n*18; as president of the British
Columbia Indian Arts and Welfare
Society, 45–53, 64; reproductions of
NWC designs by, 42, 46, 182*n*12; views
on art education in residential and day
schools, 47–48, 52; views on developing
the Indigenous art market, 62, 68; work
with W.A. Newcombe, 182*n*12

reciprocity: in the artware industry, 118,
134, 147–48, 156, 160; and building
relationships, 18, 118, 132, 150; as a core
principle in NWC societies, 8, 134–35,
137, 147; generalized, balanced, and
negative, 146–50, 159–60, 166, 197*n*36;
and potlatching, 2, 134, 139

RED products, 198*n*44

redistribution: and accumulation, 13–14,
142, 160; in the artware industry, 33, 84,
135, 142, 150–51, 155; as a business
model's core principle, 166; and cause
marketing, 154–55, 159; and corporate
social responsibility, 155; as ecological
subsistence management, 138–39; and
equity, 100, 106, 135; in NWC societies,
11, 14, 135, 137, 140, 146, 159–61; as an
obligation, 134, 142, 147–53, 160,
166–67, 197*n*36; and protocols, 144–47,
160; to restore balance, 135, 139; as a
show of respect, 151; and status,
134–35, 138–39, 141–42, 156–59;
understood in capitalist and corporate
terms, 136, 148. *See also* accumulation;
giving back; potlatching

Regent Knitting Mills, 49

Reid, Bill, 9, 81

relationality, 100, 120, 127–28, 130–32, 137;
ethical, 23, 181*n*13

relationships. *See* business relationships;
Indigenous/non-Indigenous
relationships

repatriation, 65

reputation: in the artware industry, 14, 28,
123, 125, 142, 156, 160, 167; and the
circulation of criticism, 16–17, 134,
156–57; and collaboration, 125; and
corporate social responsibility, 155; and
potlatching, 138, 142; reputational
capital, 17, 135, 142, 155, 159; and the
witnessing of redistribution practices,
138, 142, 156–57. *See also* status

research: academic, 5–6, 137; and
collecting, 74; ethics, 192*n*13; methods,
14–17, 178*n*45, 182*n*5; and trust, 181*n*16

residential and day schools, 26, 43–48, 52,
179*n*54

resources. *See* culture as a resource; natural
resources

respect: between individuals, 18, 24, 34, 113,
116; of Indigenous artists, 25, 28, 125; of
Indigenous culture, social structures,
laws, and economic principles, 5, 110–11,
117, 122, 149, 151, 160, 172; as a principle,
129, 131; self-respect, 46; of treaties, 17

responsibility: and reciprocity, 2, 8, 147–51,
156–57; to seek political relationships,
128; social, 8, 178*n*39; of stewards of
cultural heritage and property, 23,
108–10, 115, 139, 143; vis-à-vis Indigenous
artists and communities, 2, 30, 34, 43,
96(i), 99, 115, 134–37, 147–53, 157,
159–60; as a witness, 2, 139, 197*n*36. *See
also* corporate social responsibility (CSR)

retail stores: and NWC artware's local
network of distribution, 73, 75, 77;
prices, margins, markups, 57, 60, 80, 87,
105–6, 186*n*95, 193*n*15; and product
development, 123–24, 152; product
selection and exclusion, 25, 58, 86–88,
91, 102, 122, 125, 149, 187*n*103;
relationships with and treatment of
Indigenous artists and companies, 25,
29, 105, 125, 149; and shopping for
potlatch goods, 142–45, 197*n*23. *See also*
gift shops

reterritorialization. *See* deterritorialization
and reterritorialization

Richey, Lisa Ann, 155, 198*n*44

rights: to access territory and resources, 11,
144; to an image or design (*see*
copyright; flat fees; intellectual property
[IP]; royalties); of Indigenous peoples
(*see* Aboriginal rights and title;
Indigenous rights); to making and
selling Indigenous art, 116, 180*n*12; and
privileges or prerogatives, 108–11,
137, 139

risks: of cultural appropriation, 86, 89; and
cultural commodification, 4, 23, 89, 116,
136, 167; of a global artware market,
89–90, 165; of participating in the

artists and artware companies, 16, 18, 111–13, 116–19; between artware companies and consumers, 12; between Indigenous and non-Indigenous peoples, 17–18, 24–26, 107–8, 116–17; between researcher and community members, 15–16, 181n16

Truth and Reconciliation Commission, 179n54

Tseshaht, 144

Tsetsaut, 134(i)

Tsimshian, 6; artists, 20(i), 72(i), 100, 112, 119, 134(i); concepts of property and stewardship, 110; potlatching, 139, 146; society and capitalism, 11

Tsing, Anna L., 31, 174, 181n21

Tsleil-Waututh, 6

Tullis, A.J., 53

uncertainty. *See* certainty and uncertainty

Union of British Columbia Indian Chiefs, 128

United Church of Canada, 45

United Kingdom, 187n116

United Nations, 134

United States, 41, 46, 50, 51, 75, 81, 181n3; Southwest, 7, 75

University of British Columbia, 52–56

Uquillas, Jorge E., 172

urban centres and Indigenous peoples and cultures, 3, 6, 30, 144, 176n15

Vancouver (BC): as a field site, 6, 14–15; as a hub of the Northwest Coast art market, 4, 6–7, 9, 12–15, 72(i), 75, 86, 92, 198n48; Indigenous residents of, 6, 176n15; omnipresence of Northwest Coast design in, 3–4

Vancouver Art Gallery, 50

Vancouver Organizing Committee for the 2010 Olympic and Paralympic Winter Games (VANOC), 190n23, 195n60, 197n34

Vancouver School of Art, 50

Vancouver Tourist Association, 191n30

Vayda, Andrew P., 196n12

Victoria Memorial Museum, 40

voice: in archival records, 182n6; dispossession of, 111; and expressing opposition and criticism, 8, 74, 83, 120, 128, 137, 170, 199n11; and identity, 137; and instigating change, 17, 40

vulnerability: and ability to negotiate, 24, 27–29, 131, 151; to criticism, 24; taking advantage of, 114, 120

Walsh, Anthony, 48, 184n44

watleth [*wáahlaal*] (potlatch, Haida), 144

Watson, Scott, 48

wealth: accumulation vs redistribution, 11, 14, 135, 138–42, 160; drawn from the territory, 144; fair and unfair distributions of, 38, 96, 135; inalienable, 139; and indigeneity, 135; intangible forms of, 139–40, 151–52, 167–68, 173; personal, 135; and status, 138–42. *See also* economic development and prosperity in Indigenous communities

weaving, 12, 44, 47, 111, 145

Weber, Max, 10

West African: designs, 49; vendors, 76

Western: economic values, 42; display conventions, 109; worldviews, 141–42

Weston, Kath, 15

Whalen, B.A., 40

White, Douglas, 109, 111, 137

white guilt, 148–49

wholesaling, 59–62, 76, 87; and corporate gift giving, 145; and potlatch hosts, 160; and wholesale prices, 87, 103, 145

Williams-Davidson, Terri-Lynn, 108

witnessing: during potlatches, 110, 134(i), 138–43, 167, 197n36; of practices of redistribution in the artware industry, 156–61

Women's Institute, 42

World Bank, 172

Wuikinuxv, 176n13

Xwalacktun, 20(i)

Yup'ik, 169

Žižek, Slavoj, 155, 171, 198n42